LIVING IN TUSCANY

Photos and texts by BARBARA & RENÉ STOELTIE et al.
Edited by ANGELIKA TASCHEN

TASCHEN

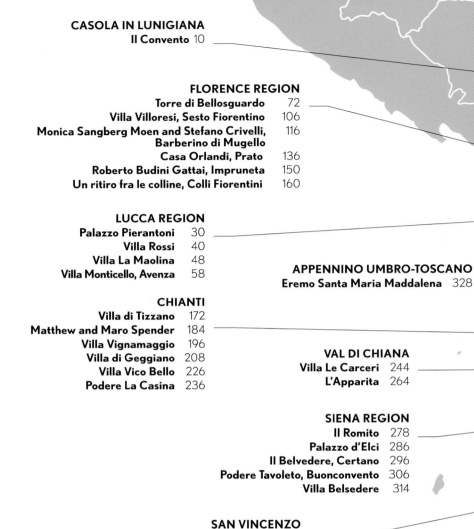

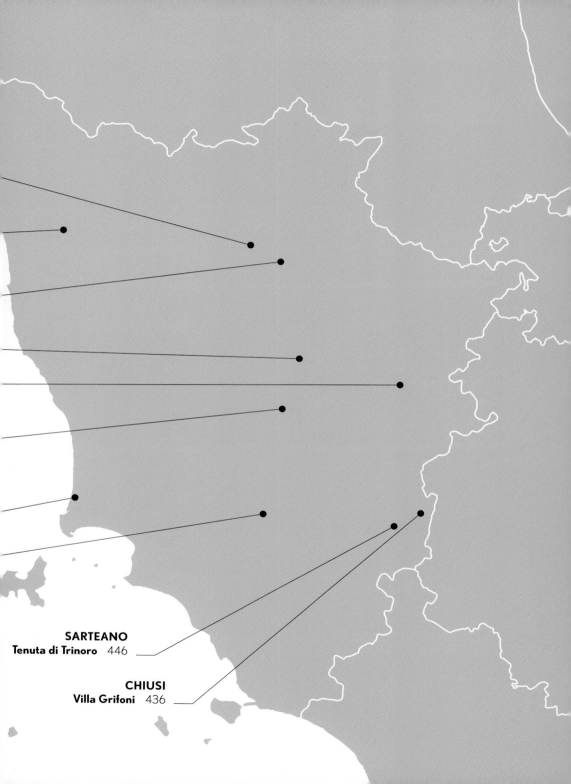

CONTENTS

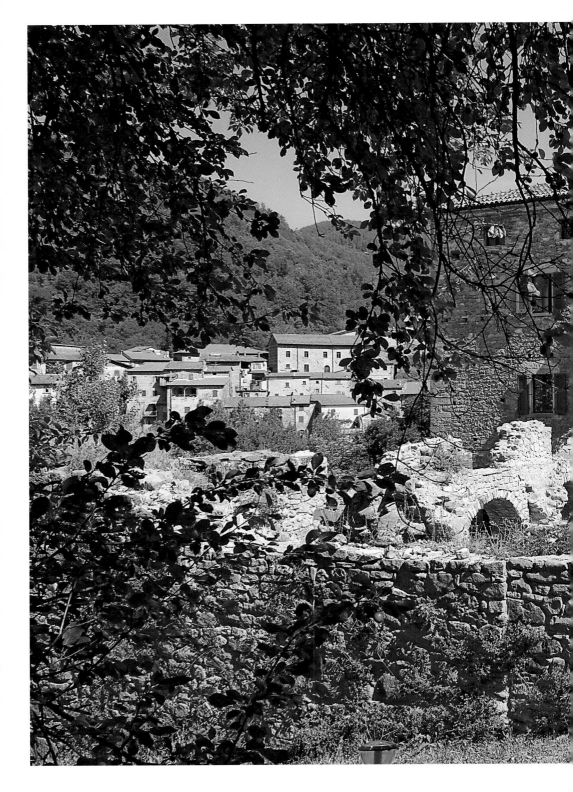

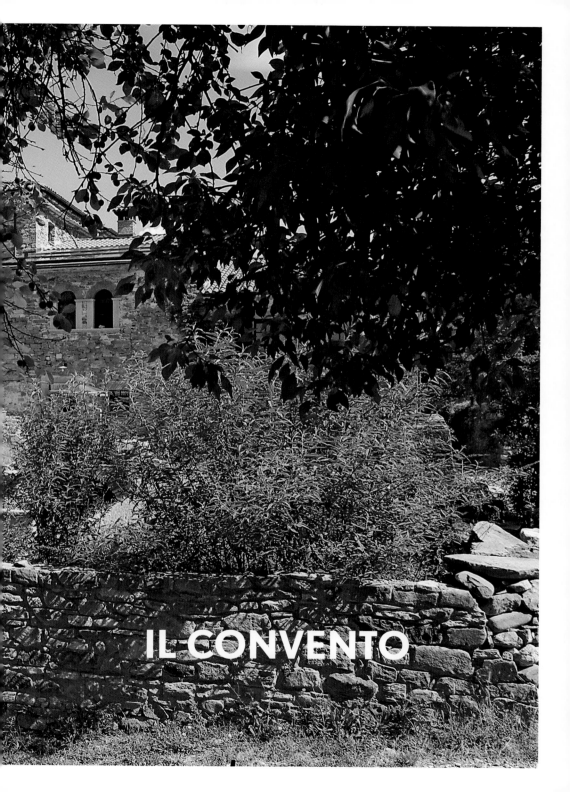

IL CONVENTO

IL CONVENTO
CASOLA IN LUNIGIANA

Il Convento, built in 1549, accommodated the nuns of Santa Marta for over three centuries. St Martha is the patron saint of housekeeping and often depicted with cooking utensils and a bunch of keys, but she is also responsible for painters and sculptors. Lunigiana, an area of countryside between Parma and Florence as yet little developed for tourism, captivates through its green hills, vineyards, endless chestnut forests, olive groves and river sources. In the vault of the former wine cellar, yoga is now practised; guests sleep in simple whitewashed rooms and read by the fireplace. The overall impression is still somewhat monastic, but in compensation the view into the valley is anything but restrained, and the cuisine is sensually Italian. You can, by the way, also find accommodation as a working guest and participate intellectually and materially, directly or indirectly in this small family's big project to create a place of peace and contemplation.

Il Convento, 1549 gebaut, beherbergte über drei Jahrhunderte den Frauenorden Santa Marta, der heiligen Martha, die als Patronin der Häuslichkeit gerne mit Kochgerät und Schlüsselbund dargestellt wird, aber auch für Maler und Bildhauer zuständig ist. Die Lunigiana, eine touristisch noch wenig erschlossene Landschaft zwischen Parma und Florenz, besticht durch ihre grünen Hügel, Weinberge, endlosen Kastanienwälder, Olivenhaine und Quellflüsse. Im Gewölbe des ehemaligen Weinkellers wird jetzt Yoga geübt, in weiß gekalkten, schlichten Zimmern wird geschlafen, am Kaminfeuer gelesen. Die gesamte Anmutung ist noch immer etwas klösterlich, dafür ist der Blick ins Tal alles andere als zurückhaltend und die Küche sinnlich italienisch. Man kann übrigens auch als Working Guest unterkommen und sich gedanklich und materiell, direkt oder indirekt beteiligen am großen Lebensprojekt der kleinen Familie, einen Ort der Ruhe und Selbstbesinnung zu schaffen.

Il Convento, construit en 1549, hébergea pendant plus de trois siècles l'ordre religieux féminin Santa Marta, de sainte Marthe patronne des foyers, souvent représentée munie d'ustensiles de cuisine et d'un trousseau de clés, également patronne des peintres et sculpteurs. La Lunigiane, région encore peu ouverte aux touristes entre Parme et Florence, séduit par ses vertes collines, ses vignobles, ses infinies forêts de châtaigniers, ses bosquets d'oliviers, ses sources jaillissantes. Sous la voûte de l'ancien cellier ont lieu désormais des séances de yoga, les austères chambres blanchies à la chaux invitent au sommeil, les feux de cheminée à la lecture. Si l'atmosphère générale est restée quelque peu monastique, le panorama de la vallée est des plus vastes et la cuisine italienne succulente à souhait. De plus, il est possible d'y séjourner en tant que *working guest*, en participant sur le plan spirituel et matériel, directement ou indirectement, au grand projet d'ensemble de la petite famille : créer un lieu de paix et de recueillement.

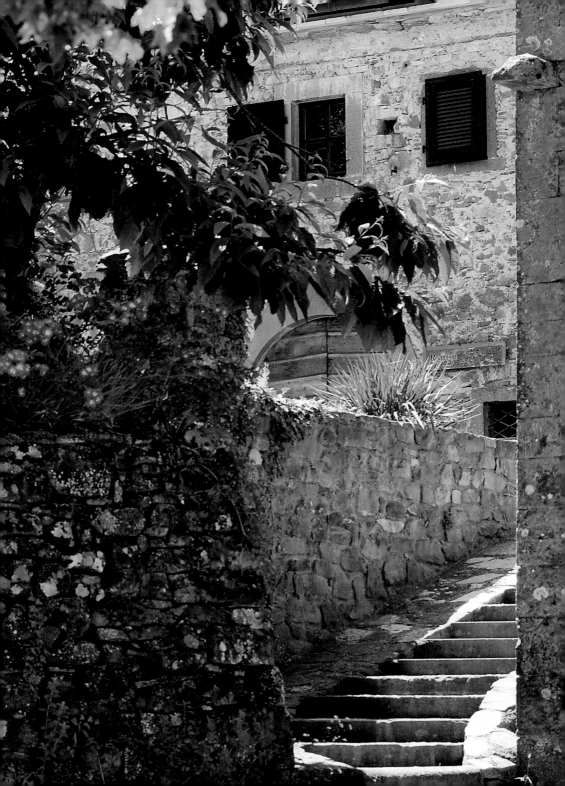

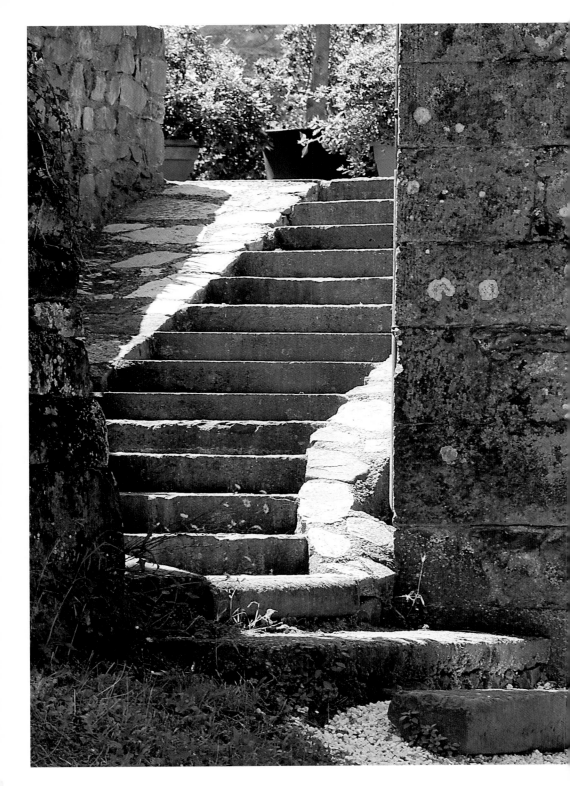

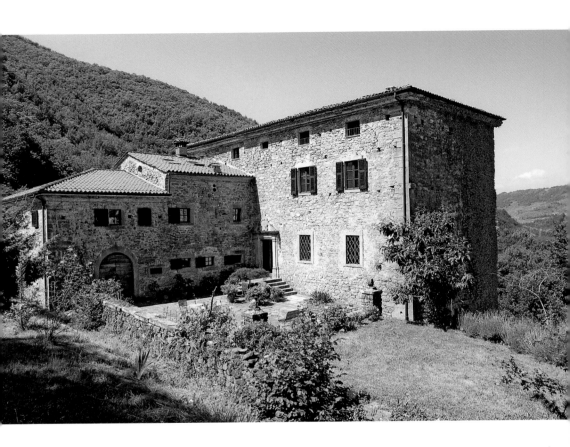

PP. 10–11 The old convent of Santa Martha is no longer home to nuns of the order named after their patron saint. It now offers bed and board to yoga devotees and anyone looking for a quiet refuge off the beaten track. • Das einstige Kloster Santa Marta beherbergt die Nonnen des Ordens, der den Namen ihrer Schutzpatronin trug, schon lange nicht mehr. Heute wird hier Yogaschülerinnen und -schülern und all jenen Unterkunft geboten, die auf der Suche nach einem stillen Ort abseits der Trampelpfade sind. • Le vieux cloître de Santa Martha n'abrite plus les religieuses de

l'ordre qui portait le nom de leur dame patronnesse et de nos jours il offre le gîte et le couvert aux adeptes du yoga et à tous ceux qui sont en quête d'un refuge paisible, loin des sentiers battus.

P. 13 Built from rough stones of unequal sizes, old Tuscan houses cast an irresistible spell on anyone who happens upon them. • Die aus ungleichmäßig und grob behauenen Quadersteinen errichteten alten toskanischen Wohnsitze üben auf jeden, der sie auf seinen Wegen entdeckt, eine unwiderstehliche Anziehungskraft aus. • Construites

avec des pierres de taille irrégulières et rugueuses, les vieilles demeures Toscanes exercent un charme irrésistible sur tous ceux qui les rencontrent sur leur chemin.

PP. 14–15 Set against a high wall, stone steps lead to a sundrenched terrace brimful of pot plants. • Eine an einer hohen Mauer entlangführende steinerne Treppe endet an einer von Topfpflanzen überwucherten sonnigen Terrasse. • Adossé contre un haut mur, un escalier en pierre conduit vers une terrasse ensoleillée envahie par des plantes en pot.

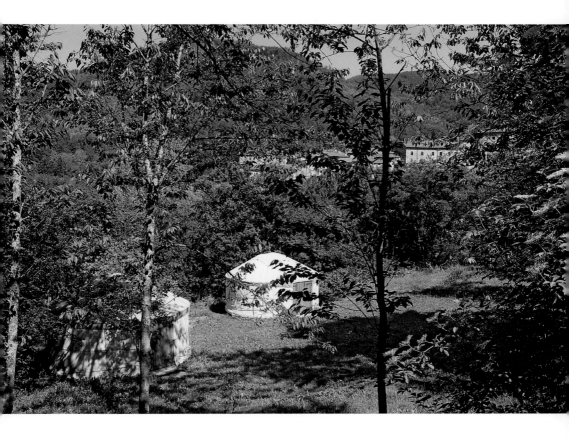

↖ Standing halfway between the green hillside and the Lunigiana valley, the former convent offers an unrestricted view of the surrounding countryside. • Das einstige, auf halbem Wege zwischen einem grünen Hügel und dem Tal der Region Lunigiana errichtete Kloster, bietet eine unverbaubare Aussicht auf die umgebende Landschaft. • Construite à mi-chemin entre la colline verdoyante et la vallée de la Lunigiane, l'ancien couvent offre une vue imprenable sur le paysage environnant.

↑ Yurt-style tents have been erected on the green space below the villa to provide shelter for guests during seminars. • Auf einem grünen Flecken unterhalb der Villa wurden ein paar Jurten aufgebaut. In solchen traditionellen Rundzelten der Nomaden Zentralasiens werden die Kursteilnehmer untergebracht. • Quelques tentes du type « yurt » ont été érigés dans l'espace vert en contrebas de la villa, pour abriter les hôtes pendant les séminaires.

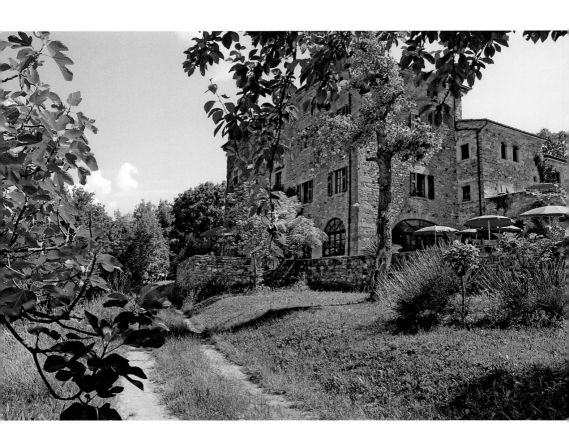

↑ Approached from the direction of
the convent, the imposing silhouette
of the villa, and the large blue parasols
protecting guests from the burning sun,
can already be seen from afar. • Schon
von Weitem ist die imposante Silhou-
ette von Il Convento zu sehen. Nähert
man sich, sind auch die großen blauen
Sonnenschirme erkennbar, die die
Gäste vor den sengenden Strahlen der
Sonne schützen. • En s'approchant
d' Il Convento on aperçoit déjà de loin
la silhouette imposante de la villa et les
grands parasols bleus qui protègent
les hôtes du soleil brûlant.

↓ The terrace is the ideal place to dine al fresco, while enjoying an uninterrupted view across the beautiful, rolling countryside. • Die Terrasse ist der ideale Ort, um die Mahlzeiten im Freien – „al fresco", wie es hier heißt – einzunehmen und dabei den freien Blick auf die schöne, sanft gewellte Landschaft mit ihren Hügeln zu genießen. • La terrasse est l'endroit par excellence pour prendre les repas « al fresco » et de profiter de la vue imprenable sur le beau paysage ondulant.

PP. 20-21 Beneath the dining room's vaulted ceiling, the convent's guests take their meals in a typically restrained monastic setting. • Wird drinnen gegessen, sitzen die Gäste im Speisesaal des Il Convento, dessen Gewölbe ein beispielhaft schlichtes, mönchisches Ambiente zu bieten hat. • Sous la voûte de la salle à manger, les hôtes de Il Convento prennent leur repas dans un décor monacal d'une sobriété exemplaire.

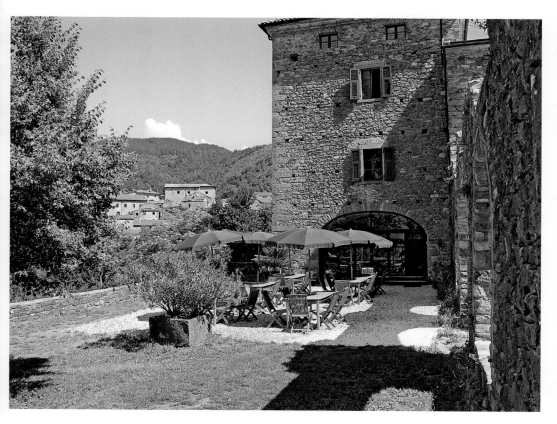

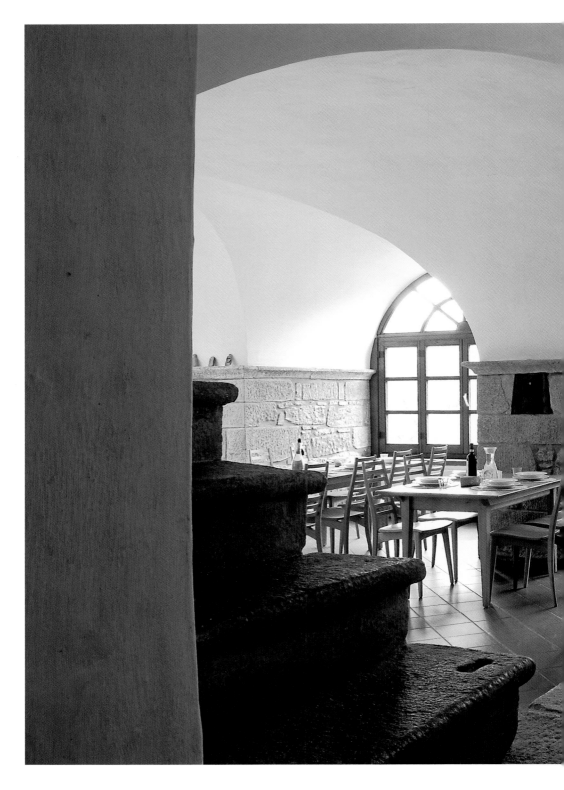

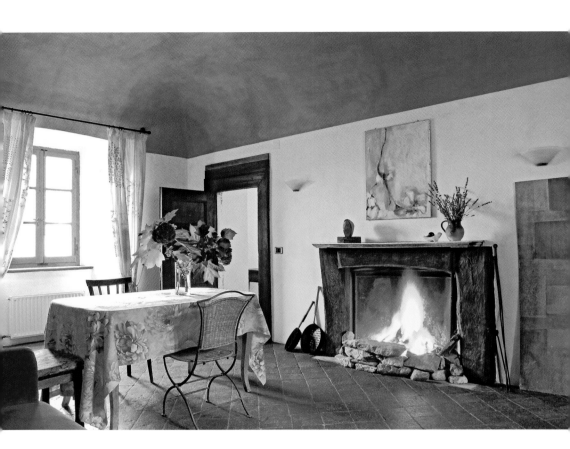

↑ There is nothing quite like an open fire crackling away in the grate, especially when the days and nights get cooler. • Nichts geht über ein prasselndes, wärmendes Feuer im Kamin, vor allem wenn die Tage und Nächte mit kühleren Temperaturen aufwarten. • Rien ne vaut un bon feu de cheminée qui crépite dans l'âtre, surtout quand les jours et les nuits se font plus frais.

→ In the monumental fireplace, the wood fire has made way for a still-life composed of a terracotta jar and a large olive branch. • Hier musste das Holzfeuer eines riesigen Kamins einem aus einem Tongefäß und einem großen Olivenzweig komponierten Stillleben weichen. • Dans une cheminée monumentale le feu de bois a cédé la place à une nature morte composée avec une jarre en terre cuite et une grand branche d'olivier.

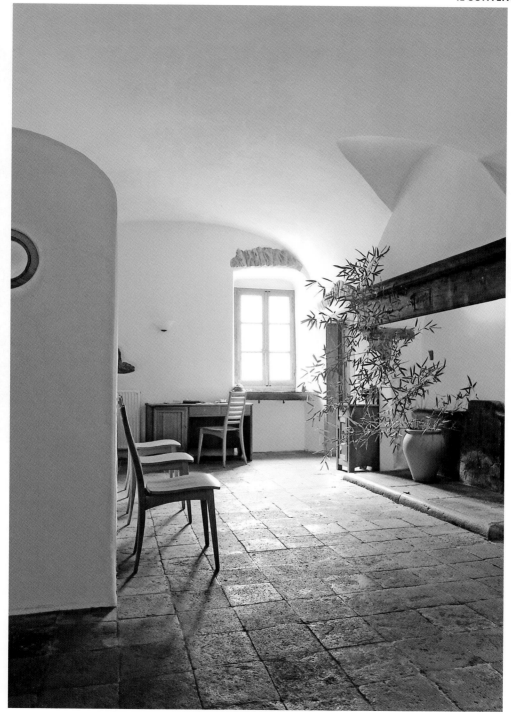

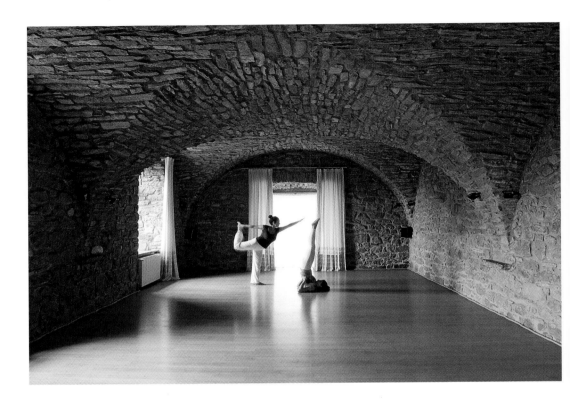

↑ In the basement of the villa, a vast space with exposed stone walls has been spruced up with a light wooden floor, creating ideal conditions for guests to practise yoga. • Ein riesiger Raum im Untergeschoss mit einem Gewölbe und Wänden aus unverputztem Stein wurde mit einem Parkett aus hellem Holz verschönert. Hier können die Gäste ihre Yoga-Übungen unter idealen Bedingungen absolvieren. • Dans le sous-sol de la villa un énorme espace voûté aux parois en pierres apparentes a été agrémenté d'un parquet en bois clair. Il permet aux hôtes de pratiquer le yoga dans des conditions idéales.

→ Yoga must be practised in a place where there are no visual distractions. The white walls and the big stucco spiral surrounding the œil-de-bœuf window both contribute to the spiritual wellbeing of those taking part. • Eine Umgebung für Yoga-Übungen sollte möglichst frei von visuellen Ablenkungen sein. Die weißen Wände und die große Spirale aus Stuck, die ein Rundfenster umschließt, befördern das spirituelle Wohlbefinden der Yogaschüler. • La pratique du yoga exige un entourage exempt de distractions visuelles. Les murs blancs et la grande spirale en stuc qui entoure une fenêtre en œil-de-bœuf contribuent au bien être spirituel des pratiquants.

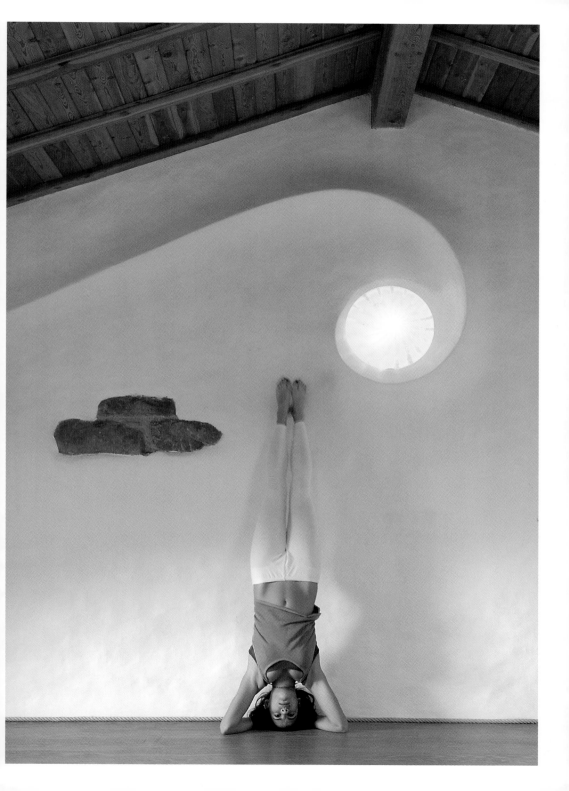

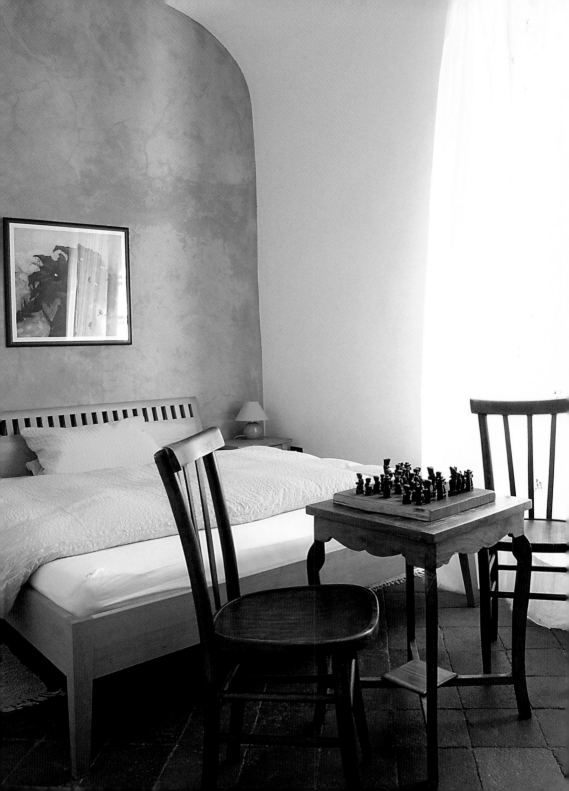

← This bedrooms has been simply furnished, with the wall behind the bedhead painted blue to match the colour of the sky. • Die Wand hinter dem Kopfende des Bettes in einem der sparsam möblierten Zimmer wurde Blau gestrichen, um die Farbe des Himmels zu evozieren. • Une des chambres a été meublée sobrement et le mur derrière la tête de lit à été peint en bleu pour rappeler la couleur du ciel.

↑ In one of the rooms, a large adobe alcove with a chest-high wall divides the "sitting room" from the bedroom. • Ein großer, von einer brusthohen Mauer eingefasster Alkoven trennt in einem der Zimmer die bequeme Sitzecke vom Schlafbereich. • Dans une des chambres, une grande alcôve en adobe équipée d'un mur à hauteur d'appui, sépare le coin « relax » de la partie « chambre à coucher ».

↑ A few stones left exposed in the stuccoed walls produce a surprising effect and show considerable originality. • Die Entscheidung, einige der unbehauenen Steine aus den ansonsten verputzten Wänden herausragen zu lassen, sorgt für einen überraschenden Effekt und zeugt von großer Originalität. • Le fait d'avoir gardé quelques pierres apparentes sur des murs couverts de stuc, crée un effet surprenant et témoigne d'une grand originalité.

→ Understated décor and simple furniture together set the mood in this brightly lit room, creating a perfect match for the white walls and the high ceiling in pale-coloured wood. • In diesem hellen Zimmer ist alles auf Schlichtheit gestimmt, und das einfache Mobiliar klingt perfekt mit den weißen Wänden und der hohen Holzdecke zusammen. • Dans cette chambre haute et claire le ton est la simplicité et le mobilier sobre se marie parfaitement aux murs blancs et au plafond en bois blond.

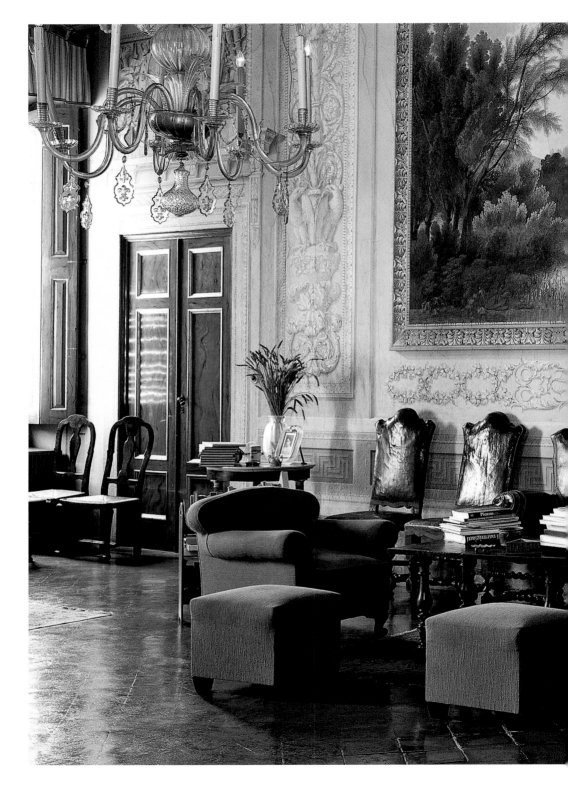

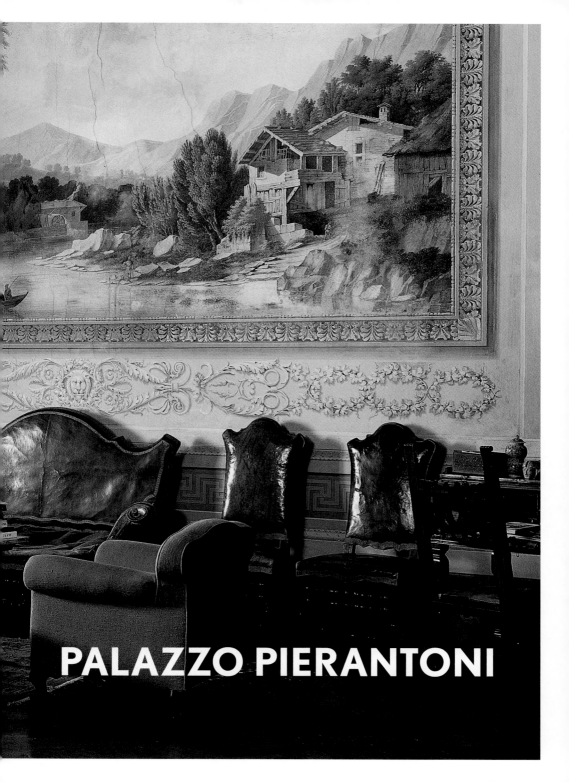

PALAZZO PIERANTONI

PALAZZO PIERANTONI
LUCCA

The first major building to be erected in Lucca after the medieval era was the one built in 1418 by Paolo Guinigi, who was "Signore", or ruler, of Lucca. Today it is known as Palazzo Pierantoni. Entry is through a hall with a great staircase leading up to the *piano nobile*. A spacious reception room occupies the entire depth of the building from the façade to the rear. Throughout the first floor, the walls are painted in a simulated wood effect, and there is a wealth of stuccos, festoons and trompe-l'œil friezes. The furnishings bear witness to a notable eclecticism of taste. Chairs upholstered in old Luccan silk stand next to 18th-century Venetian dressers, and family portraits rub shoulders with still lifes and old masters. One of the bedrooms has been decorated in a style inspired by Pompeii, and a bathroom installed in the Thirties flaunts a décor incorporating Greek inscriptions.

Paolo Guinigi, „signore" von Lucca, ließ 1418 den ersten bedeutenden neuzeitlichen Palazzo der Stadt errichten. Das heute als Palazzo Pierantoni bekannte Gebäude verfügt über ein Atrium, von dem eine prachtvolle Treppe in das „piano nobile" führt, dessen Wände aufwendig in Holznachbildung bemalt sind. Hier liegt auch ein Salon von riesigen Ausmaßen, der sich über die gesamte Tiefe des Gebäudes erstreckt. Staunend wandert der Blick über reiche Stuckverzierungen, gemalte, prächtige Girlanden und Friese in Trompe-l'Œil-Technik. An den Wänden prunken Familienporträts und Stillleben Alter Meister. Neben venezianischen Kommoden des 18. Jahrhunderts stehen Stühle, die mit alten, in Lucca gefertigten Seidenstoffen bezogen sind. Jeder Raum hat seinen eigenen eklektizistischen Charme, das Schlafzimmer im pompejanischen Stil ebenso wie das mit griechischen Zitaten geschmückte Badezimmer aus den 1930er-Jahren.

Paolo Guinigi, « signore » de Lucques entre 1400 et 1430, a fait édifier en 1418 le Palazzo Pierantoni, le premier grand édifice de la Renaissance de la ville. On y accède par un atrium depuis lequel un grand escalier mène au « piano nobile ». Là, un vaste salon occupe tout l'espace compris entre la façade et l'arrière du bâtiment. Au premier étage, on trouve partout des murs peints en faux bois, des pavements décorés, des stucs, des festons et des frises en trompe-l'œil. L'ameublement très éclectique comporte des chaises tapissées de soie ancienne de facture lucquoise, des commodes vénitiennes du 18e siècle, des portraits de famille, des natures mortes et des tableaux grandioses ; enfin, une salle de bains ajoutée dans les années trente, ornée de citations grecques, répond à une chambre à coucher meublée en style pompéien.

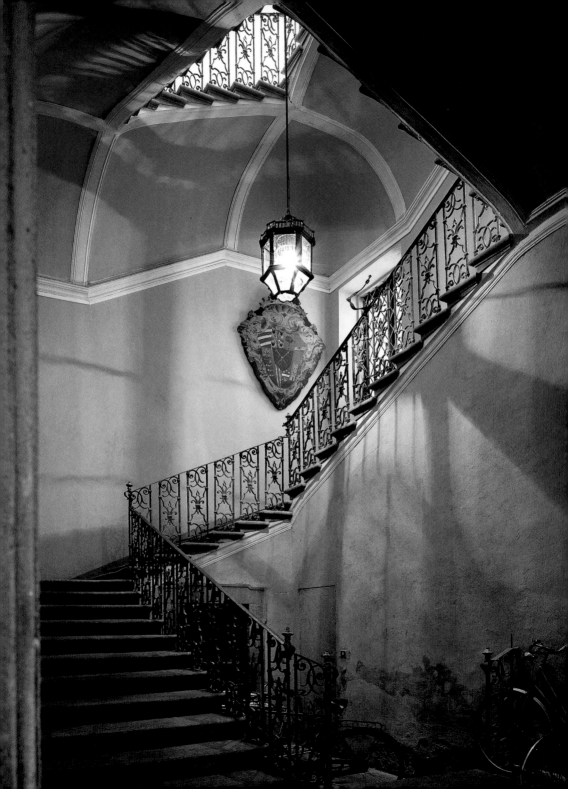

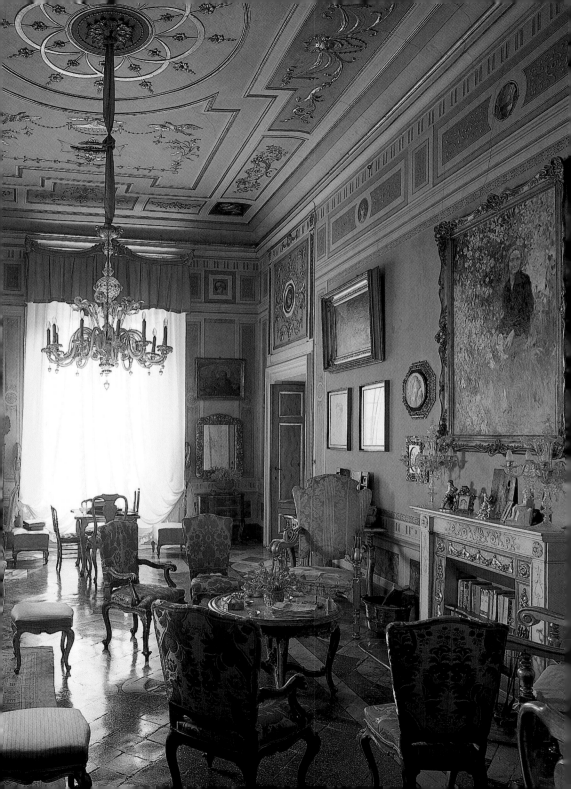

PP. 30–31 Walls and ceiling of the main reception room are richly decorated with gilt stucco. The chandelier is in Murano glass. Under an 18th-century painting there are chairs and furniture from a number of different periods. • Der zentral gelegene Salon mit dem Kristalllüster aus Murano ist an Wänden und Decke reich mit vergoldetem Stuck verziert. Vor dem Gemälde aus dem 18. Jahrhundert gruppieren sich Sitzgelegenheiten aus verschiedenen Jahrhunderten. • Les murs et le plafond du salon central sont richement décorés de stuc doré. On remarque un lampadaire

en cristal de Murano, des fauteuils et des meubles de différentes époques.

P. 33 The great staircase leading up to the first floor. • Die monumentale Treppe führt hinauf zum Hauptgeschoss. • L'escalier monumental qui mène à l'étage noble.

← A drawing room with fireplace in Carrara marble, family portraits, still lifes, a glass chandelier from Murano, silks from Lucca and a gilt stucco ceiling. • Der kleine Salon mit einem Kamin aus Carrara-Marmor, Familienporträts,

Stillleben und einem Leuchter aus venezianischem Muranoglas. Die Sitzmöbel aus dem 18. Jahrhundert sind mit in Lucca gefertigten Seidenstoffen bezogen. • Ce salon présente une cheminée de marbre de Carrare, des portraits de famille, des natures mortes, un lampadaire en cristal de Murano, des sièges de facture lucquoise et un plafond orné de stuc doré.

↑ An 18th-century chest of drawers. • Eine Kommode aus dem 18. Jahrhundert. • Une commode du 18e siècle.

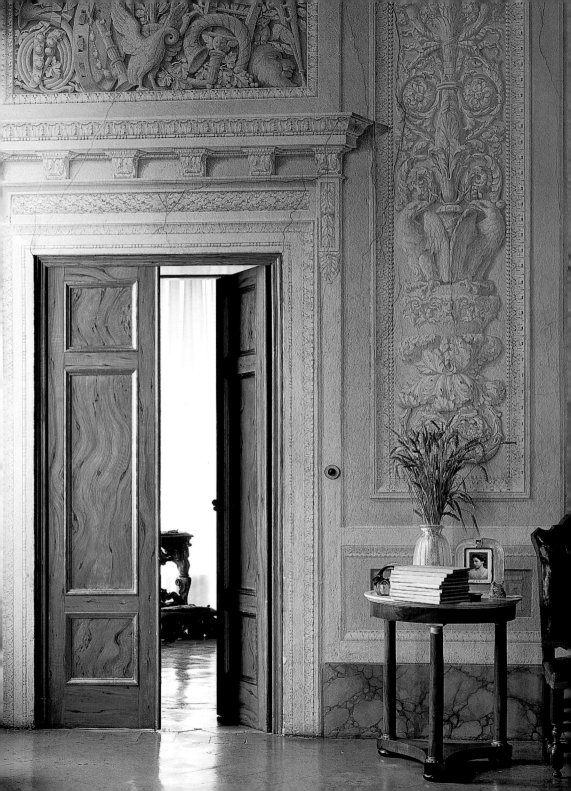

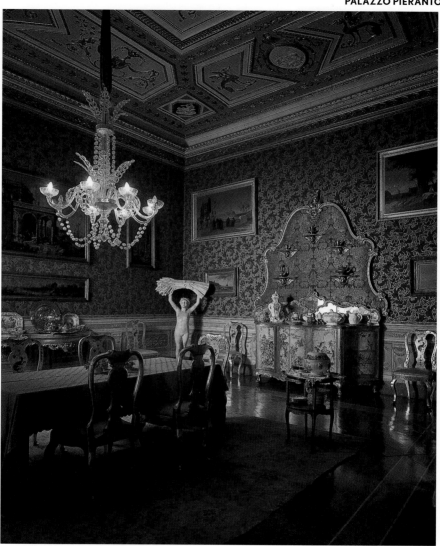

← A detail of the main reception room decorated in neoclassical style with an abundance of trompe-l'œil effects, including the wood-effect door. • Detailansicht der klassizistischen Trompe-l'Œil-Motive im Salon. Selbst die Tür ist mit einer Holznachbildung versehen. • Un détail du salon de style néoclassique, entièrement en trompe-l'œil, y compris la porte en faux bois.

↑ The sumptuous dining-room décor brings together locally made chairs and furniture from Venice under a gilt stucco ceiling. • Im opulent ausgestatteten Esszimmer finden sich Stühle aus Lucca neben Möbelstücken aus Venedig. Die Decke schmücken Dekorationen aus vergoldetem Stuck. • Dans la salle à manger richement décorée, des sièges de facture lucquoise jouxtent des meubles vénitiens. Le plafond de cette salle est aussi orné de stuc doré.

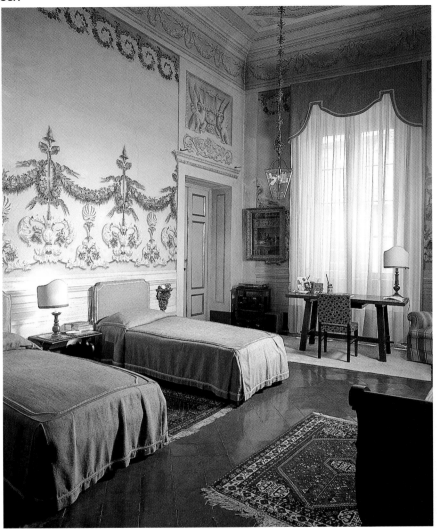

↑ The bedrooms' ceilings and walls are richly painted with friezes and festoons. • Gemalte Girlanden und Friese zieren Wände und Decken der Schlafzimmer. • Les chambres à coucher sont ornées de frises et de festons peints.

→ The bathroom was decorated in the Thirties with marine motifs. The shell-shaped soap dish and sconce continue the sea-related theme. The quotations in ancient Greek are taken from Homer's *Odyssey*. The one over the mirror means

"Water is finest" and the other, on the wall reflected in the mirror, is the verse that describes Odysseus watching Nausicaä bathing. • Das in den 1930er-Jahren entstandene Badezimmer schmücken gemalte Meeresmotive. Seifenhalter und Wandleuchter sind in Muschelform gehalten. Die griechischen Zitate stammen aus der *Odyssee*. Über dem Spiegel steht: „Wasser ist wunderschön", während die im Spiegel sichtbaren Schriftzeichen ein Ausspruch des Odysseus sind, der das Bad der

Nausikaa beobachtet. • La salle de bains réalisée dans les années trente est décorée de motifs peints à thème maritime. Le porte-savon et les appliques murales sont en forme de coquillage. Les citations grecques sont tirées de l'*Odyssée*. Au-dessus du miroir, on peut lire : « Excellente est l'eau », et les caractères visibles dans le miroir illustrent une déclaration d'Ulysse observant le bain de Nausicaa.

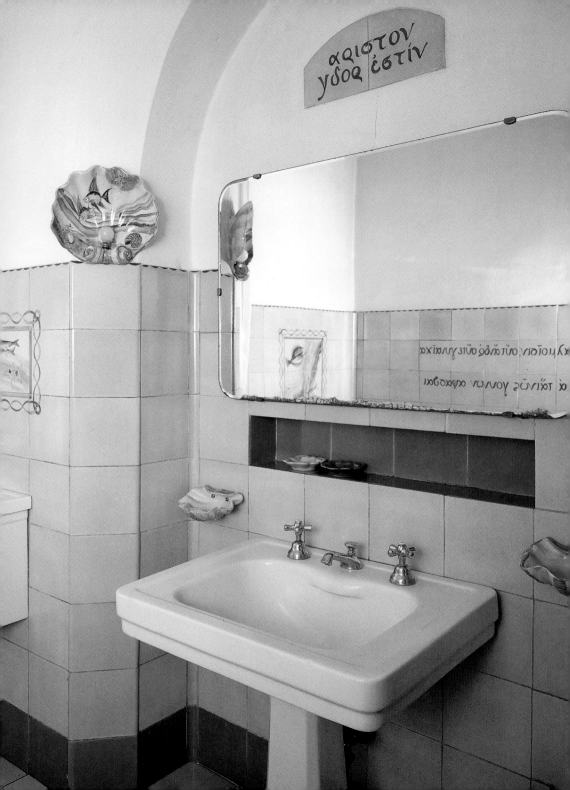

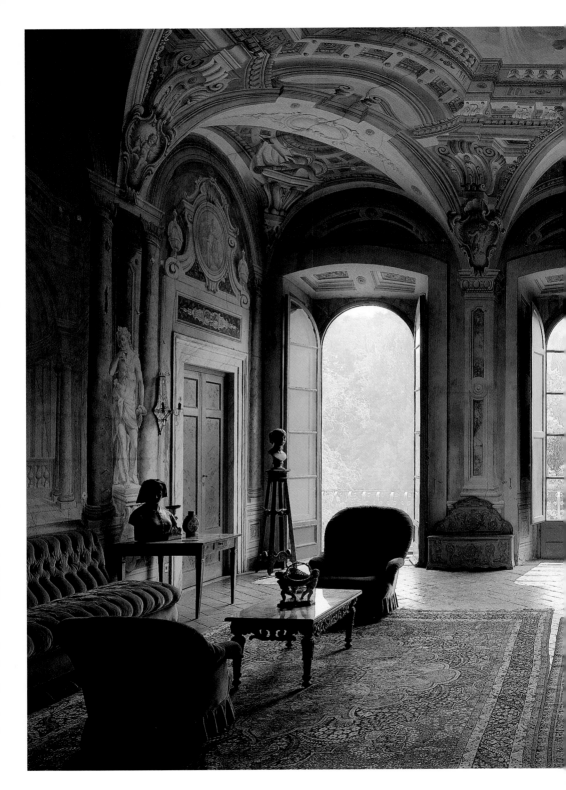

VILLA ROSSI

VILLA ROSSI
FRANCESCA DURANTI
LUCCA

This villa is the home of the novelist Francesca Duranti, and is known as Villa Rossi after her father, Paolo Rossi, who bought it just before the Second World War. The original building, begun by Francesco Burlamacchi (1498–1548), a statesman and famous opponent of the Medici family, dates from the 16th century. Since then, however, the villa has had a number of owners, including a Dutchman who was intimate with the French Emperor Napoleon III and who brought with him the imposing court portraits that still dominate the dining room opening onto the portico. The property then passed to Don Lorenzo Altieri of Lucca on his marriage to a Russian princess, ward of the Dutch owner. Francesca Duranti is deeply attached to this villa, where she spent her childhood and where she has come back to settle after many years spent living elsewhere. But Villa Rossi also has other attractions. The countryside round about is ancient and unspoiled. The hill on one side rises like a sheltering wall of green and the lawn on the other slopes down to an enchanting lily pond.

Viele Jahrhunderte sind vergangen, seit Francesco Burlamacchi (1498–1548), ein berühmter Staatsmann und Gegenspieler der Medici, die arkadengeschmückte Villa erbaute. Zahlreiche persönliche Objekte und Kunstwerke zeugen von den verschiedenen Besitzern des Hauses und deren Leben. Die ehrfurchtgebietenden höfischen Porträts, die heute das Speisezimmer beherrschen, stammen von einem holländischen Freund des französischen Kaisers Napoleon III. Der nächste Besitzer war der aus Lucca stammende Don Lorenzo Altieri, der das Mündel des Holländers, eine russische Prinzessin, heiratete. Heute ist die Schriftstellerin Francesca Duranti zurückgekehrt an den Ort ihrer Kindheit. Benannt ist das Anwesen Villa Rossi nach ihrem Vater Paolo Rossi, der es kurz vor Ausbruch des Zweiten Weltkriegs erwarb. Francescas ganzes Herz hängt an dem Haus und dessen immer noch unberührter Umgebung: dem Hügel, der sich wie ein grüner Schutzwall erhebt, und dem tiefer gelegenen Seerosenteich.

La romancière Francesca Duranti habite cette demeure baptisée Villa Rossi, du nom de son père, Paolo Rossi, qui l'acheta peu de temps avant la Seconde Guerre mondiale. Francesco Burlamacchi (1498–1548), un célèbre politicien et opposant aux Médicis, fit édifier la villa décorée d'arcades au 16ᵉ siècle. Par la suite, elle changea souvent de propriétaires. L'un d'eux, un Hollandais ami de Napoléon III, y apporta les grands portraits officiels qui trônent encore dans la salle à manger donnant sur la loggia. Un Lucquois, don Lorenzo Altieri, épousa la pupille du Hollandais et la villa lui revint. Francesca Duranti adore cette demeure où elle a passé son enfance. Elle y est revenue après avoir longtemps vécu ailleurs. Le cadre paisible accroît le charme de la villa : d'un côté, une colline érige une muraille de verdure protectrice, de l'autre, une pelouse inclinée descend jusqu'à un étang où poussent de délicates fleurs de lotus.

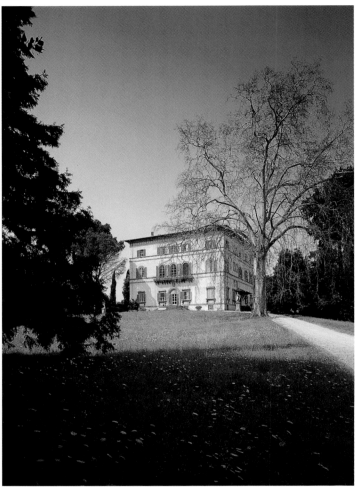

PP. 40–41 and 46 The frescoed reception room on the first floor, which was originally used as a library. The frescoes, painted in the 17th century by a local artist, include trompe-l'œil architectural effects with perspectives, mock statues of the Four Seasons and an allegorical representation of Dawn on the ceiling. The French windows look out onto the rich vegetation of the hillside. • In dem mit Fresken geschmückten Salon im ersten Geschoss befand sich ursprünglich die Bibliothek. Die Fresken aus dem 17. Jahrhundert stammen von einem lokalen Künstler und beeindrucken durch perspektivische Scheinarchitekturen.

Die Decke schmückt eine allegorische Darstellung der Aurora; die Wände zieren gemalte Statuen. Durch die hohen Fenstertüren leuchtet das Grün eines Hügels. • Au premier étage, le salon décoré de fresques où se trouvait autrefois la bibliothèque. Un peintre local du 17e siècle l'a orné de fresques en trompe-l'œil; elles représentent des éléments d'architecture vus en perspective, des statues des Quatre Saisons et, au plafond, une allégorie de l'Aurore. Les grandes portes-fenêtres donnent sur une colline verdoyante.

P. 43 The bridge over the pond where the writer went boating as a child. • Die kleine Brücke über den Teich, auf dem Francesca als Kind Bootsfahrten unternahm. • L'étang et son petit pont; Francesca Duranti s'y promenait en barque lorsqu'elle était enfant.

↑ A rear view of the villa and portico from the slope leading down to the pond. • Blick auf die Rückseite der Villa mit der Loggia. Die Wiese führt zum Teich. • L'arrière de la villa, avec la loggia, vu de la pente qui mène à l'étang.

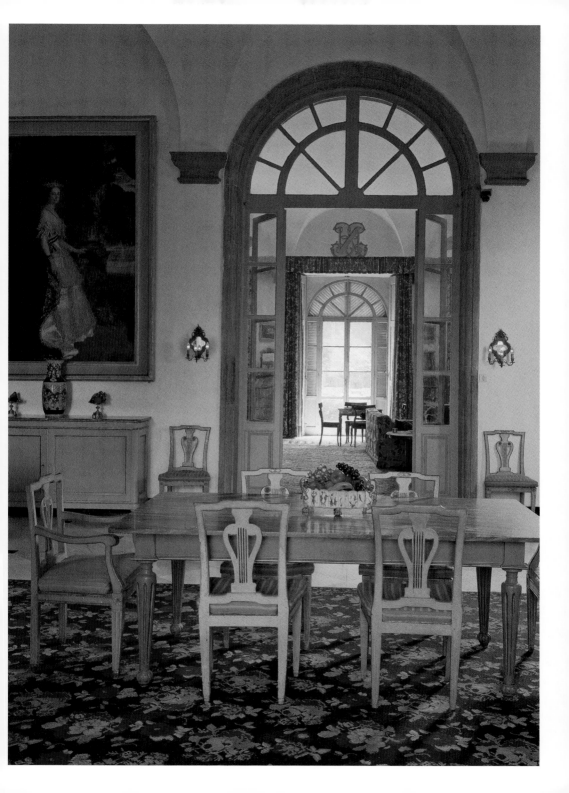

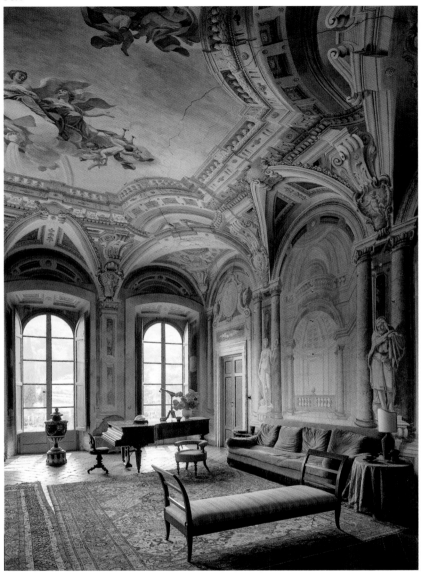

P. 45 The dining room on the ground floor, looking through to the library. A formal portrait of the French Empress Eugenia de Montijo, wife of Napoleon III, hangs on the wall. • Vom Speisezimmer im Erdgeschoss aus erhascht man einen Blick in die Bibliothek. An der Wand hängt ein offizielles Bildnis der französischen Kaiserin Eugénie, der Gemahlin Napoleons III. • La salle à manger du rez-de-chaussée, d'où l'on aperçoit la bibliothèque. Au mur trône un portrait officiel de l'impératrice Eugénie de Montijo.

→ The most striking features of the Villa Rossi's magnificent loggia are its ample proportions and the timeless beauty of its frescoes. • Die wunderbare Loggia der Villa Rossi beeindruckt durch ihre majestätischen Proportionen und die zeitlose Schönheit ihrer Fresken • La magnifique loggia de la Villa Rossi impressionne par ses proportions majestueuses et par la beauté intemporelle de ses fresques.

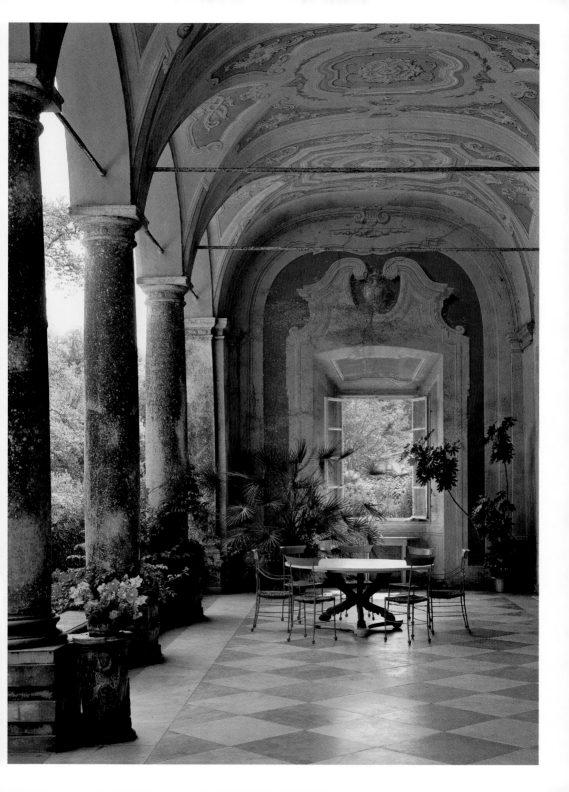

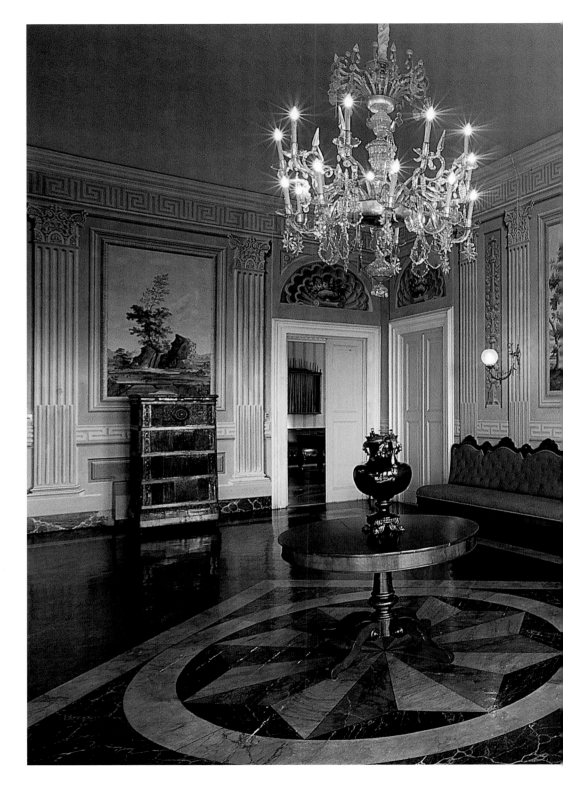

VILLA LA MAOLINA

VILLA LA MAOLINA
LUCCA

Villa La Maolina lies in a stunning location at the foot of the Apuan Alps amid woods, vineyards and olive groves. It is a *fattoria*, a working agricultural estate, as well as a country residence, with several holdings and tenant farmers' houses, whose olive oil and wine have contributed to its fame. The owners spend as much time as possible on the estate, alternating its uncomplicated lifestyle with the faster pace of nearby Lucca. A balustraded double flight of steps takes the visitor up to a large glass-fronted door leading straight into the main reception room, where an 18th-century wood-topped billiard table is the undisputed focus of attention. Guests are entertained both in summer and in winter, when the rooms are heated by stoves or fireplaces and the smell of woodsmoke mingles with that of meat roasting in the huge kitchen. Measuring over 60 square metres, it is the heart of life at the villa.

Vom hoch gelegenen Landgut La Maolina eröffnet sich ein weites Panorama über die Olivenhaine, Weingärten und Wälder, die miniaturähnlich zu Füßen der Apuanischen Alpen liegen. Seit jeher ist die „fattoria", zu der auch mehrere Bauern- und Pächterhäuser gehören, bekannt für Olivenöl und Wein von ausgezeichneter Qualität. Die äußerst gast-freundlichen Besitzer führen ein einfaches Leben, abseits des geschäftigen Treibens im nahen Lucca. Sie empfangen oft Freunde in dem eindrucksvollen Salon, in den man über eine zweiarmige Treppe mit Brüstung hinaufsteigt. Den Blickfang bildet hier ein Billardtisch aus dem 18. Jahrhundert. Besonders schön ist es im Winter, wenn die Räume mit Öfen und Kaminen beheizt werden. Dann vermischt sich der charakteristische Geruch der brennenden Holzscheite mit dem Duft der kulinarischen Köstlichkeiten, die in der riesigen, über sechzig Quadratmeter großen Küche zuberei-tet werden.

Bâtie sur les premiers contreforts des Alpes apuanes, au milieu des bois, des vignes et des oliviers, la Villa La Maolina jouit d'un magnifique panorama. C'est une «fattoria» qui produit une huile et un vin très renommés. Tout en possédant une autre demeure dans la ville voisine de Lucques, ses propriétaires y passent le plus clair de leur temps car ils appré-cient la vie simple, plus authentique, de la campagne. Un double escalier à balustrade mène à une grande porte vitrée. Celle-ci donne directement accès au salon où trône un billard du 18e siècle. La villa est souvent pleine d'amis, même en hiver. On allume alors les poêles et les cheminées, et l'odeur du feu de bois se mêle à celle des grillades provenant de l'immense cuisine de soixante mètres carrés qui constitue le véritable cœur de la maison.

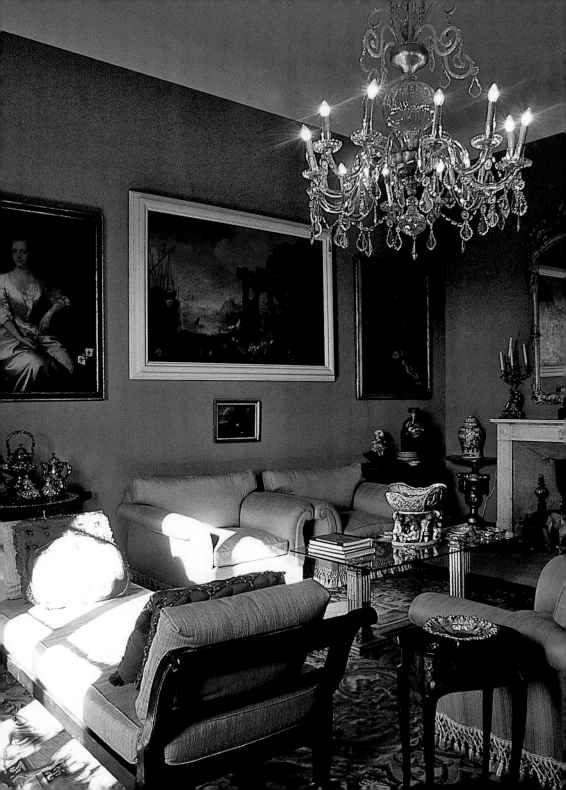

PP. 48–49 The ballroom floor is inlaid marble. The frescoes and decorations on the walls date back to the end of the 18th century, as do the two long sofas standing against the wall and the table. The chandelier is in Murano glass. • Der prunkvolle Ballsaal, dessen Fußboden reich mit Marmoreinlegearbeiten verziert ist. Die Fresken und Wanddekorationen stammen aus dem ausgehenden 18. Jahrhundert, ebenso wie die beiden Sofas an der Wand und der kleine Tisch. Der Leuchter ist aus Muranoglas. • La salle de bal au magnifique pavement de marbre marqueté. Les fresques et les décorations murales datent de la fin du 18ᵉ siècle, ainsi que les deux longs divans adossés au mur et le guéridon. Le lustre vient de Murano.

P. 51 Another reception room with a fireplace and a late-18th-century glass chandelier. The paintings on the walls also date from the same period but the sofas and armchairs are modern. The carpets are Persian. • Ein weiterer Salon mit Kamin. Der Kristallleuchter und die Gemälde stammen aus dem ausgehenden 18. Jahrhundert. Persische Teppiche sowie moderne Sofas und Sessel vervollständigen die Einrichtung. • Un autre salon avec sa cheminée ; le lampadaire de cristal et les tableaux accrochés au mur datent de la fin du 18ᵉ siècle, alors que les divans et les fauteuils sont modernes ; au sol, des tapis persans.

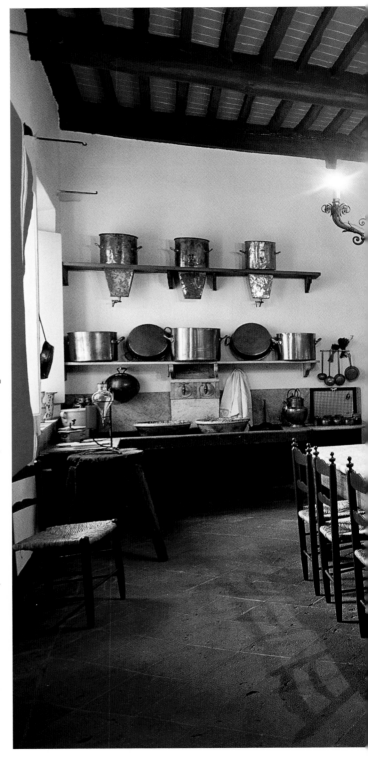

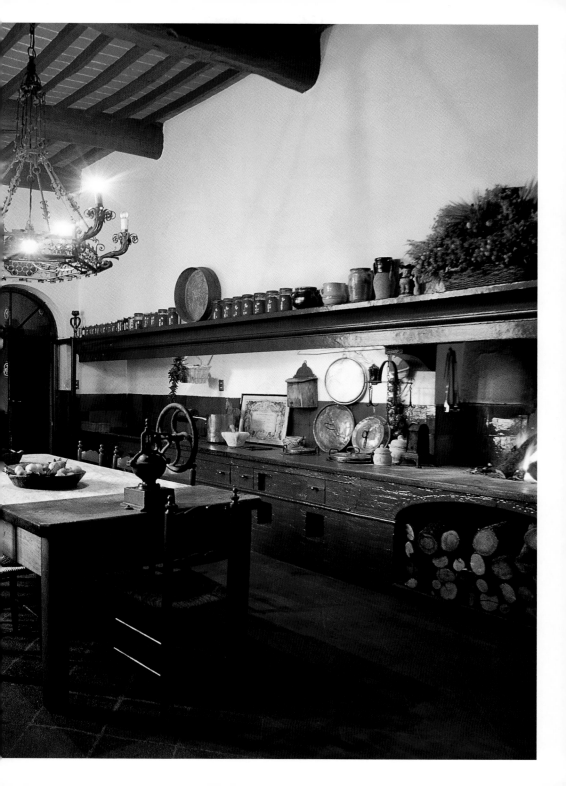

PP. 52–53 A view of the original 18th-century kitchen, its imposing wooden table and the straw-bottomed chairs. The villa was built as the focal point of a winemaking estate that gave employment to a considerable number of agricultural workers. At the heart of this busy concern was the kitchen, which had to be large and functional. • Die Originalküche aus dem 18. Jahrhundert mit dem Holztisch und rustikalen Stühlen. Früher war die Küche das Herz des ehemaligen Weinguts, auf dem zahlreiche Menschen beschäftigt waren. Deshalb musste sie vor allem geräumig und praktisch sein. • La cuisine du 18e siècle, avec sa table en bois massif, ses chaises de paille rustiques et ses meubles. A l'origine, la villa se trouvait

au centre d'une exploitation qui produisait du vin et employait un grand nombre de personnes. La cuisine constituait le cœur de ce microcosme et se devait d'être avant tout vaste et fonctionnelle.

↑ The original taps, which date from the 18th century, like everything else that has been so lovingly conserved in the kitchen. • Wie alle anderen Gegenstände in der Küche werden auch die Wasserhähne liebevoll gepflegt. • Les vieux robinets, du 18e siècle comme tout le reste, ont été amoureusement conservés.

→ The kitchen shelves feature a display of objects from the past. Most are bulky

copper utensils that are rarely used nowadays. At one time they were called into service during the grape harvest when many casual workers came to the villa to help with the vintage. • Eine wunderschöne Sammlung von alten Küchengeräten in den Regalen. Die meisten Gegenstände bestehen aus Kupfer und sind auffallend groß, denn in ihnen wurde während der Weinlese das Essen für die vielen Erntehelfer zubereitet. • Dans la cuisine, sur les étagères, on peut voir une belle collection d'ustensiles et de récipients anciens de grandes dimensions, surtout en cuivre. Aujourd'hui rarement utilisés, ils servaient autrefois durant les vendanges, car un grand nombre de travailleurs se retrouvaient alors dans la villa.

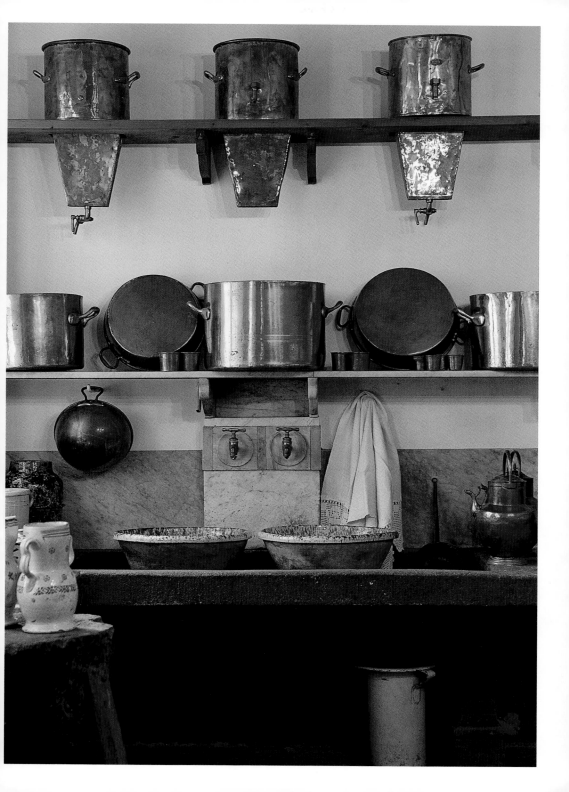

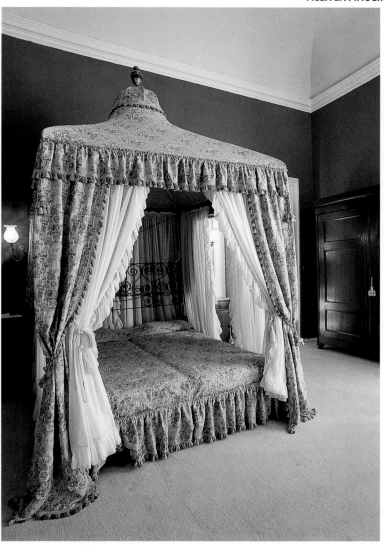

← The 19th-century dressing table has been covered with modern fabrics to capture the romantic spirit of the age that inspired its design, which is also reflected in the luxurious sweep of the curtains. In the background is a chest of drawers on which stands a 19th-century mirror. • In diesem Schlafzimmer fühlt man sich in die Romantik zurückversetzt. Die Stoffe des Toilettentischs wurden zum Stil passend ausgewählt. Die Spiegelkommode im Hintergrund stammt aus dem 19. Jahrhundert. • La coiffeuse date du 19ᵉ siècle et elle est recouverte de tissus qui, avec les rideaux drapés, restituent l'esprit romantique de l'époque. Au fond, une commode à miroir du 19ᵉ siècle.

↑ A four-poster bed whose structure dates from the 19th century. The fabrics have been selected with great care to reflect the style of the period. The bed was found in the villa by the present owners. • Dieses Himmelbett fanden die derzeitigen Besitzer im Schlafzimmer vor. Das Originalgestell aus dem 19. Jahrhundert ist mit dem Stil jener Epoche entsprechend ausgewählten Stoffen sorgfältig bespannt. • Le lit à baldaquin; la structure date du 19ᵉ siècle et est revêtue de tissus modernes choisis avec soin pour s'harmoniser avec le style d'origine. Les propriétaires actuels de la villa ont trouvé ce lit sur place.

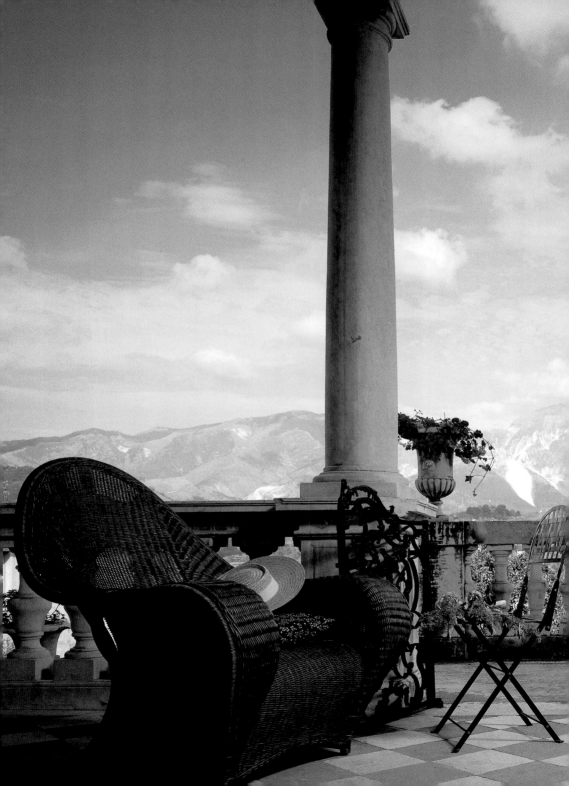

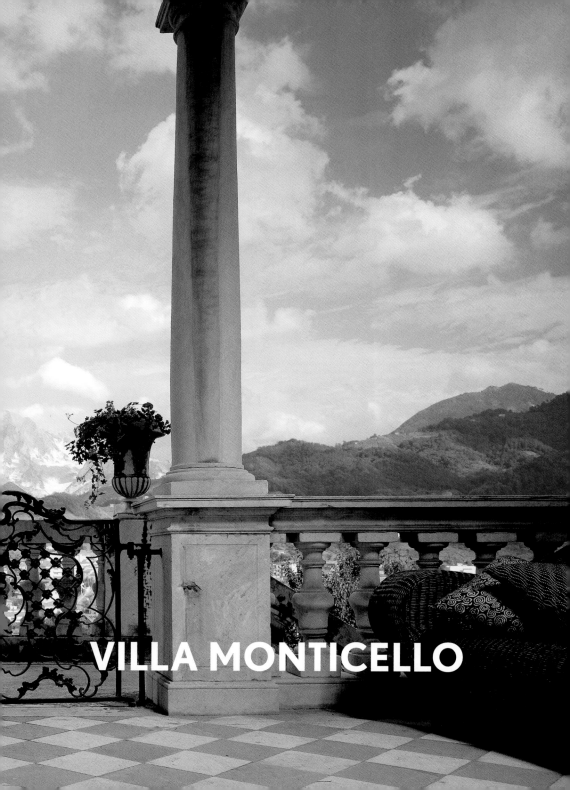

VILLA MONTICELLO

VILLA MONTICELLO
AVENZA

When it was built in 1766 by the counts of Orsolini at Avenza, near Carrara, Villa Monticello was just a small country retreat. And so it remained until it was acquired in the late 19th century by the French Dervillé family, who enlarged and embellished it in exquisite taste. They added grand flights of steps at the front and back, and built loggias on three sides. Statues and fragments of ancient sculptures adorned the frontage while marble vases and a marble gable were placed on the roof. Today Villa Monticello is owned by Marzia Vanelli Dazzi, who lives there with her husband and children, occupying both the magnificently sumptuous *piano nobile* and the more modestly proportioned accommodation on the ground floor. In summer, the villa's location near the coast ensures that the family are never short of visiting friends to entertain.

Die Villa Monticello liegt in Avenza nahe Carrara und wurde im Jahre 1766 als bescheidenes Landhaus für die Grafen Orsolini errichtet. Die Familie Dervillé aus Frankreich erweiterte das Haus Ende des 19. Jahrhunderts zu einer pracht-vollen Villa mit Loggien an drei Seiten des Gebäudes. Aus dieser Zeit stammen auch die mit Statuen und Fragmenten antiker Statuen geschmückte Freitreppe und das marmorne Tympanon. An der rückwärtigen Fassade schließlich führt eine beeindruckende Treppe aus weißem Marmor direkt hinauf in den Salon. Heute bewohnt Marzia Vanelli Dazzi gemeinsam mit ihrem Mann und ihren Kindern die elegante Villa. Während des Sommers sind hier zahlreiche Freunde zu Gast, und das liegt sicher nicht nur an der Nähe des Meeres.

Edifiée en 1766 à Avenza, près de Carrare, pour les comtes Orsolini, la Villa Monticello n'était à l'origine qu'une modeste résidence campagnarde. Mais à la fin du 19e siècle, elle fut achetée par une famille française, les Dervillé, qui décida de la transformer pour la rendre plus fastueuse. On fit ériger le grand escalier monumental bordé de statues et de fragments de sculptures antiques, ajouter des loggias sur trois côtés, des vases de marbre aux angles du toit et un fronton, de marbre également. Enfin, on construisit sur l'arrière un magnifique escalier de marbre blanc permettant d'accéder directement au salon du premier étage. La Villa Monticello appartient aujourd'hui à Madame Marzia Vanelli Dazzi, qui occupe avec son mari et ses enfants aussi bien le « piano nobile » à l'aspect solennel que le rez-de-chaussée plus intime. La mer est toute proche et l'été, la villa accueille toujours de nombreux amis.

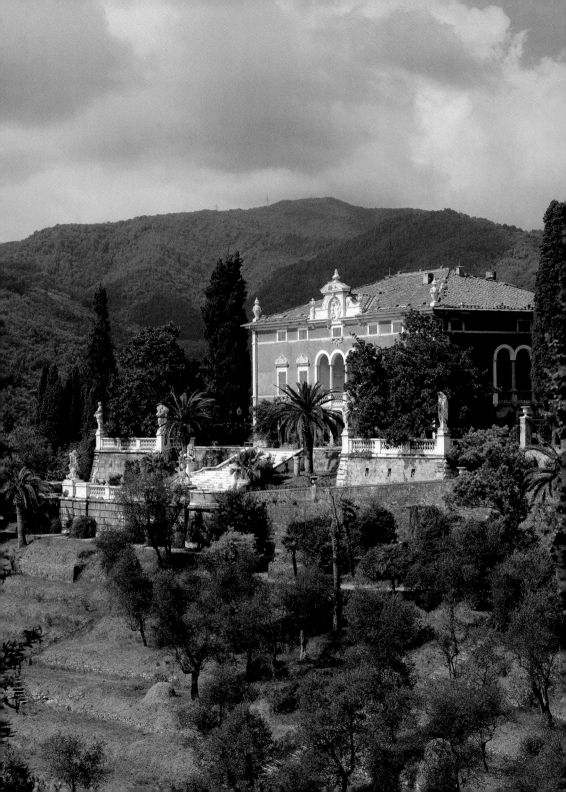

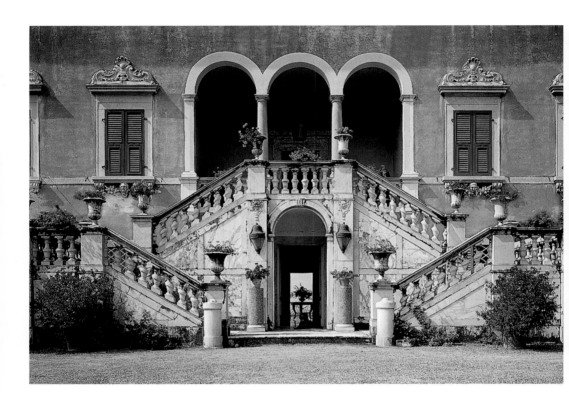

PP. 58–59 View from the first-floor loggia at the rear of the house looking out over the Apuan Alps and marble quarries. The balustrade, columns and grey-and-white chequered floor are all in marble. • Von der rückwärtigen Loggia im ersten Stock blickt man auf die Apuanischen Alpen und die Marmorbrüche von Carrara. Die Brüstung, die Säulen und der weiß-grau gewürfelte Boden sind aus Marmor. • La loggia du premier étage, à l'arrière de la villa, offre le beau panorama des Alpes apuanes et des carrières de marbre. Les balustrades, les colonnes et le dallage à carreaux gris et blancs sont en marbre.

P. 61 The Villa Monticello appears like a mirage from the surrounding greenery, with a theatricality worthy of a stage set for an Italian opera. • Wie eine Fata Morgana erhebt sich die Villa Monticello vor dem Hintergrund der grünen Landschaft. Die theatralische Wirkung ihrer Erscheinung könnte jeder italienischen Oper als Kulisse dienen. • La Villa Monticello émerge de son écrin de verdure comme une «fata morgana» et son aspect théâtral est digne d'un décor d'opéra italien.

← Its majestic double staircase, built entirely of white marble, is adorned with a multitude of Medici vases. It leads to a loggia and to the sumptuous salon on the *piano nobile*. • Eine Vielzahl von Medici-Vasen schmückt die ganz aus weißem Marmor gebaute majestätische Doppeltreppe. Sie gewährt Zugang zu einer Loggia und zum großen Salon des „piano nobile", der Beletage. • Le majestueux escalier à double évolution, construit entièrement en marbre blanc, s'orne d'une multitude de vases Médicis. Il donne accès à une loggia et au grand salon du Piano Nobile.

↓ From the top of the steps, residents and their guests can enjoy an uninterrupted view of the park, planted with palms and cypress trees, and also look out across the surrounding landscape. • Vom oberen Treppenabsatz aus genießen die Bewohner des Hauses und ihre Gäste die freie Aussicht auf den von Palmen und Zypressen bewachsenen Park und auf das Panorama der umgebenden Landschaft. • Du haut de l'escalier, les habitants et leurs hôtes jouissent d'une vue imprenable sur le parc planté de palmiers et de cyprès et sur le panorama de la campagne environnante.

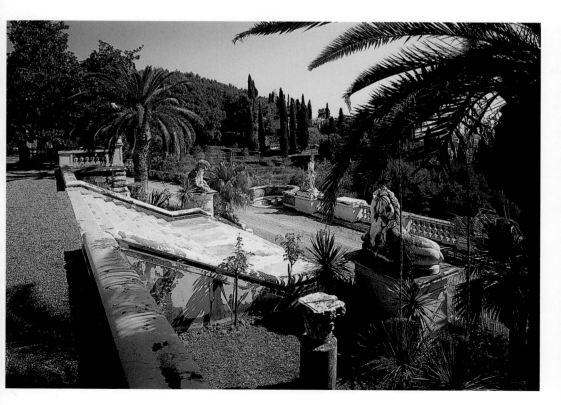

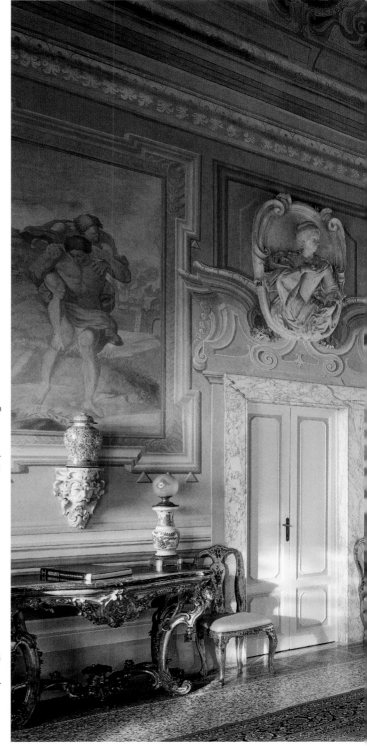

The first-floor reception room from which all the bedrooms lead off. The walls are decorated with frescoes of mythological subjects enclosed in fake painted frames. The marble architraves of the doors are surmounted by 18th-century medallions, also in marble. The two console tables are Baroque while the two gilt chairs are in the characteristic Luccan *pattona* style. The round table is Empire and the chandelier, which has been restored, is an 18th-century piece from France. • Um den Salon im ersten Geschoss sind sämtliche Schlafzimmer angeordnet. Die Wände schmücken mythologische Szenen in gemalten Rahmen. Über den Türen mit Marmorpfosten prunken große Marmormedaillons aus dem 18. Jahrhundert. Unter dem restaurierten französischen Lüster aus demselben Jahrhundert steht ein Empiretisch. Im Hintergrund sind barocke Konsoltische und typisch lucchesische „pattona"-Stühle zu sehen. • Le salon du premier étage, sur lequel donnent toutes les chambres. Les parois sont ornées de fresques représentant des scènes mythologiques, entourées de faux cadres peints. Au-dessus de chaque porte à l'encadrement de marbre, on peut voir des médaillons de marbre du 18ᵉ siècle. Les chaises dorées qui jouxtent les deux consoles baroques sont de classiques « pattone » lucquoises. La table ronde est de style Empire et le lustre restauré d'origine française date du 18ᵉ siècle.

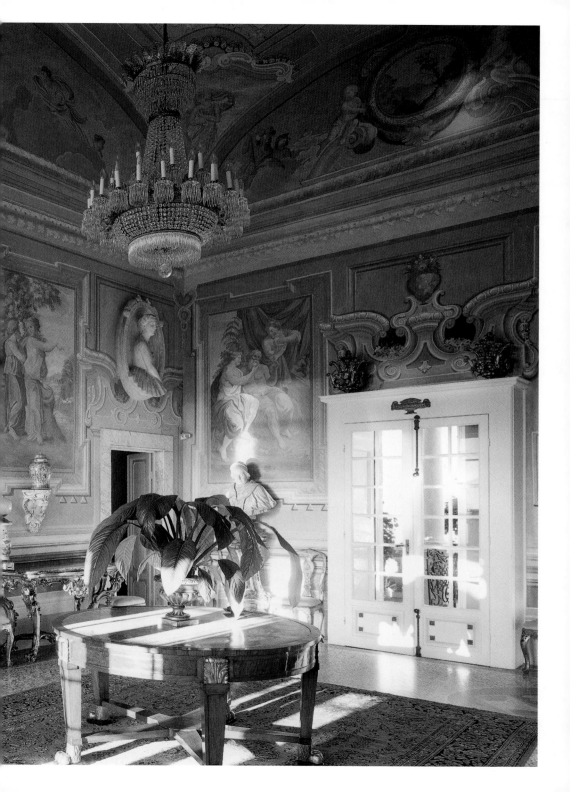

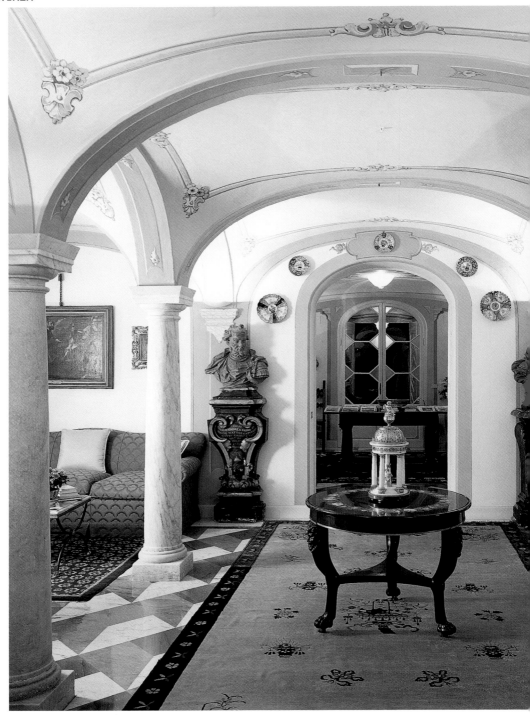

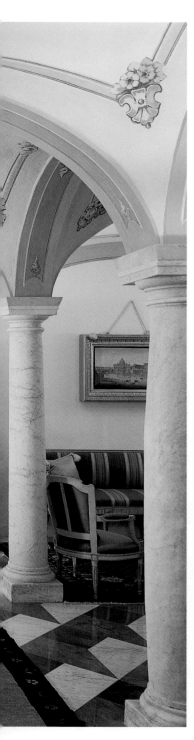

← The ground-floor living area is divided up harmoniously by the white marble columns that support the vaulted ceiling. The table with the shrine and the pair of pedestal tables supporting the two terracotta busts on either side of the door are French and date from the 18th century. The carpet is Chinese. • Der Wohnraum im Erdgeschoss mit den prachtvoll dekorierten Deckengewölben wird durch marmorne Säulen unterteilt. Auf dem chinesischen Teppich steht ein Tisch mit einem Miniaturtempel. Er stammt ebenso wie die beiden Piedestale mit den Terrakottabüsten aus dem Frankreich des 18. Jahrhunderts. • L'espace du séjour, au rez-de-chaussée, est rythmé par les colonnes de marbre blanc qui soutiennent les voûtes décorées du plafond. La petite table sur laquelle est posée un petit temple et les deux piédestaux surmontés de bustes en terre cuite qui flanquent la porte datent du 18e siècle et sont d'origine française, alors que le tapis vient de Chine.

PP. 68–69 Glass doors in the marble-floored dining room open onto the garden. The vaults are frescoed and a Baroque bust stands alongside vases from China. The chairs around the table, which is set with 18th-century porcelain, are English while the marquetry cabinet on the far wall was made in Ferrara in the 18th century. • Das Esszimmer mit seinem wunderschönen Marmorfußboden und den freskierten Stichkappen ist ein wahres Schmuckstück. Durch große Flügelfenster blickt man in den Garten. Um den mit einem Service aus dem 18. Jahrhundert gedeckten Tisch sind englische Stühle gruppiert. Neben der Barockbüste stehen chinesische Vasen. Der Schrank aus dem 18. Jahrhundert mit Ebenholzintarsien stammt aus Ferrara. • La salle à manger pavée de marbre, aux grandes baies ouvrant sur le jardin et aux voûtes ornées de fresques. A côté des vases chinois, un buste baroque. Sur la table mise, on voit des assiettes du 18e siècle. Les chaises qui l'entourent sont d'origine anglaise et le buffet du 18e siècle à incrustations d'ébène, au fond, provient de Ferrare.

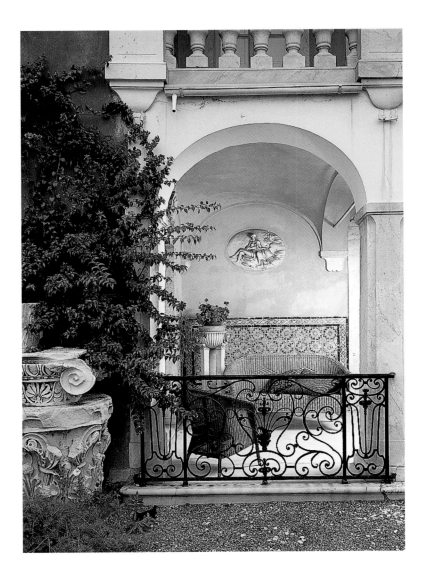

↑ One of the loggias on the ground floor, closed off by a wrought-iron gate. The internal wall is decorated with a colourful fascia of tiles. • Eine Loggia im Erdgeschoss wird von einem kleinen schmiedeeisernen Tor abgeschlossen. Farbige Kacheln zieren die Innenwand der Loggia. • Une loggia au rez-de-chaussée, fermée par une grille basse de fer forgé. La paroi interne est décorée d'un bandeau de carreaux de faïence polychromes.

→ A bedroom with elegantly frescoed walls and ceiling. The furniture and the terracotta bust in the corner come from France. • Ein Schlafzimmer mit eleganten Fresken. Die Möbel und die Terrakottabüste in der Ecke stammen aus Frankreich. • Une chambre à coucher aux parois et au plafond ornés de fresques élégantes. Les meubles et le buste en terre cuite, dans l'angle, sont d'origine française.

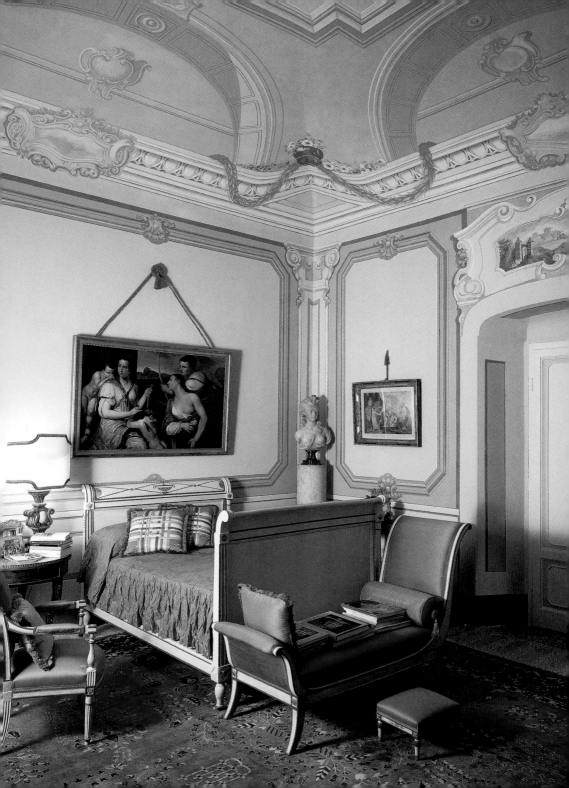

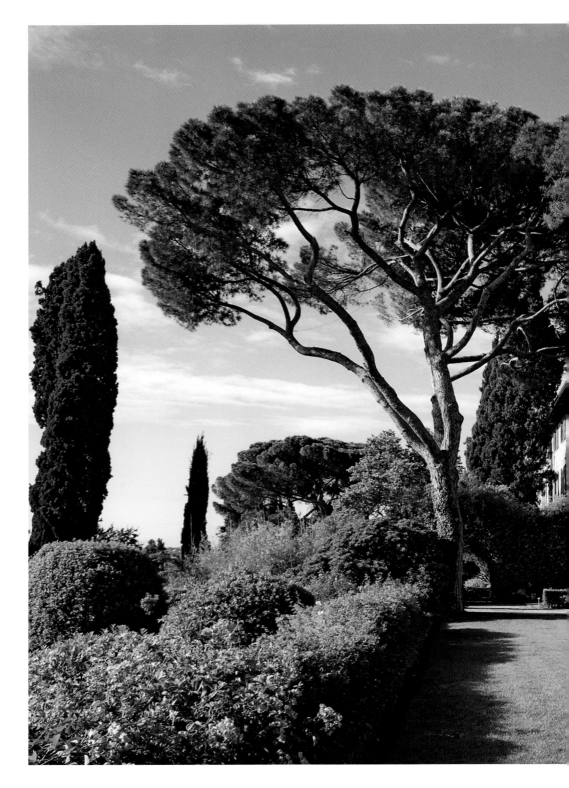

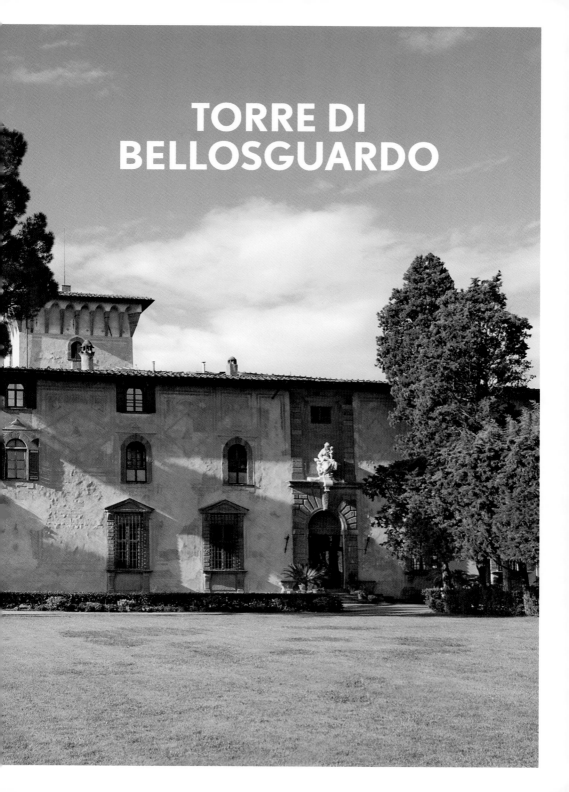

TORRE DI BELLOSGUARDO

TORRE DI BELLOSGUARDO
FLORENCE

There is only one way to get out of the tourist bustle of Florence: a trip into the hills that surround the historic centre and afford a sensational prospect of the cathedral and roofs of the city. An elevation to the south of the Arno provides the best view, as the name says: Bellosguardo, a place where the loveliest postcard motifs have been photographed, where painters have captured the panorama in oil on canvas and thinkers have found inspiration – among them Galileo Galilei, who wrote his *Dialogue Concerning the Two Chief World Systems* on Bellosguardo. A friend of Dante built the tower in the 13th century as a hunting lodge, and during the Renaissance the Marchesi Roti Michelozzi added a villa. Artists and aristocrats from all over Europe have always been guests here. To this day the *torre* has an atmosphere of history, nobility and Bohemian life: a statue of Mercy by Pietro Francavilla still greets visitors, frescoes by Bernardino Poccetti adorn the lobby and the rooms are museums where almost all the furniture derives from the former owners.

Um dem Touristentrubel von Florenz zu entkommen, gibt es nur ein Mittel: ein Ausflug auf die Hügel, die das Zentrum umgeben und eine sensationelle Sicht über Dom und Dächer eröffnen. Eine Anhöhe südlich des Arno bietet den besten Blick – und trägt ihn sogar im Namen: Vom Bellosguardo aus wurden die schönsten Postkartenmotive fotografiert, Maler verewigten das Panorama in Öl, Denker fanden hier Inspiration – unter ihnen Galileo Galilei, der auf dem Bellosguardo seinen „Dialog über die beiden hauptsächlichen Weltsysteme" verfasste. Ein Freund Dantes ließ den Turm im 13. Jahrhundert als Jagdschloss errichten, die Marchesi Roti Michelozzi fügten in der Renaissance eine Villa hinzu. Stets waren hier Künstler und Adlige aus ganz Europa zu Gast. Bis heute besitzt der Torre ein Flair von Historie, Noblesse und Boheme: So heißt noch immer eine Statue der Barmherzigkeit von Pietro Francavilla Besucher willkommen, die Lobby schmücken Fresken von Bernardino Poccetti, und die Zimmer sind Museen, in denen nahezu alle Möbel von den einstigen Eigentümern stammen.

Pour admirer la beauté de Florence, il suffit de faire une excursion sur les collines qui l'entourent et offrent une vue sensationnelle sur le dôme et les toits. Une hauteur située au sud de l'Arno, le Bellosguardo, propose le meilleur panorama. C'est d'ici que des peintres ont immortalisé la vue sur la toile, des penseurs y ont trouvé l'inspiration – c'est le cas de Galilée qui a rédigé sur le Bellosguardo son «Dialogue concernant les deux principaux systèmes du monde». Au XIIIe siècle, un ami de Dante fit ériger la tour qui servait de pavillon de chasse, les marquis Roti Michelozzi y ajoutèrent une villa à la Renaissance. Des aristocrates et des artistes venus de toute l'Europe ont toujours été les bienvenus ici. Jusqu'à ce jour, la Tour a conservé son atmosphère historique et aristocratique ainsi que son esprit bohème : ainsi, les visiteurs sont toujours accueillis par une statue de la Charité de Pietro Francavilla, le hall est agrémenté de fresques de Bernardino Poccetti et les chambres, dont presque tous les meubles proviennent des anciens propriétaires, sont de véritables musées.

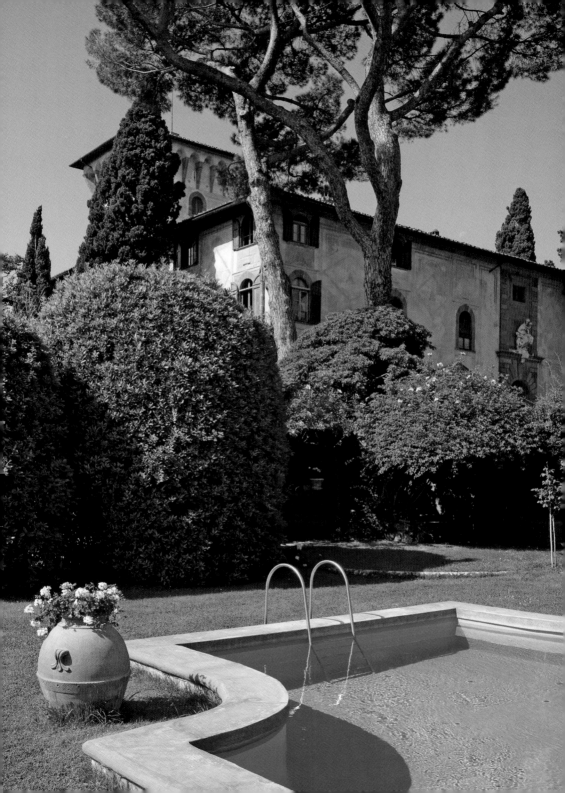

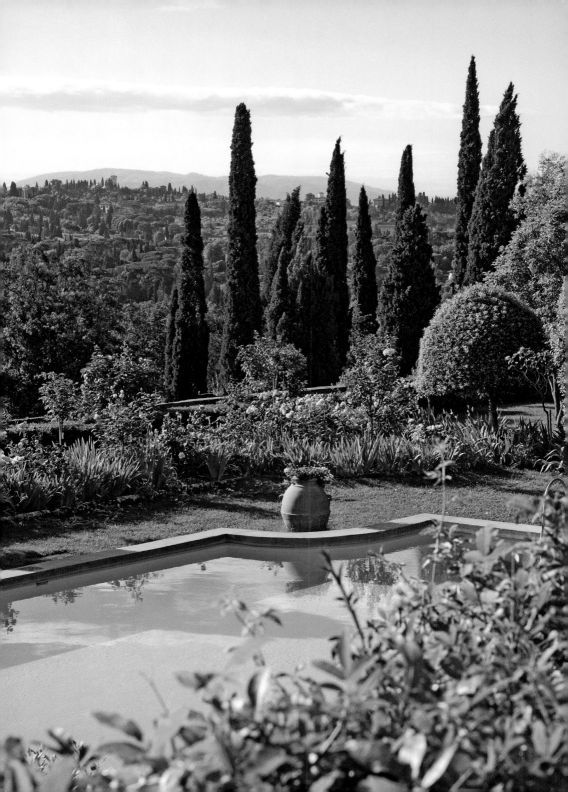

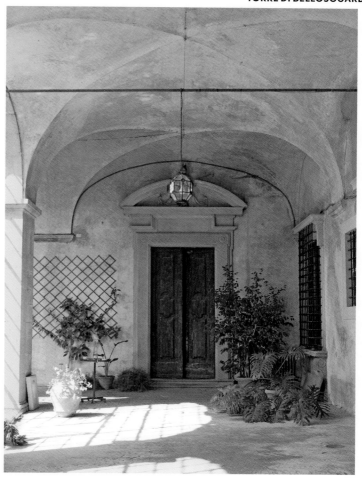

PP. 72-73 Surrounded by a large garden, this stunning Florentine property consists of a medieval tower and a villa built during the Renaissance. Standing proudly beside the building is an enormous parasol pine with a magnificent crown. • Dieses grandiose florentinische Anwesen besteht aus einem mittelalterlichen Turm und einer Villa, die während der Renaissance erbaut wurde. Am Rande des Grundstücks erhebt sich stolz eine riesige Schirmpinie mit majestätischer Baumkrone. • Entourée d'un grand jardin, cette magnifique propriété Florentine se compose d'une tour médiévale et d'une villa construite pendant la Renaissance. Un énorme pin parasol

doté d'une couronne majestueuse se tient fièrement à ses côtés.

P. 75 Set on the terrace, the swimming pool is surrounded by a large rectangular lawn and benefits from a screen of greenery created by huge trimmed box trees. • Der auf der Terrasse einge lassene, von einer großen rechteckigen Rasenfläche umgebene Swimmingpool profitiert vom Schatten des ihn flankierenden Grüns aus riesigen beschnittenen Buchsbäumen. • La piscine, implantée sur la terrasse s'entoure d'un grand rectangle de gazon, et profite de la proximité d'un écran de verdure composé d'énormes buis taillés.

← On the terrace, a lush garden bordered by flowerbeds extends as far as the surrounding wall, beyond which can be seen a row of tall cypresses and a panoramic view of the hills. • Ein prachtvoller Garten dehnt sich von der Terrasse bis zur Einfriedung hin aus. Jenseits des Mäuerchens ist eine Reihe hoher Zypressen zu sehen und man hat einen Panoramablick auf die Hügel. • Sur la terrasse un jardin luxuriant bordé de fleurs s'étend jusqu'à l'enceinte et au delà du muret on découvre une rangée de haut cyprès et une vue panoramique sur les collines.

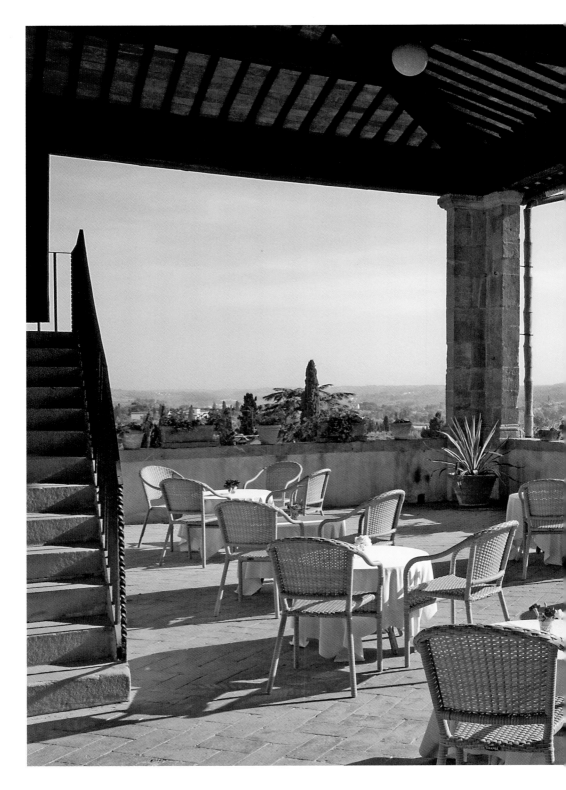

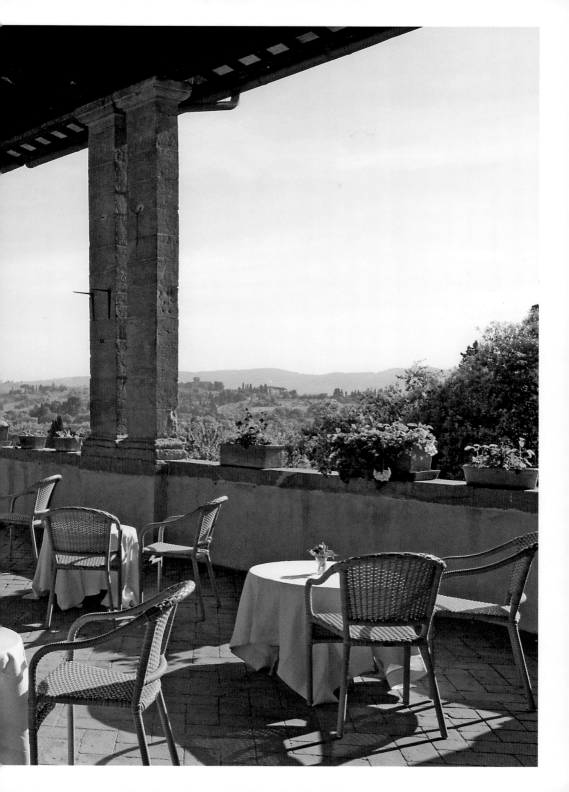

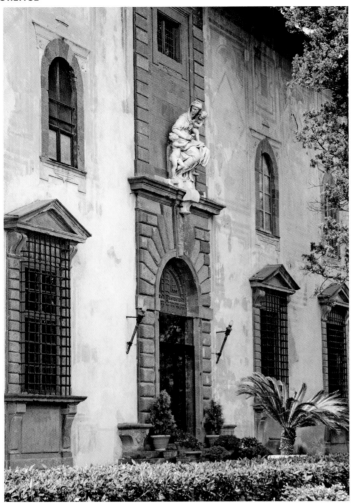

P. 77 The gallery is characterised by its generous proportions and austere architecture. The presence of pot plants adds a touch of colour to the largely monochrome décor. • Der Säulengang zeichnet sich durch seine großzügigen Proportionen und eine schmucklose Architektur aus. So verleihen die Topfpflanzen diesem im Wesentlichen monochromen Ambiente ein paar Farbtupfer. • La galerie se distingue par ses proportions généreuses et une architecture dépouillée. La présence de plantes en pot ajoute une note de couleur dans ce décor principalement monochrome.

PP. 78-79 Tuscan villas would not be the same without their spacious loggias, where it is such a pleasure to relax in the shade or to dine al fresco, while admiring a spectacular sunset. • Was wären die toskanischen Villen ohne ihre luftigen Loggias, in deren Schatten man sich so gut ausruhen oder seine Mahlzeiten „al fresco" einnehmen und dabei einen herrlichen Sonnenuntergang bewundern kann ... • Que seraient les villas de Toscane sans leurs loggias spacieuses où il fait bon se reposer dans l'ombre ou de prendre un repas « al fresco » en admirant un superbe coucher de soleil...

↑ Above the front door stands a monumental white marble statue of Our Lady of Mercy, a major work of the French sculptor Pietro Francavilla (1548-1616). • Die monumentale Statue aus weißem Marmor über der Eingangstür stellt die Barmherzigkeit dar. Sie ist ein Hauptwerk des französischen Bildhauers Pietro Francavilla (1548-1616). • Au-dessus de la porte d'entrée une monumentale statue en marbre blanc représente La Miséricorde. Elle est une œuvre majeure du sculpteur français Pietro Francavilla (1548-1616).

P. 81 The garden consists of beds of flowers running alongside trimmed box-wood hedges. Centuries-old trees offer protection from the sun, providing a cool, shady place to take a stroll. • Blumenbeete, die von Hecken aus beschnittenem Buchsbaum begrenzt werden, bilden die Grundstruktur der Gartenanlage. Jahrhundertealte Bäume bieten dem Spaziergänger Schutz vor der Sonne und sorgen für Schatten und Kühle. • Le jardin se compose de parterres fleuris bordés par des haies en buis taillé. Des arbres séculaires protègent le promeneur du soleil et apportent ombre et fraîcheur.

↑ Detail of a bronze door-knocker on a solid oak door. • Bronzener Türklopfer auf einer robusten Tür aus Eichenholz. • Détail d'un heurtoir en bronze sur une robuste porte en chêne.

→ The stone brick surround of this large studded double door recalls the Moorish architecture of ancient North African houses. • Die steinerne Umfassung einer großen beschlagenen Tür mit zwei Flügeln erinnert an die maurische Architektur alter maghrebinischer Häuser. • L'encadrement en pierre qui entoure une grande porte cloutée à deux battants fait écho à l'architecture mauresque des anciennes demeures Magrébines.

PP. 84–85 Blonde rattan conservatory furniture gives the feel of a hothouse in the loggia, with its arched windows. The impression is intensified by the presence of a large number of potted plants and trees. • Die Ausstattung des Wintergartens mit hellen Korbmöbeln verleiht der Loggia mit ihren verglasten Rund-bögen eine Atmosphäre wie in einem Gewächshaus. Die vielen Topfpflanzen und -bäume unterstreichen diesen Eindruck. • Le mobilier de jardin d'hiver en rotin clair donnent à la loggia aux arches vitrées un aspect de serre chaude et la présence d'un grand nombre de plantes et d'arbres en pot accentue cette impression.

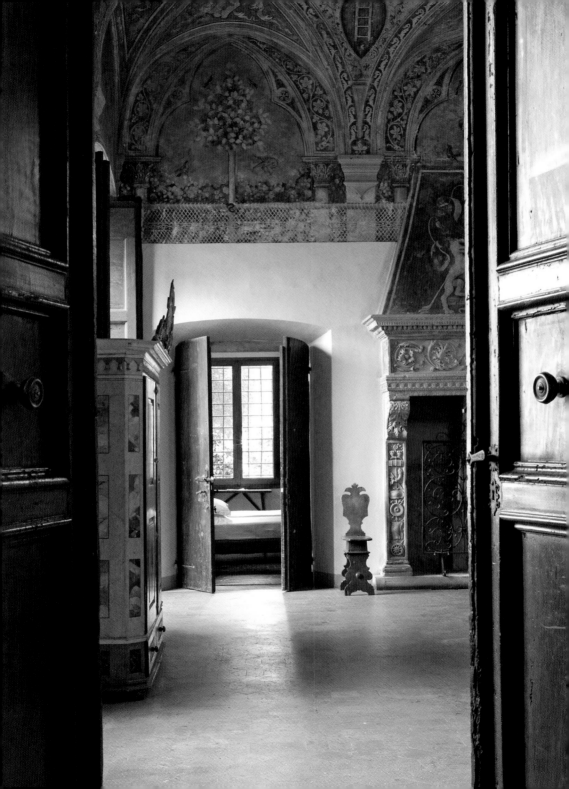

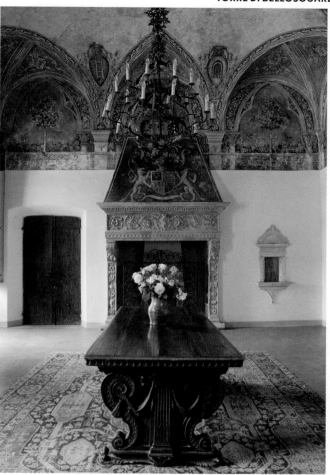

← With their high vaulted ceilings decorated with frescoes, Torre di Bellosguardo's spacious reception rooms bear witness to the architectural splendour of the era of Marquis Roti Michelozzo. • Die großen Empfangsräume im Torre di Bellosguardo mit ihren hohen, mit Fresken geschmückten Deckengewölben, zeugen vom architektonischen Glanz der Zeiten des Marchese Roti Michelozzo. • A Torre di Bellosguardo les grandes pièces de réception avec leurs hauts plafonds voûtes décorés de fresques témoignent de la splendeur architecturale du temps du Marquis Roti Michelozzo.

↑ The interior of the villa abounds with superb furniture dating from the Renaissance, such as the monumental carved wooden table taking pride of place right in the centre of the room. • Die Innenräume der Villa sind mit einer Vielzahl prachtvoller Möbel der Renaissance ausgestattet. Dieser monumentale Tisch aus geschnitztem Holz zum Beispiel ist der Blickfang in einem der Salons. • L'intérieur de la villa regorge d'un mobilier splendide qui date de la Renaissance, telle cette table monumentale en bois sculpté qui trône au beau milieu d'un salon.

PP. 88–89 These days it is called the "lobby" but the villa's large entrance hall, adorned with biblical frescoes created by the Florentine painter Bernardino Poccetti (1548–1612), truly deserves to be dubbed "the Throne Room". • Heutzutage spricht man von einer „Lobby". Doch der weiträumige, mit biblischen Fresken von der Hand des Florentiner Malers Bernardino Poccetti (1548–1612) ausgeschmückte Eingangsbereich der Villa verdient eigentlich die Bezeichnung Thronsaal! • De nos jours, il se fait appeler « lobby » mais la grande entrée de la villa décorée de fresques bibliques de la main du peintre Florentin Bernardino Poccetti (1548–1612) mérite pleinement le titre de Salle du Trône !

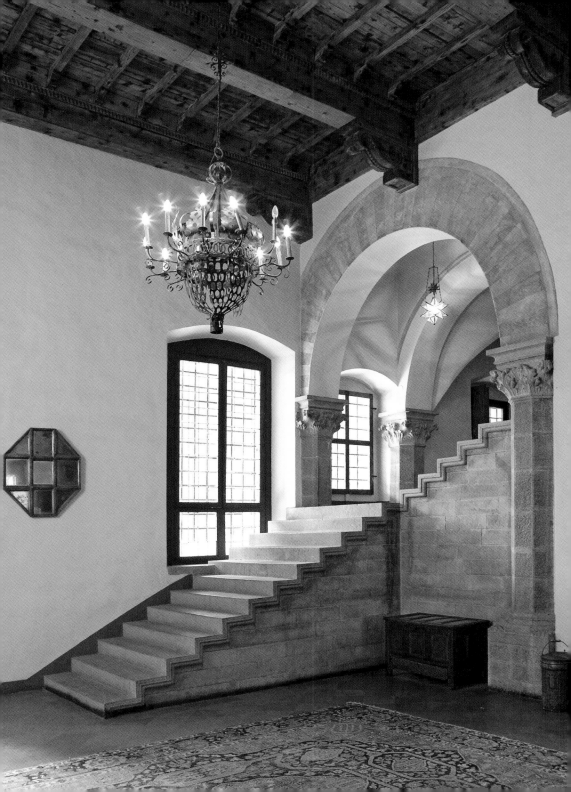

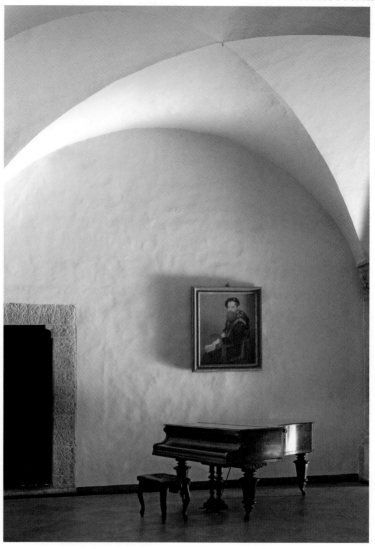

← Modern-day designers might well find inspiration in the stone staircase leading to the upper floors, with its unusual zigzag structure. • Eine steinerne Treppe führt hinauf in die oberen Etagen. Ihre ungewöhnliche Anlage in Zickzack-Form könnte durchaus auch Designer unserer Zeit inspirieren. • Un escalier en pierre conduit vers les étages et sa construction inhabituelle en forme de « zig-zag » pourrait bien inspirer les designers de notre époque.

↑ A stately home in the style of Torre di Bellosguardo must of necessity possess a music room, where the presence of a grand piano recalls the musical soirées hosted by one of the famous guests, Walburga, Lady Paget (1839–1921). • Für ein herrschaftliches Anwesen vom Range des Torre di Bellosguardo ist ein Musiksalon ein Muss. Der Flügel zeugt von den Musikabenden, die eine der berühmten Besucherinnen des Hauses, die Schriftstellerin Lady Walburga Paget (1839–1921) veranstaltete. • Une demeure seigneuriale de l'allure de Torre di Bellosguardo se doit de posséder un salon de musique et la présence d'un piano à queue témoigne des soirées musicales organisées par une de ces hôtes célèbres, l'écrivain Lady Walburga Paget (1839–1921).

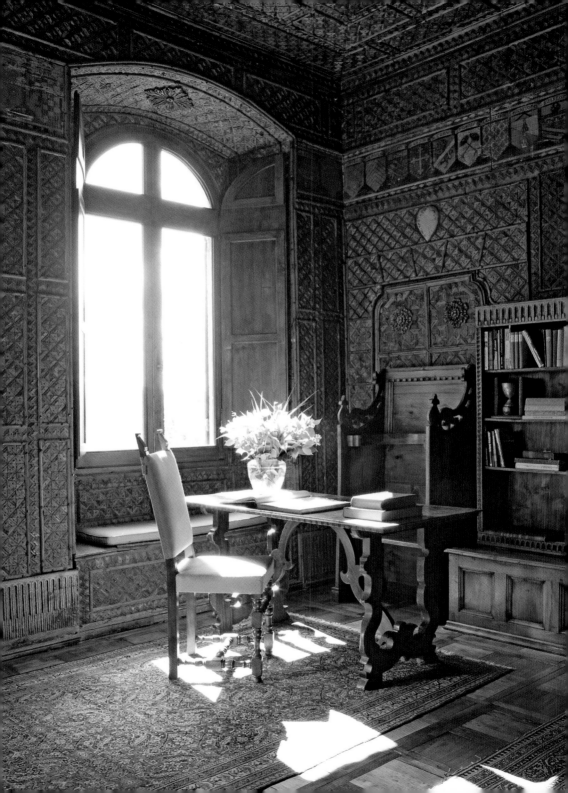

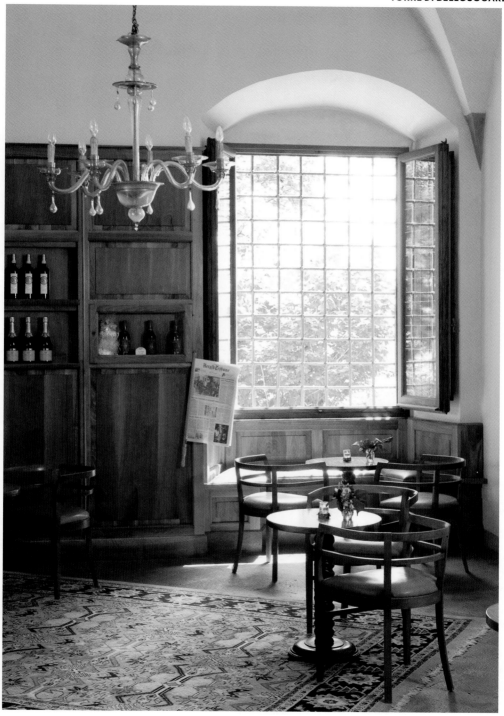

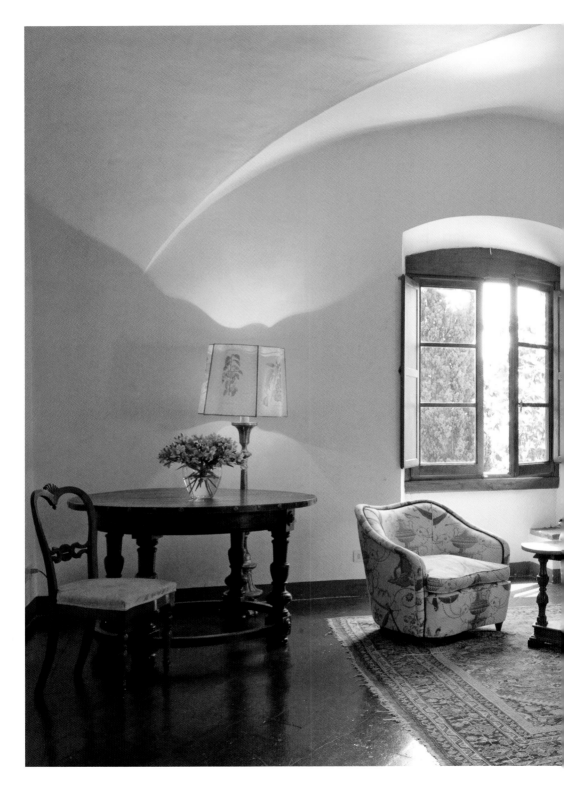

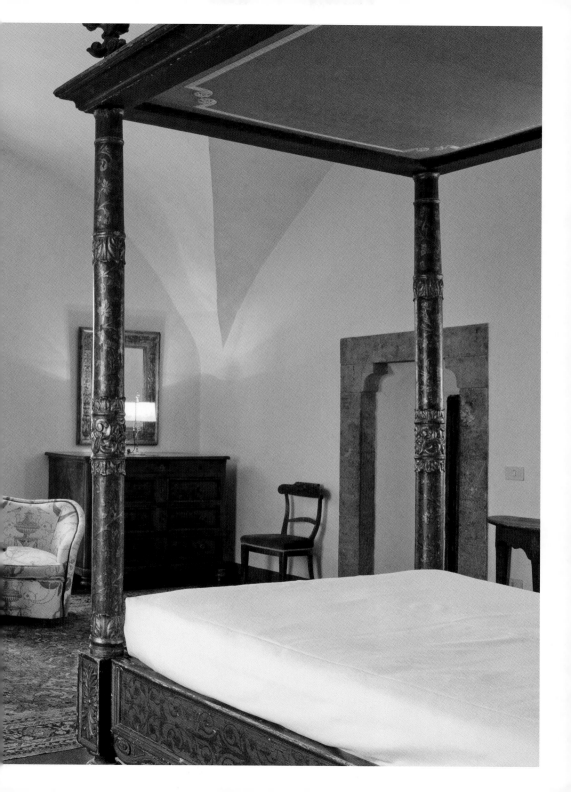

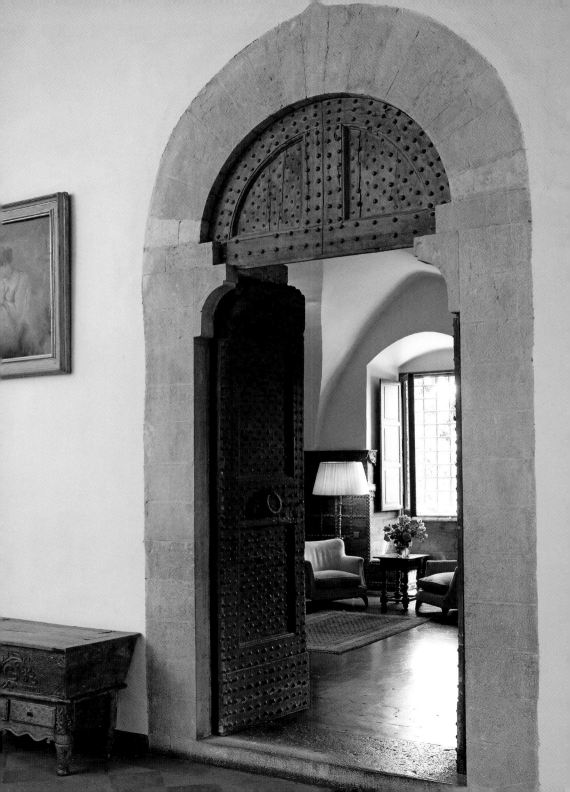

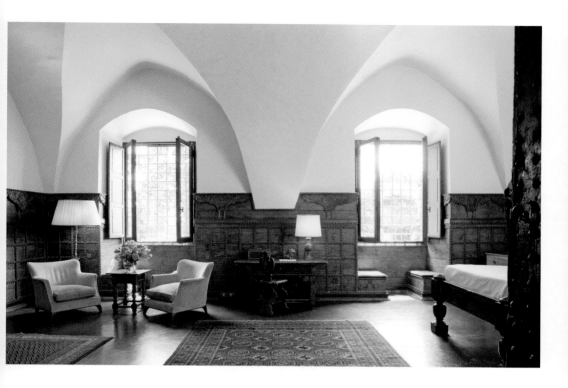

P. 92 Time stands still in the old library, which is just the place to linger for a while, if only to admire its fine wood paneling and savour its tranquil atmosphere. • In der alten Bibliothek ist die Zeit stehen geblieben. Es tut gut, sich dort aufzuhalten, und sei es nur, um die schöne Holzvertäfelung zu bewundern und die gedämpfte Stille des Raums zu genießen. • Le temps s'est arrêté dans l'ancienne bibliothèque et il fait bon s'y attarder un moment, ne serait-ce que pour admirer ses belles boiseries et son ambiance feutrée.

P. 93 In the evenings, guests at the villa can enjoy a moment of relaxation in the bar. They gather for a drink in an intimate space furnished with tables and chairs inspired by Liberty style – the Italian version of Art Nouveau. • Am Abend können die Gäste der Villa entspannte Augenblicke in der Bar genießen und sich dabei zu einem Drink in diesem gemütlichen Raum versammeln, der mit

Tischen und Stühlen ausgestattet ist, die vom Stile Liberty inspiriert sind. • Le soir, les hôtes de la villa peuvent profiter d'un moment de détente dans le bar et se réunir autour d'un «drink» dans un espace intime meublé avec des tables et des chaises inspirés par le style Liberty.

PP. 94–95 Spotless white walls, antique furniture, and a four-poster bed with carved, polychromed uprights, turns this beautiful bedroom into a haven of peace. • Wände von makellosem Weiß, alte Möbel und ein Himmelbett mit geschnitzten und bemalten Stützen verwandeln dieses Zimmer in eine Oase des Friedens. • Des murs d'un blanc immaculé, des meubles anciens et un lit à baldaquin aux montants sculptés et polychromés, transforment cette chambre en un havre de paix et de beauté.

← A Moorish door leads into a bedroom decorated in elegant, classic style. Could it be here that Ugo Foscolo wrote

his famous poem "Le Grazie" ("The Graces")? • Eine maurisch gestaltete Tür gewährt Einlass in ein klassisch und elegant gehaltenes Zimmer. Hat der Dichter Ugo Foscolo hier sein berühmtes Gedicht „Le Grazie" geschrieben? • Une porte mauresque donne accès à une chambre au décor classique et élégant. Est-ce ici que le poète Ugo Foscolo écrit son célèbre poème «Le Grazie»?

↑ In this generously proportioned bedroom, the choice of period furniture and fittings accentuates the elegance of the overall design. • Die Auswahl der Möbel und der Accessoires für dieses großzügige Zimmer unterstreicht den eleganten Charakter der Einrichtung. • Dans une chambre aux proportions généreuses, le choix des meubles et des accessoires classiques accentue le caractère élégant de la décoration.

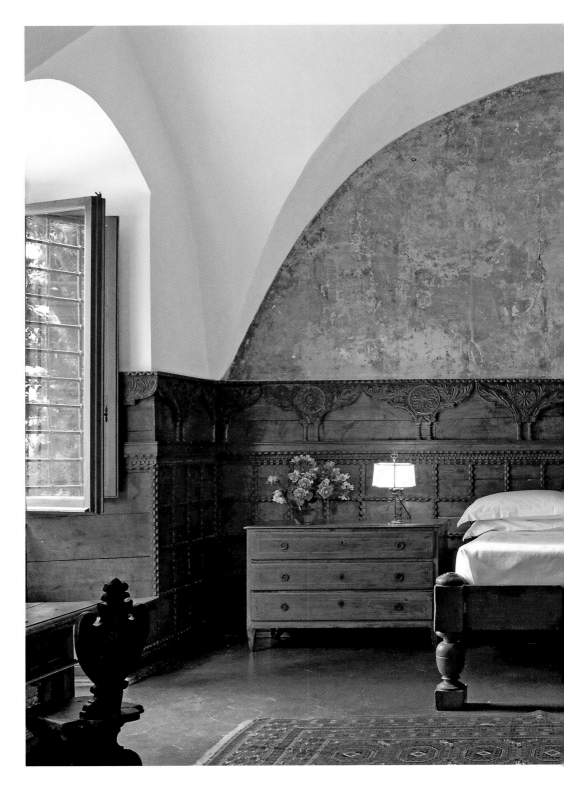

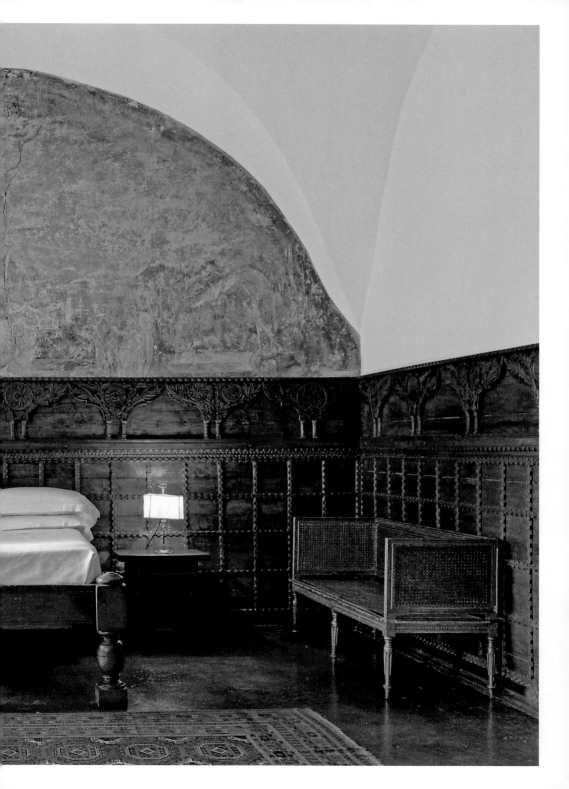

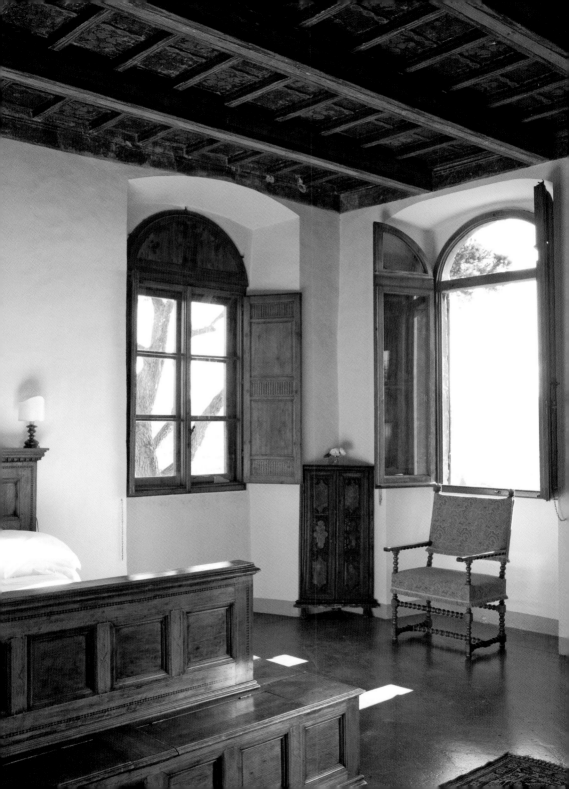

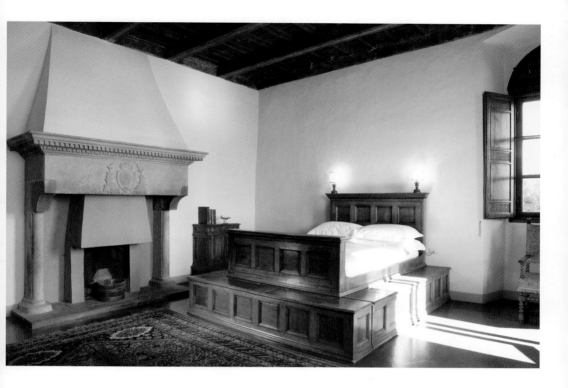

PP. 98-99 This room with a vaulted ceiling owes its appeal to the predominant presence of carved wood panelling dating from the Renaissance. The décor is completed by the sturdy bed and other carefully chosen pieces of furniture. • Die Eleganz dieses Zimmers mit der gewölbten Decke verdankt sich der Wirkung einer geschnitzten Holzvertäfelung aus der Renaissance. Ein stabiles Bett und wenige sorgfältig ausgewählte Möbel vervollständigen die Einrichtung. • L'allure de cette chambre voûtée doit tout à la présence dominante d'un soubassement en bois sculpté d'époque Renaissance. Un lit robuste et quelques meubles choisis avec soin complètent le décor.

← The monastic character of the bedrooms is ideally suited to the imposing architecture of the villa, while the marriage between the austere furniture and the space free from superfluous adornments is a definite asset. • Das klösterliche Ambiente der Zimmer passt vorzüglich zur noblen Architektur der Villa. Die sparsame Möblierung im Verein mit dem Verzicht auf jeglichen überflüssigen Schmuck macht den Charme des Hauses aus. • L'ambiance monacale des chambres sied à merveille à l'architecture noble de la villa et le mariage entre le mobilier sobre et l 'espace exempt d'embellissements superflus est un atout majeur.

↑ Two important features catch the eye in this bedroom – the massive stone fireplace and the oversized bed, perched proudly on its platform, taking centre stage. • Zwei wesentliche Elemente ziehen in diesem Zimmer die Aufmerksamkeit auf sich: der monumentale, aus Stein gehauene Kamin und das großzügig bemessene Bett, das auf majestätisch auf seinem Podest thront. • Deux éléments importants attirent l'attention dans cette chambre: la cheminée monumentale en pierre et le lit aux proportions démesurées qui trône majestueusement sur son dais.

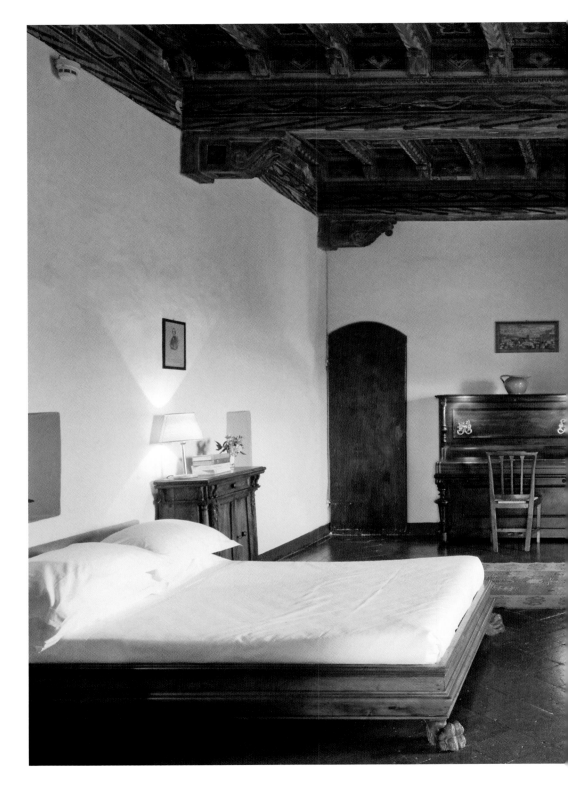

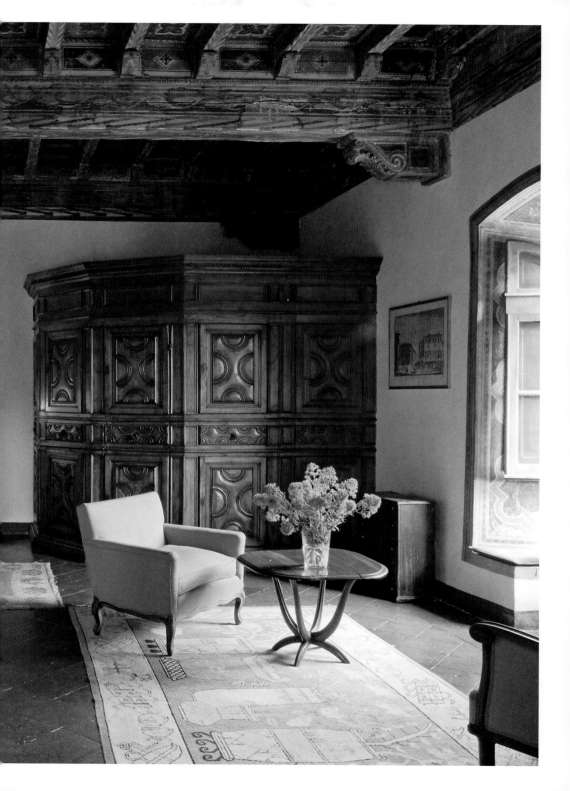

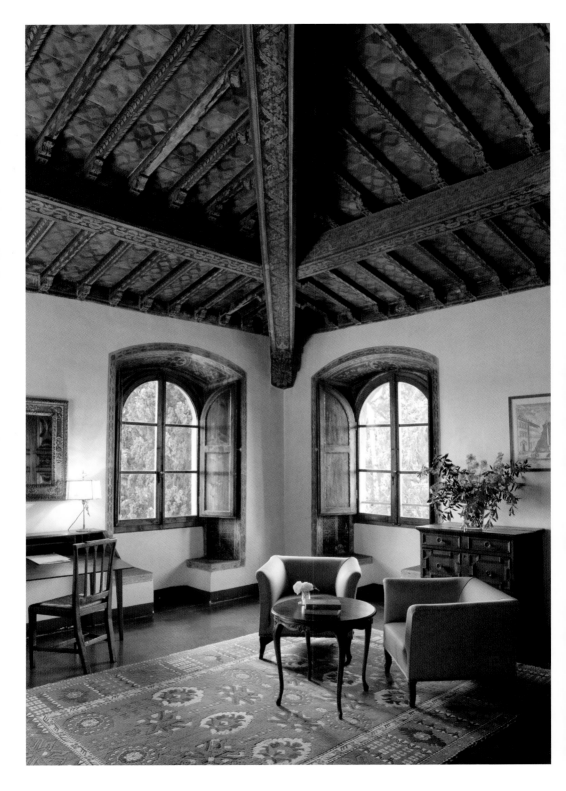

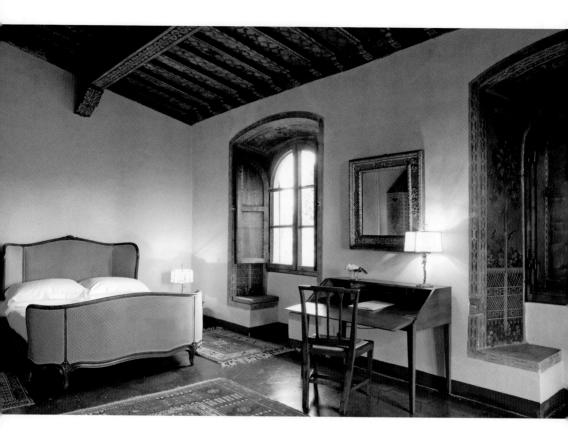

PP. 102–103 A large built-in wardrobe – an indisputable masterpiece of Italian cabinetmaking – takes pride of place in this huge bedroom with its magnificent coffered ceiling. • Ein großer Einbauschrank – tatsächlich ein Meisterwerk italienischer Kunsttischlerei – besetzt einen prominenten Platz in diesem großen Zimmer mit seiner wunderbaren Kassettendecke. • Une grande armoire encastrée – un chef-d'œuvre incontestable de l'ébénisterie Italienne – occupe une place importante dans cette vaste chambre dotée d'un magnifique plafond à caissons.

← The vertiginous pyramidal ceiling of this stunning room has retained its original exposed beams, adorned with "period" arabesque motifs. • Die pyramidenförmige Decke mit ihrer frei liegenden Balkenkonstruktion und den Verzierungen mit Arabesken ist in diesem hinreißenden Zimmer originalgetreu erhalten. • Dans cette très belle chambre à la hauteur vertigineuse, le plafond pyramidal a conservé sa construction en poutres apparentes et sa décoration d'arabesques d'époque.

↑ Here, a splendid Louis Quinze bed covered with sky-blue velvet adds a note of femininity to the deliberately understated décor. • Ein prächtiges, mit himmelblauem Samt bezogenes Bett im Louis-Quinze-Stil, verleiht dem bewusst strengen Ambiente eine weibliche Note. • Un splendide lit de style Louis Quinze recouvert d'un velours bleu ciel ajoute une note de féminité dans un décor volontairement austère.

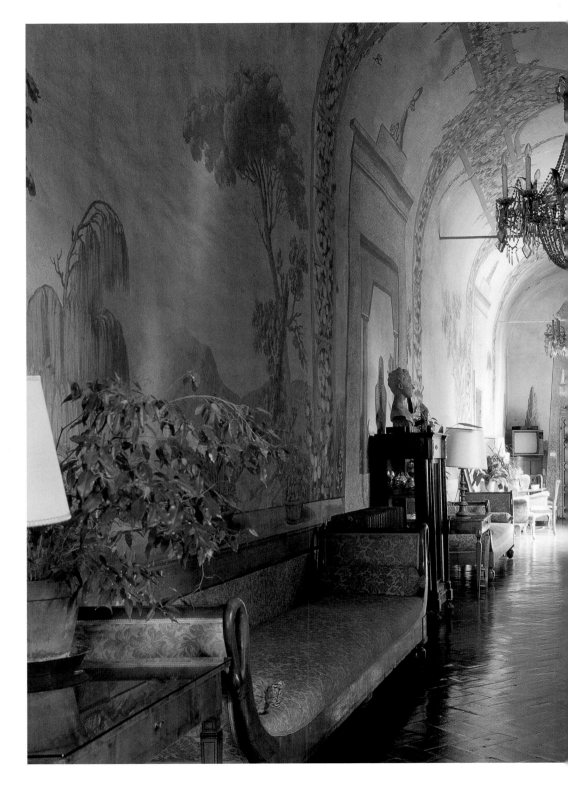

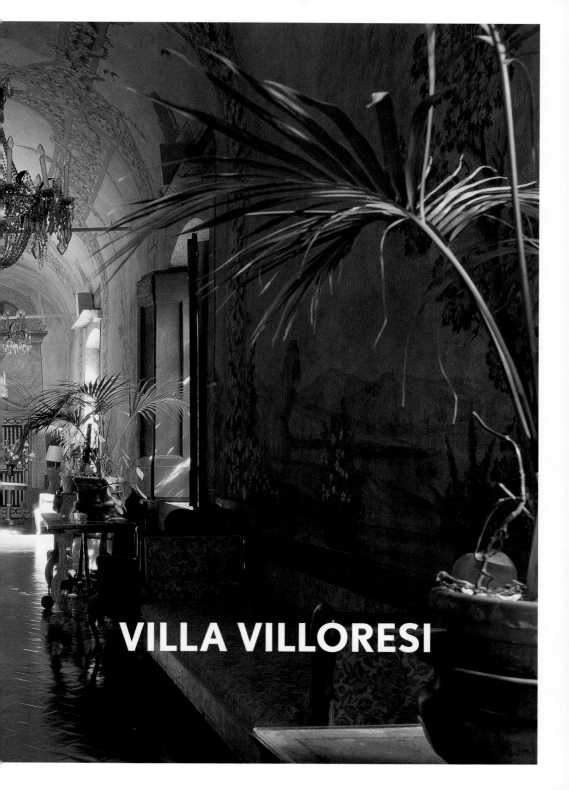

VILLA VILLORESI

VILLA VILLORESI
CRISTINA VILLORESI
SESTO FIORENTINO

The infectious laughter of the late Cristina Villoresi still rings through the *galleria* with Egyptian-style frescoes that leads to the salons and bedrooms making up the almost endless labyrinth of her magnificent ancestral home. One wonders if the echo of her voice reminds guests at the Villa Villoresi of the ancient legend that Gemma Donati, wife of Dante, took refuge in this house during the poet's exile in the early 14th century. The Villoresi family is justly proud of the villa near Florence, which began as a 12th-century fortress, was converted into a pleasure palace during the Renaissance and finally became a country hotel in the mid 1960s. Proceeding from the armoury – once a restaurant – by way of the *limonaia* orangerie, and the dining room decorated in the early 19th century with popular scenes by Bartolomeo Pinelli, you arrive at what is billed as the longest loggia in Tuscany and a series of very elegant bedrooms adorned with antique-style frescoes. And in the evening, while the intoxicating scents of roses, lemon blossom and wild oranges waft through the open French windows, it becomes clear that the magic of Tuscany knows no equal.

Das ansteckende Lachen der verstorbenen Cristina Villoresi hallt noch immer durch die mit ägyptisierenden Fresken verzierte „galleria", die Zugang zu einem verwirrenden Labyrinth von Salons und Räumen gewährt. Und man fragt sich unwillkürlich, ob das Echo ihrer Stimme wohl die Geister der Vergangenheit weckt. In einer der Legenden um die Villa Villoresi heißt es, dass Gemma Donati, die Frau von Dante, sich Anfang des 14. Jahrhunderts, während des Exils ihres Mannes, hierhin flüchtete. Die Familie Villoresi ist stolz auf ihren Familiensitz bei Florenz. Als Burg im 12. Jahrhundert errichtet, wurde er in der Renaissance zu einem Lustpalast umgebaut und Mitte der 1960er-Jahre in ein Landhotel verwandelt. Geht man vorbei an der Waffenkammer, die einst ein Restaurant war, an der „limonaia", der Orangerie, und am Esszimmer, das im frühen 19. Jahrhundert von Bartolomeo Pinelli ausgemalt wurde, erreicht man schließlich die Loggia – angeblich die längste der Toskana – und etliche elegante Schlafzimmer mit Fresken in antikisierendem Stil. Und am Abend, wenn der betörende Duft der Rosen durch die Verandatüren hereinweht, wird deutlich, dass der Zauber der Toskane seinesgleichen sucht.

Le rire contagieux de feu Cristina Villoresi retentit encore dans la « galleria » ornée de fresques à l'égyptienne qui mène aux salons et aux chambres. Ceux-ci constituent le labyrinthe quasi interminable de sa magnifique demeure ancestrale près de Sienne, et on se demande si l'écho de sa voix rappelle aux hôtes de la Villa Villoresi la très ancienne légende selon laquelle Gemma Donati – l'épouse de Dante – se serait réfugiée dans cette maison pendant l'exil du poète au début du 14ᵉ siècle. La famille Villoresi se montre fière de cette forteresse du 12ᵉ siècle, transformée en maison de plaisance pendant la Renaissance et devenue un relais de campagne au milieu des années soixante. De la Salle d'armes – qui fut un restaurant – en passant par la « limonaia », l'orangerie, et par la salle à manger décorée au début du 19ᵉ siècle de scènes populaires par Bartolomeo Pinelli, on atteint la loggia dite « la plus longue de Toscane », ainsi qu'un ensemble de chambres à coucher élégantes, ornées de fresques à l'antique. Et le soir, quand le parfum enivrant des roses, des citronniers et des orangers sauvages entre par les portes-fenêtres grandes ouvertes, il apparaît véritablement à quel point la magie de la Toscane est à nulle autre pareille.

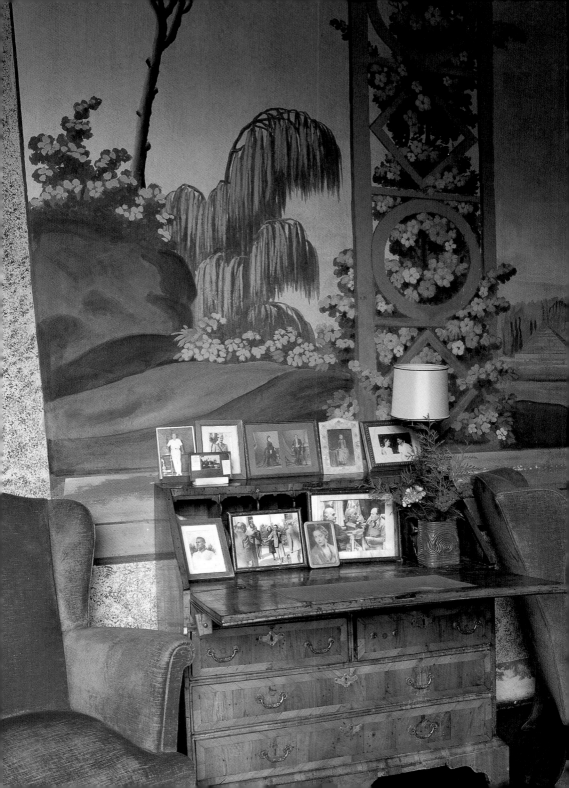

PP. 106–107 The *galleria* was formerly the coach entrance. The Egyptian-style frescoes by the painter Luzzi date from 1829. • Früher diente die „galleria" als Kutschenzufahrt. Die Fresken im ägyptisierenden Stil schuf der Maler Luzzi im Jahr 1829. • Jadis, la galleria servait d'entrée cochère. Les fresques à l'égyptienne ont été réalisées en 1829 par le peintre Luzzi.

P. 109 Half-moon window and balcony overlooking the inner courtyard. • Das halbkreisförmige Fenster und der Balkon bieten einen Blick in den Innenhof. • Une fenêtre en demi-lune et un balcon donnent directement sur la cour intérieure.

← Family photos on an 18th-century desk. • Familienfotos auf einem Sekretär aus dem 18. Jahrhundert. • Des

photos de famille sur un secrétaire à abattant 18ᵉ.

↑ Detail of a fresco in one of the first-floor bedrooms. • Ein Freskende-tail in einem der Schlafzimmer in der ersten Etage. • Détail d'un décor a fresco dans une des chambres du premier étage.

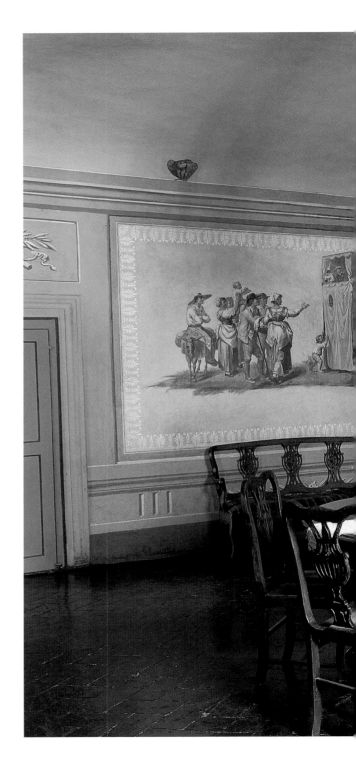

→ In the Villoresi dining room the walls
are painted with scenes from traditional
folklore. The celebrated Roman artist
Bartolomeo Pinelli (1781–1835) – who
created these charming vignettes –
was a frequent guest of the family. • Im
Esszimmer der Villoresis zieren volks-
tümliche Motive die Wände. Der
Schöpfer dieser charmanten Szenen,
der bekannte Künstler Bartolomeo
Pinelli (1781–1835) aus Rom, war häufig
zu Gast bei der Familie. • Dans la salle
à manger des Villoresi, les murs sont
ornés de scènes charmantes inspirées
par le folklore populaire. Leur auteur,
le célèbre artiste romain Bartolomeo
Pinelli (1781–1835) était souvent l'hôte
de la famille.

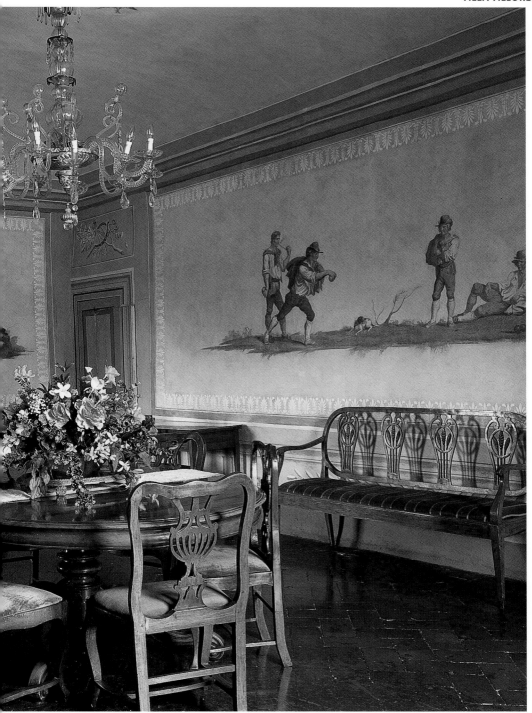

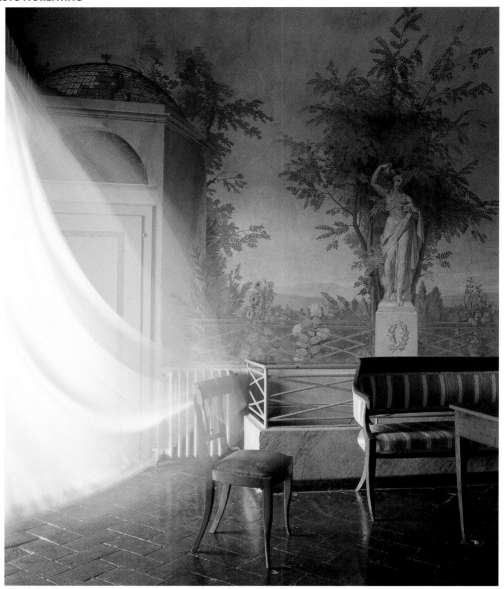

↑ Siesta time – and a warm breath of air from outside lifts a corner of the diaphanous curtain. • Es ist Zeit für die Siesta, während eine leichte Brise die Vorhänge sanft bewegt ... • C'est l'heure de la sieste et le souffle tiède de la brise soulève les voilages diaphanes ...

→ In one of the main bedrooms the walls are covered with trompe l'œil pastoral scenes. Birdcages and statues inspired by antiquity stand against a backdrop of the Tuscan landscape. • In einem der Zimmer der Hausherrin sind die Wände mit Hirtenmotiven in Trompe-l'Œil-Manier bemalt. Vogel-volieren und antikisierende Statuen stehen vor einer toskanischen Landschaft. • Sur les murs d'une des chambres maîtresses, des compositions pastorales en trompe-l'œil. Des volières et des statues à l'antique s'y détachent sur un fond de paysage toscan.

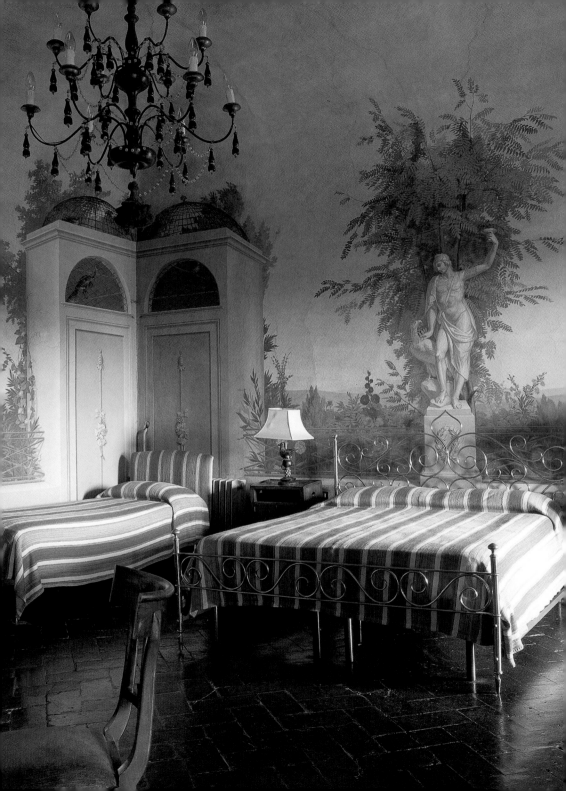

MONICA SANGBERG MOEN AND STEFANO CRIVELLI

MONICA SANGBERG MOEN
AND STEFANO CRIVELLI
BARBERINO DI MUGELLO

About twenty years ago, Monica Sangberg Moen and Stefano Crivelli were out exploring 40 miles north of Florence when they fell into a kind of trance. Artist Monica, who is Swedish, and architect Stefano, who is Italian-American, came upon an old iron gate. "I recognised it right away," recalled Monica. "It was my house, and it was waiting for me. To get to it, we had to crawl through barbed wire and thorned blackberry bushes." It was actually two family houses, one from the 13th century and the other from the 16th century, which were joined and turned into one house. Inside there was little to see but a blackened fireplace and a couple of old motorcycles. Now it is furnished with antiques that adapted to the rooms like pieces of a puzzle. "As with any old house, ours has its own individual soul," said Monica. "Its spirit is particularly kind and comforting. Everything here is a little temporary, a little serious, and a little playful, just like life."

Vor etwa zwanzig Jahren entdeckten Monica Sangberg Moen und Stefano Crivelli bei einem Ausflug dieses Haus ungefähr 60 Kilometer nördlich von Florenz und verliebten sich auf Anhieb. Die schwedische Künstlerin Monica und der italienisch-amerikanische Architekt Stefano standen damals vor dem alten Eisentor: „Ich wusste es sofort", erinnert sich Monica. „Hier stand mein Haus und es wartete auf mich. Um hineinzukommen, mussten wir durch Stacheldraht und dorniges Brombeergestrüpp kriechen." Eigentlich waren es zwei Gebäude, eines aus dem 13. Jahrhundert und das andere aus dem 16. Jahrhundert, die man zusammengelegt hatte. Im Inneren gab es nicht viel zu sehen außer einem verrußten Kamin und ein paar alten Motorrädern. Jetzt ist das Haus mit Antiquitäten eingerichtet, die gut in die Räume passen. „So wie jedes alte Haus hat auch dieses eine eigene Seele", meint Monica. „Und unser Haus ist besonders freundlich und angenehm. Alles hier ist ein bisschen provisorisch, ein bisschen ernsthaft und ein bisschen verspielt – eben so wie das Leben."

Il y a une vingtaine d'années, l'artiste suédoise Monica Sangberg Moen et l'architecte italo-américain Stefano Crivelli exploraient la campagne toscane une soixantaine de kilomètres au nord de Florence lorsqu'ils tombèrent en arrêt devant un portail en fer. « Je l'ai tout de suite reconnue » explique Monica. « C'était ma maison, elle m'attendait. Pour y accéder, il fallait ramper sous des fils de fer barbelé et des ronces chargées de mûres ». En fait, il s'agissait de deux maisons de famille, l'une datant du 13e siècle, l'autre du 16e siècle, qui avaient été réunies en un seul bâtiment. A l'intérieur, il n'y avait pas grand chose à voir hormis une cheminée noircie et deux vieilles motocyclettes. Aujourd'hui, elle est meublée d'antiquités qui se sont adaptées aux différentes pièces comme les éléments d'un puzzle. « Comme toute vieille maison, la nôtre à son âme », confie Monica. « Elle est particulièrement douce et apaisante. Tout ici est un peu éphémère, un peu sérieux, un peu ludique... comme la vie ».

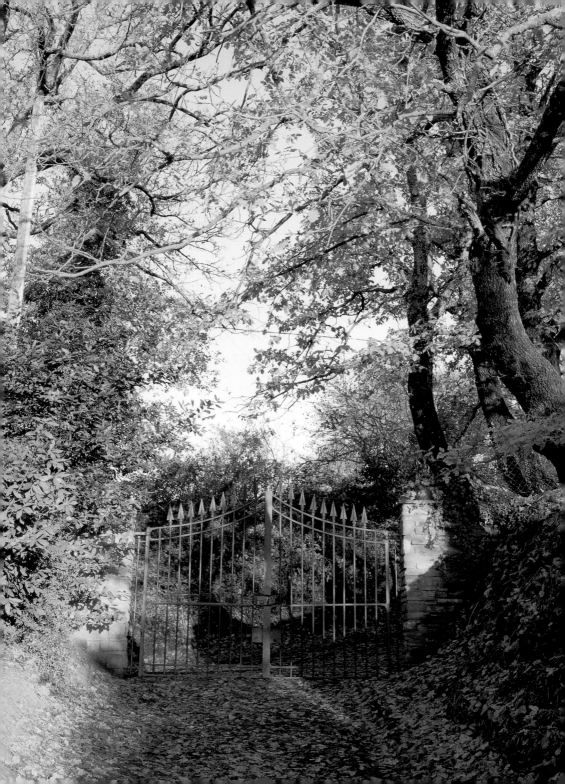

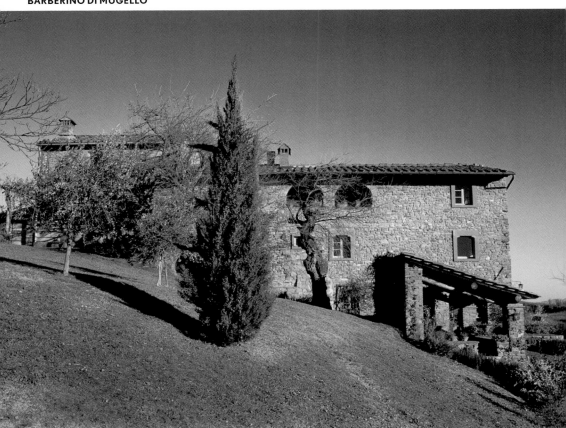

PP. 116–117 and P. 123 That's country life: dreaming beside the mulberry tree in the golden light of afternoon. • Das ist Landleben: unter einem stattlichen alten Maulbeerbaum im goldenen Licht der Nachmittagssonne Träumereien nachhängen. • La vie à la campagne : rêver sous son mûrier dans la lumière dorée de l'après-midi.

P. 119 The entry gate. It was exactly this mysterious, half-deserted landscape that first drew Monica and Stefano to their domain. • Das Gartentor. Es war genau diese geheimnisvolle, halb verlassene Atmosphäre, die Monica und Stefano von Anfang an in ihren Bann zog. • Le portail d'entrée. C'est ce paysage mystérieux et à demi abandonné qui a attiré Monica et Stefano.

←↓ The old farmhouse rescued by Monica Sangberg Moen and Stefano Crivelli stands squarely on the hilltop overlooking undulating hills, with no signs of people. The house and the woodshed were built of stone from local quarries. • Unerschütterlich steht das alte, von Monica Sangberg Moen und Stefano Crivelli restaurierte Landhaus auf dem kleinen Berg. Von hier aus hat man einen herrlichen Blick auf die hügelige menschenleere Landschaft.

Die Steine für das Haus und den Holzschuppen kommen aus nahe gelegenen Steinbrüchen. • La vieille ferme sauvée par Monica Sangberg Moen et Stefano Crivelli se dresse fièrement au sommet d'une colline, surplombant un paysage vallonné. Aucune autre habitation n'est visible à la ronde. La maison et sa remise ont été construites avec des pierres extraites de carrières locales.

↑ An impromptu lunch served on a hand-hewn table near the mulberry tree. • Ein improvisiertes Mittagessen auf einem selbst gezimmerten Tisch neben dem Maulbeerbaum. • Un déjeuner improvisé servi sous le mûrier.

↑ The couple purchase demijohns of wines, such as Chianti, and then fill their own carafes from the wicker-wrapped traditional containers. · Monica und Stefano kaufen Wein in großen Korbflaschen und füllen ihn dann in kleinere Flaschen um. · Le couple achète des dames-jeannes de vin, puis remplit ses carafes à partir de ces bonbonnes traditionnelles gainées d'osier.

→ There is always a push-and-pull when refurbishing and restoring a 500-year-old house. The couple worked with great respect and devotion, yet still bestowing on it the blessings of today's aesthetic. Monica and Stefano danced this waltz together, and orchestrated a balanced harmony. The old stones, bricks, beams and apertures are there – and there is the shock of the painterly green. · Ein 500 Jahre altes Haus zu restaurieren ist ein ständiges Auf und Ab. Monica und Stefano widmeten sich dieser Aufgabe mit Hingabe und Respekt, wollten aber auf eine moderne Ästhetik nicht verzichten. So schufen sie gemeinsam ein perfekt aufeinander abgestimmtes Ganzes: Sie beließen die alten Steine, Ziegel, Balken und Durchgänge und inszenierten dazu schreiend grün gestrichene Wände. · Restaurer et réaménager une maison vieille de cinq siècles n'est pas une mince affaire. Monica et Stefano ont abordé ensemble ce délicat pas de deux avec grand respect et dévotion, tout en apportant leur propre touche d'esthétique contemporaine. Ils ont orchestré une harmonie équilibrée : les vieilles pierres, briques, poutres et ouvertures sont toujours à leur place, rehaussées d'un vert pictural.

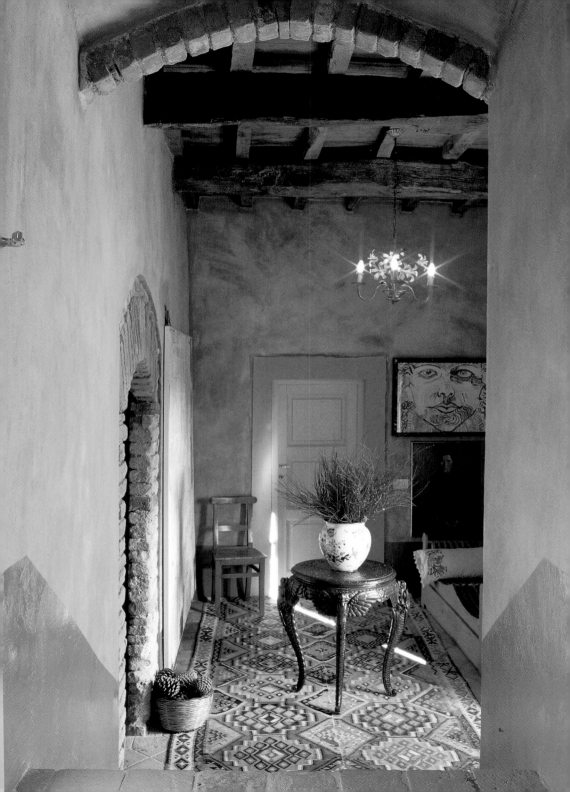

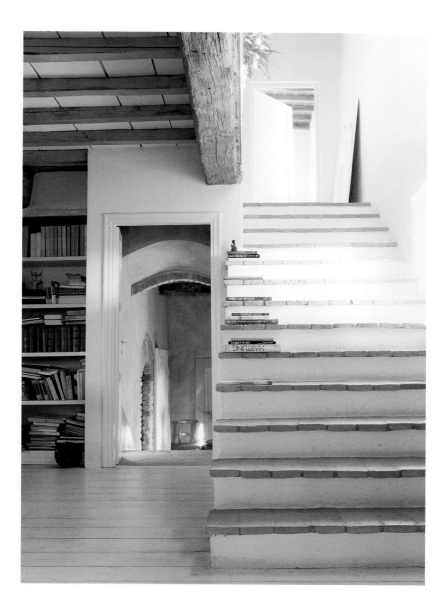

← ↑ The transitional rooms of the house have been handled with great bravado, warmed with Turkish rugs, framed in bold brick doorways, and graced with a simple staircase. • Die kühn gestalteten Durchgangsräume wirken durch den türkischen Teppich, die Torbögen aus Ziegelsteinen und das schlichte Treppenhaus einladend. • Les pièces de passage de la maison ont été traitées avec panache, réchauffées par des tapis turcs. Le pourtour des portes a été laissé en briques nues. L'escalier a la grâce de la simplicité.

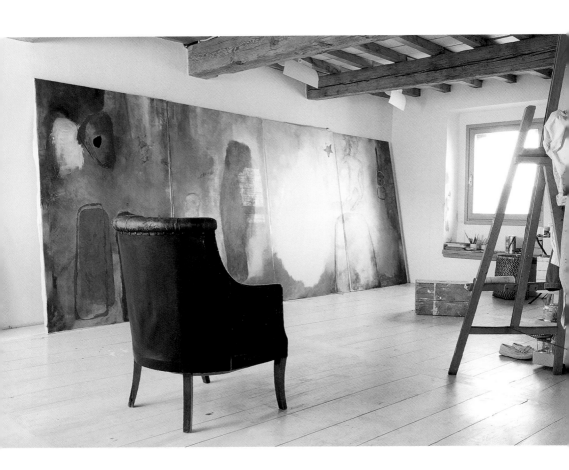

PP. 128–129 In the bedroom on the second floor, the Swedish headboard, with its ruffles and flourishes, was painted by a talented family member. • Das Schlafzimmer liegt im Obergeschoss. Ein Familienmitglied bemalte das aus Schweden stammende Kopfteil des Bettes mit Ornamenten und Schnörkeln. • Dans la chambre du premier étage, la tête de lit suédoise, avec ses arabesques et entrelacs, a été peinte par un talentueux membre de la famille.

↑ Monica Sangberg Moen's studio, has the ideal light. Monica has exhibited throughout Europe, including Italy, Sweden and Switzerland. • Das Atelier von Monica Sangberg Moen verfügt über idealen Lichteinfall. Monicas Werke wurden in ganz Europa ausgestellt, auch in Italien, Schweden und der Schweiz. • L'atelier de Monica Sangberg Moen jouit d'une lumière idéale. Monica a exposé dans toute l'Europe, y compris en Italie, en Suède et en Suisse.

→ Sangberg Moen and Crivelli understand the power of colour to startle, and stimulate. "The house has great atmosphere," said the couple. "It's very calm and silent, with beautiful light." • Sangberg Moen und Crivelli wissen um die Kraft der Farben, wenn es um verblüffende oder anregende Effekte geht. „Das Haus hat sehr viel Atmosphäre", sagen beide. „Es ist sehr ruhig und still, mit wundervollem Licht." • Sangberg Moen et Crivelli comprennent le pouvoir de la couleur qui surprend et stimule. « La maison a une belle atmosphère », confie le couple. « Elle est très calme et silencieuse, avec une lumière superbe ».

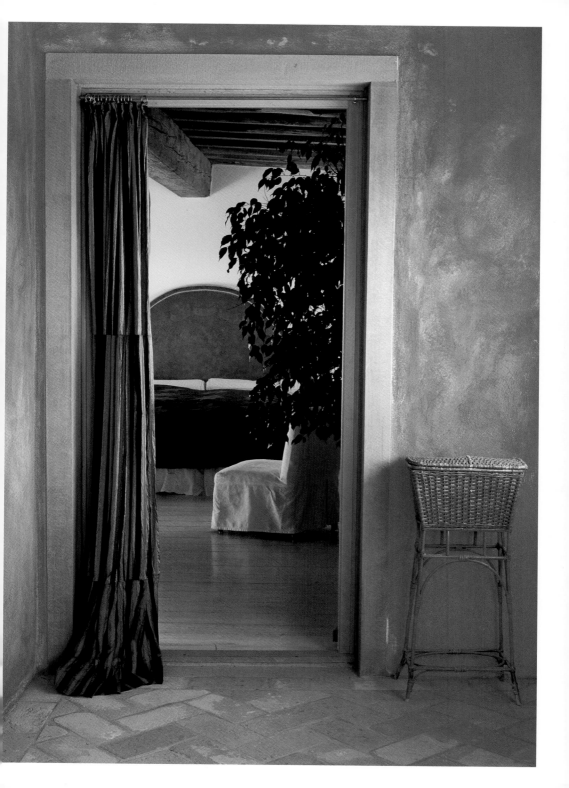

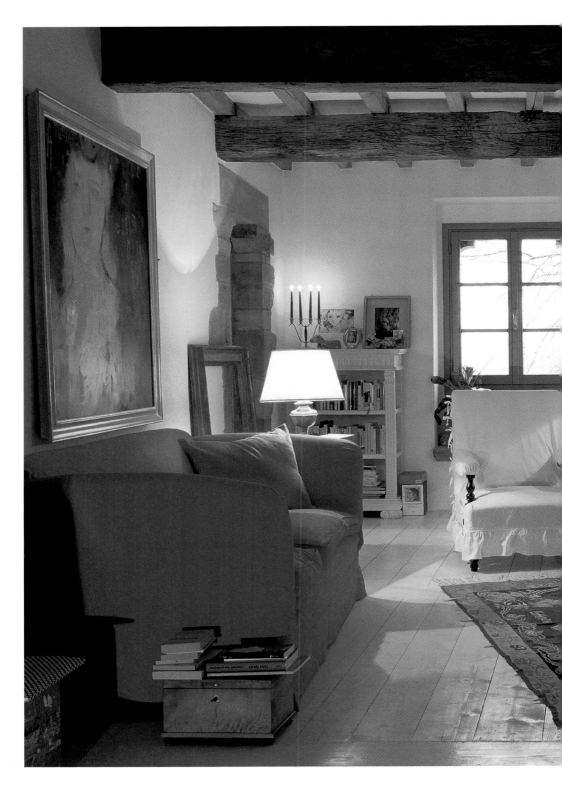

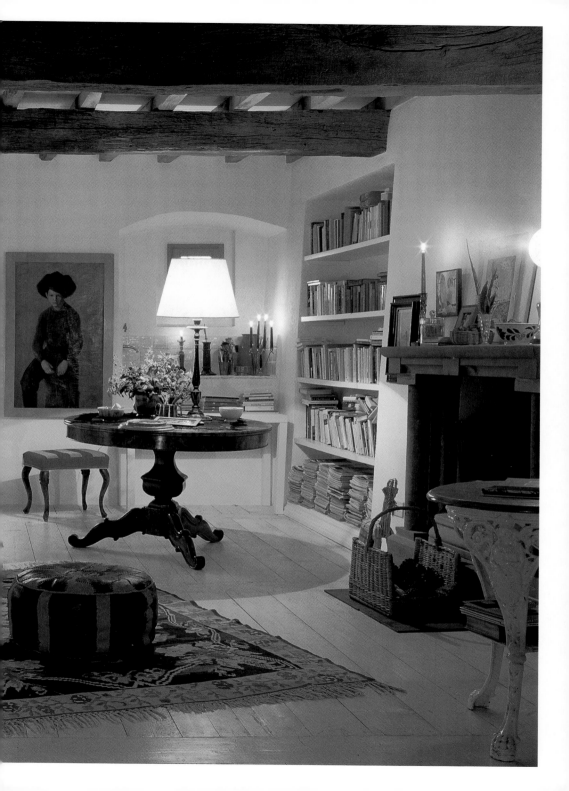

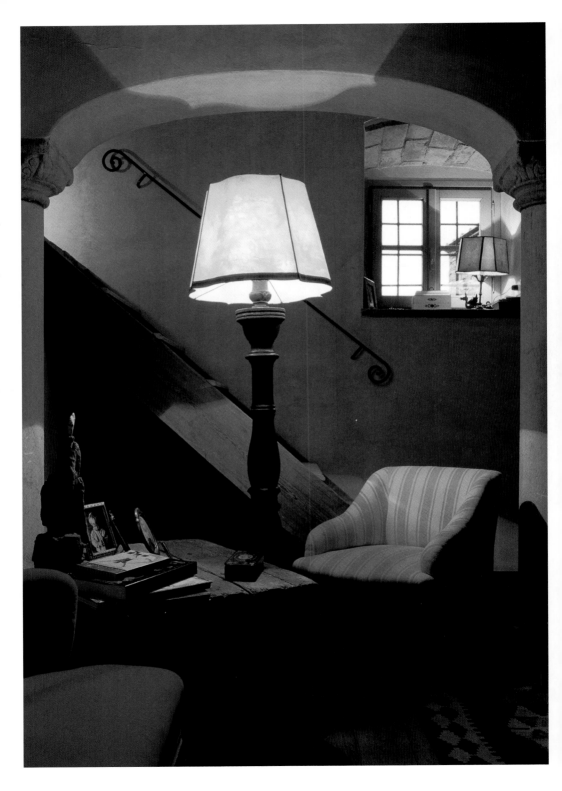

PP. 132–133 Monica painted the floor and the walls of the sitting room with eco-friendly milk-based paints. Their decor includes a polyglot collection of furniture, paintings and objets trouvés. • Monica versah den Boden und die Wände im Wohnzimmer mit einem umweltfreundlichen Anstrich auf Milchbasis. Die Einrichtung besteht aus einer bunten Sammlung von Möbeln, Gemälden und Objekten aus aller Welt. • Monica a enduit le sol et les murs du pe-

tit salon de peintures écologiques à base de lait. Le décor inclut une collection cosmopolite de meubles, de tableaux et d'objets trouvés.

← The wooden staircase was found discarded in a corner of the deserted villa. It fits perfectly. The old iron hand rail was a fortuitous gift to Stefano from friends. • Die Holztreppe lag in einer Ecke der verlassenen Villa. Den alten Handlauf aus Eisen bekam Stefano von

Freunden geschenkt. • L'escalier en bois a été retrouvé, oublié, dans un coin de la bâtisse abandonnée. Il a trouvé sa juste place. La vieille rampe en fer est un cadeau providentiel des amis de Stefano.

↑ The floor of this salon is crafted from salvaged old beams. • Der Fußboden wurde mit wieder verwendeten Balken belegt. • Le sol de ce salon a été réalisé avec des poutres récupérées.

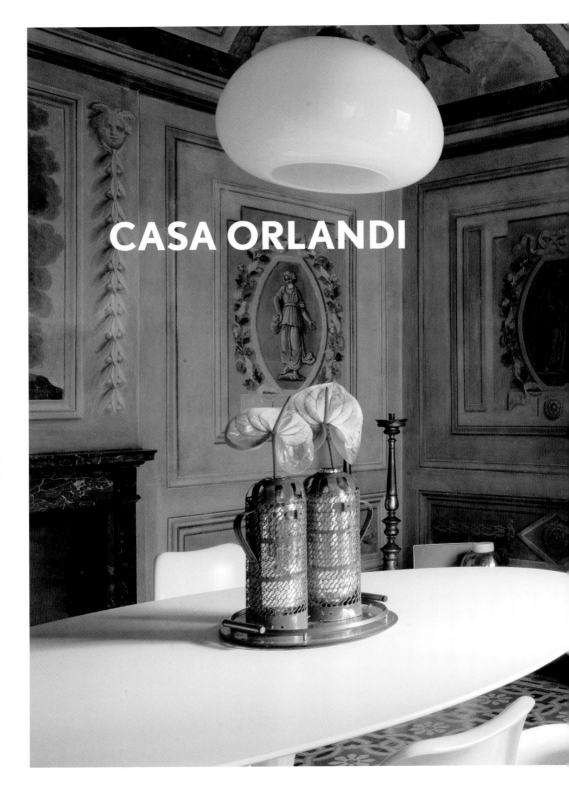

CASA ORLANDI

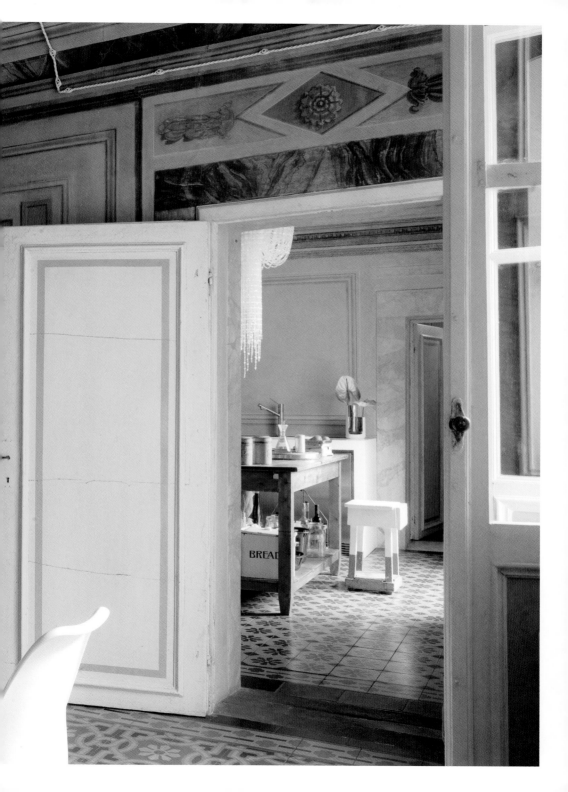

CASA ORLANDI
PRATO

The very glamour of the Casa Orlandi stems from its alternating mix of ancient and contemporary. A contemporaneity that is neither stereotypical nor, as often happens, dependent only on the big names of Italian design.

Der Glamour der Casa Orlandi entsteht aus der Mischung von Alt und Modern – eine Modernität, die nicht stereotyp ist und sich auch nicht, wie so häufig, nur auf die großen Namen des italienischen Designs verlässt.

Tout le glamour de la Casa Orlandi vient de l'alternance de l'ancien et du moderne. Une contemporanéité qui n'est ni un stéréotype ni, comme c'est souvent le cas, uniquement dépendante des grands noms du design italien.

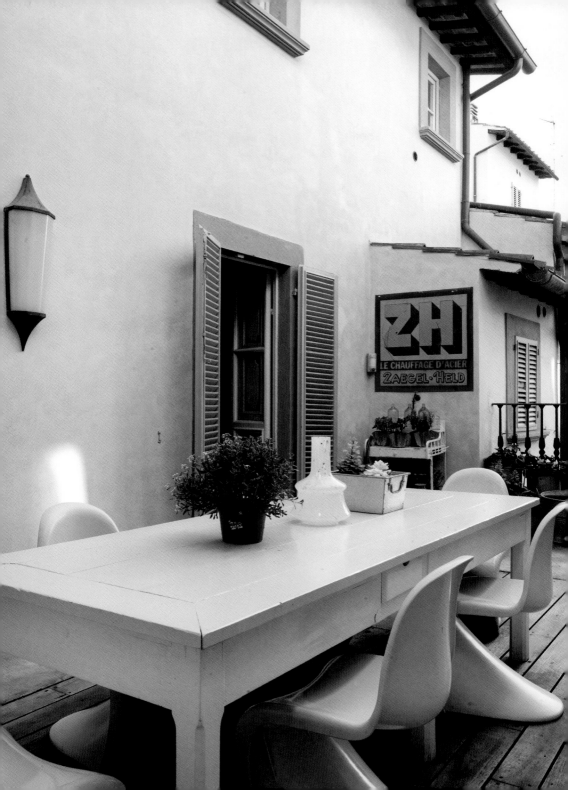

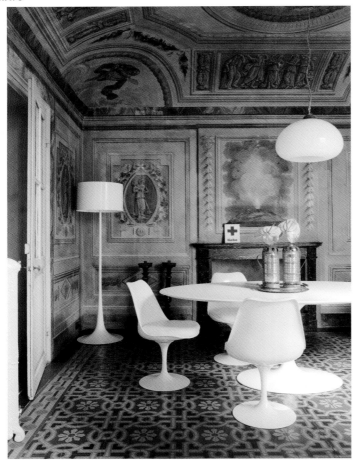

PP. 136-137 The art of mingling ancient and modern does not come easily, but in the case of Casa Orlandi, rescued *in extremis* by the architect Sabrina Bignami, the harmonious combination of 18th-century décor and furniture of contemporary design verges on perfection. • Die Kunst, Altes und Zeitgenössisches zu kombinieren, hat im Falle der Casa Orlandi nichts Zufälliges. Die Architektin Sabrina Bignami achtet peinlich genau darauf, dass die harmonische Verbindung der Einrichtung aus dem 18. Jahrhundert mit zeitgenössischen Designer-Möbeln auf perfekte Weise erhalten bleibt. • L'art de combiner l'ancien et le contemporain n'a rien d'évident et dans le cas de la Casa Orlandi, sauvée in extremis par l'ar-

chitecte Sabrina Bignami, le mariage harmonieux entre un décor d'époque 18e et un mobilier design contemporain, touche à la perfection.

P. 139 The new owner had no hesitation in furnishing the terrace with a rustic white-painted table and some chairs designed by Verner Panton. • Die neue Besitzerin hat nicht gezögert, die Terrasse mit einem weiß gestrichenen rustikalen Tisch und Stühlen von Verner Panton auszustatten. • La nouvelle propriétaire n'a pas hésité de meubler la terrasse avec une table rustique peinte en blanc et des chaises signé Verner Panton.

↑ In the dining room, the 18th-century frescoes in muted shades have under-

gone extensive restoration. The table and chairs are reproductions of the original Tulip models designed for Knoll International by Eero Saarinen (1919-1961). • Die aus dem 18. Jahrhundert stammenden Fresken im Esszimmer mit ihren subtilen Farben wurden einer sorgfältigen Restaurierung unterzogen. Der Tisch und die Tulip-Stühle sind zeitgenössische Neuauflagen der von Eero Saarinen (1919-1961) für Knoll International entworfenen Originalmodelle. • Dans la salle à manger les fresques 18e aux tons subtils ont subi une restauration majeure. La table et les chaises « Tulip » sont des rééditions de modèles originaux crées par Eero Saarinen (1919-1961) pour Knoll International.

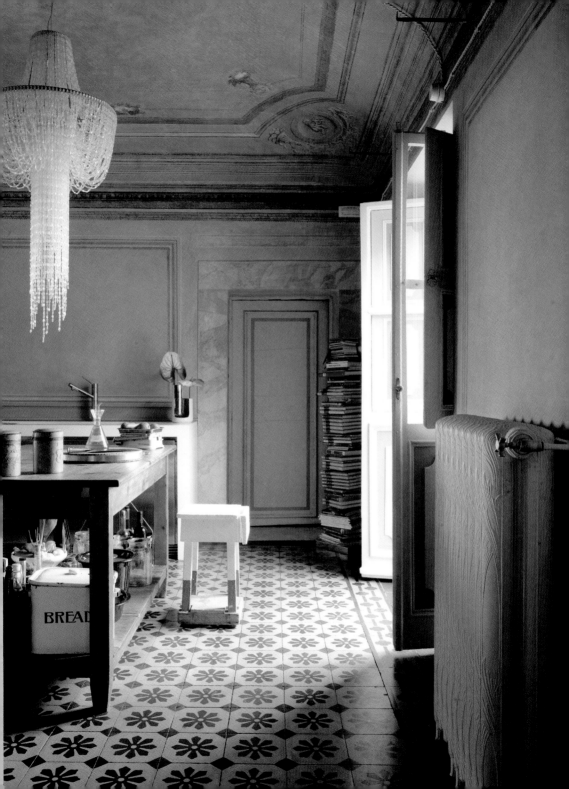

P. 141 It takes a touch of bravado (and a lot of talent) to hang a Solzi Luce crystal chandelier in a kitchen! The floor tiles are the originals, while the mountainous pile of books is another bright and amusing idea. • Es braucht schon einen gewissen Wagemut (und viel Talent), einen Kristallleuchter von Solzi Luce in eine Küche zu hängen! Die Fußbodenkacheln sind original erhalten und der mannshohe Bücherstapel ein mit einem Augenzwinkern geschaffenes Zufallsprodukt. • Il faut de l'audace (et beaucoup de talent) pour introduire un lustre en cristal de chez Solzi Luce dans une cuisine! Le

carrelage est d'origine et la montagne de livres empilés une trouvaille pleine d'humour.

PP. 142–143 The kitchen boasts the very latest in modern gadgets, while the molded walls, painted pale grey, imitate traditional panelling. • Die Küche wurde topaktuell und hochmodern eingerichtet. Die mit blassgrauem Stuck verputzten Wände imitieren eine klassische Vertäfelung. • La cuisine a été équipée avec le dernier cri du confort moderne. Les murs moulurés peint en gris pâle imitent un lambris classique.

← The pristine white of the suite of Living Divani sofas, and the pastel shades of the trompe-l'oeil frescoes, lend the living room an atmosphere flooded with light. • Das makellose Weiß der Canapés von Living Divani und die Pastelltöne der Trompe-l'Œil-Fresken verleihen diesem Wohnraum eine von Licht gesättigte Atmosphäre. • Le blanc immaculé d'une paire de canapés de chez Living Divani et les tons pastel des fresques en trompe l'œil confèrent à ce séjour une ambiance saturée de lumière.

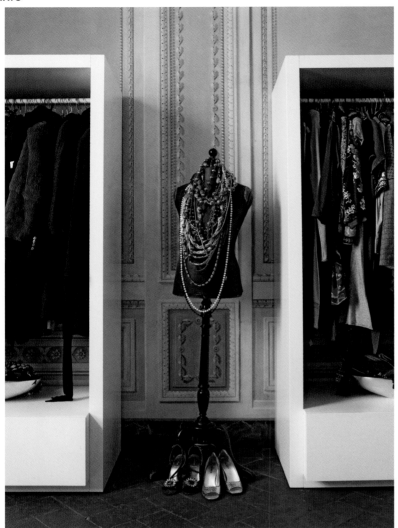

P. 145 An elegantly stylish but simple spray of willow branches adds to the minimalist character of the room. · Das elegante, schlichte Arrangement aus Weidenzweigen trägt das Seine zum minimalistischen Stil des Dekors bei. · Le graphisme élégant d'un simple bouquet composé avec quelques branches de saule contribue au caractère minimal de la décoration.

↑ One of the guest rooms features a pair of wardrobes and a dressmaker's dummy used as a jewellery display stand. · In einem der Gästezimmer sind zwei Wandschränke und der Torso einer Schaufensterpuppe zu entdecken, der als Schmuckhalter dient. · Dans une des chambres d'hôte, on découvre une paire de penderies et un mannequin d'étalage qui fait office de porte-bijoux.

→ The cubic four-poster bed, lacquered in white, and the two aluminium and Perspex Champaign chairs by Estelle and Erwin Laverne add the finishing touch to the room design. · Das Bett mit seinem kargen, kubisch geformten Gestänge wurde weiß lackiert und die beiden von Estelle und Erwin Laverne entworfenen „Champagne Chairs" aus Aluminium und Perspex vervollständigen die Einrichtung. · Le lit-squelette de forme cubique a été laqué en blanc et la paire de « Champagne Chair » en aluminium et Perspex signé Estelle et Erwin Laverne complètent la décoration.

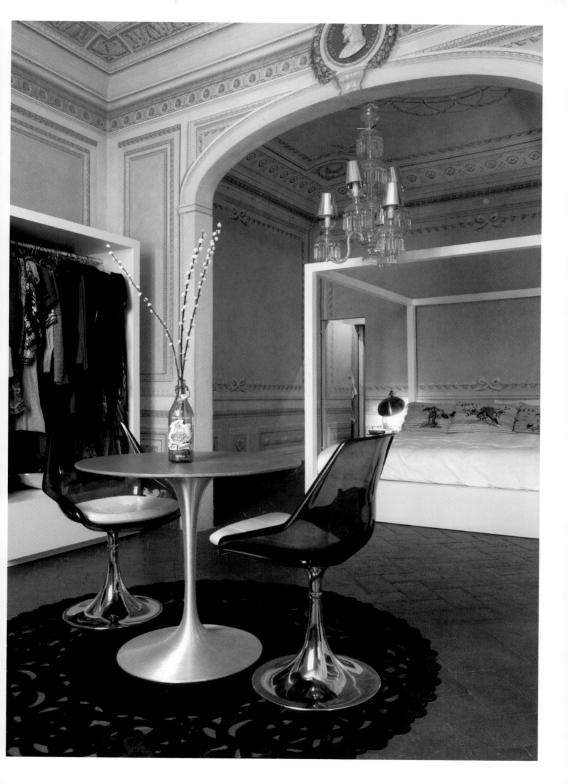

↑ The contemporary sculpture perched on the bedside table is inspired by the word *Fine*, which in days gone by appeared onscreen with the closing credits of Italian films. • Die auf dem Beistelltisch am Kopfende des Bettes installierte zeitgenössische Skulptur greift das Wort „Fine" auf, mit dem der Nachspann italienischer Filme einst endete. • La sculpture contemporaine installée sur la table de chevet s'inspire du mot « Fine » qui jadis clôturait le générique des films italiens.

→ The generously proportioned, open-work, woollen bedspread from the Cyrus Company forms a large rectangular splash of colour in a room decorated in pastel shades. • Die edle Tagesdecke aus durchbrochener Wolle, die dem Bett der Cyrus Company aufliegt, bildet in einem von Pastelltönen dominierten Zimmer ein großes Rechteck von lebhafter Farbe. • Le beau couvre-lit en laine ajouré qui habille le lit de chez la Cyrus Company, forme un grand rectangle de couleur vif dans une chambre aux tons pastel.

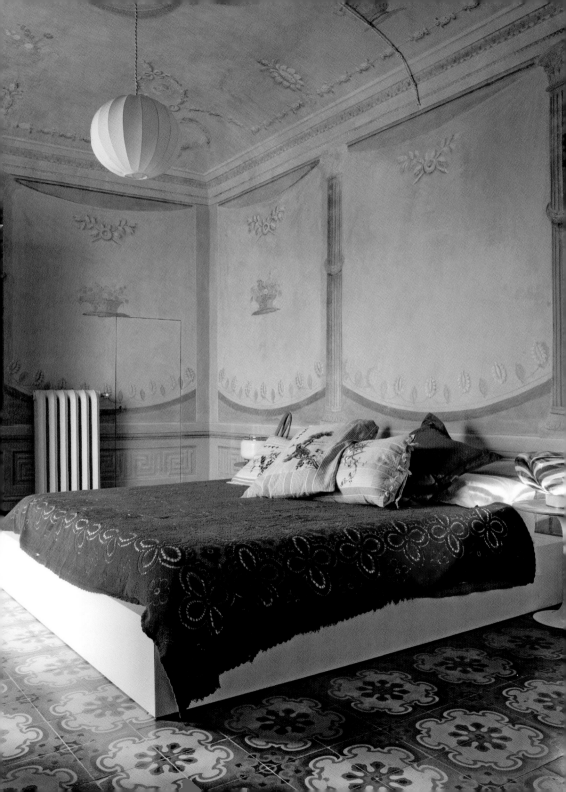

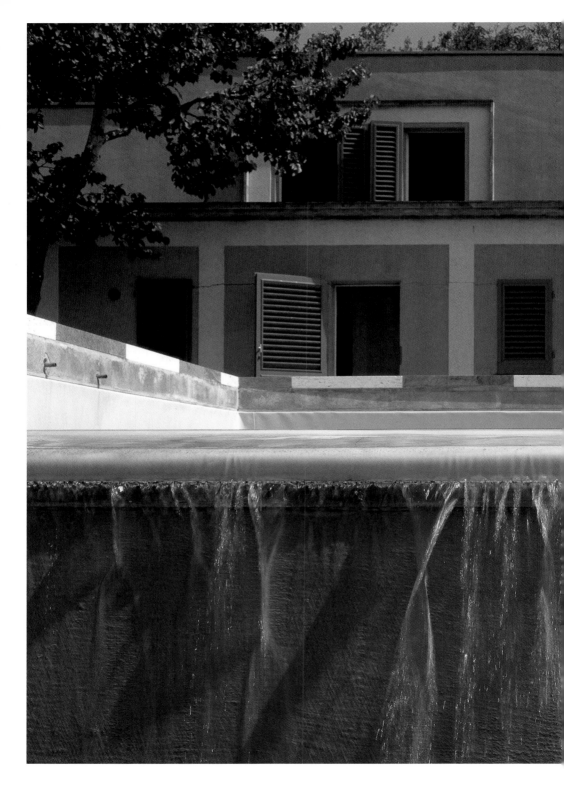

ROBERTO BUDINI GATTAI

ROBERTO BUDINI GATTAI

IMPRUNETA

To begin with, it was only a modest winegrower's house eaten away by time and the weather. Architect Roberto Budini Gattai freely admits he bought it on an impulse because it had something beyond price: a view across the whole of Florence and the surrounding countryside. Budini Gattai never tires of asserting that a resolutely contemporary architecture does not exclude the application of traditional techniques, and his creations strike a balance between the pure lines of today and the colours, structures and patinas of the past. In converting the old structure, he added a swimming pool in the best Californian taste, but apart from this homage to David Hockney, he did not fail to cover the walls with a pink *stucco antico*, crown the roof with earthenware vases planted with agaves and equip the window frames with traditional shutters. Inside, one is lulled by an ambience of permanent siesta: the white walls, solitary deckchair and sofa covered in a thinly striped cotton fabric supply a perfect complement to the filtered rays of the sun and discreet murmur of fountains outside the closed shutters.

Zu Anfang gab es nur ein bescheidenes Weinbauern-Haus, an dem schon der Zahn der Zeit seine Spuren hinterlassen hatte. Der Architekt Roberto Budini Gattai gibt offen zu, das Gebäude spontan gekauft zu haben, und zwar wegen des herrlichen Ausblicks auf Florenz und die ländliche Umgebung. Er betont gerne, dass eine bewusst moderne Architektur und alte Arbeitstechniken einander nicht ausschließen. So zeichnen sich Budini Gattais Entwürfe oft durch die perfekte Synthese zwischen den klaren Konturen des 20. Jahrhunderts und althergebrachten Farben, Strukturen und Patina aus. Beim Umbau des maroden Gebäudes ließ er einen kalifornisch anmutenden Swimmingpool à la David Hockney anlegen, und gemäß seiner Überzeugung überzog er die Mauern trotzdem mit dem rosafarbenem „stucco antico" der Toskana. Agaven in glasierten Keramiktöpfen bekrönen das Dach, und an den hohen Türen ergänzte der Hausherr traditionelle Fensterläden. Im Inneren des Hauses laden die weißen Wände, der einsame Liegestuhl und eine Couch, die mit fein gestreifter Baumwolle bezogen ist, zu ausgiebiger Siesta ein. Durch die Fensterläden dringt gedämpftes Sonnenlicht herein, während in der Ferne diskret das Wasser in den Brunnen plätschert.

Au début ce n'était qu'un modeste pavillon de vigneron rongé par le temps et par les éléments, et l'architecte Roberto Budini Gattai avoue volontiers qu'il l'acheta sur un coup de tête parce qu'il lui offrait le luxe inestimable d'une vue panoramique sur Florence et la campagne environnante. Budini Gattai ne se lasse pas de proclamer qu'une architecture résolument contemporaine n'exclut pas l'application de techniques anciennes, et ses créations se distinguent souvent par l'harmonie qui règne entre les formes épurées d'aujourd'hui et les couleurs, les structures et les patines d'hier. En transformant le pavillon vétuste, il l'a doté d'une piscine dans le plus pur goût californien, mais, à côté de cet hommage à David Hockney, il n'oublia pas de couvrir les murs d'un « stucco antico » rosâtre, de couronner le toit de vases en faïence ornés d'agaves et d'équiper les portes-fenêtres de volets à jalousies traditionnels. A l'intérieur règne une ambiance de sieste permanente, et les murs blancs, le transat solitaire et le canapé revêtu d'une cotonnade à fines rayures complètent à merveille les rayons de soleil filtrés et le murmure discret des jets d'eau derrière les volets fermés.

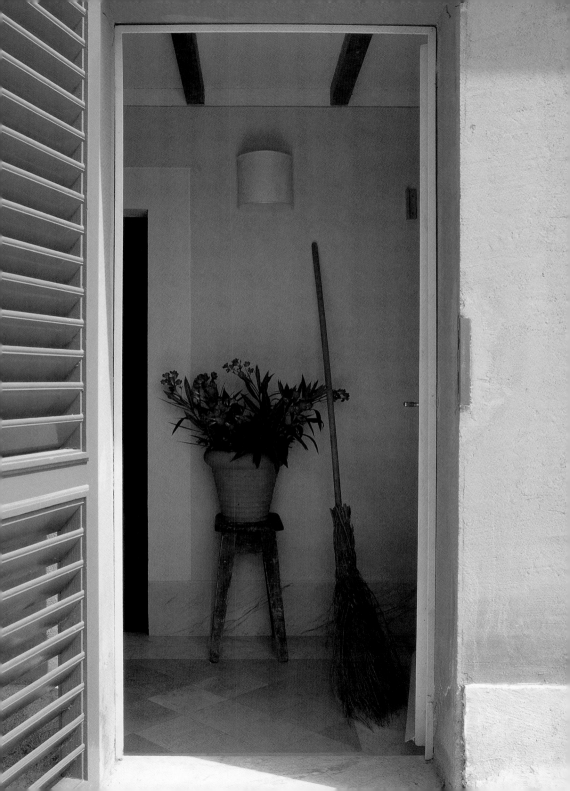

PP. 150–151 A turquoise pool, ochre-red façade and green shutters against a blue sky: Budini Gattai is a worshipper of bright colours. • Der türkisfarbene Pool, die ockerrote Fassade und grüne Fensterläden vor einem azurblauen Himmel: Budini Gattai liebt die Farbenvielfalt. • Piscine turquoise, façade ocre rouge et volets verts sur fond d'azur: Budini Gattai adore la couleur.

P. 153 In the entrance hall, a broom and a terracotta pot packed with olean-der. • Ein Besen und ein Terrakottatopf mit Oleander im Eingangsbereich. • Dans l'entrée, on découvre un balai et un pot en terre cuite où se serrent des branches de laurier-rose.

↑ Forty degrees in the shade, and the pool offers the only refuge from the heat. • Vierzig Grad im Schatten! Der Hausherr sucht Zuflucht im kühlen Pool. • Quarante degrés à l'ombre! Roberto cherche refuge dans l'eau fraîche de la piscine.

→ By noon, the shutters are closed and Roberto Budini Gattai, like everyone else in Italy, is hidden away from the *sol leone*. • Mittagszeit, die Fensterläden sind geschlossen, und wie alle Italiener meidet der Hausherr die Sonne. • Midi a sonné, les volets sont fermés, et comme tout le monde en Italie Roberto Budini Gattai se protège du soleil.

← In the bedroom, the pale wood used for the floorboards, hanging cupboards and sloping ceiling is in perfect harmony with the pinkish ochre of the walls. • Im Schlafzimmer ist das helle Holz der Bodendielen, der Schränke und der Dachbalken fein auf das Rosa der Wände abgestimmt. • Dans la chambre à coucher, le bois blond du plancher, des placards et du toit en pente s'harmonise à merveille avec l'ocre rosé des murs.

↑ In the bedroom, a Forties' vase and a piece of broken marble combine to make a simple but sophisticated still life. • Im Schlafzimmer bilden eine Keramikvase aus den 1940er-Jahren und ein Stück Marmor ein elegantes Arrangement. • Dans la chambre à coucher, un vase en faïence des années 1940 et un fragment de marbre créent une nature morte sobre et raffinée.

↑ A venerable, deformed olive branch on the terrace acts as contemporary sculpture. • Der gewundene Ast eines alten Olivenbaums auf der Terrasse wirkt wie eine moderne Skulptur. • Sur la terrasse, une très vieille branche _d'olivier tordue joue les sculptures contemporaines.

→ Sunshine filtering through the shutters casts diagonal shadows along the red stucco of the façade. • Die Schatten der Fensterläden zeichnen sich auf dem rötlichen „stucco" der Fassade ab. • A travers les jalousies, le soleil dessine des ombres diagonales sur le stuc rougeâtre de la façade.

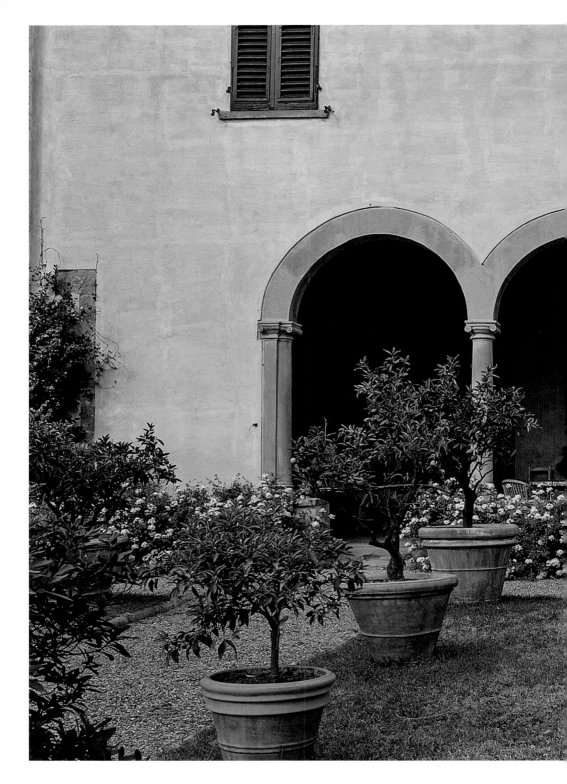

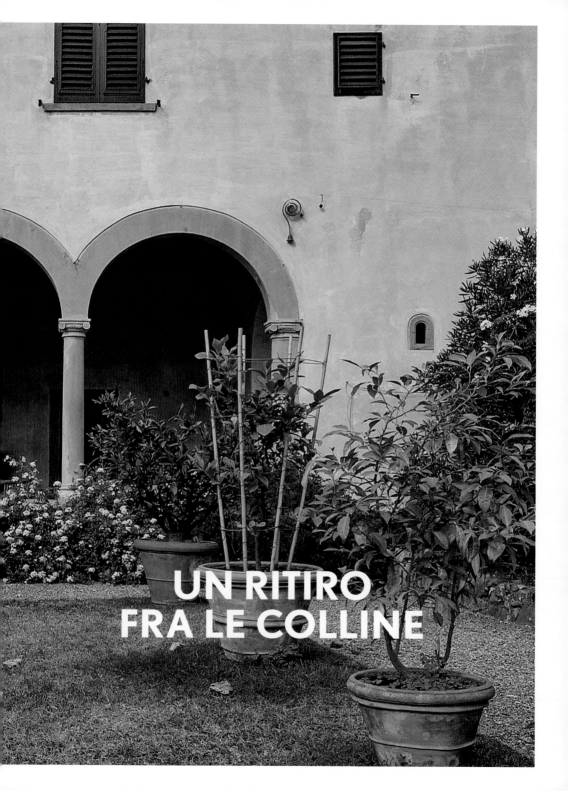

UN RITIRO
FRA LE COLLINE

UN RITIRO FRA LE COLLINE
COLLI FIORENTINI

From behind its thick stone walls, this elegant villa in the Florentine hills exudes an air of untroubled peacefulness. It was built in the 16th century by a wealthy Florentine family as a summer pavilion, and is indeed a perfect place to escape from the oppressive summer heat of the city. Bought at the beginning of the 20th century by the forefathers of the current owner, it was carefully restored to its original state in the Sixties. The pale ochre of the stuccoed exterior, untouched since then, the multitude of family mementoes inside and the filtered sunlight, which seems to stop, almost from habitual deference, at door and window, add to the serene if old-fashioned atmosphere, making this a true sanctuary from the rigours of day-to-day living. The loggia has been the summer drawing room from time immemorial. The stunning view of the *limonaia*, the green landscape and the vestiges of a nymphæum may have something to do with this, along with the omnipresent sunshine, which makes this hidden corner of Tuscany a real paradise.

Mit ihren dicken Steinmauern strahlt die auf einem Hügel bei Florenz gelegene elegante Villa eine angenehme Ruhe aus. Im 16. Jahrhundert wurde sie als Sommersitz einer reichen Florentiner Familie errichtet und ist bis heute ein idealer Platz, um der drückenden Schwüle der Stadt zu entkommen. Anfang des 20. Jahrhunderts von den Vorfahren der heutigen Besitzerin erworben, wurde das Steingebäude in den 1960er-Jahren originalgetreu restauriert. Der helle ockerfarbene „stucco", der seitdem unverändert erhalten blieb, die zahlreichen Familienerbstücke und das Sonnenlicht, das nur gedämpft durch die Türen und Fenster dringt, tragen zu der freundlich-nostalgischen Atmosphäre bei. Hierher kann man sich zurückziehen vor den Anfechtungen des täglichen Lebens. Immer schon diente die Loggia im Sommer als Wohnraum. Das mag damit zu tun haben, dass sich von hier eine atemberaubende Aussicht bietet: auf die „limonaia", die Orangerie, auf die zartgrünen Hügel und die Überreste eines ehemaligen Nymphäums. Und auch die allgegenwärtige Sonne trägt dazu bei, diesen verborgenen Winkel der Toskana in ein wahres Paradies zu verwandeln.

Située sur une colline près de Florence et ceinte d'épais murs de pierre, cette villa élégante rayonne de sérénité. Elle fut construite au 16ᵉ siècle par une riche famille florentine qui en fit son pavillon d'été, et de nos jours encore, on ne peut rêver de meilleur endroit pour échapper à la chaleur oppressante de la ville. Acquise par les ancêtres de la propriétaire actuelle au début du 20ᵉ siècle, la demeure a été méticuleusement restaurée durant les années 1960. Le stuc ocre pâle des murs resté intact depuis, les nombreux souvenirs de famille et la lumière du soleil tamisée qui filtre par les portes et les fenêtres, tout cela contribue à créer une ambiance paisible et surannée, faisant de ce lieu la retraite idéale contre les rigueurs de la vie quotidienne. Depuis toujours, la loggia fait office de salon en été ; la vue époustouflante qu'elle offre sur la « limonaia », sur le paysage verdoyant et sur les vestiges d'un nymphée y sont sans doute pour quelque chose, tout comme le soleil omniprésent, qui fait de cet endroit bien caché, un vrai coin de paradis.

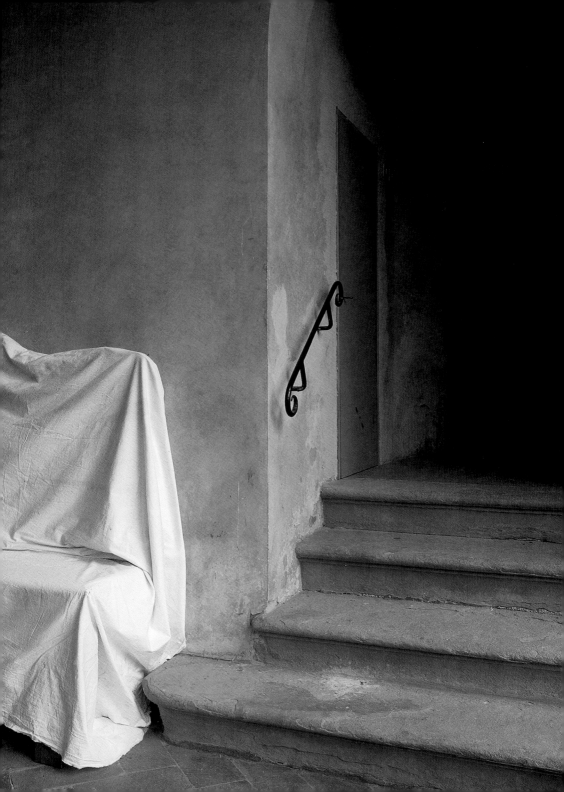

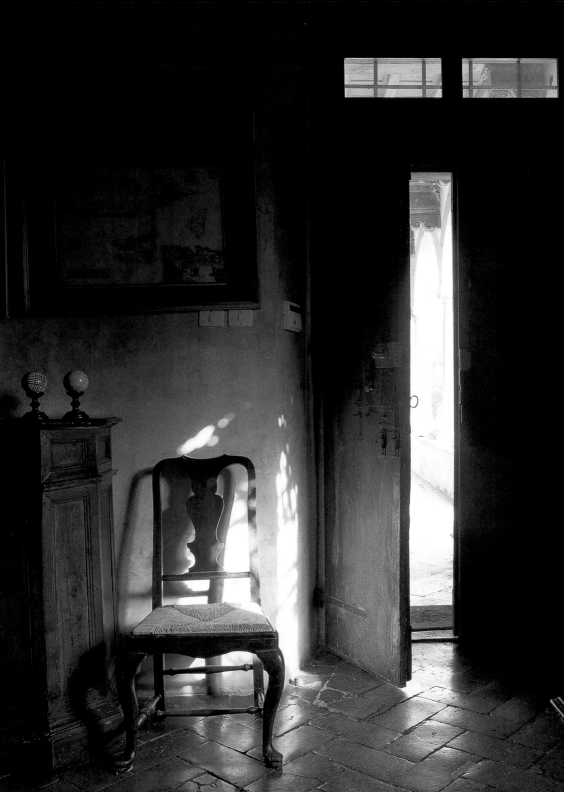

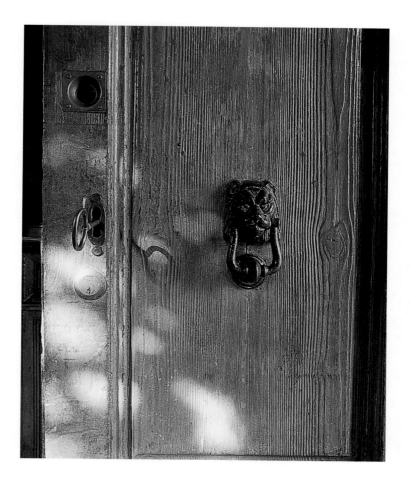

PP. 160–161 From the *limonaia* there is a fine view of the villa and the loggia with its three elegant arches. • Von der „limonaia" bietet sich ein schöner Blick auf die Loggia mit den drei eleganten Bögen. • De la « limonaia », on a une très jolie vue sur la villa et sur la loggia et ses trois arches élégantes.

P. 163 Stone steps leading up to the portico of the villa. • Eine Steintreppe

führt zum Eingangsportal der Villa. • Un escalier en pierre mène vers le portique de la villa.

← In Tuscany, the burning sunshine is a redoubtable enemy, to be thwarted with closed shutters and tiled floors providing shade and coolness. • In der Toskana wird die pralle Sonne nicht geschätzt. Fensterläden, Terrakottafliesen und Halbschatten sorgen für kühle Räume. •

En Toscane, le soleil brûlant n'est pas un ami : les volets fermés et les dalles en terre cuite apportent la pénombre et la fraîcheur tant désirées.

↑ The knocker on the front door is shaped like a lion's head. • Der Türklopfer an der Eingangstür hat die Form eines Löwenkopfes. • Le heurtoir de la porte d'entrée a la forme d'une tête de lion.

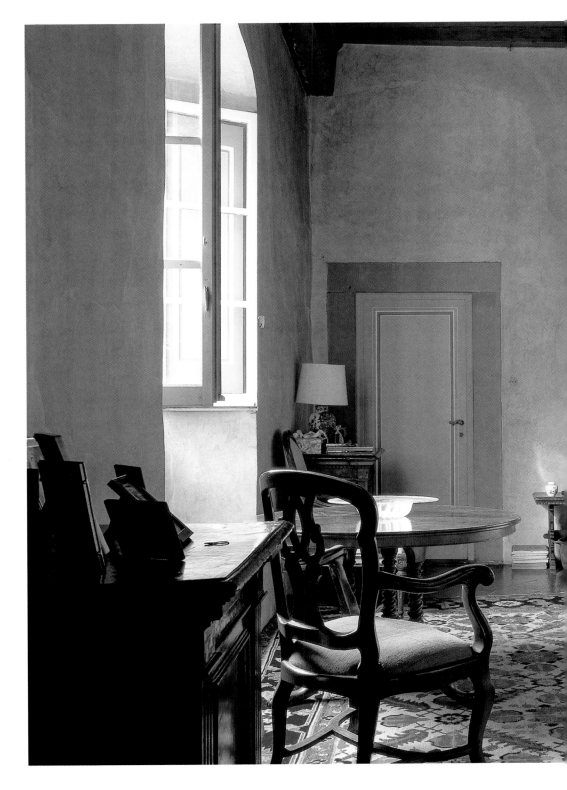

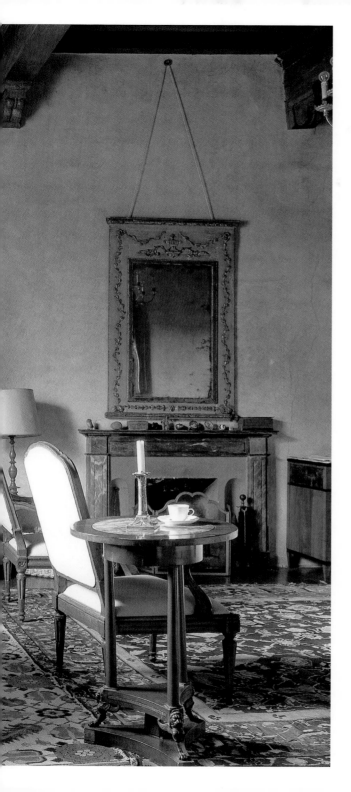

← In the ochre drawing room, the
earth tones create an atmosphere of
warmth. • Die Ocker- und Erdtöne
lassen diesen Raum gemütlich wirken. •
Dans le salon, les ocres et les couleurs
de terre forment un ensemble
chaleureux.

167

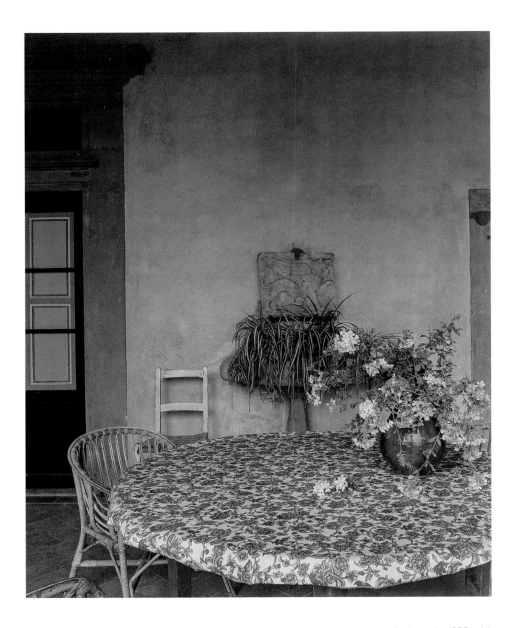

↑ The loggia serves as a drawing and dining room during summer. • Die Loggia dient im Sommer als Salon und Esszimmer. • En été, la loggia sert de salon et de salle à manger.

→ The kitchen, which is on the first floor, still has its original large linen cupboard, built-in larder and Thirties' wooden sink stand. • In der Küche in der ersten Etage befinden sich noch der Wäsche-schrank, ein eingebauter Vorratsschrank und die Spüle aus den 1930er-Jahren. • La cuisine, située à l'étage, a gardé sa grande lingère, son garde-manger encastré et son meuble évier des années 1930.

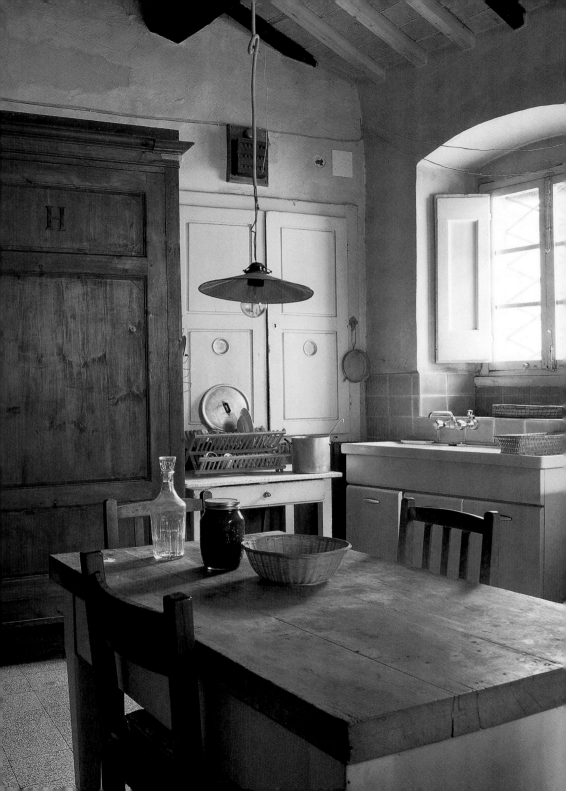

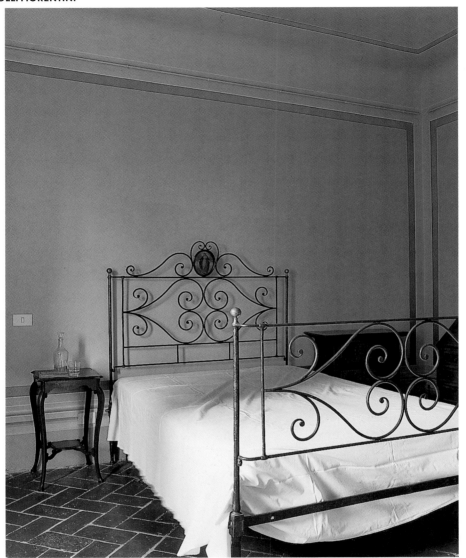

↑ In the principal bedroom, the wrought-iron curves of the bedstead stand out against the painted wall panelling. • Im Schlafzimmer der Hausherrin heben sich die schmiedeeisernen Arabesken des Betts von den hellen Wänden ab. • Dans la chambre maîtresse, les arabesques d'un lit en fer forgé se détachent sur les murs décorés de faux lambris.

→ The room has regained its original 17th-century colours, Louis Seize wing chair and footrest. • In diesem Zimmer wurde die originale Farbgebung des 17. Jahrhunderts wiederhergestellt. Auch der Ohrensessel und die Fußbank im Louis-Seize-Stil stammen aus dieser Zeit. • La chambre a retrouvé ses couleurs 17e d'origine, son fauteuil à oreilles et son repose-pied de style Louis Seize.

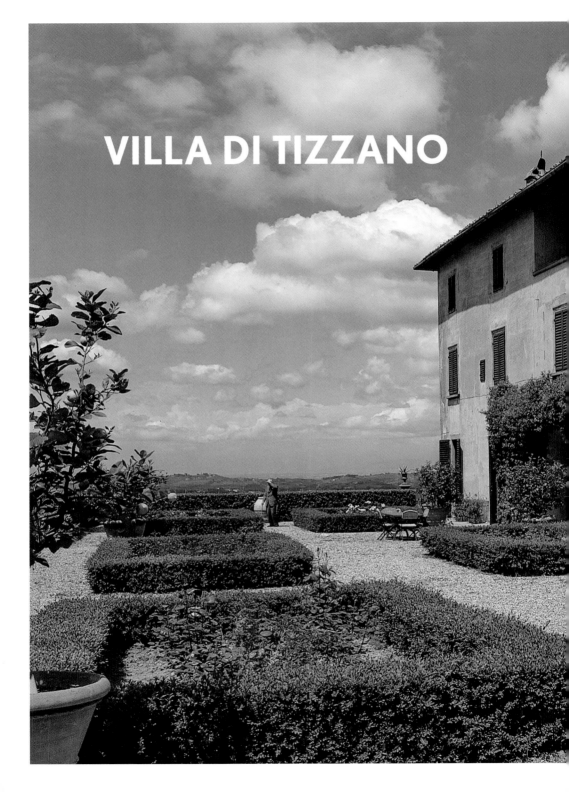

VILLA DI TIZZANO

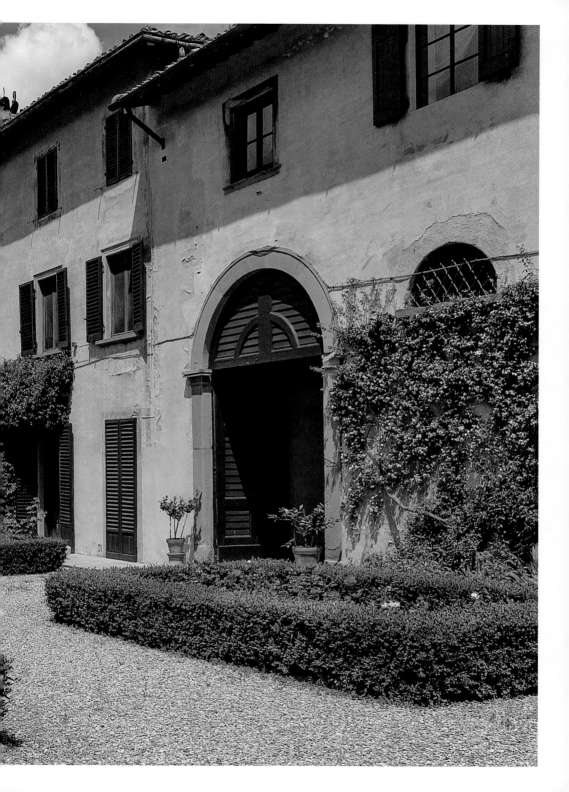

VILLA DI TIZZANO
ELISABETTA PANDOLFINI
CHIANTI

It's hard to imagine the Villa di Tizzano without its owner Elisabetta Pandolfini. It is the painter's eye and sculptor's hands of the remarkable Elisabetta that have transformed the interiors of this big, beautiful patrician house in one of the loveliest parts of the Chianti region. To visit Elisabetta is to fall under the spell of her engaging personality – especially in the great rooms where her own paintings and sculptures live in perfect harmony with the works of other artists. The Villa di Tizzano once belonged to the Talleyrand family and was bought by the Pandolfinis in the 19th century. Living here, Elisabetta has chosen to turn her back on the world and focus her attention on the people she loves. It is hard to describe the unique beauty of her flower-filled garden with its centuries-old trees, or the broad terrace with its Medici urns and breathtaking view. From her attic studio, which is in some sense her ivory tower, she contemplates the landscape of Chianti and, far away, the steeples of her native Florence. The view would be inspiring enough for any mortal, but for a gifted artist it is nothing short of stupendous.

Es fällt schwer, sich die Villa di Tizzano ohne ihre Besitzerin Elisabetta Pandolfini vorzustellen – denn sie war es, die dem stattlichen Patrizierhaus in einer der malerischsten Gegenden des Chianti mit den Augen einer Malerin und talentierten Bildhauerhänden den letzten Schliff gab. Wer Elisabetta besucht, verfällt unweigerlich der sehr persönlichen Australung ihres Hauses. In den geräumigen Salons stehen ihre Gemälde und Skulpturen Seite an Seite mit den Werken von Künstlerkollegen. Die Villa di Tizzano gehörte einst der Familie Talleyrand und wurde im 19. Jahrhundert von den Pandolfinis erworben. Die Besitzerin lebt zurückgezogen und sucht Kontakt nur zu den wenigen Menschen, die ihr nahe stehen. Es ist gar nicht leicht, die ganz besondere Stimmung des Gartens in Worte zu fassen, mit seinen Blumen und den jahrhundertealten Bäumen. Die Aussicht von der großen Terrasse mit den Medici-Vasen gehört zu den Dingen, die Elisabetta immer wieder aufs Neue begeistern. Von ihrem „Elfenbeinturm", dem Atelier unter dem Dach, blickt sie über das Chianti bis zu ihrer entfernten Geburtsstadt Florenz – die perfekte Inspiration für neue Werke.

Il est difficile d'imaginer la Villa di Tizzano sans sa propriétaire Elisabetta Pandolfini, car c'est l'œil de peintre de la remarquable Elisabetta et ses mains de sculpteur qui ont transformé les intérieurs de cette belle et vaste demeure patricienne située dans une des régions les plus pittoresques du Chianti. Rendre visite à Elisabetta, c'est tomber sous le charme de sa personnalité attachante et s'imprégner de l'image de ces grand salons où ses propres tableaux et sculptures côtoient harmonieusement les œuvres d'autres artistes. La Villa di Tizzano – elle appartenait jadis aux Talleyrand et fut achetée au 19e siècle par les comtes Pandolfini – ressemble à sa propriétaire car celle-ci a, comme sa maison, choisi de tourner le dos au monde et de veiller sur ceux qu'elle aime. Il est difficile de décrire l'ambiance unique de ce jardin fleuri aux arbres séculaires et de cette grande terrasse ornée de vases Médicis qui surplombe un panorama dont la beauté ne cesse d'étonner Elisabetta. De son atelier sous les combles, dont elle a fait sa tour d'ivoire, elle contemple le Chianti et son Florence natal, lointain, et pense déjà aux créations qui s'échapperont bientôt de sous ses doigts avides de rêve.

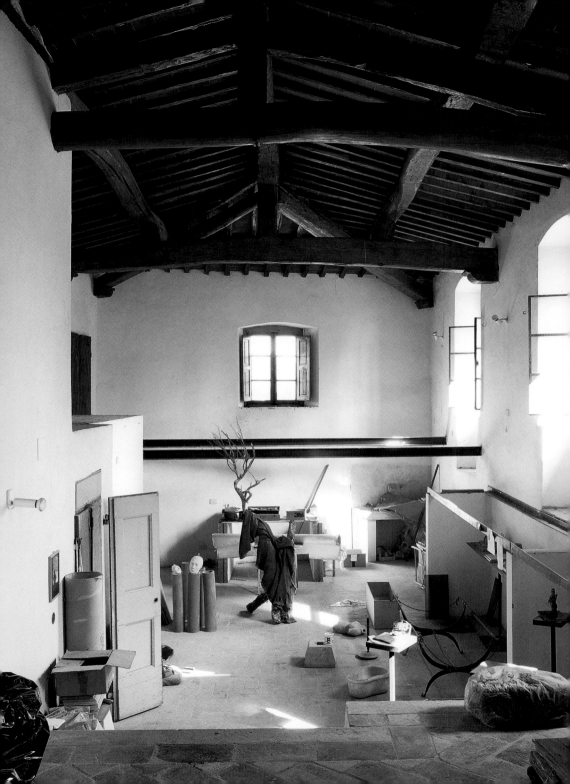

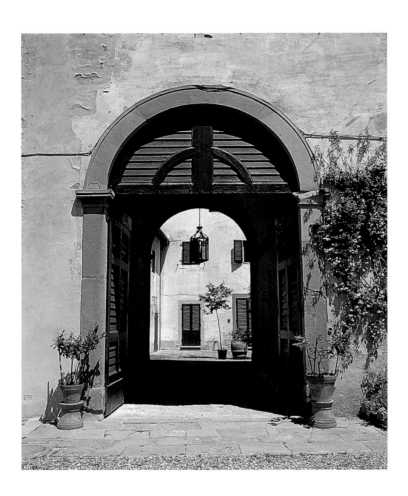

PP. 172–173 From the terrace there is a breathtaking view across the rolling Chianti countryside. • Von der Terrasse hat man einen atemberaubenden Blick auf die herrliche Hügellandschaft des Chianti. • De la terrasse, on a une vue à couper le souffle sur le merveilleux paysage ondoyant du Chianti.

P. 175 In the attic, Elisabetta has created a spacious, well-lit artist's studio. •

Im Dachgeschoss der Villa hat sich Elisabetta ein geräumiges lichtdurchflutetes „Künstlernest" geschaffen. • Sous les combles de la villa, Elisabetta s'est créée un nid d'artiste spacieux et inondé de lumière.

↑ The archway leads through to a sunny courtyard. • Der Torbogen führt in einen sonnigen Hof. • Le porche s'ouvre sur une cour ensoleillée.

→ In the studio, a rough clay model for a sculpture awaits the skilled hands of Elisabetta. • Im „studiolo", dem Atelier, wartet eine Rohskulptur aus Ton auf die geschickten Hände der Künstlerin. • Dans le « studiolo », une ébauche en terre glaise attend l'intervention de mains habiles.

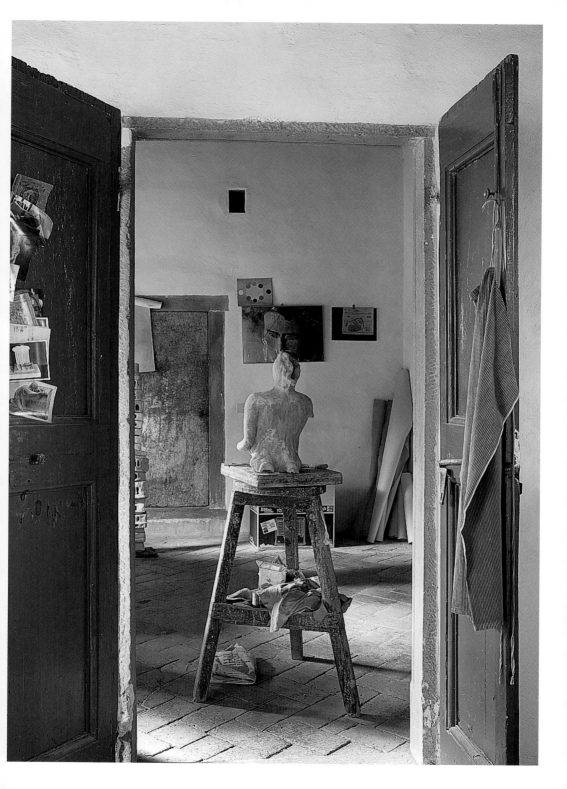

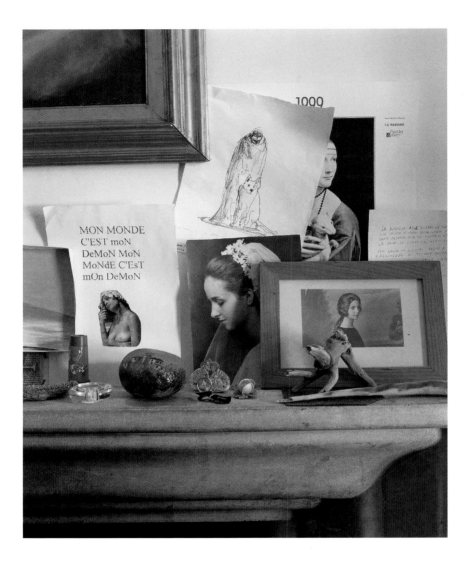

↑ Souvenirs of a lifetime: on the mantelpiece, Elisabetta has assembled a sentimental still life. • Souvenirs, Souvenirs ... Auf einem Kaminsims sammelt die Hausherrin Erinnerungsstücke. • Souvenirs, souvenirs. Sur la tablette d'une cheminée, la maîtresse de maison a composé une nature morte sentimentale.

→ Elisabetta is especially fond of yellow, which for her is synonymous with heat and sunshine. Yellow is the colour of the walls of her drawing room and the armchairs and soft, comfortable sofas in it. • Elisabetta liebt die Farbe Gelb, die sie mit Sonne und Wärme verbindet. Ihre Lieblingsfarbe findet sich an den Wänden des Salons und in den Bezugsstoffen der behaglichen Couch und der

Sessel. • Elisabetta adore le jaune, pour elle synonyme de soleil et de chaleur. Sa couleur favorite habille les murs du salon ainsi que les fauteuils et les canapés douillets et confortables.

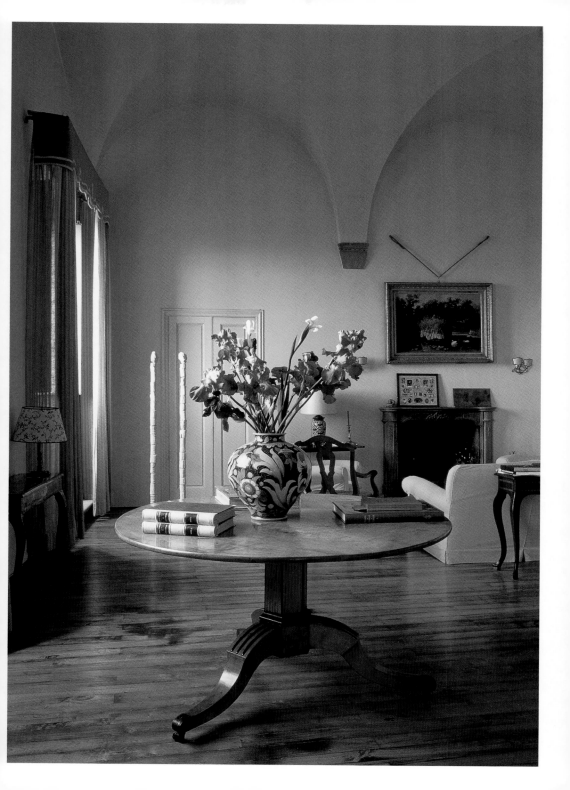

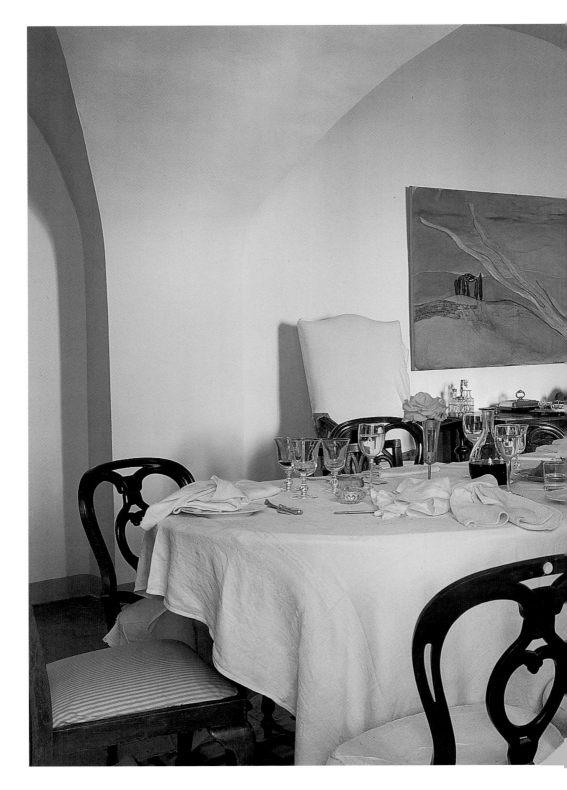

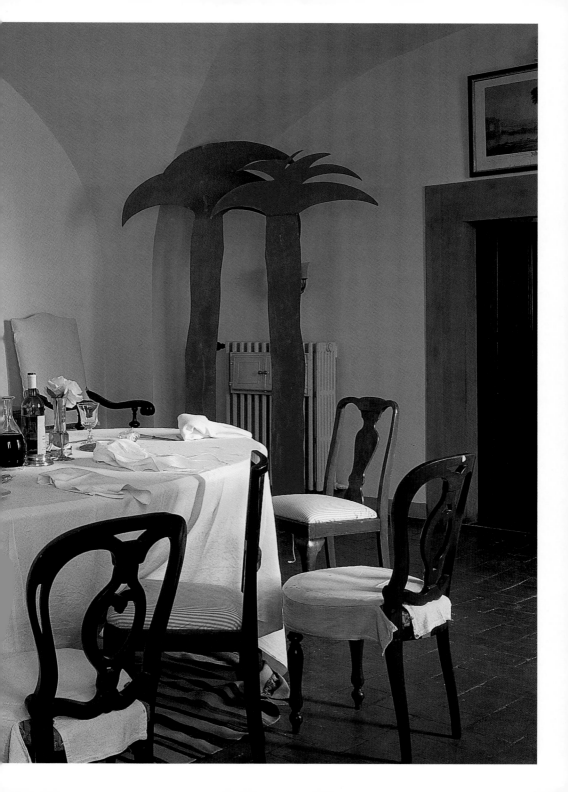

PP. 180–181 In the dining room, Sunday lunch has come to an end and the guests have just risen from table. • Im Esszimmer ist das Sonntagsessen beendet. Die Gäste haben gerade den Tisch verlassen. • Dans la salle à manger, le déjeuner dominical vient de s'achever et les invités ont quitté la table.

↑ In one of the ground-floor rooms, the graceful outline of an 18th-century chair stands out against the curtains. •

In einem der Räume im Erdgeschoss zeichnet ein Stuhl aus dem 18. Jahrhundert ein graziles Schattenspiel auf die Vorhänge. • Dans un des salons du rez-de-chaussée, la silhouette gracieuse d'un siège 18e se détache en ombre chinoise sur les rideaux opaques.

→ During the Thirties, Elisabetta's father Count Filippo (Pippo) Pandolfini installed the typically Art Deco bathrooms. His daughter has preserved them out of respect for him. • In den

1930er-Jahren ließ der Vater von Elisabetta, Graf Filippo Pandolfini – genannt „Pippo" – das Art-déco-Badezimmer installieren. Aus Respekt hat die Tochter nichts verändert. • Dans les années 1930, le père d'Elisabetta, le comte Filippo, dit « Pippo », Pandolfini, installa des salles de bains typiquement Art Déco. Par respect, sa fille n'y a pas touché.

MATTHEW AND MARO SPENDER

MATTHEW AND MARO SPENDER

CHIANTI

This idyllic *fattoria*, an 18th-century farmhouse, served Italian director Bernardo Bertolucci as the model for the house in his film *Stealing Beauty*. The life led by the owners Matthew and Maro Spender is typical of that led by the many foreigners, particularly those from England, who have chosen to settle in Tuscany, affectionately known as "Chiantishire". Matthew, a well-known sculptor, is the son of the English poet Sir Stephen Spender, while his wife Maro is the daughter of the émigré Armenian painter Arshile Gorky. Both like to think of themselves as Bohemians, living the way all true artists used to live. Since the late Sixties, they have been bringing up their children and making their own wine on their 18th-century farm at San Sano. They till the soil, grow flowers and vegetables, and make furniture by hand. Of course, they also find time for sculpture, painting and drawing.

Diese idyllische „fattoria", ein Gutshof aus dem 18. Jahrhundert, hätte dem italienischen Regisseur Bernardo Bertolucci als Vorbild für das Haus in seinem Film „Gefühl und Verführung" dienen können. Auch das Leben, das die Besitzer Matthew und Maro Spender führen, findet sich in Bertoluccis Schilderungen wieder. Es ist typisch für die vielen, insbesondere englischen Aussteiger, die in der Toskana, vor allem im sogenannten „Chiantishire", ihr Domizil haben. Der Bildhauer und seine Frau leben seit den späten 1960er-Jahren hier in San Sano. Sie ziehen ihre Kinder groß, bauen ihren eigenen Wein an, ernten auf den Feldern Gemüse und schreinern sogar ihre Möbel selbst. Aber sie finden auch Zeit zum Bildhauern, Malen und Zeichnen. Die Kunst liegt ihnen im Blut, denn Matthews Vater ist der englische Schriftsteller Sir Stephen Spender, während Maro die Tochter des armenisch-amerikanischen Malers Arshile Gorky ist.

Le cinéaste italien Bernardo Bertolucci aurait pu s'inspirer de cette «fattoria» de rêve pour son film «Beauté volée». D'ailleurs, on retrouve dans l'argument du film la façon dont Matthew et Maro Spender vivent en terre toscane. Elle est en effet caractéristique de celle de nombreux étrangers, surtout des Anglais, venus s'installer dans cette région que l'on surnomme parfois le «Chiantishire». Le sculpteur et son épouse vivent depuis la fin des années soixante à San Sano, avec leurs enfants, dans cette ferme du 18e siècle. Ils produisent du vin, cultivent des légumes et fabriquent eux-mêmes leurs meubles. Mais ils trouvent également le temps de sculpter, de peindre et de dessiner. L'art fait partie intrinsèque de leur vie. En effet, Matthew est le fils du poète anglais Sir Stephen Spender et sa femme Maro la fille d'Arshile Gorky, peintre américain d'origine arménienne.

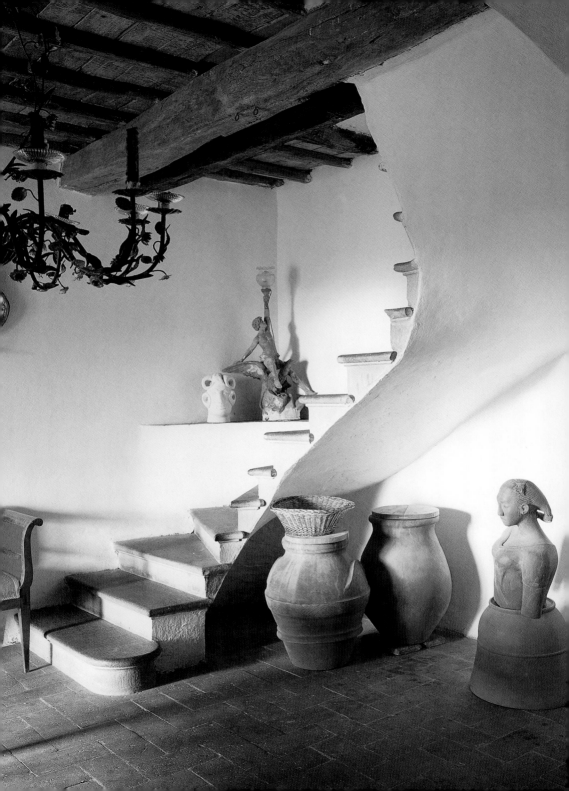

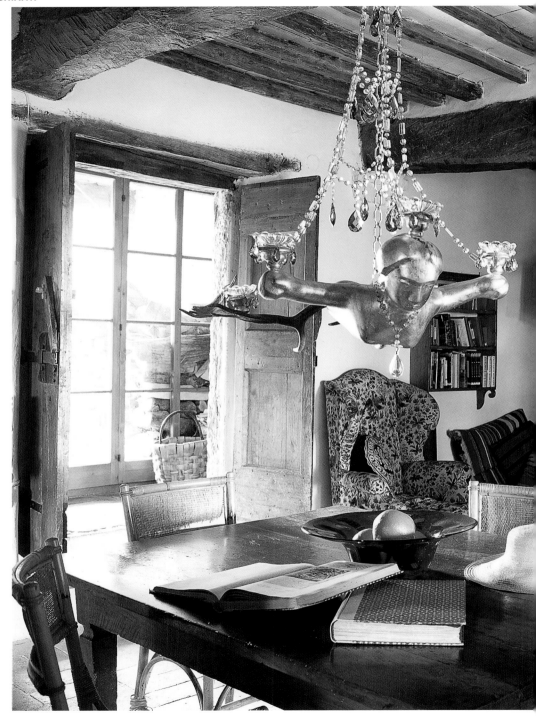

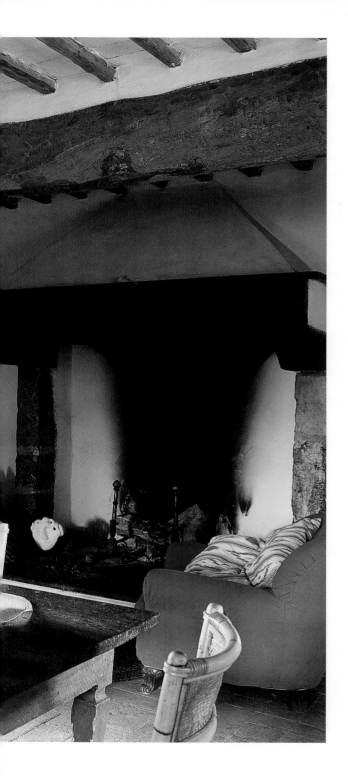

PP. 184–185 Matthew Spender at work surrounded by his sculptures. • Matthew Spender bei der Arbeit in seinem Atelier. • Matthew Spender au travail dans son atelier, au milieu de ses sculptures.

P. 187 One of the jars next to the steep, twisting staircase holds salt and the other sugar. The female terracotta figure is Matthew's work. In the corner, halfway up the stairs, there is an Art Nouveau "Ganymede Mounted on an Eagle", which was a gift from an antiquarian. The Florentine wrought-iron chandelier was picked up at a second-hand market in Florence and repainted by Maro. • Die beiden Gefäße neben der geschwungenen Treppe enthalten Salz und Zucker. Die weibliche Terrakotta-Skulptur ist ein Werk von Matthew. Ein Antiquitätenhändler schenkte den Spenders die Jugendstilskulptur „Ganymed auf dem Adler" in der Ecke an der Treppe. Den ortstypischen schmiedeeisernen Leuchter, den Maro neu bemalt hat, haben die Spenders auf einem Flohmarkt in Florenz entdeckt. • Les deux jarres disposées au pied de l'escalier sinusoïdal contiennent l'une du sel, l'autre du sucre. La sculpture féminine en terre cuite est l'œuvre de Matthew. Le « Ganymède chevauchant l'aigle » de style art nouveau, dans l'angle de l'escalier, est le cadeau d'un antiquaire. Le lustre florentin en fer forgé a été déniché dans un marché aux puces de Florence et repeint par Maro.

← An unusual chandelier that Matthew made hangs over the dining table next to the imposing fireplace. • Über dem Esstisch vor dem imposanten Kamin hängt eine eigenwillige Lampe von Matthew. • Un curieux lustre réalisé par Matthew surmonte la table de la salle à manger, à côté de la grande cheminée.

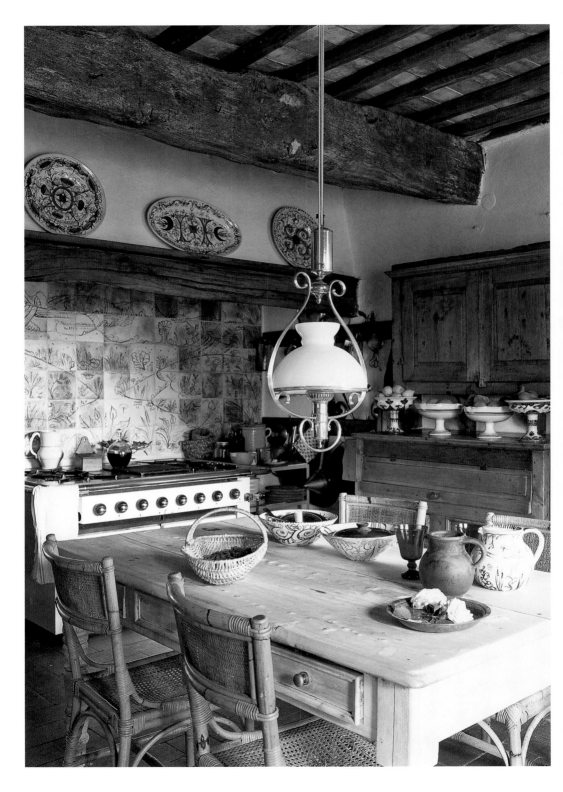

← The kitchen is furnished with old pieces, such as the cypress table and the wicker chairs that the couple acquired from an antiquarian. Maro made all the decorated majolica and ceramics, including the bowls, plates, fruit bowls and the tiles. • Den Tisch aus Zypressenholz und die Bambusstühle in der gemütlichen Küche fanden die Spenders bei einem Antiquitätenhändler. Die zahlreichen Majolika- und Keramikarbeiten – Schüsseln, Teller, Obstschalen und sogar Kacheln – fertigte Maro selbst. •

La cuisine comporte de vieux meubles, comme la table en bois de cyprès et les chaises cannées, trouvées chez un antiquaire. Toutes les majoliques et les céramiques décorées, bols, assiettes, compotiers, ainsi que les carreaux qui ornent les parois, sont l'œuvre de Maro.

↑ The old plain stone sink. • Ein schlichtes, altes Steinbecken. • Un simple évier de pierre ancien.

← Detail of the kitchen. The picture under the kitchen clock is a mosaic portrait of Maro's godmother, the American artist Jeanne Reynald. The marble head is Matthew's work. • Ansicht der Küche. Das Mosaikporträt unter der Uhr ist ein Geschenk von Maros Patentante, der amerikanischen Künstlerin Jeanne Reynald. Der Marmorkopf ist ein Werk von Matthew. • Un détail de la cuisine. Le tableau placé sous l'horloge est une mosaïque réalisée par la marraine de Maro, l'artiste américaine Jeanne Reynald. La tête de marbre est une œuvre de Matthew.

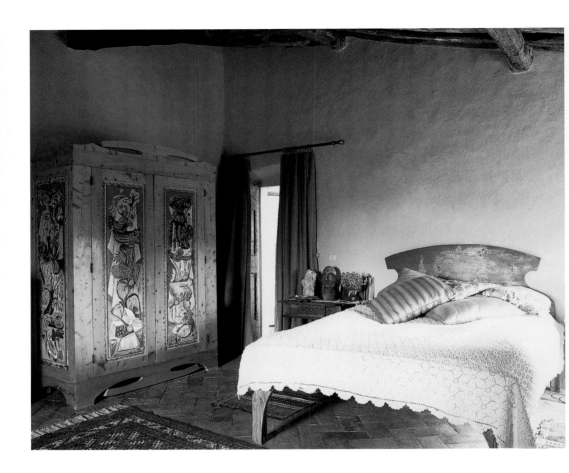

↑ Bedroom furniture hand-made by Matthew and hand-decorated by Maro. • Matthew schreinerte Bett und Schrank, Maro verzierte sie anschließend. • Le lit et l'armoire ont été fabriqués par Matthew et décorés par Maro.

→ The bathroom. The tub positioned in the centre of the room creates two distinct spaces. All of the pictures were executed by Maro or her daughters. The head in the window on the right is by Matthew, who also made the raised lavatory and cupboard unit on the left, inspired by the shape of the papal throne in the cathedral of Anagni. The chandelier is in Bohemian glass and the original beamed ceiling has been restored and painted blue. • Die frei stehende Wanne unterteilt das Badezimmer. Sämtliche Gemälde stammen von Maro und ihren beiden Töchtern, während Matthew die Büste auf der rechten Fensterbank schuf. Zu der erhöhten Toilette mit integriertem Stauraum inspirierte ihn der Papstthron in der Kathedrale von Anagni. Von der Decke mit den restaurierten, blau gestrichenen Balken hängt ein böhmischer Kristalleuchter. • La salle de bains. La baignoire placée au centre divise la pièce en deux. Tous les tableaux ont été réalisés par Maro et ses deux filles, alors que la tête posée sur le rebord de la fenêtre est de Matthew, comme le water-closet surélevé et doté d'un rangement, à gauche, dont la forme s'inspire du trône papal de la cathédrale d'Anagni. Le lustre est en cristal de Bohême. Le vieux plafond aux poutres apparentes a été restauré et peint en bleu.

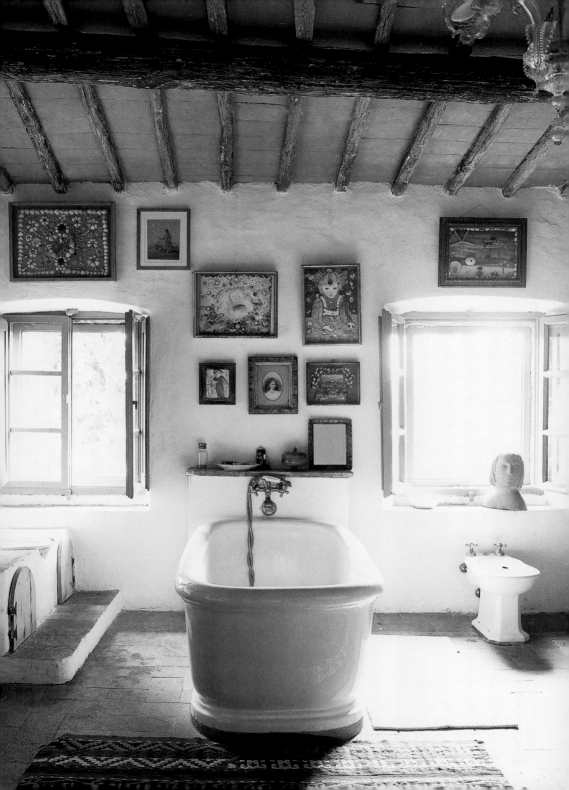

VILLA VIGNAMAGGIO

VILLA VIGNAMAGGIO
CHIANTI

The approach to Villa Vignamaggio, an estate of some hundred hectares of vineyards and olive groves, is from Panzano near Greve in Chianti, along the Vecchia Chiantigiana road. The villa was originally built in the 15th century but took on its present aspect about a century later when a new wing, which today houses the cellars, was added. Villa Vignamaggio is known also as Villa Gherardini after the family of the former owners. Some historians believe that it was a member of the Gherardini family, Lisa (born in the villa in 1479), whose portrait was painted by Leonardo da Vinci. What is certain is that da Vinci stayed at Villa Gherardini for a short time before abandoning Tuscany for Milan in 1506; and it may have been against the backdrop of these hills that the artist painted the world's most famous canvas, the portrait of a lady with an inscrutably enigmatic smile.

Vielleicht ist die „Mona Lisa" zwischen den grünen Hügeln bei Greve in Chianti entstanden – jedenfalls hielt sich das Universalgenie Leonardo da Vinci kurz in der Villa Vignamaggio auf, bevor er 1506 nach Mailand ging. Und wenn er das berühmteste Gemälde der Welt tatsächlich hier malte, dann stand ihm für das Porträt der Frau mit dem geheimnisvollen Lächeln vermutlich die schöne Lisa Modell, die 1479 in dieser Villa geboren wurde. Die Villa Vignamaggio – oder auch nach ihren früheren Besitzern Villa Gherardini genannt – liegt an der „Vecchia Chiantigiana", einer Weinstraße, die seit Jahrhunderten durch das Chianti-Gebiet führt. Heute werden auf dem Anwesen, das etwa hundert Hektar umfasst, vorwiegend Wein und Oliven angebaut. Die Villa entstand bereits im 15. Jahrhundert, aber sie erhielt ihr gegenwärtiges Aussehen hundert Jahre später mit dem Anbau eines Seitenflügels, der heute die Weinkeller beherbergt.

Peut-être la Joconde est-elle née ici, dans les vertes collines du Chianti, près de Greve – quoi qu'il en soit, il est attesté que Léonard de Vinci a effectué un bref séjour à la Villa Vignamaggio, avant de quitter la Toscane pour Milan en 1506. Et s'il a vraiment peint ici le tableau le plus célèbre de l'histoire de l'art, la belle Lisa, née dans cette villa en 1479, serait alors probablement la mystérieuse Mona Lisa au sourire insaisissable. Pour se rendre à la Villa Vignamaggio – dite aussi Villa Gherardini d'après le nom de ses ex-propriétaires – il faut emprunter la « Vecchia Chiantigiana », la route du chianti, qui traverse la région du nord au sud depuis des siècles. Aujourd'hui, on y exploite une centaine d'hectares, plantés de vignobles et d'oliveraies. La villa date du 15e siècle, mais son aspect actuel est dû à l'adjonction d'une aile un siècle plus tard ; c'est là que se trouvent aujourd'hui les chais.

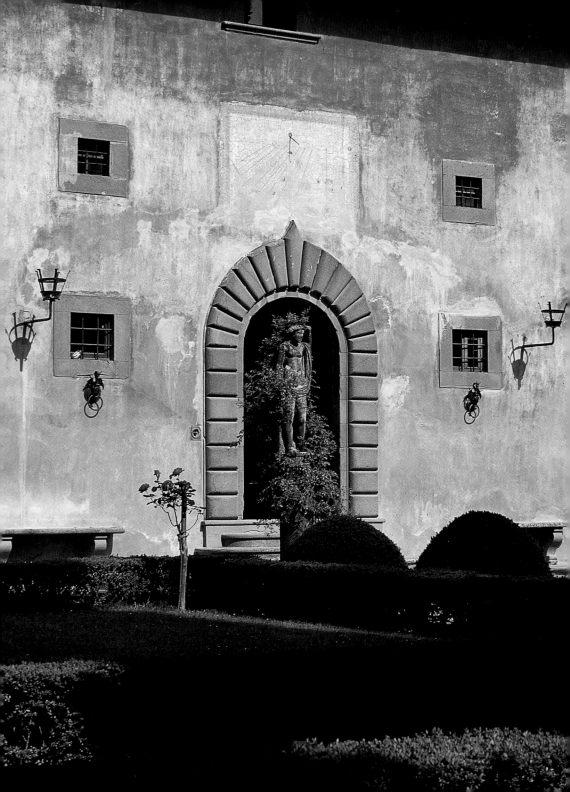

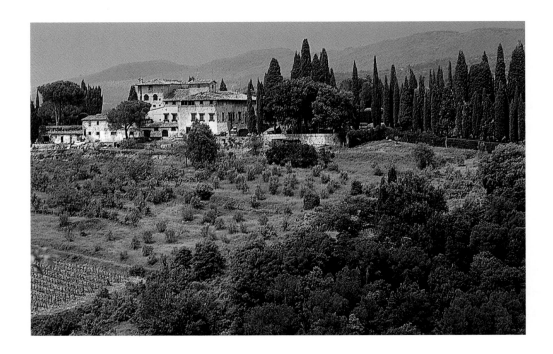

PP. 196–197 Approaching the Villa Vignamaggio, it is not hard to imagine Leonardo da Vinci arriving there, for little – apart from the weathered walls – has changed since he stayed at the villa in 1506. • Nähert man sich der Villa Vignamaggio, kann man sich sehr gut die Ankunft Leonardo da Vincis vorstellen, denn seit seinem Aufenthalt hier im Jahre 1506 hat sich – bis auf die Patina auf den Mauern der Fassade – sehr wenig verändert. • En s'approchant de la Villa Vignamaggio on n'a aucun mal à s'imaginer l'arrivée de Léonard de Vinci car très peu de choses ont changé depuis son séjour en 1506, à l'exception de la patine sur les murs de la façade…

P. 199 An 18th-century statue can be seen in a niche at the rear of the villa. • Eine Nische an der Rückseite der Villa mit einer Statue aus dem 18. Jahrhundert. • Une statue du 18e siècle placée dans une niche à l'arrière de la villa.

↑ The villa is surrounded by olive groves and a gently sloping vineyard. The famous Vecchia Chiantigiana road, lined with vine-growing estates, is only a stone's throw away. • Die Villa ist von Olivenbäumen und einem Wingert umgeben, der sich über den sanft abfallenden Abhang ausbreitet. Die „Vecchia Chiantigiana" zieht sich ganz in der Nähe durch die Weinberge. • La villa est

entourée d'oliviers et d'un vignoble en pente douce. La célèbre « Vecchia Chiantigiana » bordée de propriétés viticoles est à deux pas.

→ and P. 204 Details of door and passageways in the courtyards. • Malerische Ansichten von Türen in den Innenhöfen und Hofdurchgängen. • Aperçus évocateurs de portes et de passages faisant communiquer les cours.

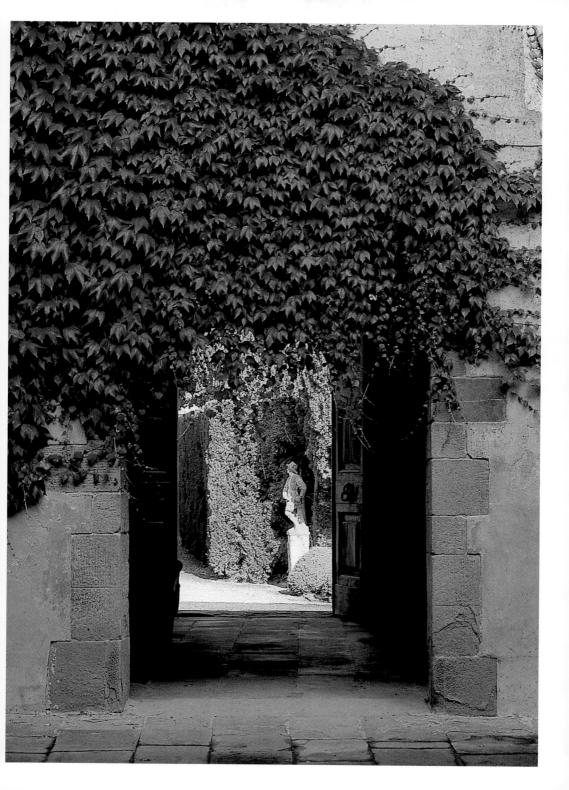

↑ → The stone coat-of-arms amid the ivy bears the crest of a very ancient aristocratic family. The well on the terrace dates back to the time when the villa was built and, on the *piano nobile*, the loggia's walls are covered by an avalanche of creepers and climbing roses. • Ein von wucherndem Efeu umgebenes Wappen zeigt die Insignien eines sehr alten Adelsgeschlechts. Der Brunnen auf der Terrasse stammt aus der Zeit, in dem das Anwesen errichtet wurde, und die Wände der Loggia in der Beletage sind von einer wahren Lawine von Efeu und Kletterrosen bedeckt. • Un écusson en pierre encerclé de lierre porte les armoiries d'une très ancienne famille noble. Le puits à eau sur la terrasse date de l'époque de la construction et à l'étage noble les murs de la loggia se couvrent d'une avalanche de lierre et de roses grimpantes.

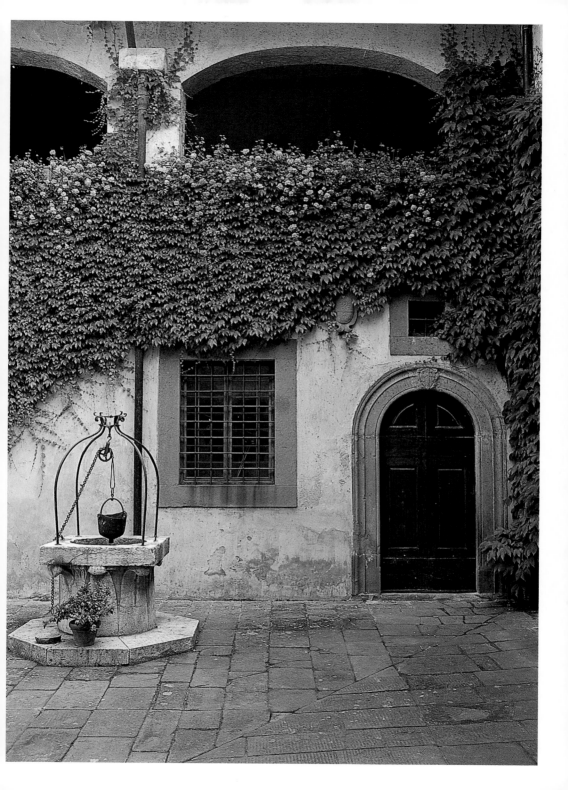

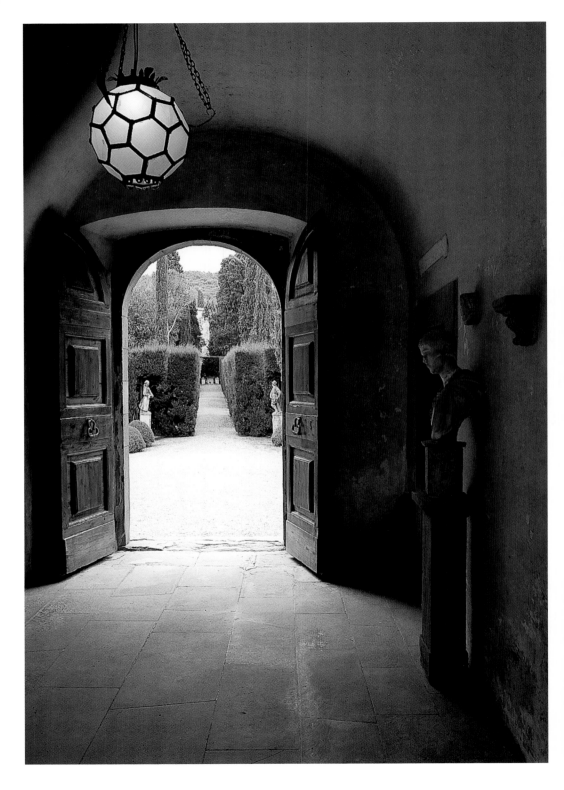

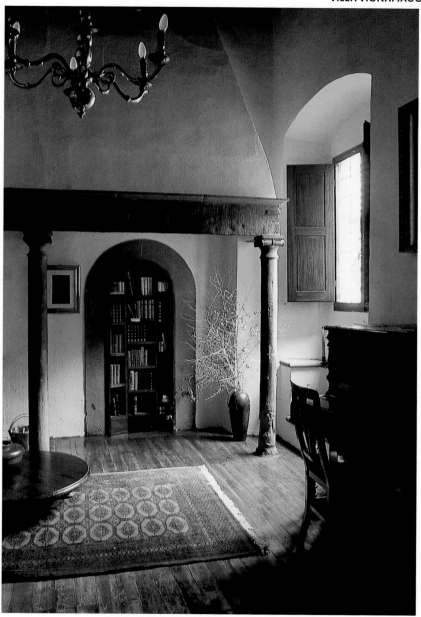

↑ A passageway to the library. Note the colonnaded porch and the oriental rug with its unusual circular pattern. • Der Durchgang zur Bibliothek. Auffallend sind der von Säulen getragene Portikus und der Orientteppich mit den ungewöhnlichen Kreismustern. • Un passage menant à la bibliothèque. On remarque un petit portique à colonnes et un tapis persan aux motifs circulaires assez inhabituels.

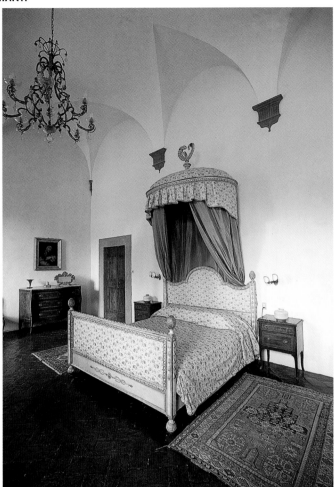

↑ A bedroom with vaulted ceiling and an 18th-century wall-mounted fabric tester, which the present owner found in the villa when he acquired it. The chandelier is in Murano glass. • Im Schlafzimmer mit der Gewölbedecke befindet sich ein Himmelbett, dessen Stoffbaldachin noch aus dem 18. Jahrhundert stammt. Der heutige Eigentümer fand ihn bereits in der Villa vor. Von der Decke hängt ein Murano-Leuchter. • Une chambre à coucher au plafond voûté, avec un baldaquin en tissu du 18ᵉ siècle fixé au mur, qui se trouvait déjà dans la villa à l'arrivée du propriétaire actuel. On peut noter un lustre de Murano.

→ The dining room in the oldest part of the villa has a sail-vaulted ceiling and a solid-wood table, around which are arranged traditional Tuscan dining chairs. The painting on the far wall is by an anonymous 17th-century Neapolitan artist. The silver candelabrum also originates from the south of Italy. In the background on the left, a typical Tuscan stone seat can be observed under the window. • Im ältesten Teil des Hauses liegt das Speisezimmer mit der Gewölbedecke mit Stichkappen. Um den Tisch aus Massivholz gruppieren sich toskanische Stühle. Das Gemälde im Hintergrund stammt von einem unbekannten neapo-

litanischen Maler des 17. Jahrhunderts. Auch der Silberleuchter ist süditalienischer Herkunft. Links in der Fensternische befindet sich eine für die Toskana typische Steinsitzbank. • La salle à manger, dans la partie la plus ancienne de la villa, avec son plafond aux voûtes en calotte. Autour de la table en bois massif sont disposés des sièges toscans traditionnels. Le tableau qui orne le mur du fond est l'œuvre d'un artiste napolitain anonyme du 17ᵉ siècle. Le lustre d'argent provient également du sud de l'Italie. A gauche, sous la fenêtre, on remarque un siège de pierre caractéristique de la Toscane.

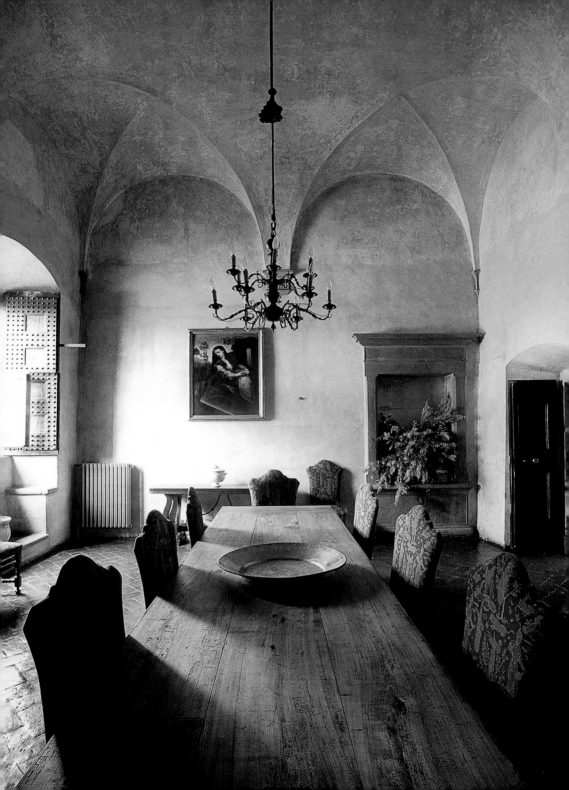

VILLA DI GEGGIANO

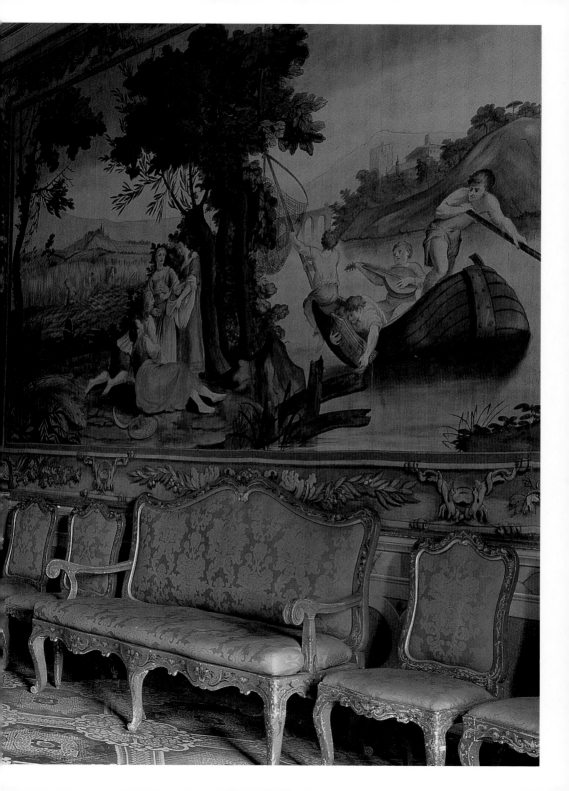

VILLA DI GEGGIANO

ALESSANDRA BIANCHI BANDINELLI AND RUGGIERO BOSCU
GEGGIANO

The Villa di Geggiano rises from its lush surrounding landscape like a dignified old lady covered in jewels and swathed in sumptuous green silk. The avenue of cypresses, elegant façade, *teatrino all'aperto* (open-air theatre), porticoes festooned with cherubs, and, finally, the chapel remind one that this is no ordinary place: The Bianchi Bandinellis, who built the house on much older foundations at the end of the 18th century, have a family tree that includes Pope Alexander III and a world-class archeologist-cum-art historian. The owners of the Villa di Geggiano, Ruggiero Boscu and his wife Alessandra Bianchi Bandinelli, are passionate about the property and its vineyards, and have passed on their enthusiasm to their sons Andrea and Alessandro. Today, the two brothers and their families have turned their backs on the stresses of life in Rome and settled at Geggiano among the frescoes by Ignazio Moder and furniture by Agostino Fantastici to look after their vines and preserve their incomparable inheritance.

Wie sich die Villa di Geggiano in der Landschaft erhebt, gleicht sie einer würdevollen alten Dame mit Juwelen und grüner Seidenstola. Die zypressengesäumte Allee, die elegante Fassade, das kleine „teatrino all'aperto" (Freilichttheater), die Kapelle und die Putti über den Portalen – all dies lässt auf einen außergewöhnlichen Ort schließen. Die Familie Bianchi Bandinelli, zu deren Stammbaum auch Papst Alexander III. und ein weltberühmter Archäologe und Kunsthistoriker gehören, ließ die Villa Ende des 18. Jahrhunderts auf den Grundmauern eines älteren Gebäudes errichten und hat sie seitdem hingebungsvoll instand gehalten. Die Liebe zu Haus und Weinbergen hat sich von den heutigen Besitzern Ruggiero Boscu und seiner Frau Alessandra Bianchi Bandinelli längst auf ihre Söhne Andrea und Alessandro übertragen. Inzwischen haben die beiden Brüder samt ihren Familien dem Stress von Rom den Rücken gekehrt, um in Geggiano zu leben, umgeben von Fresken Ignazio Moders und den Möbeln von Agostino Fantastici. Sie verwalten ihr Weingut und die Ländereien und kümmern sich um ihr unvergleichliches Anwesen.

Telle une vieille dame très digne parée de ses bijoux et portant un somptueux boa de plumes, la villa di Geggiano émerge du paysage luxuriant qui l'entoure. Son allée bordée de cyprès, sa façade élégante, son teatrino all'aperto (petit théâtre en plein air) ses portiques ornés de chérubins et sa chapelle nous révèlent son caractère exceptionnel. La maison a été édifiée sur des vestiges plus anciens vers la fin du 18e siècle par la famille Bianchi Bandinelli dont l'arbre généalogique peut s'enorgueillir d'un pape, Alexandre III, et d'un archéologue et historien d'art, dont la réputation internationale n'est plus à faire. La famille s'occupe toujours avec le même dévouement de la demeure ancestrale, et les actuels propriétaires, Ruggiero Boscu et son épouse Alessandra Bianchi Bandinelli, éprouvent une telle passion pour la villa et ses vignobles qu'ils ont réussi à transmettre leur enthousiasme à leurs fils Andrea et Alessandro. Aujourd'hui, les deux frères et leurs familles ont tourné le dos à la vie stressante de Rome et sont venus vivre à Geggiano entre les fresques d'Ignazio Moder et les meubles d'Agostino Fantastici, pour veiller sur les vignobles et, surtout, pour préserver un héritage incomparable.

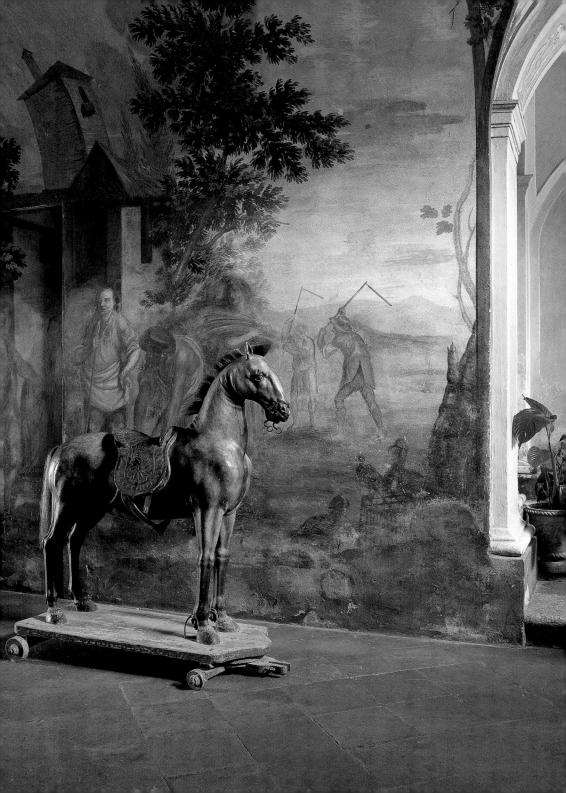

PP. 208–209 The tapestry rooms contain magnificent painted furniture made in about 1790, though the "tapestries" in question are no more than large canvases. • Im Gobelin-Salon stehen herrlich bemalte Möbel von 1790. Die „Gobelins" entpuppen sich allerdings bei näherem Hinsehen als auf Leinwand gemalt. • Le salon des Tapisseries abrite un magnifique mobilier peint exécuté vers 1790, mais les tapisseries ne sont en réalité que de grandes toiles peintes.

P. 211 Towards the end of the 18th century, the Duke of Lorraine presented the Bianchi Bandinelli children with this superb wooden horse. • Gegen

Ende des 18. Jahrhunderts schenkte der Herzog von Lothringen den Kindern der Familie Bianchi Bandinelli dieses wunderbare Holzpferd. • Ce superbe cheval en bois sculpté polychrome a été offert par le duc de Lorraine aux enfants des Bianchi Bandinelli vers la fin du 18ᵉ siècle.

↑ The classical beauty of the Villa di Geggiano has been preserved by the family like a precious gem. • Die klassische Schönheit der Villa di Geggiano wurde von der Familie wie ein kostbares Juwel gehütet. • La beauté classique de la Villa di Geggiano a été préservée comme s'il s'agissait d'un bijou précieux.

→ The dogs also have villas, built to scale. • Die Hunde haben ihre eigenen Villen – in passender Größe! • Les chiens aussi ont une villa à leur taille!

P. 214 and 215 The visitor is greeted by the late 18th-century frescoes of Ignazio Moder. • Schon am Eingang erwarten den Besucher die Fresken Ignazio Moders von Ende des 18. Jahrhunderts. • Le visiteur est accueilli dès l'entrée par les fresques peintes vers la fin du 18ᵉ siècle par Ignazio Moder.

PP. 216-217 The celebrated *ciarlatorio* decorated by the Sienese painter Agostino Fantastici (1782-1849). This room, which has the proportions of a corridor, was a place to gossip. • Das berühmte „ciarlatorio" malte der sienesische Künstler Agostino Fantastici (1782-1849) aus. Es besteht aus einem flurartigen Raum, in dem man sich früher der Konversation widmete. • Le célèbre «ciarlatorio» décoré par le peintre siennois Agostino Fantastici (1782-1849), une pièce en forme de couloir où l'on s'adonnait jadis à l'art du commérage.

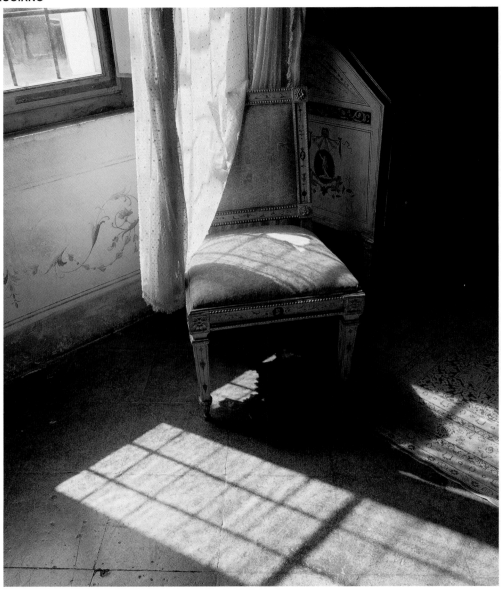

↑ In the Alfieri Bedroom, a tentative ray of sunshine falls from the tall transomed windows. • In das sogenannte Alfieri-Zimmer scheint die Sonne zögerlich durch die hohen Sprossenfenster. • Dans la chambre dite d'Alfieri, un soleil hésitant entre par les hautes fenêtres à meneaux.

→ From this window one has a fine view of the *teatrino all'aperto*. • Von diesem Fenster hat man einen guten Blick auf das „teatrino all'aperto". • Sur cette fenêtre on peut admirer le «teatrino all'aperto».

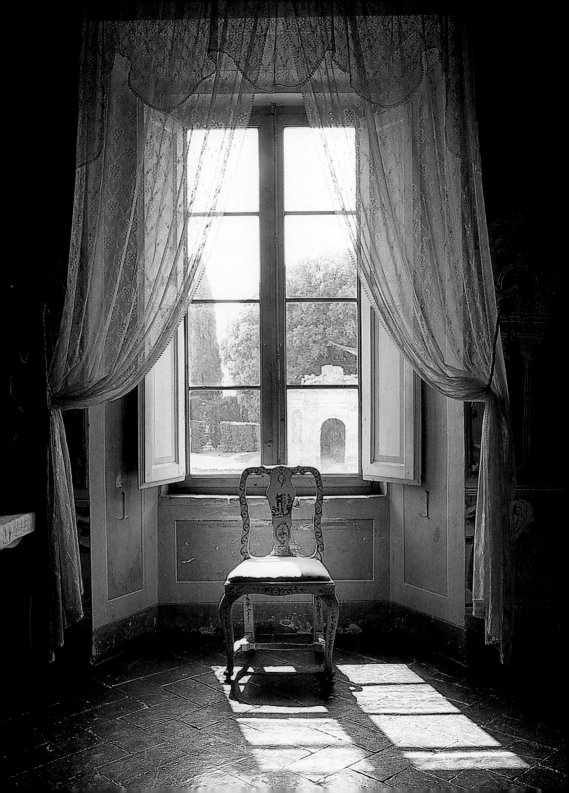

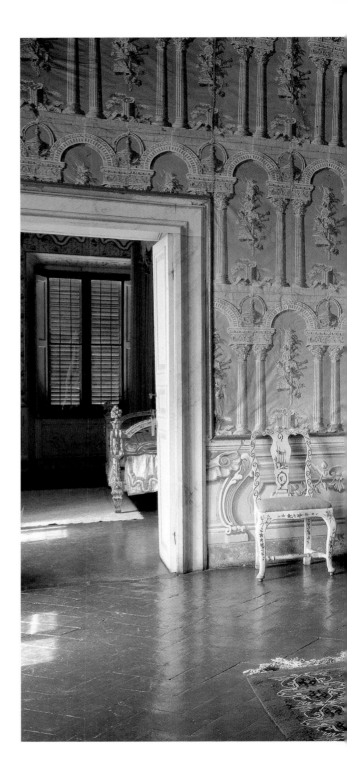

→ In the Blue Salon, the walls are covered with wallpaper from the former Paris store "Au Grand Balcon". • Die Tapete im Blauen Salon stammt aus dem damaligen Pariser Geschäft „Au Grand Balcon". • Dans le Salon bleu, le papier peint des murs provient de l'ancien magasin parisien « Au Grand Balcon ».

PP. 222 and 223 Sienese cabinetmakers of the late 18th century decorated the furniture in the Blue Salon like porcelain, in blue and white. The fan and the small electric lamp both date from the early 20th century. • Kunsttischler aus Siena verzierten gegen Ende des 18. Jahrhunderts die Möbel im Blauen Salon mit blau-weißem Dekor, der an Porzellan denken lässt. Der Fächer und die kleine Lampe stammen vom Anfang des 20. Jahrhunderts. • Des ébénistes siennois de la fin du 18e siècle décorèrent le mobilier dans le Salon bleu en imitant la porcelaine bleue et blanche. L'éventail et la petite lampe électrique datent du début du 20e siècle.

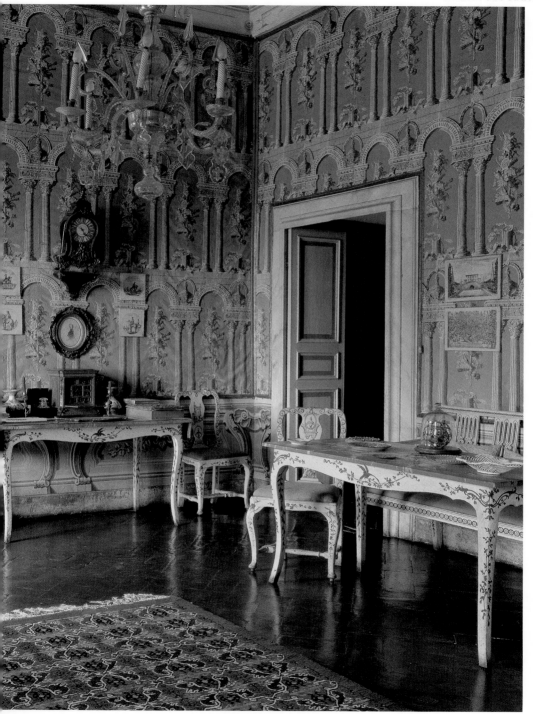

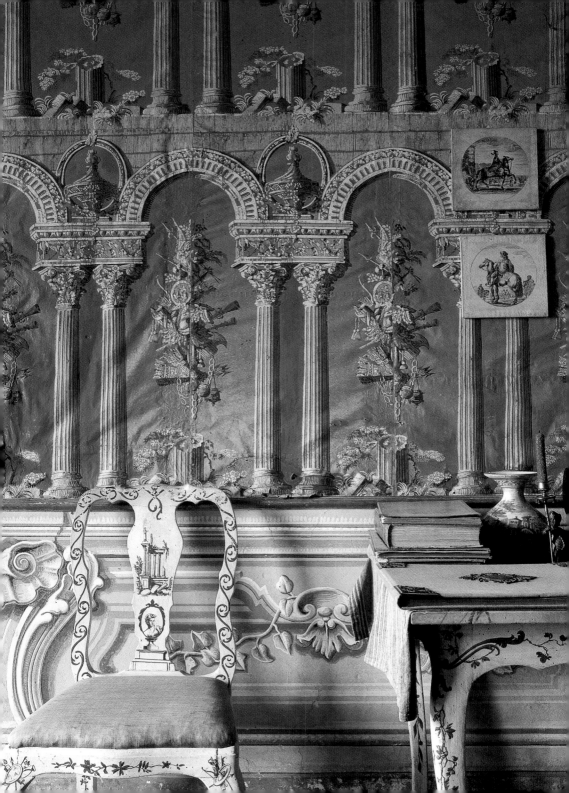

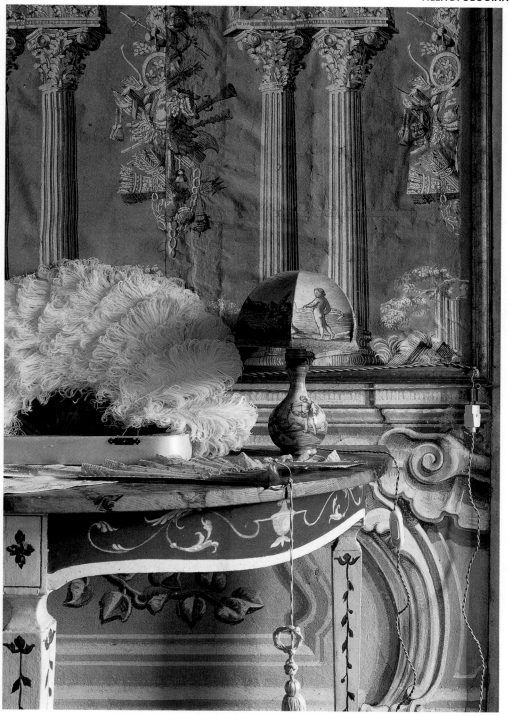

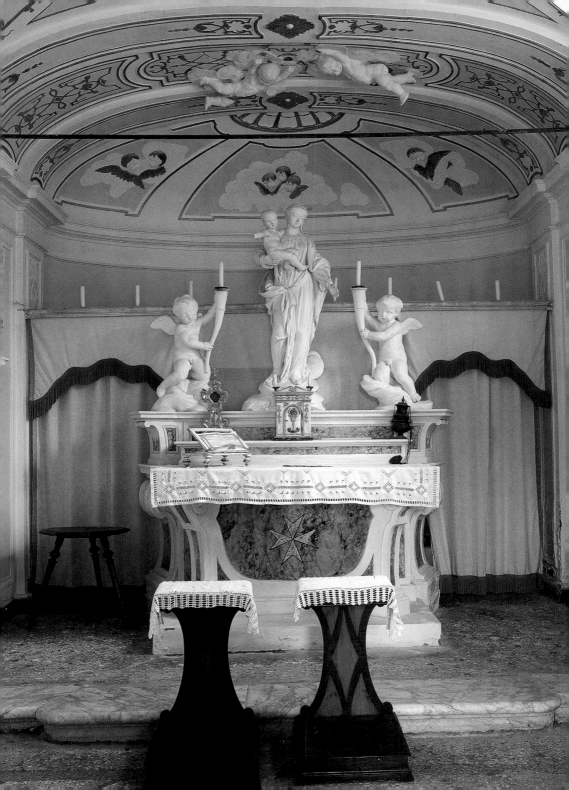

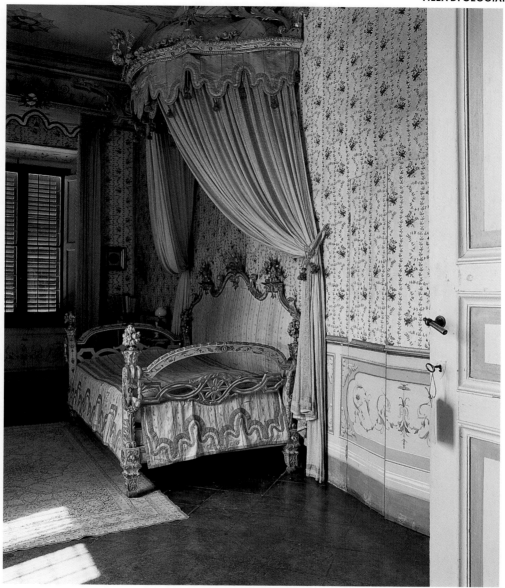

← In the private chapel, the decor shows the Bianchi Bandinellis' taste for luxury and elegance. • In der Privatkapelle zeugt die prächtige Ausgestaltung vom erlesenen Geschmack der Familie Bianchi Bandinelli. • Dans la chapelle privée, le décor témoigne du goût des Bianchi Bandinelli pour le faste élégant.

↑ In this bedroom the playwright Vittorio Alfieri (1749–1803) – who was a frequent house guest – spent many nights in the superb silk-hung four-poster bed. • In diesem Zimmer schlief der Dramatiker Vittorio Alfieri (1749–1803), der häufig zu Gast war, unter einem seidenen Betthimmel. • L'auteur

dramatique Vittorio Alfieri (1749–1803) passa souvent la nuit dans ce superbe lit à baldaquin drapé de soie.

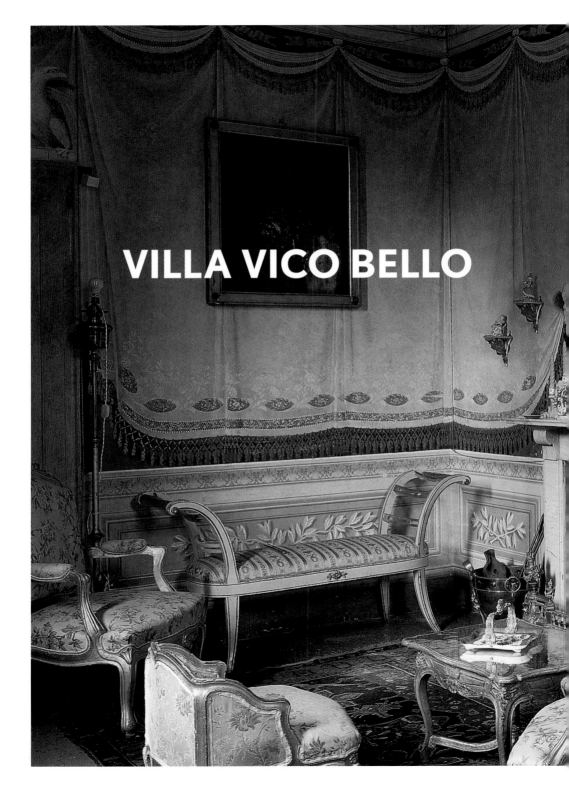

VILLA VICO BELLO

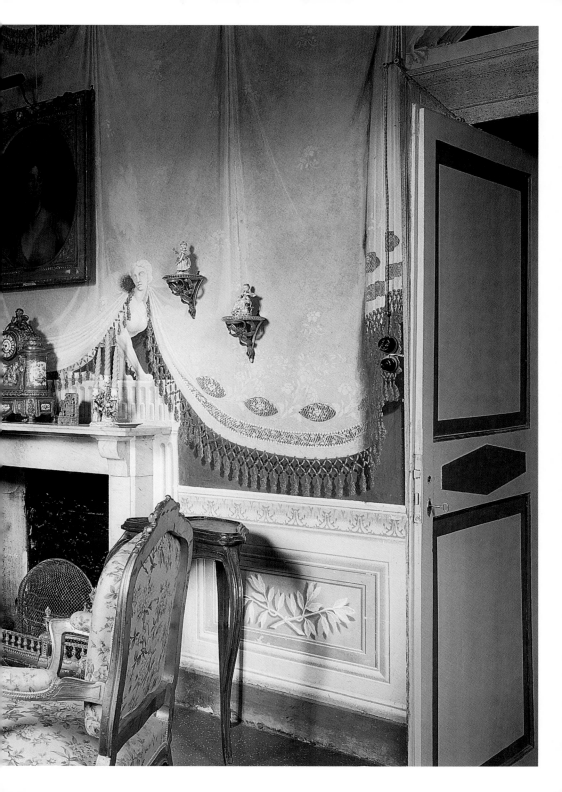

VILLA VICO BELLO

FAMIGLIA ANSELMI ZONDADARI
VICO BELLO

This house was built in the 16th century by the architect Baldassare Peruzzi for the very ancient family of Chigi-Zondadari. If you leave Siena and head northward in the direction of the residential suburb of Vico Bello, before long you will see in the distance the stark silhouette of the villa on the summit of a wooded hill. Certainly Peruzzi, who endowed the house with a chapel, stables, an orangery and several pavilions, made the best of the view across the city to the Torre del Mangia and the Duomo. The arms of the Chigi family – six little mounds of stones with a star above – stand proudly above the terrace; there is a broad inner courtyard filled with boxed lemon and orange trees, and beyond these an architectural ensemble and a series of interiors that are uniformly elegant. Most enchanting of all is the collection of pastel-coloured frescoes and trompe l'œils, representing sundry landscapes, diaphanous draperies, enigmatic sphinxes and indecipherable hieroglyphs. These serve as a backdrop to a wonderfully varied stock of furniture, lovingly assembled by generation after generation with an eye for beauty.

Im 16. Jahrhundert wurde die Villa von dem bekannten Architekten Baldassare Peruzzi für die alte Adelsfamilie Chigi-Zondadari erbaut und mit einer Kapelle, Ställen, einer Orangerie und mehreren Pavillons ausgestattet. Wenn man von Siena aus nach Norden in Richtung des Dorfes Vico Bello fährt, entdeckt man schon von weitem am hügeligen, baumbewachsenen Horizont die strenge Silhouette der Villa, die der schönen Landschaft den Namen gab. Von der Villa Vico Bello aus überblickt man Siena und hat eine fantastische Aussicht auf die Torre del Mangia und den Duomo. Über der Terrasse ist das Wappen der Familie Chigi angebracht: sechs Hügel und ein Stern. Von dem großen Innenhof aus, in dem zahlreiche Töpfe mit Zitronen- und Orangenbäumen stehen, gelangt man in ein Ensemble elegant ausgestatteter Innenräume. Besonders bezaubernd wirken die Fresken und die pastellfarbenen Trompe-l'Œil-Malereien. Sie bieten den passenden Rahmen für die äußerst unterschiedlichen Einrichtungsstücke, von Generationen von Bewohnern liebevoll und mit viel Sinn für Schönheit gesammelt.

Elle fut construite au 16ᵉ siècle par le célèbre architecte Baldassare Peruzzi pour la très ancienne et noble famille Chigi-Zondadari. En quittant Sienne vers le nord en direction du quartier résidentiel de Vico Bello, on aperçoit de loin, au sommet d'une colline boisée, la silhouette sévère de la villa qui prêta si gracieusement son nom aux alentours. Peruzzi, qui gratifia la demeure d'une chapelle, d'écuries, d'une orangerie et de plusieurs pavillons, était certainement conscient du fait que la vue sur la ville et sur les silhouettes de la Torre del Mangia et du Duomo, est l'un des atouts principaux de ce site exceptionnel. Les armes de la famille Chigi – six monticules en pierre surmontés d'une étoile – dominent la terrasse ; de la vaste cour intérieure embellie par des rangées de citronniers et d'orangers en pots, on a accès à un ensemble architectural et à des intérieurs d'une très rare élégance. Ce qui enchante ici, ce sont les fresques et les trompe-l'œil couleur pastel, représentant des paysages, des drapés diaphanes, des sphinges énigmatiques et des hiéroglyphes indéchiffrables. Ils servent de décor à un mobilier hétéroclite, rassemblé avec amour par des générations successives d'occupants avides de beauté.

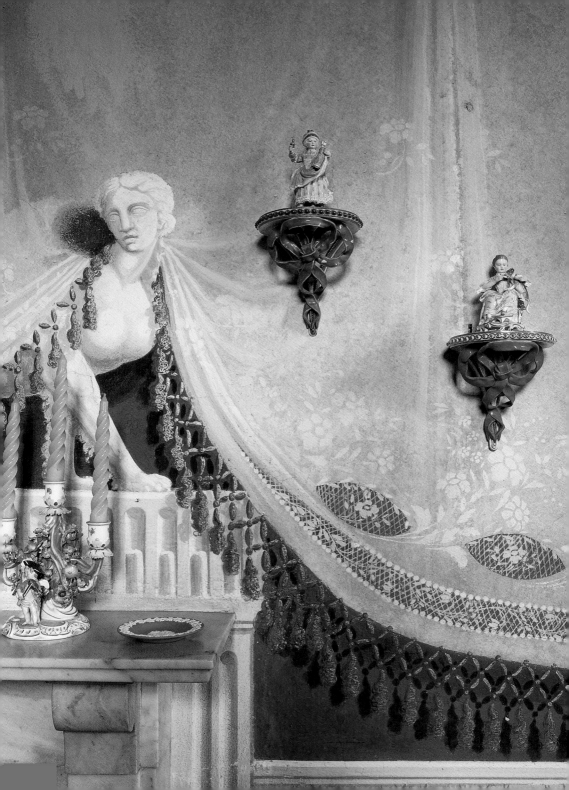

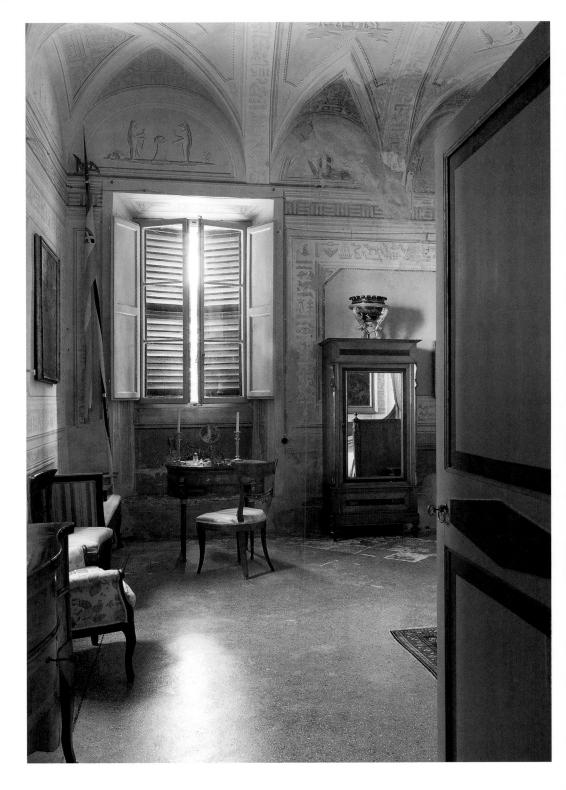

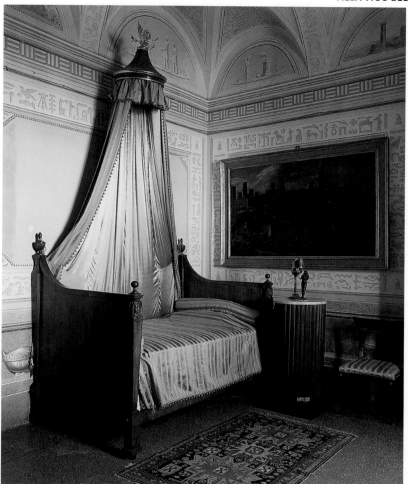

PP. 226-227 In this *salottino* the fine portrait of a woman above the fireplace is attributed to the celebrated English painter Sir Thomas Lawrence (1769-1830). · Das Frauenporträt über dem Kamin in diesem „salottino" wird dem bekannten englischen Maler Sir Thomas Lawrence (1769-1830) zugeschrieben. · Dans ce «salottino», le charmant portrait de femme au-dessus de la cheminée est attribué au célèbre peintre anglais Sir Thomas Lawrence (1769-1830).

P. 229 In this room, the richly draped net curtain being lifted by sphinxes is a

trompe l'œil. · In einem der Salons sind die Wände mit einer Trompe-l'Œil-Malerei aus großzügigen Draperien und Sphingen dekoriert. · Ce voilage richement drapé que soulèvent des sphinges dans un des salons est un trompe-l'œil.

← The shutters are closed and the room with the Egyptian frescoes lies in semi-darkness. · Die Fensterläden sind geschlossen, und das Zimmer mit den ägyptisierenden Fresken ruht im Dämmerlicht. · Les volets sont fermés et la chambre aux fresques à l'égyptienne somnole dans une lumière tamisée.

↑ In one of the bedrooms a mahogany Empire bed is crowned by a canopy and surrounded by an extraordinary décor of hieroglyphs. · Ein Baldachin krönt das prachtvolle Empire-Bett aus Mahagoni in einem der Schlafzimmer. An den Wänden ein ungewöhnlicher Hieroglyphendekor. · Dans une des chambres à coucher, le splendide lit Empire en acajou est couronné d'un baldaquin et entouré d'un étonnant décor de hiéroglyphes.

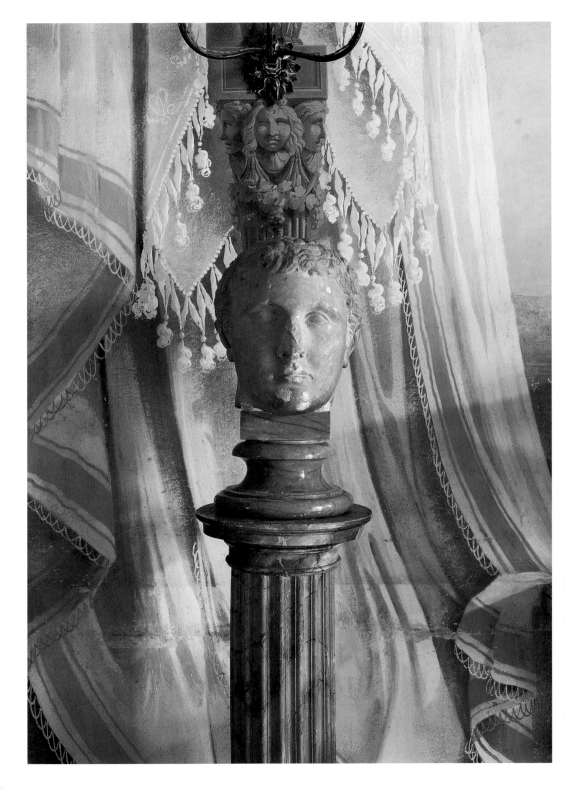

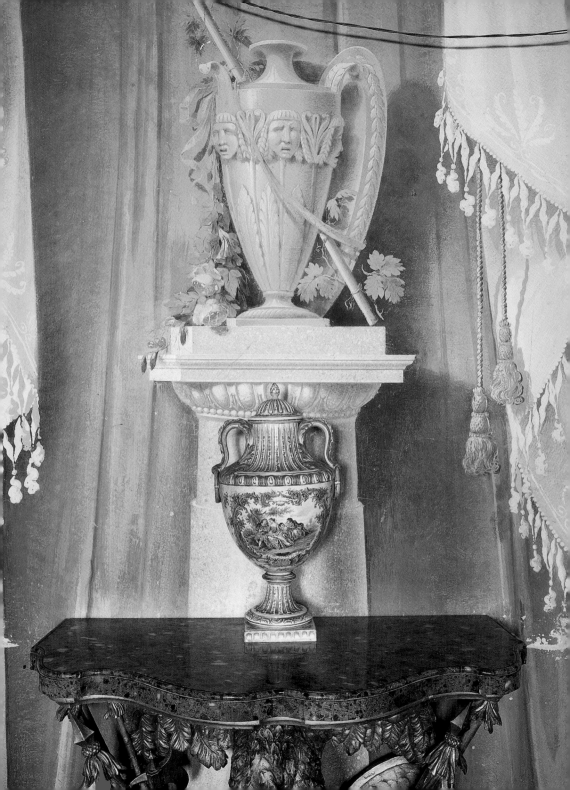

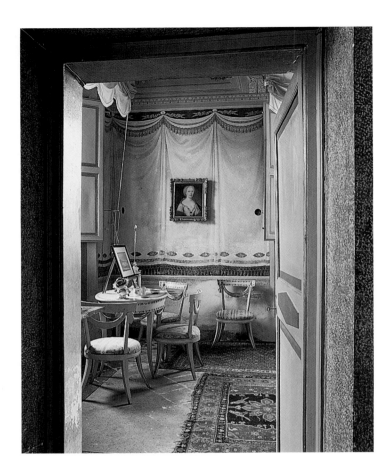

PP. 232 and 233 A magnificent trompe l'œil of landscapes, draperies, columns and antique vases covers the walls of the principal formal room. • Die Wände in diesem prunkvollen Salon ziert eine prächtige Trompe-l'Œil-Malerei mit Landschaften, Draperien, Säulen und Vasen in antikisierendem Stil. • Le grand salon d'apparat est décoré d'un splendide trompe-l'œil tout de paysages, de draperies, de colonnes et de vases « à l'antique ».

↑ The pale colours of this small salon on the ground floor and the elegant white and gold furniture are reminiscent of Gustavian pastel tones. • Pastelltöne im kleinen Salon im Erdgeschoss und die eleganten Möbel in Weiß und Gold erinnern an den gustavianischen Stil. • Les pâles couleurs de ce petit salon du rez-de-chaussée et l'élégant mobilier blanc et or évoquent les tons pastel gustaviens.

→ One of the girls, Margarita, has just been married: her dress and veil have been left on the wrought-iron bed, in a room decorated with neoclassical frescoes. • Eine der beiden Töchter, Margarita, hat gerade geheiratet, und ihr Brautkleid und der Schleier liegen noch auf dem schmiedeeisernen Bett in einem Schlafzimmer, das mit klassizistischen Fresken verziert ist. • Une des filles, Margarita, vient de se marier et sa robe et son voile sont restés sur un lit en fer forgé dans une des chambres décorée de fresques néoclassiques.

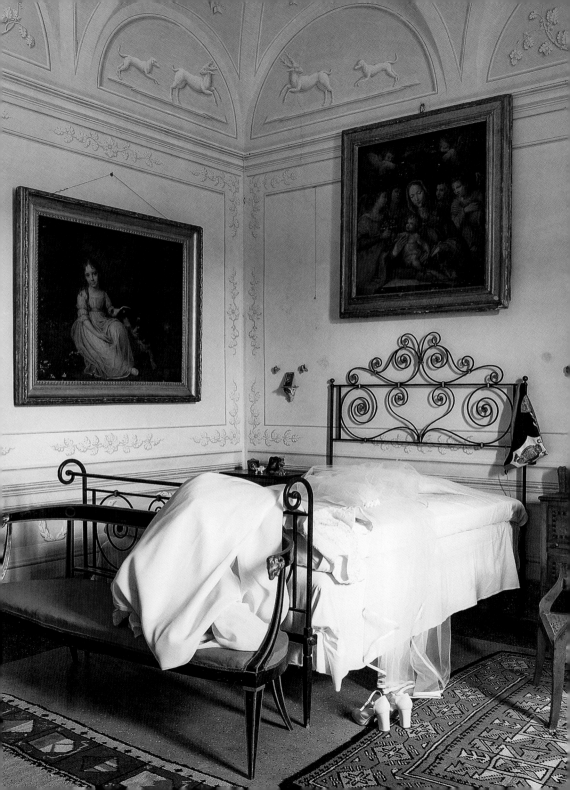

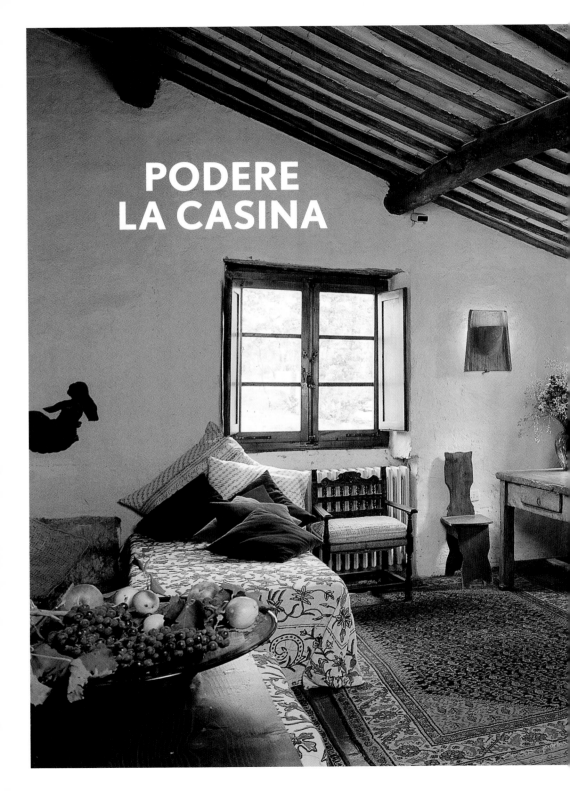

PODERE
LA CASINA

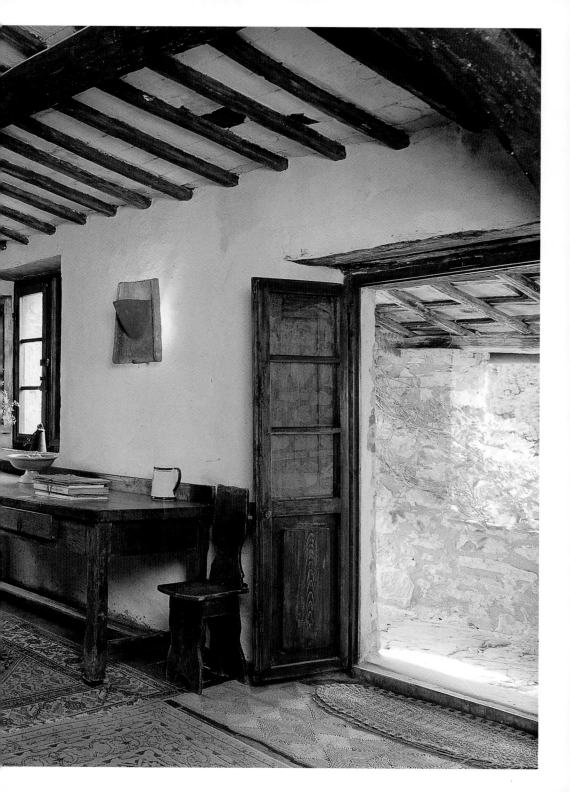

PODERE LA CASINA
CHIANTI

This farmhouse is the traditional refuge in summer and winter of the family that purchased the property many years ago. Lovers of the simple life, they take refuge in this rustic hideaway with its splendid views of the surrounding countryside, where the sun climbs and descends in the silent splendour of a natural environment. Around them grow the olive trees and vines that yield the oil and wine they share with the many friends they have made in the area. Part of the estate has been left as woodland, which helps to keep the climate cool in the summer and mild in winter. Only a few essential alterations have been made to the property but with the avowed intention of maintaining the structure and style of the building and conserving the features that were already there, such as the beams of the ceilings and the door and window fittings. All the furniture is made locally.

Abgeschieden und still liegt das Landgut La Casina in der herrlichen Hügellandschaft unweit von Siena. Hier lassen sich atemberaubende Sonnenaufgänge und -untergänge erleben. Seit vielen Jahren genießt die Familie der Besitzer das einfache, ländliche Leben auf dem „podere". Sie bauen ihren eigenen Wein und auch Oliven an, die sie dann gemeinsam mit den neu gewonnenen Freunden aus der Nachbarschaft kosten. Im Sommer wie im Winter sorgt der nahe gelegene dichte Wald für ein angenehmes Klima. Die einfühlsame Restaurierung konzentrierte sich auf das Wesentliche: die ursprünglichen Strukturen, der Stil des Gebäudes sowie die Deckenbalken, Tür- und Fenstereinfassungen sollten erhalten bleiben. Selbst die Möbel stammen aus der Umgebung.

Cette ferme isolée sert depuis de longues années de refuge, hiver comme été, à une famille qui apprécie les vacances toutes simples, dans un cadre rustique. Au milieu d'une campagne splendide, c'est l'endroit idéal pour contempler des aurores et des couchers de soleil magnifiques dans le silence recueilli de la nature. Les oliviers et les vignes fournissent l'huile et le vin que l'on consomme avec les amis qui vivent dans les environs. Le bois touffu qui couvre une partie de la propriété contribue à la douceur du climat. Seuls quelques travaux de restauration indispensables ont été effectués, pour entretenir les structures de la demeure, retrouver son style d'origine et conserver les éléments préexistants, comme les poutres des plafonds ou les encadrements des portes et fenêtres. Les meubles viennent de la région.

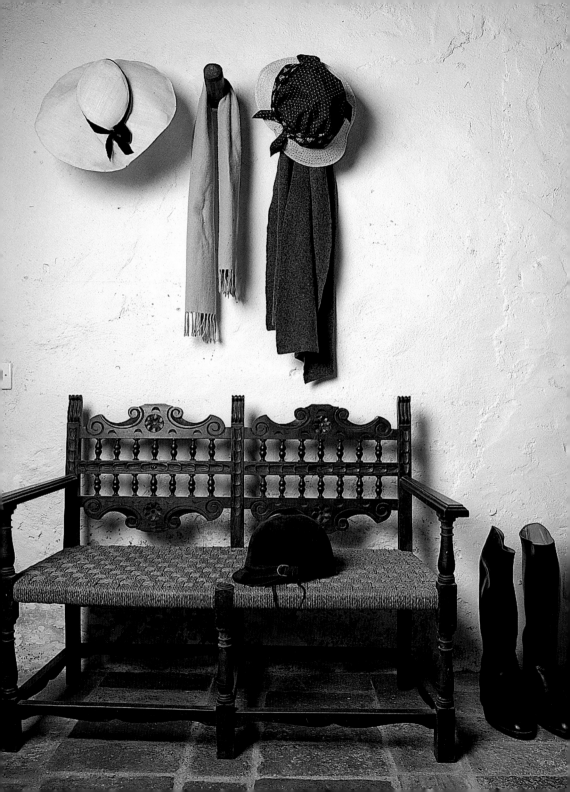

PP. 236-237 The intimate entrance is furnished with a table and chairs in the Tuscan style, a cloth-upholstered divan bed and terracotta wall lamps. • Im gemütlichen Eingangsbereich stehen ein kissenbedecktes Sofa, ein toskanischer Tisch und Stühle. Die Wandleuchten sind aus Terrakotta. • L'entrée comporte un sommier recouvert de tissu, une table et des sièges toscans ainsi que des appliques en terre cuite.

P. 239 Straw hats hanging above a bench in the entrance. • Über einer Bank im Eingangsbereich hängen Strohhüte. • Un banc dans l'entrée, surmonté de chapeaux de paille.

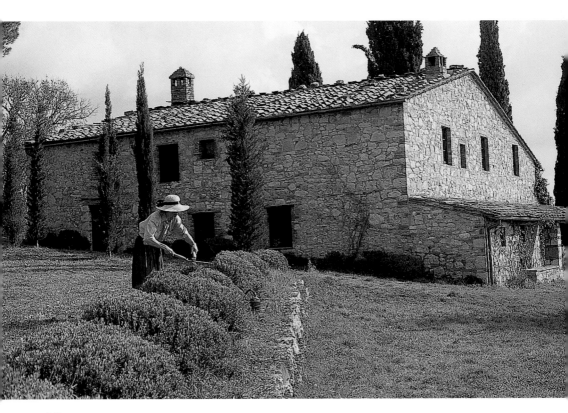

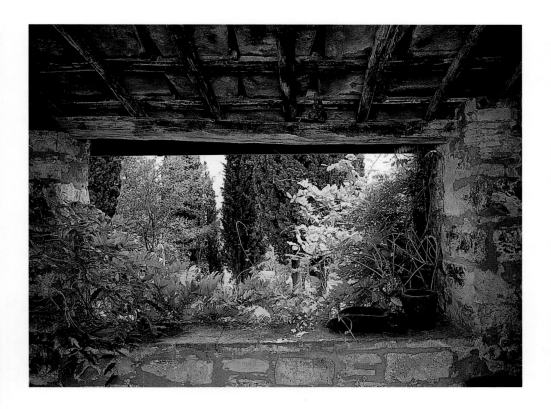

← Podere La Casina • Podere La
Casina • Podere La Casina

↑ A view of the nearby woods from
one of the windows. • Durch ein Fenster
blickt man auf den nahe gelegenen
Wald. • Le bois proche vu par l'embra-
sure d'une fenêtre.

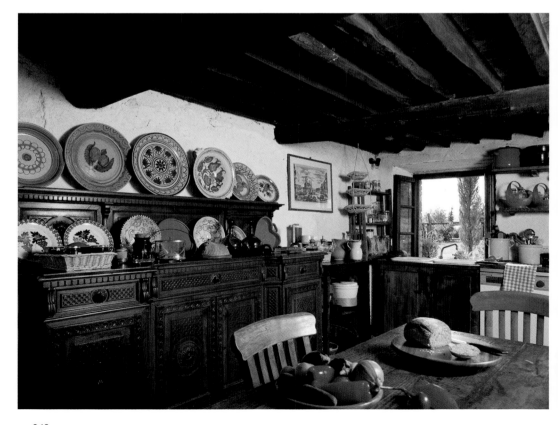

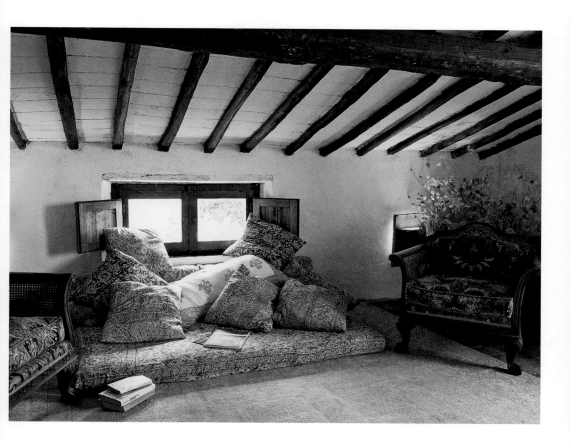

← The kitchen is full of furniture and crockery from Tuscany and Sicily. · Die Küche ist mit Möbeln und Keramik aus der Toskana und Sizilien ausgestattet. · La cuisine avec ses meubles et ses plats toscans et siciliens.

↑ A guest room. The mattress and cushions are upholstered with *mezzeri*, a traditional printed cloth. · Ein Gästezimmer. Matratze und Kissen sind mit „mezzeri" überzogen, traditionell bedruckten Baumwollstoffen. · Une chambre d'amis au matelas et aux coussins recouverts de «mezzeri», des toiles de coton imprimé traditionnelles.

VILLA LE CARCERI

VILLA LE CARCERI
VAL DI CHIANA

You spy it long before you reach it – a beautiful 16th-century villa with stout walls, square outlines, a small private chapel and a roof topped by a small edifice in which, they tell you, many gallons of sweet *vin santo* lie maturing. The villa's inhabitants, however, remain in the shade of the great cypress trees, or in the cool salons which protect them from prying eyes. For those privileged to enter, the house and its occupants have no secrets; the interior is warm and welcoming. Le Carceri is filled to overflowing with family furniture and paintings. There is a bust inspired by Canova in an 18th-century corner niche, a steel Empire bed adorned with the gilded bronze head of an Egyptian and a kitchen in which the walls are hung with dozens of cake and jelly moulds made of copper. Is this the retreat of some grandee, or the lair of a wonderfully gifted decorator? We won't tell you – all we can say is that Le Carceri lives, breathes and sparkles despite its great age. And its most recent acquisition, a small drawing room adorned with a trompe l'œil vista painted by the distinguished painter Luchani is proof of it.

Schon von Weitem erblickt man die zauberhafte quaderförmige Villa aus dem 16. Jahrhundert mit ihren dicken Mauern und der kleinen Kapelle. Unter der kleinen Maisonette-Haube auf dem Dach reift der milde „vin santo" heran. Die Bewohner halten sich lieber im Schatten der riesigen Zypressen im Garten oder in den kühlen Salons auf, wo sie vor neugierigen Blicken geschützt sind. Der Esstisch unter der eindrucksvollen Billardlampe ist stets reich mit auserlesenen Speisen und Weinen gedeckt. Die Räume der Villa Le Carceri sind angefüllt mit Familienerbstücken und Gemälden. Da gibt es die von Canova inspirierte Marmorbüste, die auf einem Sockel aus dem 18. Jahrhundert thront, ein Empire-Bett aus Stahl, an dessen Kopfteil ein vergoldeter ägyptischer Bronzekopf befestigt ist, und die Küche, deren Wände über und über mit kupfernen Kuchenformen bedeckt sind. Zeugt all das von einem adeligen Besitzer oder einem talentierten Innenarchitekten? Wir lüften das Geheimnis nicht. Die Villa Le Carceri lebt, atmet und sprüht vor Lebenslust – trotz ihres stattlichen Alters. Das beweist schon die jüngste Neuerung: ein kleiner Salon mit einer Gloriette, die von dem berühmten Luchani in Trompe l'Œil-Manier mit einem Gartenlaubenmotiv ausgemalt wurde.

On la voit déjà de loin, cette belle villa carrée du 16ᵉ siècle aux murs robustes, avec sa petite chapelle et son toit coiffé d'une maisonnette où mûrit le doux « vin santo », mais ses habitants préfèrent rester à l'ombre des cyprès et dans la fraîcheur des vastes salons qui les protègent des regards curieux. La table de la salle à manger surmontée d'une remarquable lampe de billard est toujours garnie de mets et de vins de qualité. Qui dit Le Carceri évoque tout de suite l'image de tableaux et de meubles de famille, d'un buste en marbre inspiré par Canova placé sur une encoignure 18ᵉ, d'un lit Empire en acier orné d'une tête d'Egyptien en bronze doré et d'une cuisine aux murs recouverts d'une multitude de moules en cuivre. Repère d'un noble seigneur ou gîte d'un décorateur de talent ? Nous ne dévoilerons pas son identité. Le Carceri vit, respire et pétille malgré son grand âge et la dernière acquisition, un petit salon orné d'une gloriette en trompe-l'œil peinte par le célèbre maestro Luchani, en est la preuve tangible.

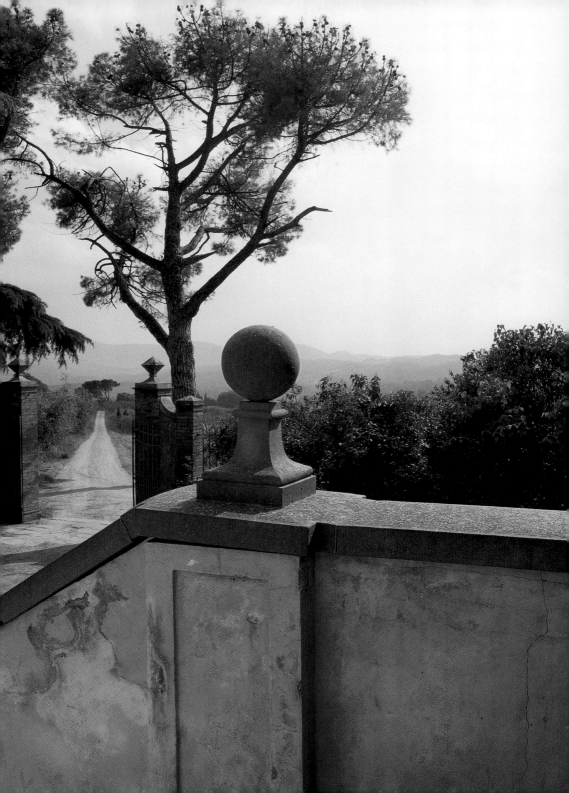

PP. 244–245 and P. 247 The lovely façade is covered in a yellow-ochre wash. The road stretches away into the distance beneath the late afternoon sunshine. • Einen schönen Anblick bieten das ockergelb gestrichene Haus und die Landstraße im weichen Licht der späten Nachmittagssonne. • Quoi de plus beau qu'une façade couleur d'ocre et un chemin de campagne sous un doux soleil de fin d'après-midi?

↑ Thanks to the virtuoso skills of the painter, the Tuscan landscape has entered the house. • Ein virtuoser Maler hat die toskanische Landschaft in das Haus geholt. • Grâce au talent du peintre, le paysage toscan est entré dans la maison.

→ In one of the frescoes, a goldfinch is tempted by cherries. • Ein gemalter Distelfink findet Gefallen an einigen Kirschen. • Sur une des fresques, un chardonneret guette quelques cerises.

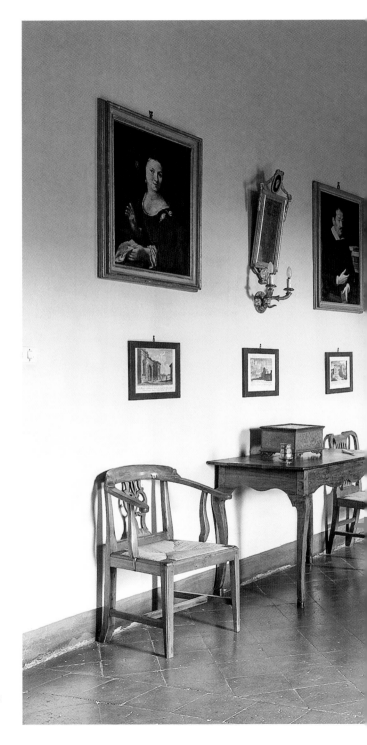

→ In the hall, the starkly arranged décor includes portraits of family ancestors, a collection of old engravings and one or two very fine pieces of inherited furniture. • In der Eingangshalle schaffen Ahnenporträts, eine Sammlung von Stichen und einige schöne Möbel aus Familienbesitz eine besondere Stimmung. • Dans le hall d'entrée, des portraits d'ancêtres, des gravures anciennes et quelques très beaux meubles de famille forment une composition sévère.

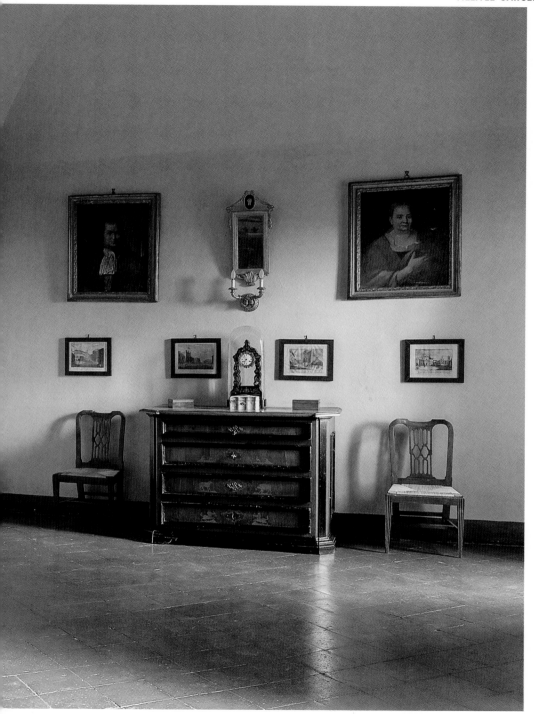

↑ The keys are kept in the kitchen, with devotional pictures in attendance. • In der Küche werden die Schlüssel an einem Bord aufbewahrt, darüber ein Andachtsbildchen. • Dans la cuisine, un « tableau de bord » qui croule sous les clefs côtoie des images pieuses.

→ Though it appears to date from the Renaissance, the decoration of the kitchen is no older than the oilcloth cover on

the table. The trusty Ivana is currently occupied in cleaning her silver. A traditional Tuscan dish often served at Le Carceri is *lingua al dragoncello* (calf's tongue with tarragon sauce). • Die Kücheneinrichtung könnte aus der Renaissance stammen, doch sie ist nicht älter als das Wachstuch auf dem Tisch. Hier kümmert sich die freundliche Ivana um die Töpfe und das Silber. Als echte Toskaner schätzen die Besitzer von Le

Carceri besonders „lingua al dragoncello" (Kalbszunge in Estragonsauce). • Même si elle donne l'impression de dater de la Renaissance, la décoration de la cuisine n'est pas plus ancienne que la toile cirée sur la table. C'est ici que la fidèle Ivana s'occupe des casseroles et de l'argenterie. En bons Toscans, les habitants de Le Carceri adorent « La lingua al dragoncello » (la langue de veau à l'estragon).

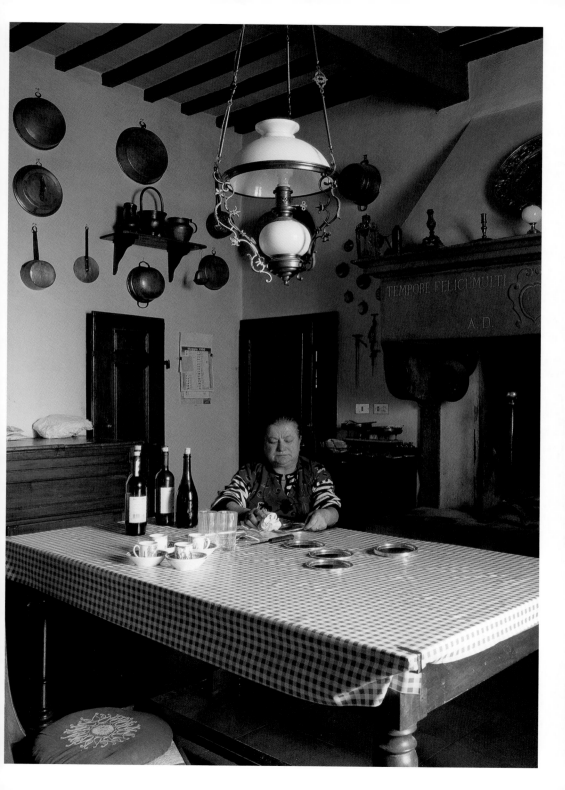

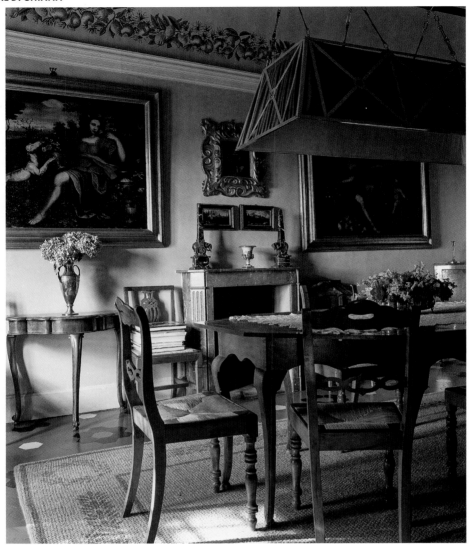

↑ In the dining room, it feels as though the period furniture and pictures have been in exactly the same place for nearly 200 years. The billiard lamp above the table is an original work by a friend of the family, the interior designer Cesare Rovatti. • Im Esszimmer hat man den Eindruck, dass die Möbel und die Bilder seit ihrer Entstehungszeit vor zweihundert Jahren unverändert an ihrem Platz geblieben sind. Die Billardlampe über dem Tisch ist eine Schöpfung des Desig-

ners Cesare Rovatti, eines Freundes der Familie. • Dans la salle à manger, on à l'impression que les meubles et les tableaux d'époque n'ont pas quitté leur place depuis bientôt deux siècles. La lampe de billard au-dessus de la table est une création originale d'un ami de la famille, le décorateur Cesare Rovatti.

→ In his study, the master of the house is surrounded by bookcases crammed with rare and antiquarian books. The exposed

beams have been decorated with arabesques • Im Arbeitszimmer des Hausherrn quellen die Bibliotheksschränke vor alten Büchern und seltenen Bänden über. Das Gebälk wurde mit Arabesken verziert. • Dans le bureau du maître de maison, les armoires-bibliothèque regorgent de livres anciens et de volumes rares. Les poutres apparentes ont été décorées avec des arabesques.

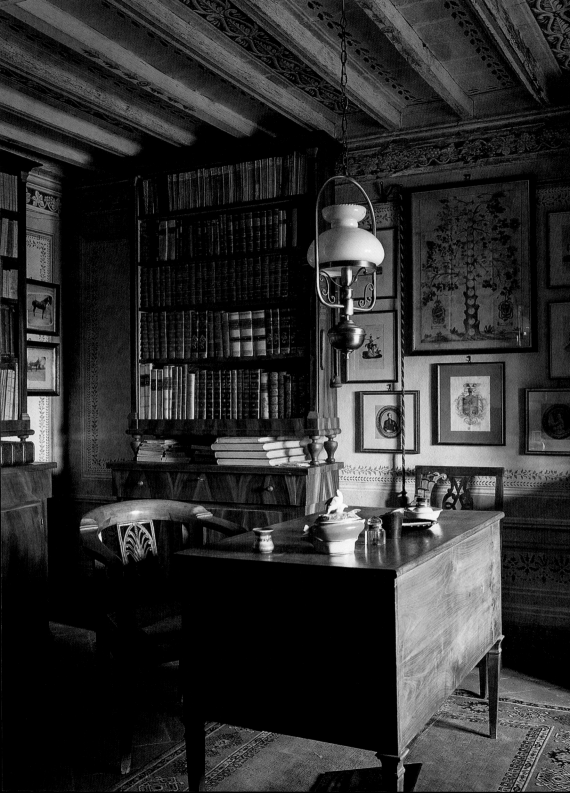

↑→ In the library a candlestick and
a marble ball mounted on a plinth. • In
der Bibliothek steht die Marmorkugel
auf einem Sockel neben einem Kerzen-
ständer. • Dans la bibliothèque, une
boule en marbre montée sur socle et
un bougeoir.

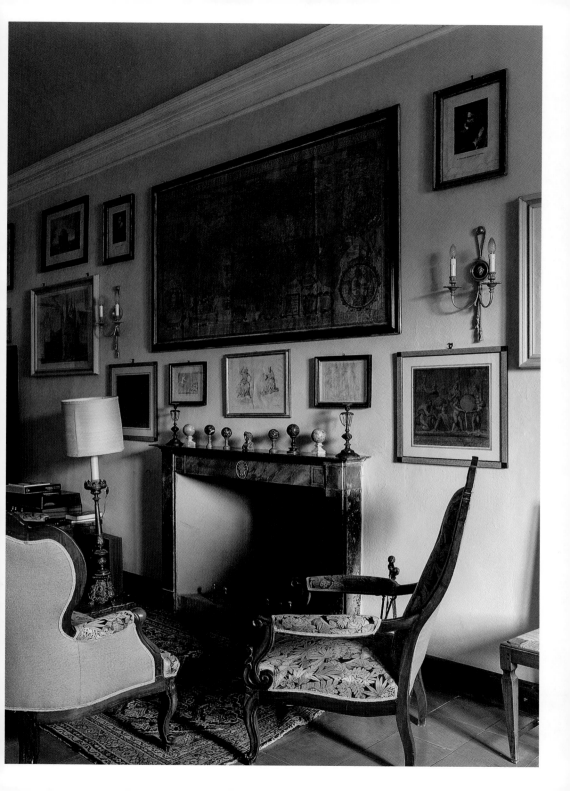

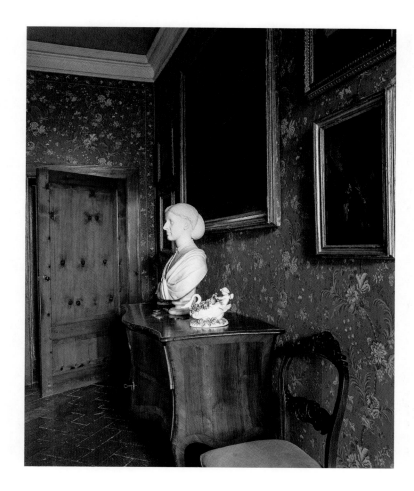

← The drawing-room walls are completely covered with an extremely beautiful floral fabric, woven in accordance with a centuries-old set of instructions. • Eine sehr schöne Stoffbespannung mit Blumenmustern, die nach alten Vorlagen gewebt wurde, bedeckt vollständig die Wände des Salons. • Un très beau tissu floral tissé à partir d'un document ancien recouvre entièrement les murs du salon d'apparat.

↑ Perched on a curved antique chest of drawers, the white marble bust of a woman, the work of an Italian sculptor, represents an ancestor of the Orlandini

family. • Die aus weißem Marmor gefertigte Büste einer Frau, die eine alte Kommode ziert, ist das Werk eines italienischen Bildhauers und stellt eine Vorfahrin der Familie Orlandini dar. • Sur une ancienne commode galbée un buste de femme en marbre blanc, œuvre d'un sculpteur italien, représente une des ancêtres de la famille Orlandini.

PP. 260–261 The choice of furniture in the lounge reflects Beppe Orlandini's refined taste and reveals his predilection for the opulent interiors of Italy's wealthy middle class. Period armchairs and a large, comfortable settee surround

a magnificent Victorian sofa. • Die Zusammenstellung der Möbel und der Objekte im Salon spiegelt den raffinierten Geschmack von Beppe Orlandini wider und verrät seine Vorliebe für die luxuriösen Interieurs der italienischen Großbourgeoisie. Klassische Sessel und ein großes, bequemes Canapé umgeben ein herrliches viktorianisches Sofa. • Dans le salon, le choix des meubles et des objets reflète le goût raffiné de Beppe Orlandini et trahit sa prédilection pour les intérieurs cossus de la haute bourgeoisie Italienne. Des fauteuils classiques et un grand canapé confortable entourent un magnifique sofa Victorien.

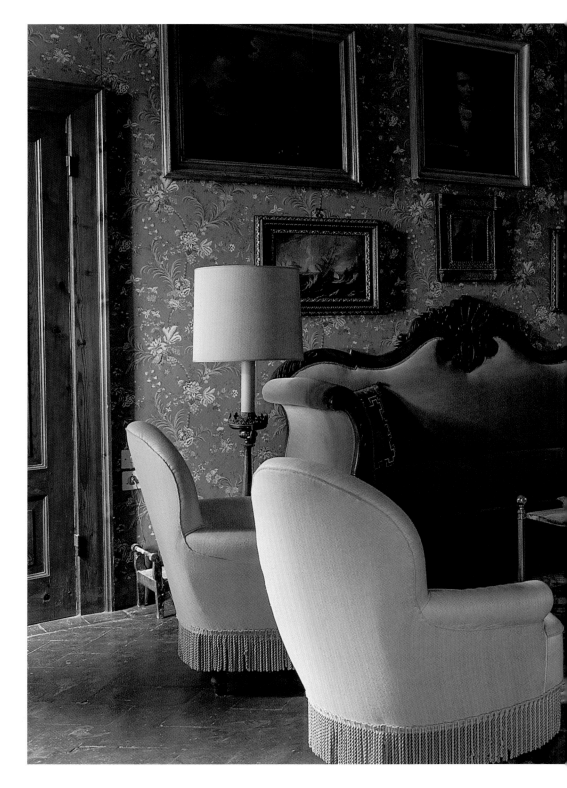

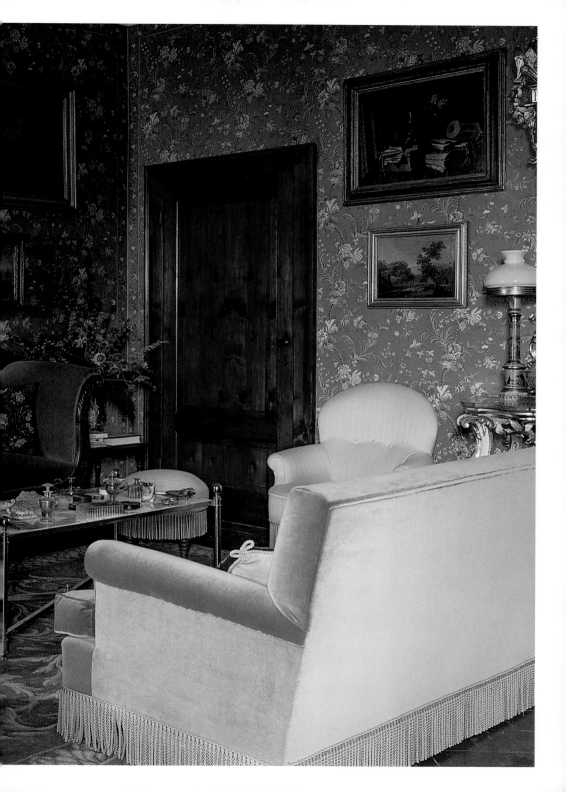

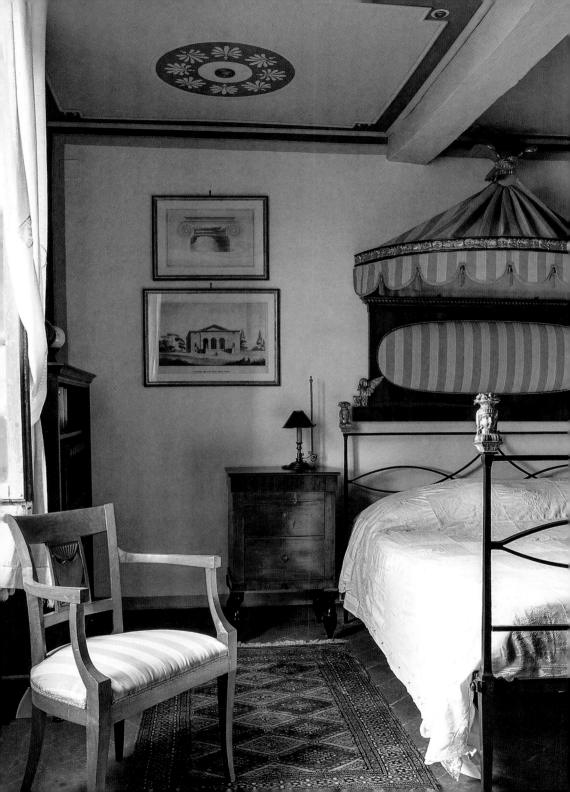

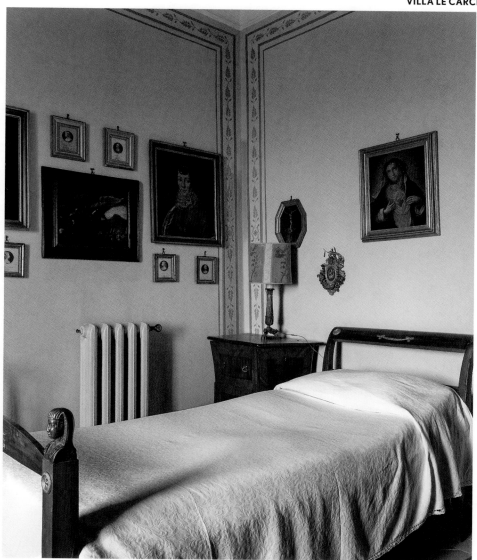

← The master bedroom is home to a splendid Empire four-poster bed in wrought iron and ormolu. • Im Schlafzimmer des Hausherrn entdeckt man unter einem Baldachin ein prachtvolles Bett, aus der Zeit des Empire, gefertigt aus Schmiedeeisen und vergoldeter Bronze. • Dans la chambre à coucher du maître de maison, on découvre un splendide lit à baldaquin d'époque Empire exécuté en fer forgé et bronze doré.

↑ The passion for Empire style is also reflected in the guest room. The Egyptian Revival mahogany bed is typical of the works of the cabinetmakers of the Lucca region. • Die Begeisterung für den Empire-Stil zeigt sich auch in der Gestaltung eines Gästezimmers, und das Bett aus Mahagoni im ägyptisierenden Stil ist typisch für die Arbeit der Kunsttischler aus der Gegend um Lucca. • L'engouement pour le style Empire se reflète aussi dans la décoration d'une chambre d'amis et le lit en acajou style « Retour d'Egypte » est typique pour le travail des ébénistes de la région de Lucques.

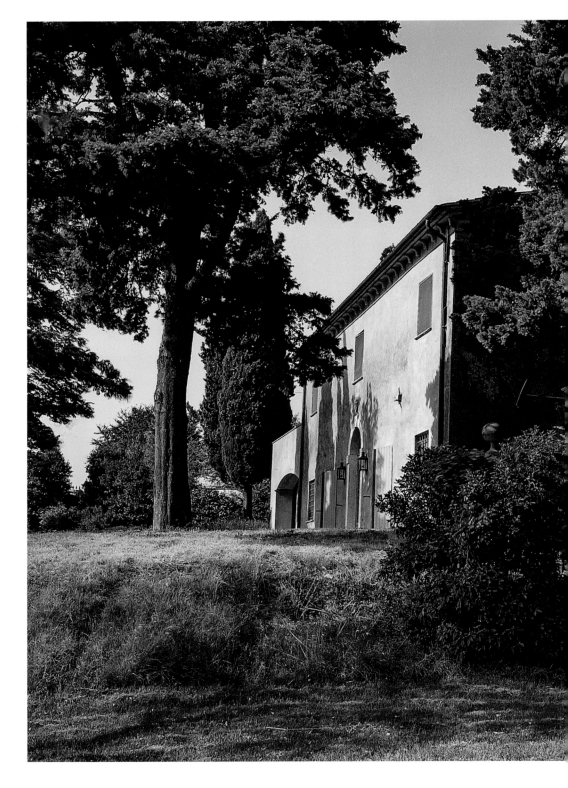

L'APPARITA

L'APPARITA
CESARE ROVATTI
VAL DI CHIANA

It takes time and effort to reach the second home of the Roman interior designer Cesare Rovatti south of Arezzo, but it is well worth the trouble. The house is on top of a hill, which is reflected on the clear surface of a lake. Originally L'Apparita was no more than a modest farmhouse, but with the advent of Rovatti it was quickly transformed into an imposing villa combining the ochre and burnt siena hues of Tuscany with the sober style of Scandinavia. Rovatti was daring in juxtaposing terracotta, *tôle*, wrought iron and earthenware pots with painted wooden chairs and a Gustavian chandelier. The imitation marble, stencilled patterns, trompe l'œil panelling and hand-printed fabrics add an unexpected note of lightness. Under the burning sun, against a background of murmuring fountains and surrounded by pine trees, cypresses and the stridulations of cicadas, all this makes for an atmosphere that is unusual, even fantastical. But after all, L'Apparita roughly translates as "she who looms up before your eyes".

Der Innenarchitekt Cesare Rovatti fährt von Rom mehr als zwei Stunden bis zu seinem Zweitwohnsitz südlich von Arezzo, der Villa L'Apparita, die wunderschön über den stillen Wassern eines Sees auf einem Hügel liegt. Ursprünglich war das Anwesen nur ein schlichtes kleines Landhaus, doch da Rovatti großzügige Proportionen liebt, verwandelte er es schnell in eine eindrucksvolle Villa. Einerseits inspirierte ihn die sienarote und ockerfarbene Palette der toskanischen Landschaft, doch gleichzeitig gibt es in den Räumen eine überraschende und originelle nordische Note. Cesare Rovatti hat eine Vorliebe für rustikale Möbel aus der Toskana, aber ebenso für Einrichtungsstücke aus dem Schweden des 18. Jahrhunderts, und er hat keine Hemmungen, Terrakotta mit Blech oder Schmiedeeisen zu kombinieren. Keramiktöpfe stehen hier neben bemalten Holzstühlen, darüber hängt ein Kronleuchter im klassizistischen gustavianischen Stil. Daneben finden sich falscher Marmor, Bordüren in Schablonentechnik, Trompe-l'Œil-Vertäfelungen und handbemalte Stoffe. In der brennenden Sonne, umgeben von Pinien und Zypressen, haftet der ganzen Szenerie etwas Unwirkliches an, besonders wenn im Hintergrund leicht die Brunnen murmeln und in der Ferne die Grillen zirpen.

Il faut du temps et des efforts pour atteindre la seconde résidence du décorateur romain Cesare Rovatti au sud d'Arezzo, mais la récompense se trouve au bout de deux heures de voiture de la capitale, au sommet d'une colline qui se mire dans les eaux limpides d'un lac. Au début, L'Apparita n'était qu'un modeste cabanon, mais grâce au talent de Rovatti et son goût pour les proportions généreuses, elle se transforma en peu de temps en une villa imposante, inspirée des ocres et des terres de Sienne de la Toscane, ce qui ne l'empêche pas de flirter avec la sobriété nordique qui lui confère une ambiance surprenante et originale. Il faut reconnaître qu'il n'a pas eu froid aux yeux en combinant la terre cuite, la tôle, le fer forgé et les pots en faïence avec des sièges en bois peint et un lustre gustavien, et que les faux marbres, les décorations au pochoir, les lambris en trompe-l'œil et les tissus décorés à la main apportent une note de légèreté inattendue. Sous le soleil brûlant, au milieu des pins et des cyprès, avec en bruit de fond le murmure des fontaines et le chant des cigales, cela tient à l'insolite et au fantastique. Mais rien de surprenant à cela : après tout, L'Apparita signifie « celle qui est apparue devant vos yeux ».

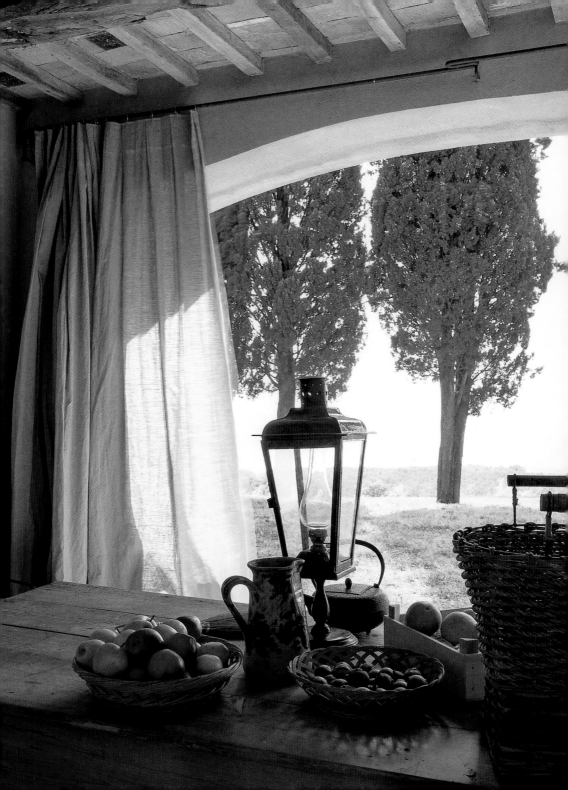

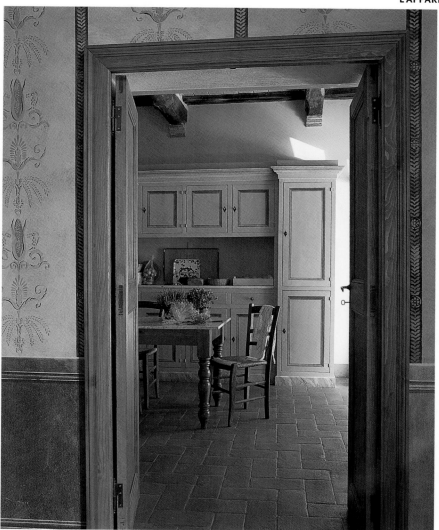

PP. 264-265 Four-square and solidly built, L'Apparita stands on the summit of a green, tree-covered hill. • Quadratisch und solide gebaut erhebt sich L'Apparita auf einem grünen Hügel. • Robuste et carrée, L'Apparita se dresse au sommet d'une colline verdoyante.

P. 267 The loggia is ideal for alfresco lunches and dinners. • Die Loggia ist ein malerischer Ort für eine Mahlzeit „al fresco". • La loggia est l'endroit idéal pour les repas al fresco.

← The colours in the hall – ochre and grey – extend to the 18th-century chair and the stencil-decorated walls. • Die Farbgebung im Eingangsbereich – Ockergelb und Dunkelgrau – setzt sich in dem Stuhl aus dem 18. Jahrhundert und den Wanddekorationen fort. • Les couleurs de l'entrée – ocre et gris – se retrouvent dans le siège 18e et les murs décorés au pochoir.

↑ A cotto floor, a rustic table and chairs and a yellow cupboard with olive-green borders are the principal features of this welcoming kitchen. • In der einladenden Küche setzen ein Boden aus Terrakottafliesen, ein massiver Tisch und rustikale Stühle Akzente. Die gelbe Anrichte ist olivgrün abgesetzt. • Un sol en «cotto», une table et des chaises campagnardes et une armoire à rangements jaune avec des rechampis vert olive sont les éléments principaux de cette cuisine accueillante.

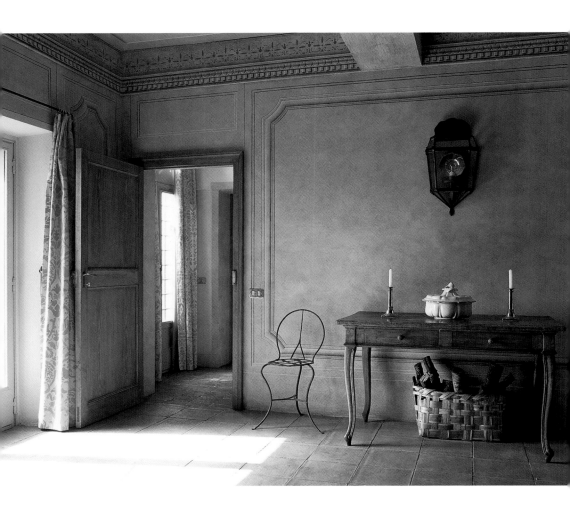

↑ The designer has hung an 18th-century metal lantern above the table, which was made in Tuscany in the same period. • Über einem toskanischen Tisch aus dem 18. Jahrhundert hat der Innenarchitekt eine Metalllampe aus der gleichen Epoche angebracht. • Au-dessus d'une table toscane 18ᵉ, le décorateur a accroché une lanterne en tôle de la même époque.

→ In the salon, Rovatti used a sophisticated camaïeu palette. The beams are decorated with stencilled patterns, the panels and cupboards are painted in trompe l'œil, and the pair of 18th-century marquise armchairs add a further note of elegance. • Den Salon hat Rovatti raffiniert Ton in Ton gehalten. Die Deckenbalken sind in Schablonentechnik bemalt, Trompe-l'Œil-Malerei

imitiert Vertäfelungen und die Schränke, und die Sessel aus dem 18. Jahrhundert geben dem Ganzen eine elegante Note. • Dans le salon, Rovatti a eu recours à des camaïeux raffinés. Les poutres sont décorées au pochoir, les lambris et les armoiries sont peints en trompe-l'œil et la paire de marquises 18ᵉ apporte une note d'élégance.

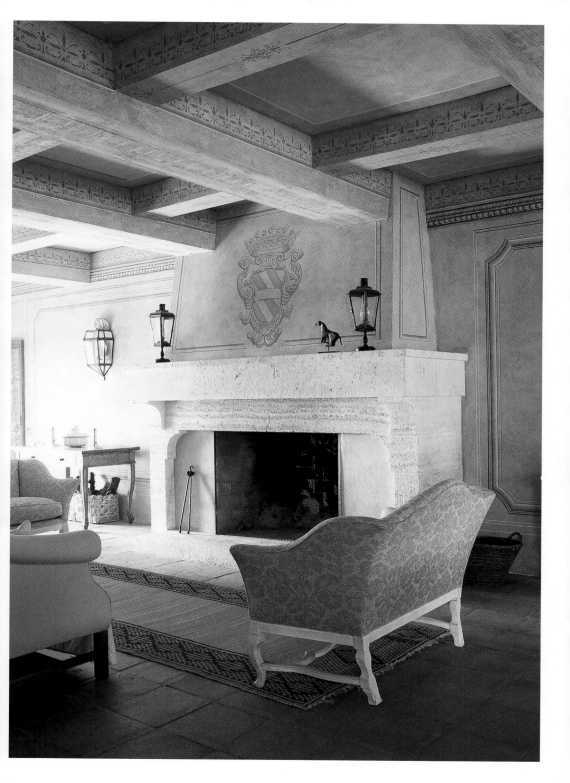

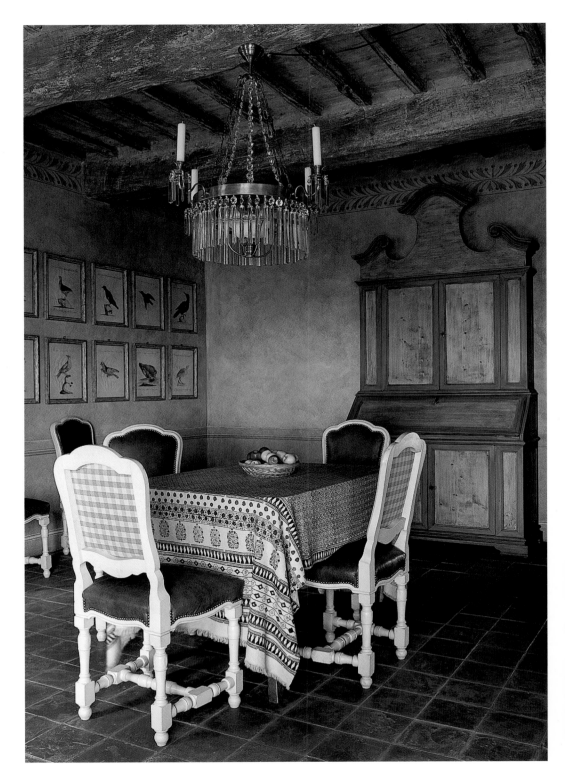

← The dining room is both countrified and sophisticated. The 18th-century chandelier is Gustavian. • Das Esszimmer ist gleichzeitig elegant und rustikal eingerichtet. Der Kronleuchter im gustavianischen Stil stammt aus dem 18. Jahrhundert. • La salle à manger est à la fois rustique et sophistiquée. Le chandelier 18e est gustavien.

↑ Sunlight lingers on the stone steps leading to the first floor. • Die Sonne verweilt auf den Steinstufen, die in die erste Etage führen. • Le soleil s'attarde sur les marches en pierre qui mènent au premier étage.

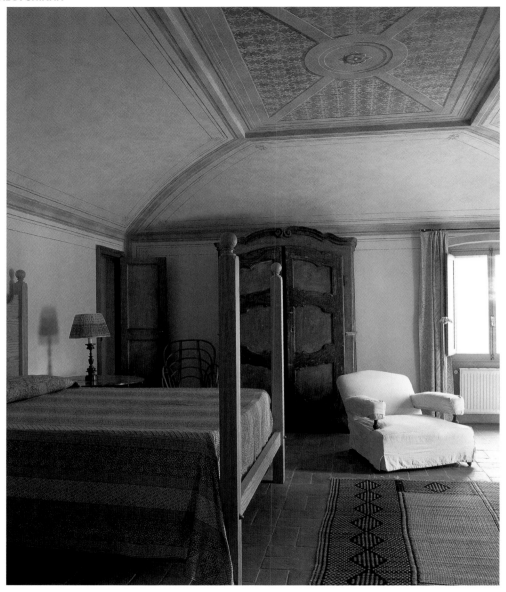

↑ In Cesare's bedroom, the vaulted ceiling is decorated with trompe l'œil panelling. The Piedmontese wardrobe is 18th-century, but the bed with its uprights is Cesare Rovatti's personal creation. • Im Zimmer von Cesare schmückt eine Trompe-lŒil-Vertäfelung das Deckengewölbe. Der pie-montesische Schrank stammt aus dem 18. Jahrhundert, doch das Bett mit den hohen Pfosten ist ein Entwurf des Hausherrn. • Dans la chambre de Cesare, le plafond voûté est décoré d'un trompe-l'œil qui imite des lambris. L'armoire piémontaise est 18ᵉ mais le lit à colonnes est une création du maître de maison.

→ In one of the bedrooms, the four-posters are lined up beneath a sloping ceiling. • In einem Schlafzimmer stehen Himmelbetten nebeneinander unter der Dachschräge. • Dans une des chambres à coucher, des lits à baldaquin s'alignent sous un toit en pente.

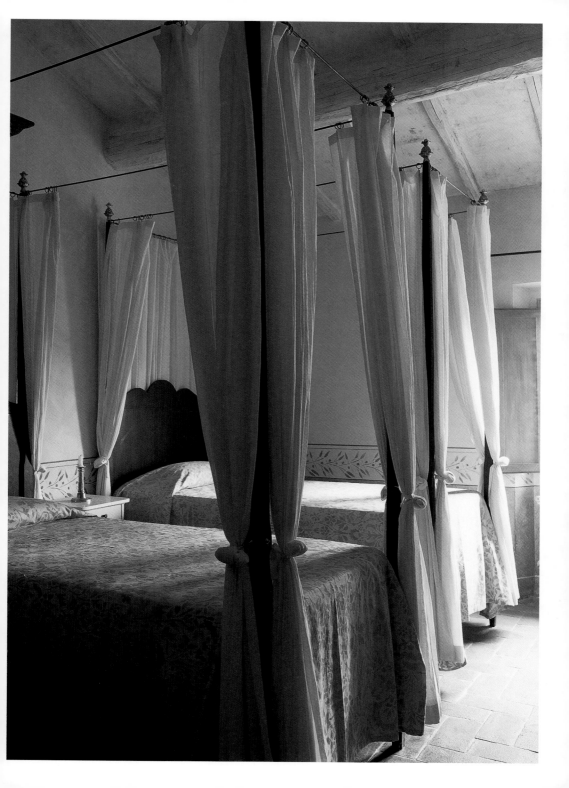

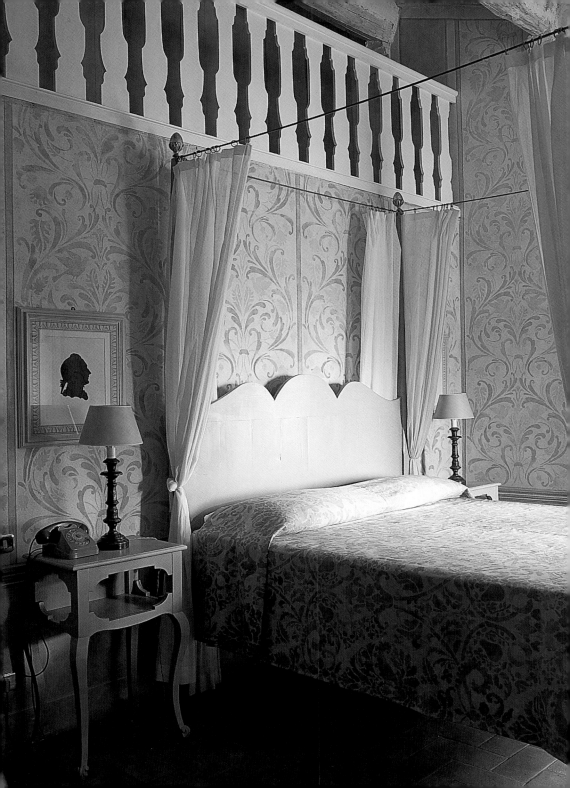

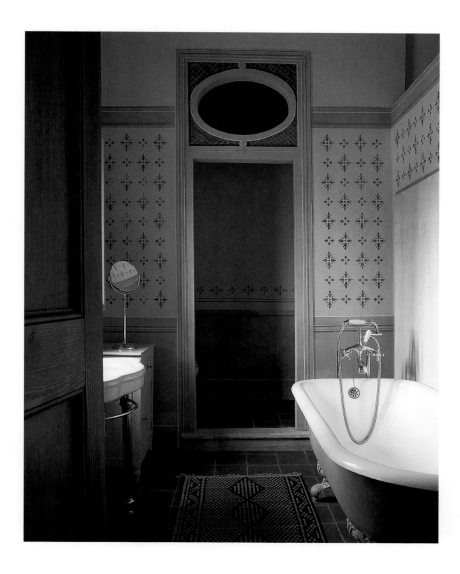

← In this bedroom the walls and the counterpane are covered with a stencilled pattern inspired by the damask fabrics of Mariano Fortuny (1871–1949). • Die Gestaltung der Wände und der Tagesdecke in diesem Schlafzimmer ist einem Muster nachempfunden, das Mariano Fortuny (1871–1949) für Damaststoffe entwarf. • Dans cette chambre à coucher, les murs et le

couvre-lit sont ornés d'un décor au pochoir inspiré des tissus damassés de Mariano Fortuny (1871–1949).

↑ The architecture of the bathroom has all the hallmarks of Rovatti – as do the tub, the old-fashioned fittings and the bull's-eye window above the door. • Auch das Badezimmer trägt die Handschrift von Cesare Rovatti, der den

Raum mit einer Badewanne und einem alten Waschbecken ausstattete. Über der Tür ließ er ein Ochsenauge anbringen. • La salle de bains porte la griffe du décorateur, en témoignent la baignoire et la robinetterie à l'ancienne, et l'œil-de-bœuf au-dessus de la porte.

277

...ERIETUR VOBIS

IL ROMITO

IL ROMITO
ELISABETTA AND CLAUDIO NALDINI
SIENA

There are times when Il Romito, the early-19th-century hermitage which stands in the Taya Grisaldi family's park at Il Serraglio, looks positively spectral in the morning mist. But as soon as the sun comes out, the old house shakes off all trace of ghostliness and becomes what it always was: a pretty, triple-arched, stone-built pavilion. Il Romito has acquired a new lease of life thanks to the magic wand of Elisabetta and Claudio Naldini. Although they only use the place as a summer retreat, the Naldinis have furnished it to withstand all seasons and weathers. The simple furniture, the bouquets of wildflowers gathered behind the house in the *bosco inglese* of cedars and sequoias – and the charming presence of an occasional devotional image – are all indicative of the Naldinis' approach to life. So is their table, which stands covered with a cloth of old cretonne and set for a delicious meal.

An manchen Tagen hüllt sich Il Romito am Morgen in einen Schleier aus Nebelschwaden und wirkt dann wie eine Erscheinung aus einer anderen Welt. Doch sobald die Sonne den Dunst auflöst, verwandelt sich die ehemalige Einsiedelei bei Siena wieder zurück in einen hübschen Steinpavillon mit drei schmückenden Bögen. Das Gebäude, das aus der ersten Hälfte des 19. Jahrhunderts stammt, liegt einsam im Park des Anwesens Il Serraglio, das der Familie von Taya Grisaldi gehört. Heute hat Il Romito zu neuem Leben zurückgefunden, dank Elisabetta und Claudio Naldini. Obwohl sie den Pavillon nur in den Sommermonaten bewohnen, haben sie ihn mit soliden Möbeln eingerichtet, die für alle Jahreszeiten tauglich sind. Hinter dem Gebäude befindet sich der „bosco inglese", ein Park mit gewaltigen Zedern und Mammutbäumen. Und im Haus sorgen ein Feldblumenstrauß, ein Heiligenbild und der reich gedeckte Tisch für ein nostalgisch-romantisches Ambiente.

Il y a des moments où Il Romito, enveloppé d'une chape de brouillard matinal, ressemble à une apparition fantomatique, mais dès que le soleil darde ses rayons, cet ancien ermitage construit durant la première moitié du 19e siècle dans le parc de « Il Serraglio » appartenant à la famille de Taya Grisaldi, secoue ses habits de spectre et redevient un joli pavillon en pierre orné de trois arches. Aujourd'hui, Il Romito est revenu à la vie grâce aux coups de baguette magique d'Elisabetta et Claudio Naldini. Bien que ce modeste pavillon ne leur serve que de maison de plaisance pendant les mois d'été, les Naldini l'ont meublé pour qu'il puisse faire face à toutes les saisons. Le mobilier robuste et simple, le bouquet champêtre cueilli derrière la maison – dans le Bosco Inglese où poussent des cèdres et même des séquoias – et la présence charmante d'une image pieuse ou d'une table nappée d'une vieille cretonne et chargée de plats succulents témoignent de leur penchant pour une ambiance teintée de bien-être, de nostalgie et de romantisme.

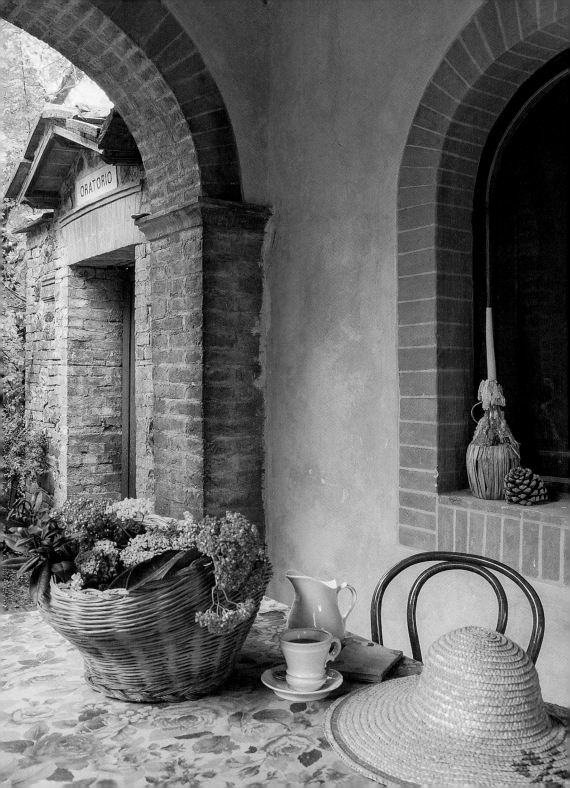

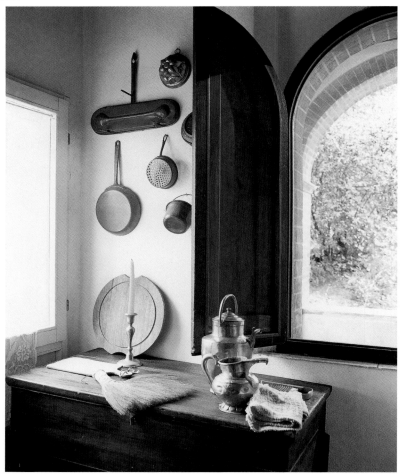

PP. 278–279 An ancient saying, inscribed above Il Romito's front door, greets visitors with the words "Knock and it shall be opened unto you." • Über dem Eingang wird der Besucher von einem sehr alten Spruch in lateinischer Sprache empfangen: „Klopft an die Pforte und man wird euch empfangen"... • Au-dessus de l'entrée d'Il Romito un très ancien dicton en latin accueille les visiteurs avec les mots : « Frappez à la porte et on vous ouvrira »...

P. 281 Under the arches of the loggia: the perfect place for a delicious *caffe latte*. • Es ist herrlich, unter den Arkaden der Loggia einen köstlichen „caffellatte"zu genießen. • Comme il fait bon se reposer sous les arcades de la loggia en sirotant un « caffellatte ».

↑ From this corner of the room, the gaze wanders out to the loggia. A hand brush and some copper vessels have been left on the chest of drawers, while the wall is hung with a collection of old kitchen utensils. • Von dieser Zimmerecke geht der Blick nach draußen auf die Loggia. Auf der antiken Kommode liegt ein Handbesen neben Kupferkannen, und an der Wand hängt eine Sammlung alter Küchengeräte. • De ce coin de la pièce, le regard se pose sur la loggia à l'extérieur. Sur la commode an-cienne, une balayette côtoie des vases de cuivre et une collection d'anciens ustensiles de cuisine est accrochée au mur.

→ A last ray of sunshine caresses the ochre walls of the sitting room. The evenings are getting colder, and the log fire burns in the grate. • Die letzten Sonnenstrahlen streichen sanft über die ockerfarbenen Wände des Wohnzimmers. Der Abend verspricht kühl zu werden und gerade wurde das Feuer im Kamin angezündet. • Un dernier rayon de soleil caresse les murs du séjour. La soirée sera fraîche et on vient d'allumer le feu dans la cheminée.

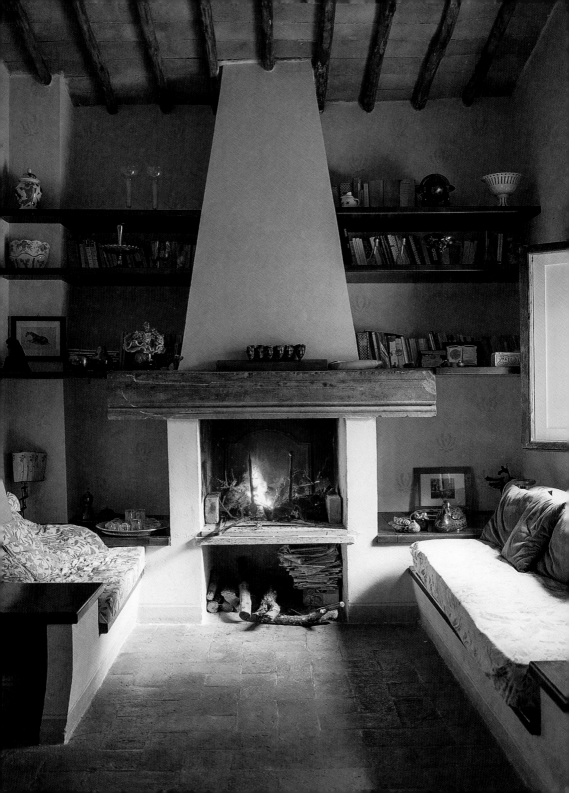

← In the bedroom, breakfast is taken *tête-à-tête* on a folding bamboo table. • Im Schlafzimmer nimmt man das Frühstück „tête à tête" an einem Klapptisch aus Bambus ein. • Dans la chambre à coucher, le petit déjeuner se déguste en tête à tête sur une table volante en bambou.

↑ Stencilled ochre walls, 19th-century Savonarona or X-frame chairs and old engravings: the decoration of Il Romito is both sober and elegant. • In Schablonentechnik verzierte ockerfarbene Wände, Savonarola- oder Scherenstühle aus dem 19. Jahrhundert und alte Stiche: Il Romito verbindet Schlichtheit und Eleganz. • Murs ocres décorés au pochoir sièges Savonarole 19ᵉ et gravures anciennes : la décoration d'Il Romito est à la fois sobre et élégante.

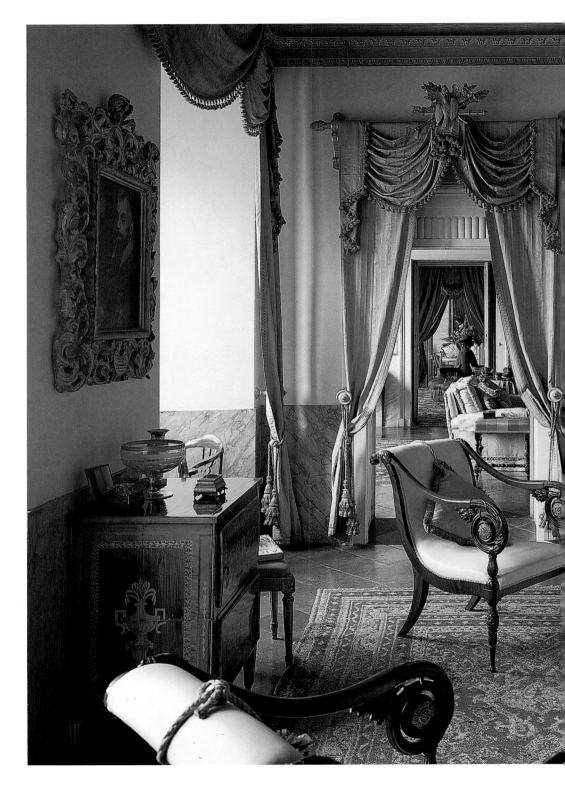

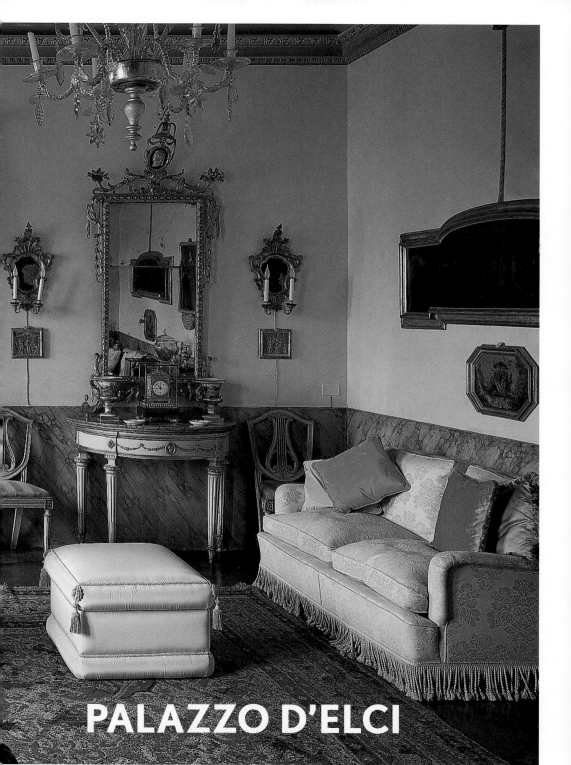

PALAZZO D'ELCI

PALAZZO D'ELCI

SIENA

The origins of Palazzo d'Elci, which overlooks the Campo, date back to Etruscan times. The building formed part of the city walls until the year 1300. Much of the furniture and the interior decoration, as it appears today, are by the Sienese architect Agostino Fantastici (1782-1849). "We have a duty to enjoy the beauty of this house," claims Countess Cesarina Pannocchieschi d'Elci, who lives in Palazzo d'Elci with her son, Andrea. Since the year 982 it had been a residence of knights, ambassadors and cardinals, and, consequently, the sumptuous rooms had, in the countess's view, acquired the atmosphere of a museum. That was why she decided to rearrange the furniture and do some restoration work. "It was like a breath of fresh air," she says, "and I'm going to leave my mark on the house, just as my forebears did."

Bis zu den Etruskern lässt sich die Geschichte des Palazzo d'Elci an der berühmten Piazza del Campo zurückverfolgen. Im frühen Mittelalter war der Palast Teil der Stadtmauer. Möbel und Dekoration der Innenräume stammen zum größten Teil von dem sienesischen Architekten Agostino Fantastici (1782-1849). „Wir betrachten es als Pflicht, uns an der Schönheit dieses Hauses zu erfreuen", sagt Contessa Cesarina Pannocchieschi d'Elci, die hier zusammen mit ihrem Sohn Andrea lebt. Noch bis vor Kurzem fühlte sie sich in den prunkvollen Räumen, in denen seit dem Jahre 982 Ritter, Gesandte und Kardinäle wohnten, wie in einem leicht verstaubten Museum. Deshalb arrangierte sie die Einrichtung neu und ließ den Palast restaurieren, auch um den Erhaltungszustand zu sichern. „Heute weht ein frischer Wind durch den Palazzo", freut sich die Contessa und fügt hinzu: „Später einmal wird man hier nicht nur die Spuren meiner Vorfahren, sondern auch meine eigenen entdecken können."

Les origines du Palazzo d'Elci, qui donne sur le Campo, remontent aux Etrusques. Englobé dans la muraille de la ville jusqu'à 1300 environ, l'édifice fut ensuite agrandi. La décoration interne et une grande partie de son mobilier sont dus à l'architecte siennois Agostino Fantastici (1782-1849). «Nous nous devons d'apprécier la beauté de cette demeure», affirme la comtesse Cesarina, qui y habite avec son fils Andrea. Considérant que les pièces somptueuses, fréquentées depuis 982 par des chevaliers, des ambassadeurs et des cardinaux, s'étaient transformées en musée, elle a changé la disposition des meubles, rafraîchi les coloris des murs et procédé à quelques travaux de restauration. «De cette manière, j'ai insufflé un peu d'air frais ; je laisserai moi aussi une trace dans l'histoire, comme mes ancêtres avant moi».

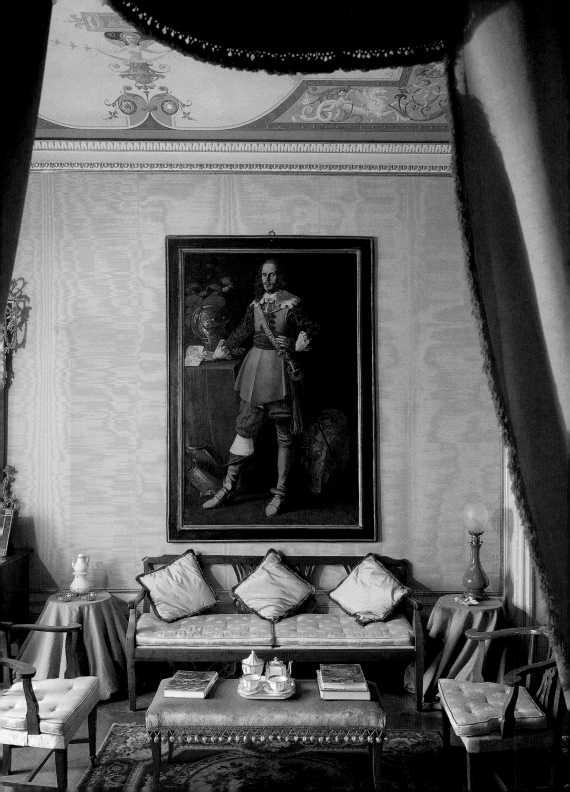

PP. 286-287 A *di passo*, or walk-through, reception room. The two chairs were made locally in the Empire style. The console table and the mirror are Louis Seize; on the left, over the 18th-century inlaid cabinet, is a painting by Rutilio Manetti (1571-1639). • Ein „salotto di passo", ein kleiner Durch-gangssalon mit zwei sienesischen Em-pire-Stühlen. An der hinteren Wand finden sich ein Konsoltisch und ein Spie-gel im Louis-Seize-Stil. Links hängt über der Kommode mit Intarsienarbeiten aus dem 18. Jahrhundert ein Gemälde von Rutilio Manetti (1571-1639). • Un salon dit « di passo » ou « de passage ». Les deux fauteuils de style Empire ont été fabri-qués à Sienne ; la console et le miroir sont de style Louis XVI. A gauche, un tableau de Rutilio Manetti (1571-1639) surmonte un meuble marqueté du 18e siècle.

P. 289 Detail of the *salone giallo*, the Yellow Room, which is used as a guest room. It was decorated in 1899. The large portrait is of a Pannocchieschi who served as ambassador to Spain. • Teil-ansicht des „salone giallo", des Gelben Salons, der als Gästezimmer genutzt

wird. Das imposante Gemälde zeigt einen Vorfahren der Pannocchieschi, der Gesandter am spanischen Hof war. Die Dekorationen stammen aus dem Jahre 1899. • Un détail du « salone gial-lo », le salon jaune, qui sert de chambre d'hôtes et qui a été décoré en 1899. Le grand portrait représente un membre de la famille Pannocchieschi qui fut am-bassadeur en Espagne.

→ The corner of a room looking onto the Campo with a view of the Torre del Mangia. The inlaid table dates from the 18th century, as does the painting in the small octagonal frame. The portrait is at-tributed to Georges de La Tour (1593-1652). Palazzo d'Elci stands in the Contrada dell'Oca, the "Goose district" of the city, which takes part in the Palio horse race held twice a year in the Cam-po. Andrea's grandfather was the Cap-tain of the Contrada dell'Oca team for eighteen years and his father, Vieri, led it for a further twenty; twice winning the Palio with his horse Salomé. • Durch das Fenster dieses Zimmers blickt man auf die Torre del Mangia. Der zierliche Tisch mit Einlegearbeiten und das Gemälde in achteckigem Rahmen

stammen aus dem 18. Jahrhundert. Das Porträt eines Mannes wird Georges de La Tour (1593-1652) zugeschrieben. Der Palazzo d'Elci gehört zur „Contrada dell'Oca", der Contrade der Gans, eine der Nachbarschaftsgemeinschaf-ten Sienas, die am zweimal jährlich stattfindenden „Palio", dem bekannten Pferderennen auf der Piazza del Cam-po, teilnehmen. Andreas Großvater war für achtzehn Jahre, sein Vater Vieri für zwanzig Jahre „Capitano" der Con-trade. Vieris Pferd Salomé verhalf der „Contrada dell'Oca" zweimal zum Sieg. • L'angle d'une pièce donnant sur le Campo, la place principale de Sienne, et la célèbre Torre del Mangia. La table en marqueterie date du 18e siècle comme le petit tableau au cadre octogonal ; le portrait d'homme est attribué à Georges de La Tour (1593-1652). Le palais est situé dans la « Contrada dell'Oca », le quartier de l'Oie, qui participe avec succès au Palio, la célèbre course de chevaux qui a lieu deux fois par an sur le Campo. Le grand-père d'Andrea a été capitaine de l'équipe pendant dix-huit ans et son père Vieri pendant vingt ans ; il a gagné deux fois avec son cheval nommé Salomé.

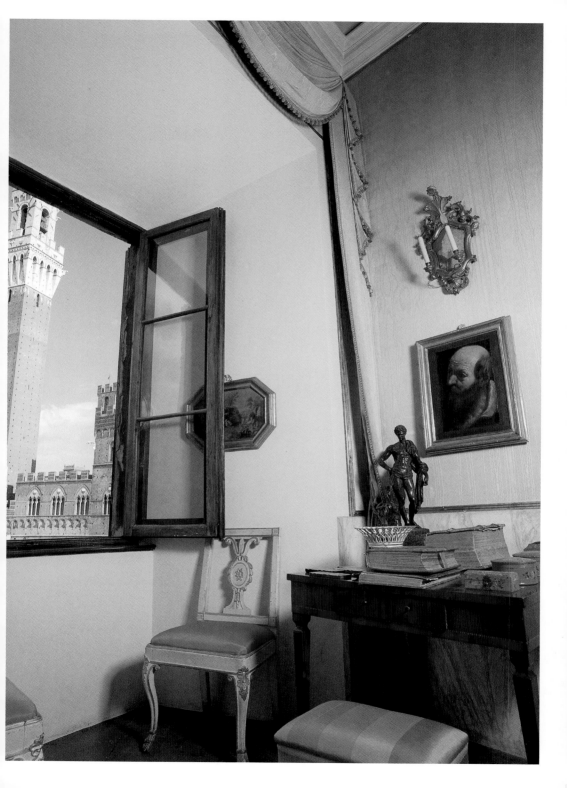

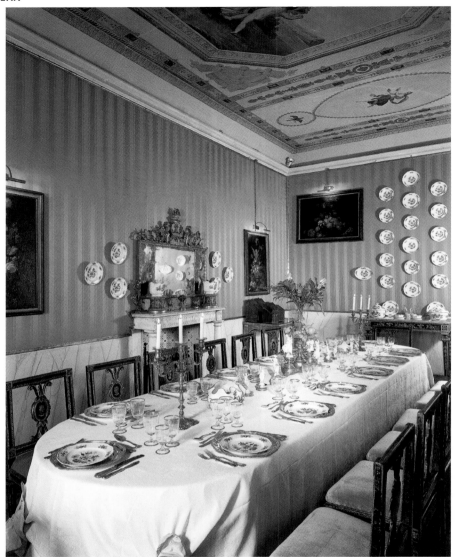

↑ The dining-room. The table is laid with floral-patterned porcelain, made by Manifattura Richard Ginori in 1756, that the countess insists on washing by hand herself. • Das Speisezimmer. Das wertvolle Porzellanservice mit Blumendekor von 1756 aus der Manufaktur Richard Ginori spült die Contessa persönlich mit der Hand. • La salle à manger. La vaisselle de porcelaine à décor floral a été

réalisée par la manufacture Richard Ginori en 1756. La comtesse a l'habitude de la laver personnellement à la main.

→ The Red Room was decorated on the occasion of the marriage of Achille Pannocchieschi d'Elci to Elena Pucci in 1859. • Der Rote Salon entstand 1859 anlässlich der Hochzeit von Achille

Pannocchieschi und Elena Pucci. • La décoration du salon rouge a été exécutée en 1859 à l'occasion du mariage d'Achille Pannocchieschi d'Elci et d'Elena Pucci.

PP. 294–295 A bedroom. • Ein Schlafzimmer. • Une chambre à coucher.

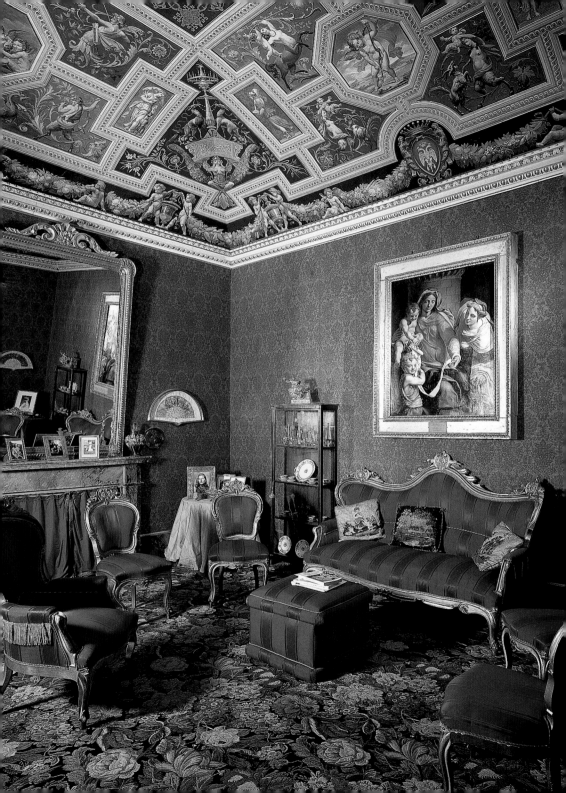

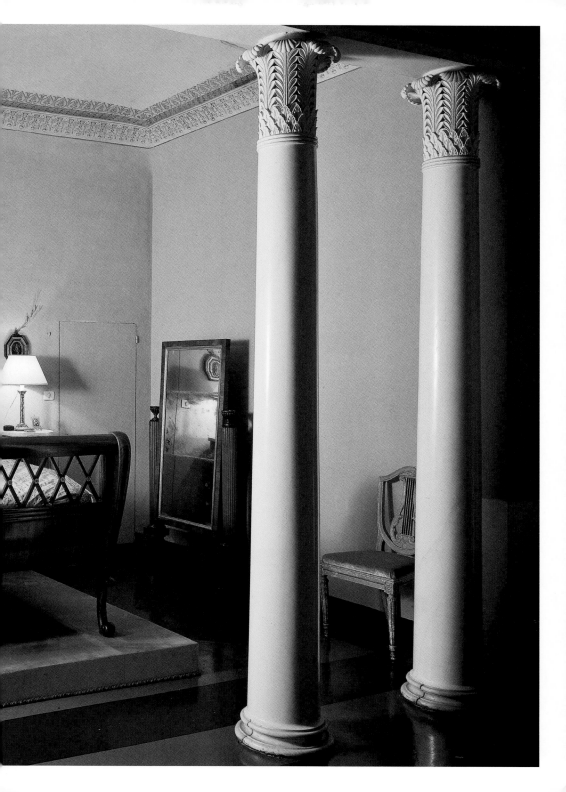

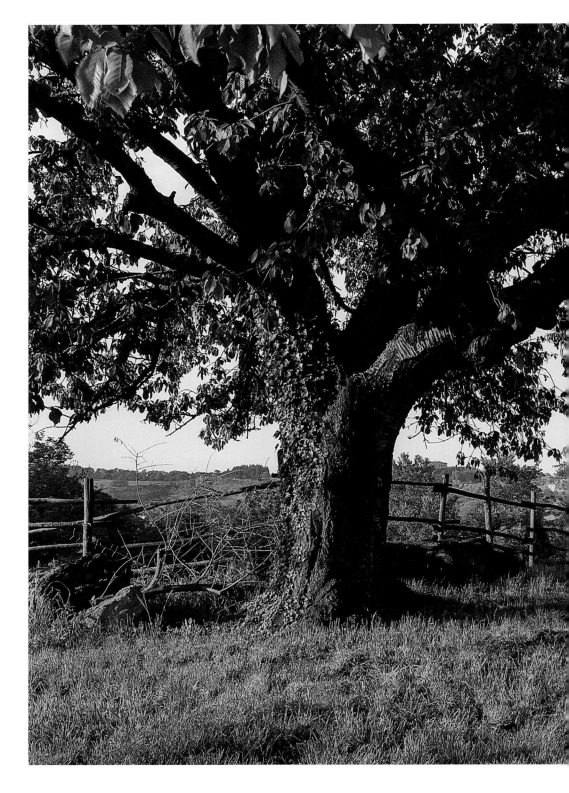

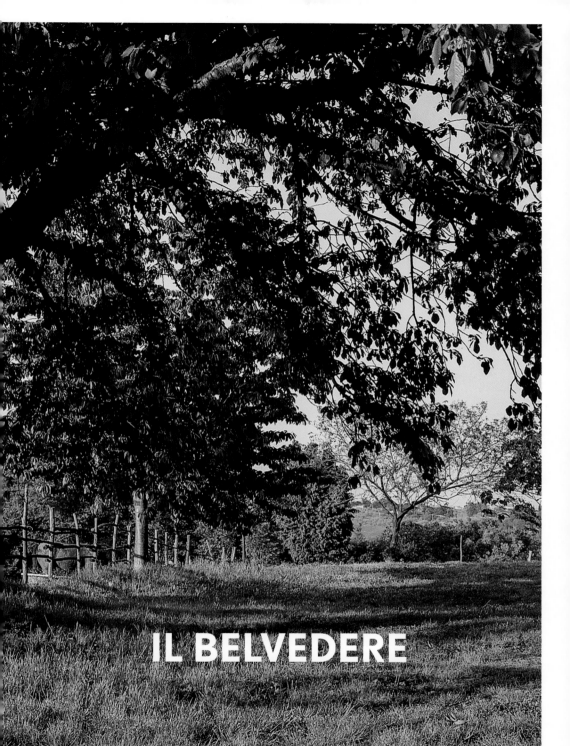

IL BELVEDERE

IL BELVEDERE
LAURIE AND ANDREA LASCHETTI
CERTANO

Laurie and Andrea Laschetti and their daughter Flavia left Italy to go and live in Switzerland. But although they exchanged the green hills of Tuscany for the snowy mountaintops of the land of William Tell, they did not abandon their beautiful country home at Certano, near Siena. Il Belvedere, which they now use as a holiday retreat, has a stunning view across a valley filled with groves of olives, vineyards and sleepy farms. In the distance rise the towers of the celebrated Piazza del Campo. Laurie is Irish and Andrea is from Rome; there is nothing pretentious about their house. What they wanted was a simple, uncluttered space, and in consequence Il Belvedere is furnished with rustic furniture and old-fashioned utensils of the kind used by the *contadini* (country people) who once lived in the house and worked the surrounding land. Here you will look in vain for any trace of sophistication. An ordinary white mosquito net covers the bed, which has an embroidered linen counterpane handed down in the family. The bedside bouquet consists of a few sage sprays arranged in an earthenware vase. And in the evening, the family gathers on the terrace to savour the delicacies concocted by *babbo* (Daddy), whose succulent *panzanella*, bread salad, is the finest in the land.

Laurie und Andrea Laschetti verließen mit ihrer Tochter Flavia Italien und zogen in die Schweiz. Doch als sie die grünen Hügel der Toskana gegen die schneebedeckten Berggipfel im Land von Wilhelm Tell eintauschten, waren sie so klug, ihr schönes Landhaus in der Nähe von Siena zu behalten. Heute als Ferienhaus genutzt, bietet Il Belvedere einen atemberaubenden Blick über ein Tal mit Olivenhainen, Weinbergen und Bauernhöfen. Laurie, eine Irin, und Andrea, der Römer, bevorzugen ein schlichtes Ambiente, und so gestalteten sie ihr Haus ohne jeden Prunk und Protz. Die Einrichtung mit den rustikalen Tischen und Stühlen sowie alten Küchengeräten lässt an die „contadini", die Bauern, denken, die hier einst lebten. Auf dem Bett liegt bestickte Bettwäsche, darüber ein weißes Moskitonetz. Salbeizweige bilden ein hübsches Arrangement in einer Keramikvase, und das Sofa verbirgt sich unter einer gesteppten Baumwolldecke. Wenn die Familie den Tag gemeinsam auf der Terrasse ausklingen lässt, genießen alle die köstlichen kleinen Gerichte von „babbo" und lassen sich besonders die „panzanella", toskanischen Brotsalat, schmecken!

Laurie et Andrea Laschetti et leur fille Flavia ont quitté l'Italie pour aller vivre en Suisse. Mais s'ils ont échangé les collines vertes de la Toscane contre les cimes neigeuses du pays de Guillaume Tell, ils se sont bien gardé d'abandonner leur belle maison de campagne près de Sienne. Devenue désormais maison de vacances, Il Belvedere offre à ses hôtes une vue époustouflante sur un vallon parsemé d'oliviers, de vignobles et de fermes rustiques et sur les tours de la célèbre Piazza del Campo. La maison de Laurie l'Irlandaise et d'Andrea le Romain n'a rien de prétentieux, et comme ils la voulaient simple et dépouillée, ils l'ont garnie de meubles rustiques et d'ustensiles anciens liés étroitement à l'existence des anciens «contadini». Ici, on cherche en vain la sophistication : le lit est coiffé d'une simple moustiquaire blanche et habillé d'un linge de grand-mère brodé, le bouquet est fait de quelques branches de sauge arrangées dans un vase en faïence et le canapé est dissimulé sous une généreuse couverture en coton piqué. Le soir, la famille réunie sur la terrasse savoure les délicieux petits plats de «babbo» dont la succulente «panzanella» fait frémir les papilles !

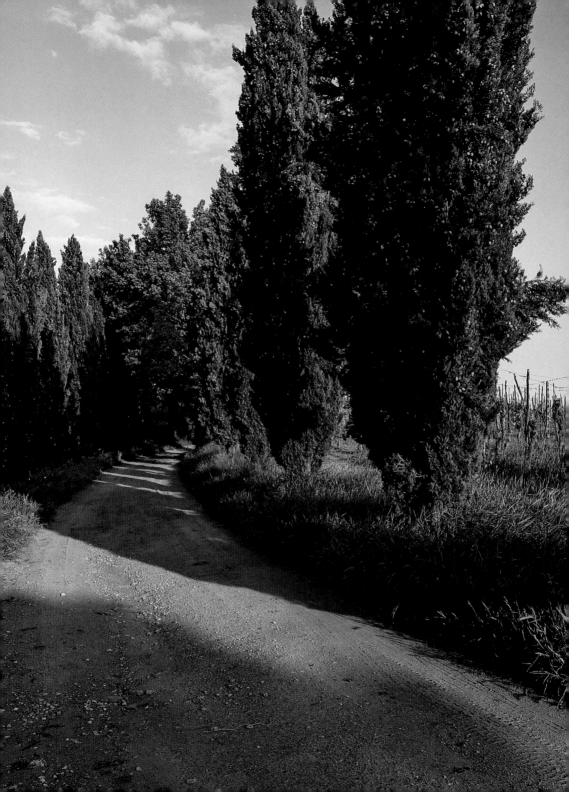

PP. 296–297 The village of Certano
is set among green hills extending as
far as the eye can see, and on a clear
day there is a breathtaking view of the
distant towers of Sienna. The Belvedere
certainly lives up to its name! • Die Ort-
schaft Certano liegt eingebettet zwi-
schen grünen Hügeln, die sich bis ins
Unendliche auszudehnen scheinen. An
klaren Tagen kann man ein atemberau-
bendes Panorama genießen und in der
Ferne die Türme von Siena erkennen.
Il Belvedere trägt seinen Namen zu
Recht! • La campagne qui entoure le
village de Certano se compose de
collines verdoyantes qui s'étendent
à perte de vue et par une journée claire
ils offrent un panorama époustouflant
sur les tours lointaines de Sienne. Le
Belvédère est bien digne de son nom!

P. 299 A cypress avenue leads up to
Il Belvedere. • Die Zypressenallee führt
zu Il Belvedere. • Une allée de cyprès
conduit au Belvedere.

→ The kitchen table, loaded with
cheeses and a fine fresh bunch of basil. •
Eine reichhaltige Käseplatte und frisches
Basilikum auf dem Küchentisch. • Sur
la table de la cuisine, un plateau de
fromages et le basilic odorant mettent
en appétit.

← There is nothing ostentatious in the decor of the living room. The white-washed walls, woven baskets and opaline lamp are quite sufficient to create an atmosphere of comfort. • Einfach und schlicht: Weiß gekälkte Wände, geflochtene Körbe und eine Milchglaslampe schaffen eine behagliche Atmosphäre. • Rien d'ostentatoire dans la décoration du séjour. Les murs blanchis à la chaux, les paniers d'osier et la lampe en opaline suffisent à créer une ambiance douillette.

↑ Detail of a wrought-iron rail. •
Detail eines schmiedeeisernen
Treppengeländers. • Détail d'une
rampe en fer forgé.

→ In the bedroom a solid country bed
with a mosquito net takes up nearly the
whole room. The 18th-century chair

was brought from Ireland. • Das Bau-
ernbett mit Moskitonetz nimmt fast das
ganze Schlafzimmer ein. Der Stuhl aus
dem 18. Jahrhundert ist ein Mitbringsel
aus Irland. • Dans la chambre à cou-
cher, un solide lit campagnard couronné
d'une moustiquaire prend toute la place.
La chaise 18ᵉ vient d'Irlande.

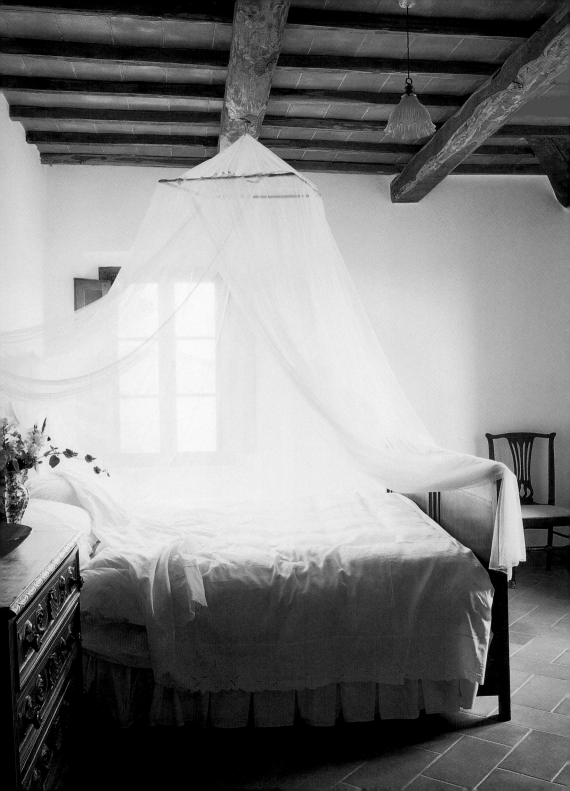

PODERE TAVOLETO

PODERE TAVOLETO
BUONCONVENTO

They moved into the big farmhouse of Podere Tavoleto in the early Forties and they've stayed there ever since: nine members of the same family, all real *contadini*. Podere dates from the end of the 19th century. It is a square brick construction boasting a fine three-arched loggia, with outbuildings, piggeries, stables and vineyards beyond. Observing this united, patiently hardworking family going about their daily existence amid these surroundings, it is hard to avoid the conclusion that time has come to a dead halt at Podere Tavoleto. In the kitchen, *la mamma* is peeling potatoes, while keeping a careful eye on the *passata di pomodoro*, tomato sauce, simmering on the venerable wood-fired range. Out on the porch the imperturbable aunt shells her way through a mountain of broad beans.

Anfang der 1940er-Jahre zog die Bauernfamilie auf das große Gut Podere Tavoleto. Als echte „contadini" sind die neun Familienmitglieder in ihrer Heimat tief verwurzelt. Das „podere", das Landgut, stammt vom Ende des 19. Jahrhunderts und besteht aus einem quaderförmigen, aus Ziegelsteinen errichteten Haupthaus, das mit einer Loggia mit drei Bögen geschmückt ist, sowie den Nebengebäuden, den Ställen, dem „porcile", dem Schweinstall, und natürlich den Weinbergen. Wenn man die ganze Familie Hand in Hand arbeiten sieht, hat man den Eindruck, die Zeit sei stehengeblieben. Die „mamma" schält in der Küche Kartoffeln. Die unerschütterliche „zia", die Tante, schnippelt draußen einen Berg Bohnen.

Ils s'installèrent dans la grande ferme du Podere Tavoleto à l'aube des années 1940 et ils y sont restés : neuf membres de la même famille, des «contadini» authentiques, ancrés à leur terre natale, que passionne la lutte parfois inégale entre l'homme et la nature. Le «podere» date de la fin du 19ᵉ siècle. Autour d'une construction carrée en briques, ornée d'une loggia embellie par trois arches, on aperçoit les dépendances, la porcherie, les étables et les vignobles et, en regardant vivre cette famille unie et laborieuse, on a l'impression que le temps s'est arrêté. La «mamma» épluche les pommes de terre dans la cuisine, promenant un œil vigilant sur la «passata di pomodoro» qui mijote sur l'ancienne cuisinière à bois, la «zia», la tante imperturbable, trie une montagne de fèves sous le porche.

PP. 306-307 The grape harvest will begin any day now, and at Podere Tavoleto preparations for the *festa dell'uva* are already well in hand. • Die Zeit der Weinernte naht und auf Podere Tavoleto freut man sich auf die „festa dell'uva" ... • La saison des vendanges approche et avec elle la « festa dell'uva » ...

P. 309 A rooster moulded out of cement stands in the centre of the farmyard. • Ein stolzer Hahn aus Zement bewacht den Hof. • Un coq en ciment garde la basse-cour.

← The pigs particularly relish a feed of pumpkins. • Der Bauer hat Kürbisse für die Schweine gebracht. • Le fermier a apporté des citrouilles et les porcs se régalent.

↑ The elder sister sifts patiently through a pile of cannellini beans which will later be used for succulent *fagioli all'uccelletto*. • Die älteste Schwester putzt geduldig die Bohnen, aus denen die köstlichen „fagioli all'uccelletto" zubereitet werden. • La sœur aînée trie patiemment les « cannellini », des haricots, qui serviront à préparer les succulents « fagioli all'uccelletto ».

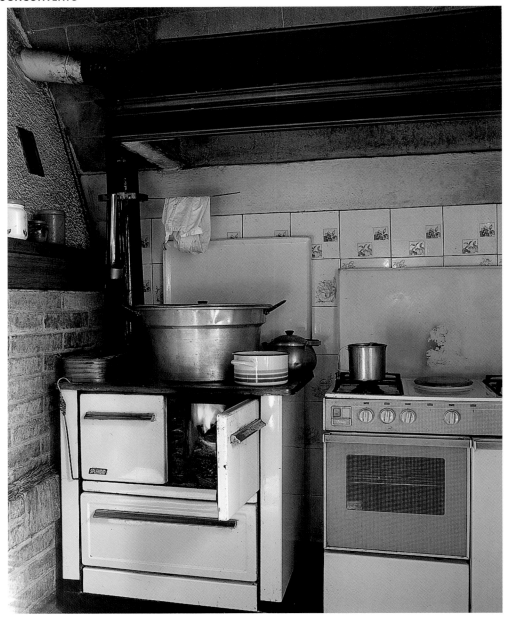

↑ A large pot filled with *pappa al pomodoro* simmers on the old wood stove, filling the kitchen with delicious smells. • Ein randvoll gefüllter Topf mit „pappa al pomodoro" köchelt auf dem alten Kohleherd und verströmt einen köstlichen Duft. • Une grande casserole remplie de purée de tomates cuit à petit feu, et son odeur met l'eau à la bouche.

→ La Mamma has decreed that today the family will dine on gnocchi. • Die „mamma" hat beschlossen, dass es heute „gnocchi" gibt. • La « mamma » a décidé que sa famille mangerait des « gnocchi » aujourd'hui.

VILLA BELSEDERE

VILLA BELSEDERE

SILVIA AND VENCESLAO DE'GORI PANNILINI
BELSEDERE

To spend a day with the De'Gori Pannilini family is an unforgettable experience. Their house, the Villa Belsedere, is, quite simply, a most enchanting place. As its "well-seated" name suggests, the villa occupies a unique site on the top of a hill dominating the broad, bare panorama of the Sienese Crete. Ada, the doyenne of the family, has spent her entire life in this magical place, with its interiors that seem to have sprung whole and entire from a film by Visconti. You can understand why some of the world's greatest film makers wanted to use the villa as a set. The bedroom with its brass bed and embroidered curtains is perfect for the heroine of a tale by Gabriele d'Annunzio; the same goes for the magnificent dining room and the succession of adjoining rooms. Furthermore, the moment when the family assembles in the kitchen to sample the succulent *finocchiona* (the typical Sienese fennel sausage) and the pecorino cheeses they make in their own creamery, has all the picturesque charm of a *tableau vivant*.

Ein Tag im Kreis der Familie De'Gori Pannilini ist ein unvergessliches Erlebnis, denn die Villa Belsedere besitzt einen ganz besonderen Charme. Wie ihr Name schon andeutet, liegt das Haus besonders schön auf einem Hügel und überragt die weite, karge Landschaft der sienesischen Crete. Familienoberhaupt Ada hat ihr ganzes langes Leben an diesem magischen Ort verbracht. Das Schlafzimmer, mit Messingbett und bestickten Vorhängen, wäre die perfekte Umgebung für eine Heldin aus einem Roman von Gabriele d'Annunzio. Gleiches gilt für das geräumige Esszimmer und die Flucht der zahlreichen angrenzenden Salons. Sogar der Anblick, wenn sich die Familie in der Küche versammelt, um die köstliche „finocchiona", eine mit Fenchel gewürzte Wurst, oder den selbst hergestellten Pecorino zu probieren, lässt an eine poetische Filmszene denken.

Passer une journée au sein de la famille De'Gori Pannilini est une expérience inoubliable car leur décor quotidien, la villa Belsedere, possède un charme incomparable. Comme le suggère son nom, « la bien-assise » se dresse sur un site exceptionnel, et du haut de sa colline elle domine le vaste paysage dépouillé des « crete senesi ». Ada, la doyenne de la famille, a passé toute sa longue vie ; dans ces intérieurs qui semblent sortis tout droit d'un film de Visconti, et on comprend pourquoi les plus grands cinéastes du monde se battent pour tourner dans la villa. La chambre à coucher avec son lit en cuivre et ses rideaux brodés leur semble idéale pour héberger l'héroïne d'un roman de Gabriele D'Annunzio, et il en va de même pour la splendide salle à manger et les salons en enfilade. D'ailleurs, le moment où la famille se réunit dans la cuisine pour goûter à la succulente « finocchiona », le saucisson au fenouil typiquement siennois, et au pecorino qu'ils fabriquent dans leur propre ferme, possède tout le charme pittoresque d'un tableau vivant.

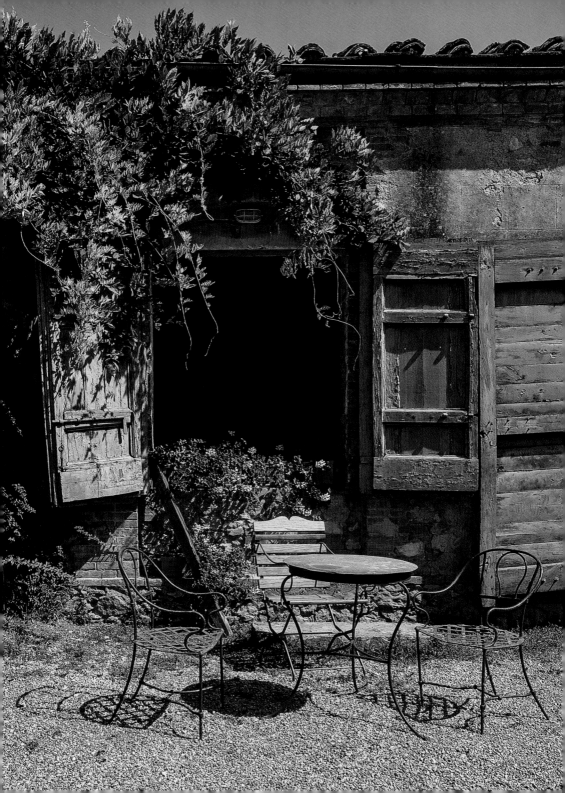

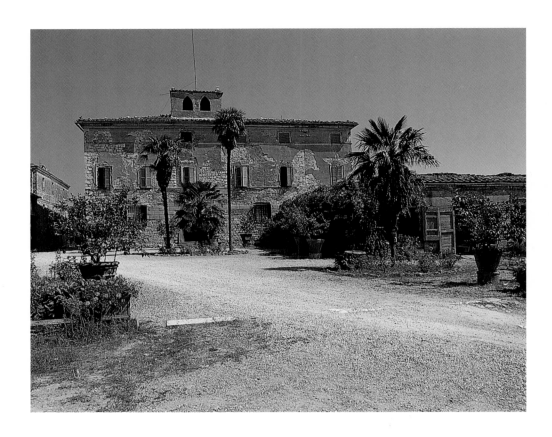

PP. 314–315 In Tuscany, shutters with flaking paint are almost a badge of nobility! • Fensterläden mit abblätternder Farbe gelten in der Toskana fast so viel wie ein Adelsprädikat! • En Toscane, avoir des volets à la peinture écaillée, c'est presque un titre de noblesse!

P. 317 One of the barns has been converted into a *gîte*. The old door and shutters have been painted blue, while the wrought-iron garden furniture adds to the relaxed atmosphere of this romantic

little spot. • Eine der Scheunen wurde zu einer Ferienunterkunft umgebaut. Die Tür und die alten Fensterläden wurden blau gestrichen, und die schmiedeeisernen Gartenmöbel vervollständigen die lockere Atmosphäre dieses romantischen Rückzugsorts. • Une des granges a été transformée en gîte. La porte et les volets anciens ont été peint en bleu et le mobilier de jardin en fer forgé complète l'ambiance décontractée de ce petit coin romantique.

↑ The Villa Belsedere was built according to the classical rules of Tuscan architecture. • Die Villa Belsedere wurde nach den klassischen Regeln der toskanischen Architektur errichtet. • La Villa Belsedere a été construite selon les règles classiques de l'architecture toscane.

→ A typical Tuscan still life ... • Ein typisch toskanisches Stillleben ... • Une nature morte typiquement toscane ...

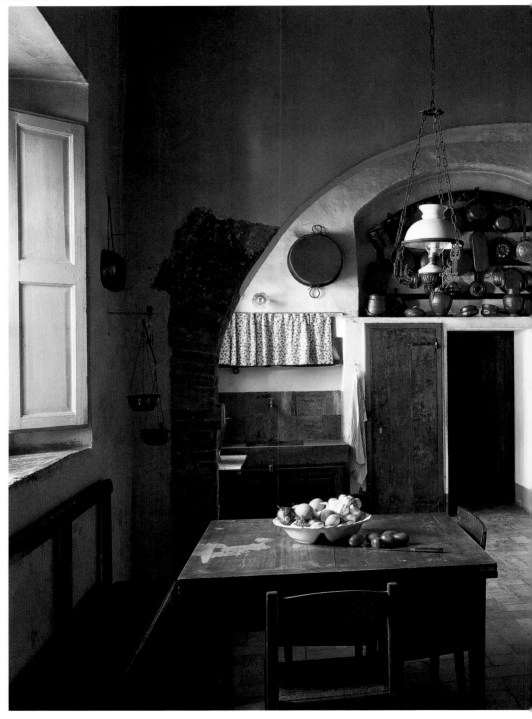

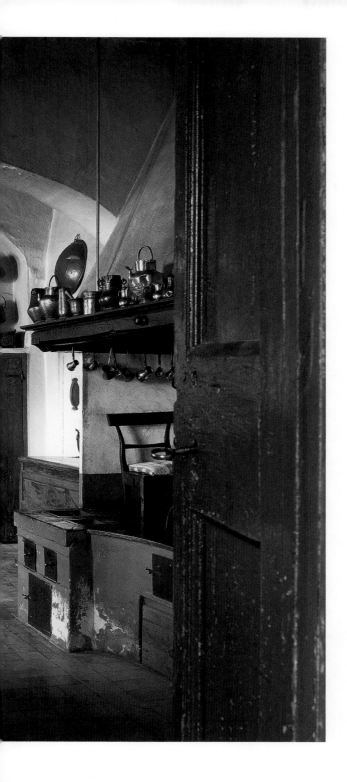

← Everything has been jealously
preserved in the old vaulted kitchen:
the ovens, the rustic furniture, the
copper utensils and even the patina on
the walls. · In der Küche mit dem alten
Gewölbe sind alle Gegenstände origi-
nal: die Öfen, die soliden Möbel, die
Kupfergerätschaften und die schöne
Patina an den Wänden! · Tout a été
jalousement préservé dans l'ancienne
cuisine voûtée : les fourneaux, le mobi-
lier rustique, les ustensiles en cuivre et
les murs joliment patinés !

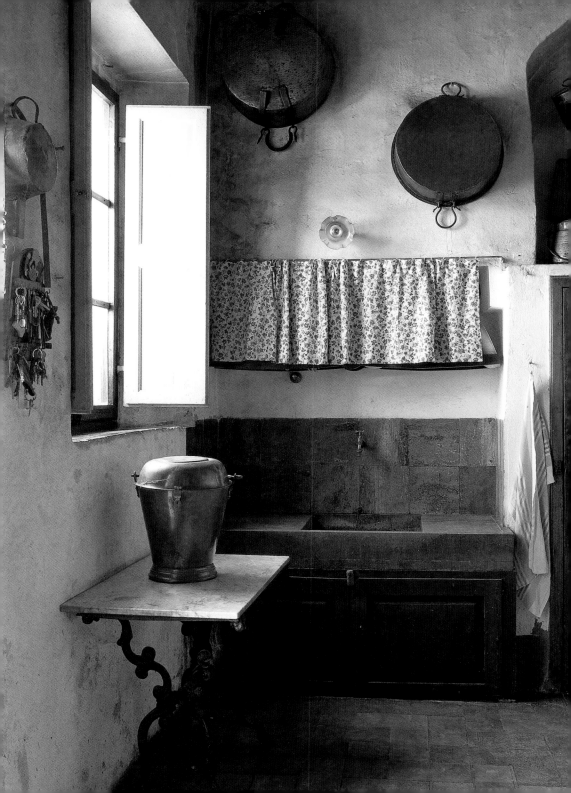

P. 322 In the kitchen, even the sink has remained the same for two centuries. • In der Küche ist selbst das Spülbecken seit fast zwei Jahrhunderten in Gebrauch. • Dans la cuisine, même l'évier n'a pas changé d'aspect depuis près de deux siècles.

P. 323 Everything in the villa has echoes of the past. The electrical fittings date from an era when electricity itself was a novelty. • Die Elektroinstallation stammt noch aus der Zeit, als der Strom gerade seinen Einzug in die Wohnungen nahm. • Même l'installation électrique date d'une époque où la fée Electricité venait de faire son entrée dans le monde.

↑ Family portraits surround a splendid Empire desk, an important piece by an unknown Tuscan cabinetmaker. • Familienporträts umrahmen einen prächtigen Empire-Sekretär, ein Meisterwerk eines unbekannten toskanischen Kunsttischlers. • Des portraits de famille entourent un splendide secrétaire Empire, œuvre majeure d'un ébéniste toscan inconnu.

→ The wallpaper in the antechamber dates from the 19th century, but the embroidery on the sofa is the work of Ada, the 88-year-old grandmother. • Die Tapete im Vorzimmer stammt aus dem 19. Jahrhundert, aber die Stickerei auf der Couch ist das Werk von Ada, der 88-jährigen Großmutter. • Le papier peint de l'antichambre date du 19ᵉ siècle, mais la broderie sur le canapé est l'œuvre d'Ada, la grand-mère octogénaire.

←↑ In this late-19th-century bedroom
with its fine wrought-iron and brass bed,
the atmosphere is vintage D'Annunzio. •
Ein Schlafzimmer wie im späten 19. Jahr-
hundert, mit einem schönen Bett aus
Schmiedeeisen und Messing. Es könnte
einem Roman von d'Annunzio entstam-
men. • Dans cette chambre à coucher
fin de siècle, avec son beau lit en cuivre
et fer forgé, règne une ambiance nostal-
gique à la D'Annunzio.

EREMO
SANTA MARIA
MADDALENA

EREMO SANTA MARIA MADDALENA
VALENTINA BONOMO
APPENNINO UMBRO-TOSCANO

Michelangelo is said to have come to Eremo Santa Maria Maddalena near Arezzo in 1556 to escape the wrath of the Pope, but the reason why Valentina's parents, the late Marilena and Lorenzo Bonomo bought this mediaeval hermitage on its steep hillside had nothing to do with the celebrated painter. The Bonomos are passionate lovers of contemporary art; in opening a gallery in Bari, Puglia, in 1971 they showed courage and foresight, given that the minimalist artists they revealed to the public in those early days had not yet achieved the international fame they presently enjoy. From the start Lorenzo, his wife Marilena and their daughters Alessandra, Gogo and Valentina were unstintingly generous and hospitable to their stable of unknown talents. The artists have left traces of their passage in the form of graffiti, drawings, texts and mural paintings, so that today the hermitage has itself become a three-dimensional work of art. There are a number of austere pieces dating from the Middle Ages and the Renaissance which complement the modern art to perfection.

Angeblich hat Michelangelo 1556 vor dem Zorn des Papstes in der ehemaligen Einsiedelei bei Arezzo Schutz gesucht. Doch als sich Valentinas Eltern Marilena und Lorenzo Bonomo entschlossen, das mittelalterliche Gebäude zu kaufen, hatte dies nichts mit dem Aufenthalt des berühmten Künstlers zu tun. Die Bonomos hegen eine Vorliebe für zeitgenössische Kunst, und sie bewiesen Weitblick und ungewöhnlichen Mut, als sie 1973 in Bari in Apulien eine Galerie eröffneten. Denn damals verfügten die Künstler der Minimal Art, die sie dem Publikum vorstellen, noch nicht über das heutige internationale Renommee. Großherzig und gastfreundlich boten Lorenzo, Marilena und ihre Töchter Alessandra, Gogo und Valentina unbekannten Talenten Unterkunft. Die Künstler hinterließen Spuren in Form von Graffiti, Zeichnungen, Texten und Wandmalereien, sodass das entlegene Haus heute selbst zu einem dreidimensionalen Kunstwerk geworden ist. In Kombination mit einigen nüchtern-strengen Möbeln aus dem Mittelalter und der Renaissance entstand ein Rahmen, in dem die Kunstwerke voll zur Geltung kommen.

On rapporte que Michel-Ange se cacha ici en 1556 pour échapper à la fureur du pape, mais la raison pour laquelle les parents de Valentina, Feu Marilena et Lorenzo Bonomo achetèrent cet ermitage médiéval aux alentours d'Arezzo, n'a rien à voir avec le séjour supposé du célèbre génie. Les Bonomo éprouvent une véritable passion pour l'art contemporain et en ouvrant une galerie à Bari dans les Pouilles en 1971, ils ont fait preuve d'une perspicacité et d'un courage hors du commun, car les artistes minimalistes qu'ils présentèrent alors au public n'avaient pas encore la renommée internationale qu'on leur connaît aujourd'hui. Lorenzo, Marilena et leurs filles Alessandra, Gogo et Valentina offrirent l'hospitalité à leur «écurie» de talents inconnus. Les artistes ont laissé ici des traces de leur passage sous forme de graffiti, de dessins, de textes et de peintures murales. Grâce à celles-ci, l'ermitage est devenu une œuvre d'art en trois dimensions. Des meubles sobres et sévères datant du Moyen Age et de la Renaissance accentuent on ne saurait mieux l'importance des œuvres d'art.

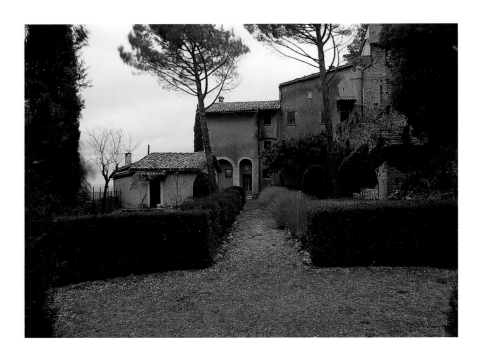

PP. 328-329 The façade of the former hermitage is distempered with a yellow-ochre wash made from natural pigments. • Die Fassade der ehemaligen Einsiedelei wurde mit ockergelber Farbe mit natürlichen Pigmenten gestrichen. • La façade de l'ancien ermitage a été badigeonnée avec un lavis ocre à base de pigments naturels.

P. 331 A Victorian armchair and rustic furniture in the front hall. • Ein viktorianischer Sessel und rustikale Möbel im Eingangsflur. • Un fauteuil victorien et les meubles rustiques dans l'entrée.

↑ The former mediaeval cloister, which backs on to a wooded hillside, is surrounded by a beautiful formal garden. • Der mittelalterliche Kreuzgang schmiegt sich an einen bewaldeten Hügel. • L'ancien cloître médiéval, adossé au flanc d'une colline boisée, est entouré d'un très beau jardin formel.

→ In the kitchen, with its sturdy rustic chairs and table, the works of art on the mantelpiece carry the signatures of Alighiero Boetti, Joel Fisher and Sol LeWitt. The red cat on the right was painted by Eva LeWitt, Sol's daughter,

as a child. • Die Kunstwerke auf dem Kaminsims in der ländlichen Küche stammen von Alighiero Boetti, Joel Fisher und Sol LeWitt. Die rote Katze rechts ist eine Kinderzeichnung von LeWitts Tochter Eva. • Dans la cuisine équipée de solides meuble campagnards, les œuvres d'art sur la tablette de la cheminée sont signées Alighiero Boetti, Joel Fisher and Sol LeWitt. Le chat rouge, à droite, est une œuvre de jeunesse d'Eva, la fille de Sol LeWitt.

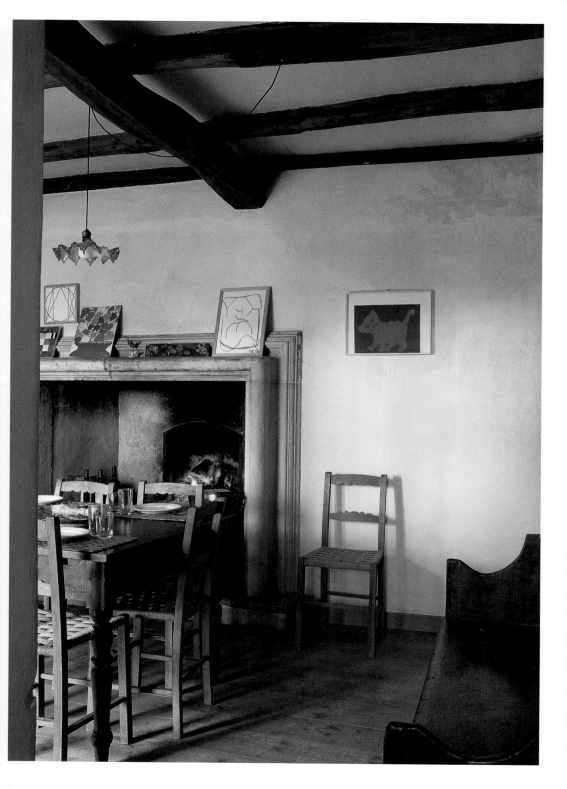

← The very sparsely furnished dining room inspired Mel Bochner to embellish the walls with the minimalist mural *Theory of Vision*. The rustic furniture dates from the Renaissance. • Die Kargheit des Esszimmers inspirierte Mel Bochner zu der minimalistischen Wandmalerei „Theory of Vision". Die rustikalen Möbel stammen aus der Renaissance. • L'aspect dépouillé de la salle à manger a incité Mel Bochner à décorer les parois de la peinture minimaliste « Theory of Vision». Le mobilier rustique date de la Renaissance.

↑ In 1971, Sol LeWitt decorated the wall on one of the landings with a pencil wall-drawing of a network of "Circles from the Center". • Sol LeWitt zeichnete 1971 sein Werk „Circles from the Center" auf die Wand eines Treppenabsatzes. • En 1971, Sol LeWitt décora le mur du fond d'un des paliers en dessinant son œuvre « Circles from the Center ».

↑ Painted cherubs stand guard over the sleeping inhabitants of this spartan bedroom. The rocaille looking glass dates from the 18th century. • In diesem schlichten Schlafzimmer wachen auf Leinwand gemalte Engel über den Schlaf der Bewohner. Der Rocaillen-spiegel stammt aus dem 18. Jahrhun-

dert. • Dans cette sobre chambre à coucher, des angelots peints sur tôle veillent sur le sommeil des habitants. Le miroir rocaille est du 18ᵉ.

→ The bathroom is built into a hollow of the rock against which the Eremo Santa Maria Maddalena is built. • Das Bade-

zimmer wurde in die Felswand gehauen, an die sich Eremo Santa Maria Madda-lena stützt. • La salle de bains est nichée dans la roche qui sert d'appui à l'Eremo Santa Maria Maddalena.

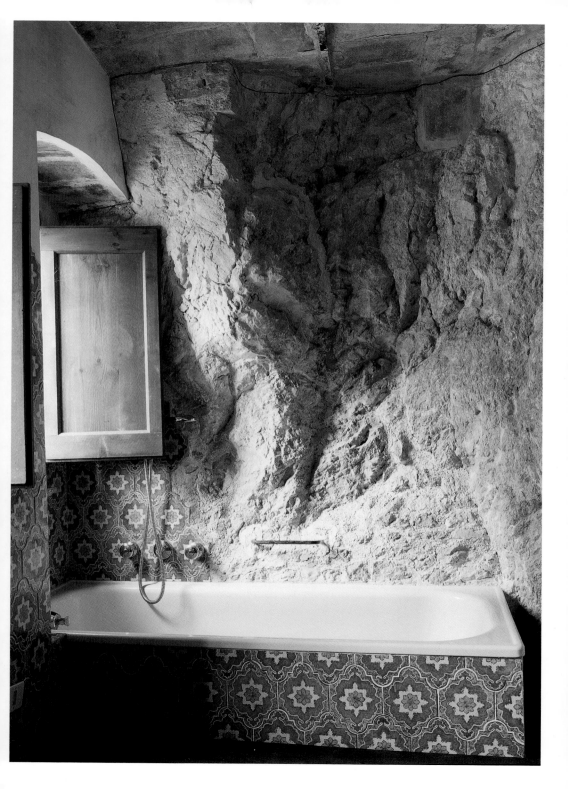

TORRE NUOVA

TORRE NUOVA
SAN VINCENZO

Torre Nuova, an old fortified tower on the shores of the Tyrrhenian Sea, was constructed in the 18th century to replace an even older building which had fallen into ruin. Thereafter it served as a lodging for the soldiers of the garrison of the Gran Ducato di Toscana, and was later converted into a *casa colonica* for the use of *contadini* and their animals. The descendants of the family that bought Torre Nuova at the beginning of the 19th century – and who regularly stay there – still remember the old farmers who once occupied the crumbling buildings. Restored and refurnished the "new" tower is the very image of simplicity. There are whitewashed walls and a huge salon with a great vault and robust furniture, features which reflect the personality of the tower's warm-hearted occupants, who are great lovers of music, the arts and food. In summer the inhabitants dine on melon and prosciutto washed down with a good local wine, and they sleep in solid country-made beds with mosquito nets spread over them. Outside is the intensely blue sea – blue as the sky, and blue as the parasol stuck in the sand. How it beckons.

Der Befestigungsturm Torre Nuova wurde im 18. Jahrhundert anstelle einer verfallenen Befestigung direkt an der Küste des Tyrrhenischen Meeres errichtet und diente den Soldaten der Garnison Gran Ducato di Toscana als Quartier. Später wurde der Turm in eine „casa colonica" – ein typisch toskanisches Bauernhaus – umgebaut. Die Nachkommen der Familie, die Torre Nuova Anfang des 19. Jahrhunderts erwarb, kamen häufig hierher und erinnern sich noch an die alten Bauern, die zuletzt in dem verfallenen Gebäude lebten. Seit knapp zwei Jahren restauriert und neu möbliert, steht der „neue Turm" nun für schlichte Schönheit – mit weiß gekalkten Wänden und dem großzügigen Salon, den ein großer Bogen und massive Möbel zieren. Das Ambiente spiegelt die Persönlichkeit der warmherzigen Bewohner, ihre Begeisterung für Musik, Kunst und ... gutes Essen! Im Sommer gibt es „prosciutto e melone", Melone mit Schinken, dazu ein Gläschen Landwein. Geschlafen wird in Bauernbetten mit Moskitonetzen. Draußen schimmert das Meer in einem intensiven Blau ... so blau wie der Himmel und wie der Sonnenschirm, der, in den Sand gesteckt, zum „dolce far niente" einlädt.

Torre Nuova, une tour fortifiée à deux pas de la mer Tyrrhénienne, a été construite au 18e siècle. Elle remplaçait une tour plus ancienne tombée en ruine et devait servir de logis aux soldats de la garnison du Gran Ducato di Toscana. Plus tard, transformée en «casa colonica», elle hébergea les «contadini» et leurs animaux, et les descendants de la famille qui acheta Torre Nuova au début du 19e siècle se souviennent encore des vieux fermiers qui occupaient les lieux délabrés. Restaurée et remeublée la «nouvelle tour» est l'image même de la simplicité. Ses murs blanchis à la chaux et son vaste salon orné d'une grande arche et d'un mobilier robuste reflètent la personnalité de ses occupants chaleureux, grands amateurs de musique, d'art et ... des plaisirs de la table! On dîne de melon parfumé et juteux, d'une belle tranche de «prosciutto» et d'un petit vin de pays, et on dort à poings fermés dans de solides lits campagnards équipés d'une moustiquaire. Dehors, il y a la mer d'un bleu intense ... Bleue comme le ciel et comme le parasol planté dans le sable et qui invite au «dolce far niente».

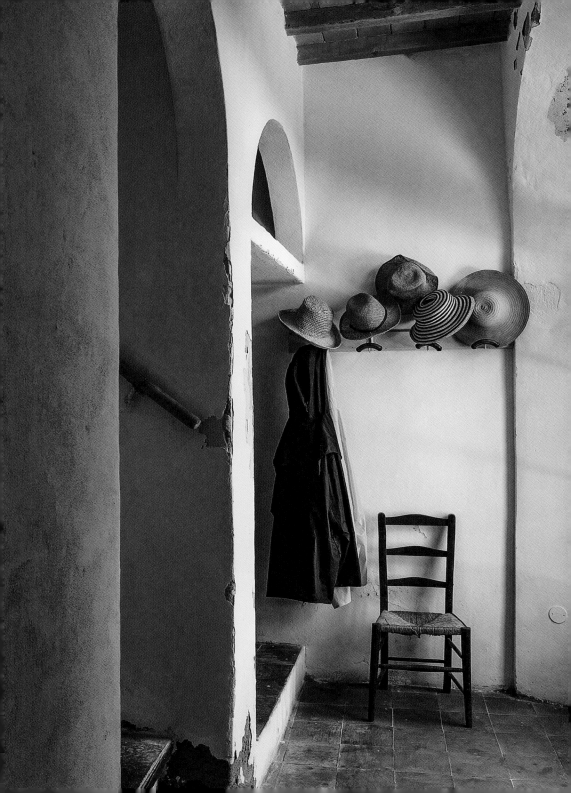

PP. 338–339 A private beach, a comfortable cast-iron bench and a parasol the same colour as the sea and the sky. Who could want more? • Ein Privatstrand, eine einladende gusseiserne Bank und ein Sonnenschirm, in dem sich die Farbe von Meer und Himmel wiederholen. Was braucht man mehr, um glücklich zu sein? • Une plage privée, un joli banc en fonte et un parasol couleur de mer et de ciel ... en faut-il plus pour être heureux ?

P. 341 The coat rack beside the front door, with its burden of straw hats, makes a charming still life. • Die Garderobe im Eingangsbereich mit Strohhüten und Ölzeug. • Près de la porte d'entrée, un portemanteau chargé de chapeaux de paille et de cirés forme une jolie nature morte.

↑ Stones found on the beach fill a blue earthenware goblet. • Kieselsteine vom Strand in einer blau glasierten Schale. •

Des galets trouvés sur la plage dans une coupe en faïence bleue.

→ The inhabitants preferred to retain the dilapidated look of the walls, which are covered in rough stucco. • Die Bewohner haben die unregelmäßige und stellenweise angegriffene Struktur der Wände bewusst erhalten. • Les habitants ont préféré garder l'aspect délabré de ces murs couverts d'un stuc irrégulier.

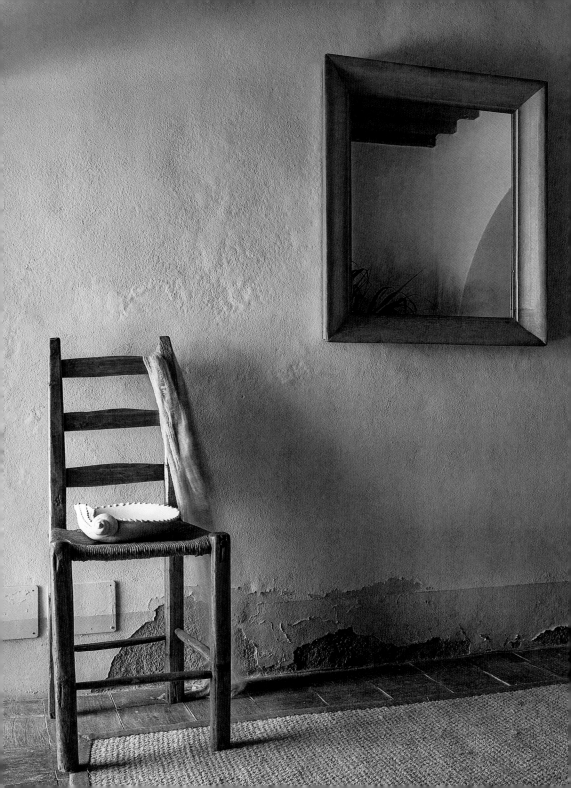

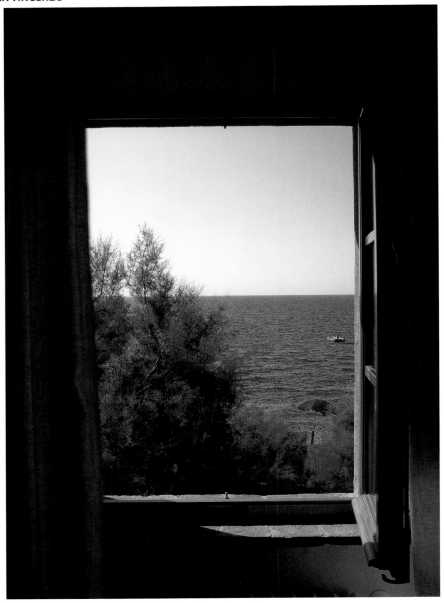

↑ *Sur la plage ensoleillée* is much more than the title of a popular French ditty. At Torre Nuova, these few words express the reality of life. • „Am sonnigen Strand" lautet der Titel eines bekannten französischen Chansons. In Torre Nuova sind diese Worte Realität geworden. •

« Sur la plage ensoleillée » est bien plus que le titre d'une chanson populaire : à Torre Nuova ces quelques mots sont devenus réalité.

→ Bliss in the absolute: a good book, and a good drink, beside a window that overlooks the sea. • Der Höhepunkt der Muße: mit einem guten Buch und einem Glas Wein an einem Fenster mit Meerblick zu sitzen. • Le sommet du bien-être : un bon livre et un bon verre près d'une fenêtre qui donne sur la mer.

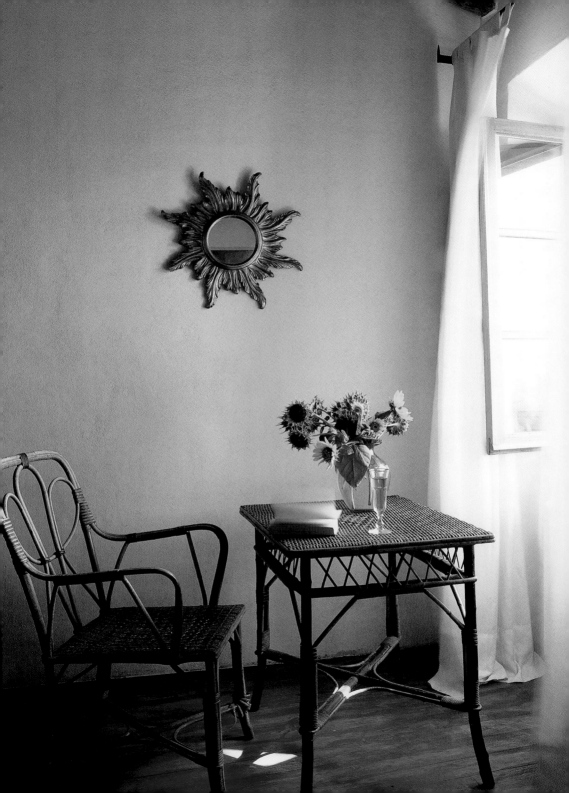

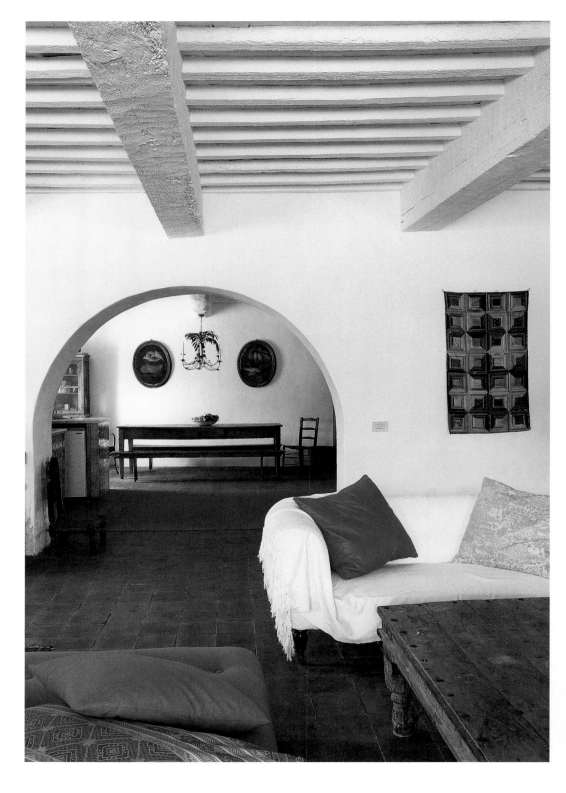

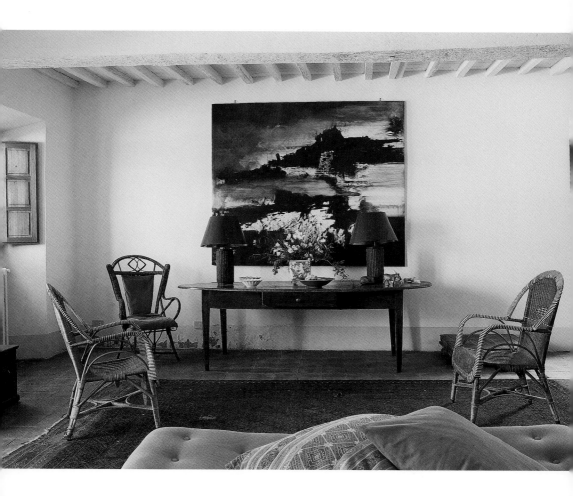

← In the former stables, where cows once lined the muddy walls, the owners have created a serenely beautiful living room. • Im ehemaligen Stall, in dem sich früher die Kühe aneinander drängten, haben sich die Bewohner ein heiteres Wohnzimmer geschaffen. • Dans l'ancienne étable, là où les vaches s'alignaient le long des murs boueux, les habitants ont créé un séjour d'une beauté sereine.

↑ The whitewashed walls accentuate the sober feel of the rattan furniture. The contemporary painting is by a friend of the family. • Die weiß gekalkten Wände sind der perfekte Hintergrund für die schlichten Korbmöbel und das Gemälde, das Werk einer guten Freundin. • Les murs blanchis à la chaux font ressortir la sobriété raffinée des meubles en rotin et d'un tableau contemporain qui porte la signature d'une amie.

PP. 348–349 Beneath a pair of 17th-century still lifes and a wrought iron chandelier, a long refectory table and matching benches form an ideal dining area within the huge living room. Today the menu consists of mozzarella, prosciutto ham and ripe melons. • Unter zwei Stillleben aus dem 17. Jahr-

hundert und einem schmiedeeisernen Kronleuchter werden die gemeinsamen Mahlzeiten an dem langen Refektoriumstisch mit den Bänken eingenommen. Heute stehen Mozzarella sowie „prosciutto e melone" auf dem Speiseplan. • Sous une paire de natures mortes 17ᵉ et d'un chandelier en fer forgé, une longue table de réfectoire et des bancs assortis forment un coin repas idéal dans le vaste séjour. Au menu aujourd'hui : mozzarella, jambon et melon !

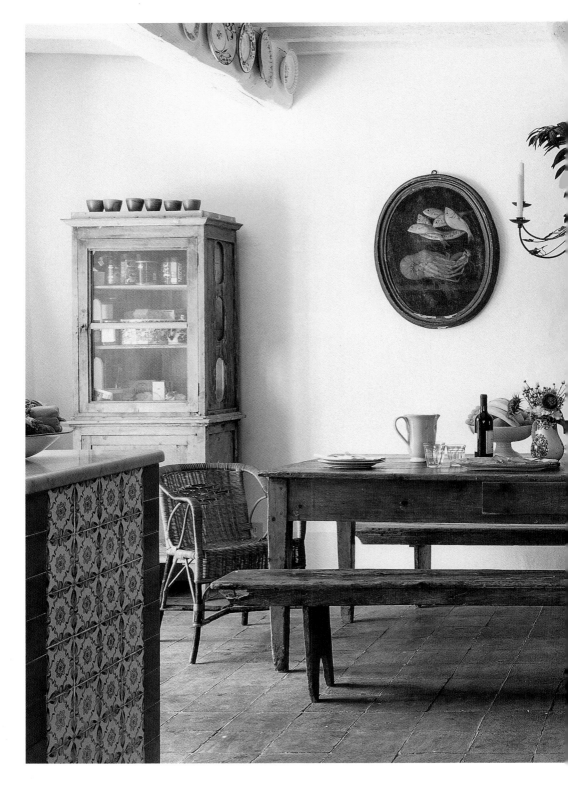

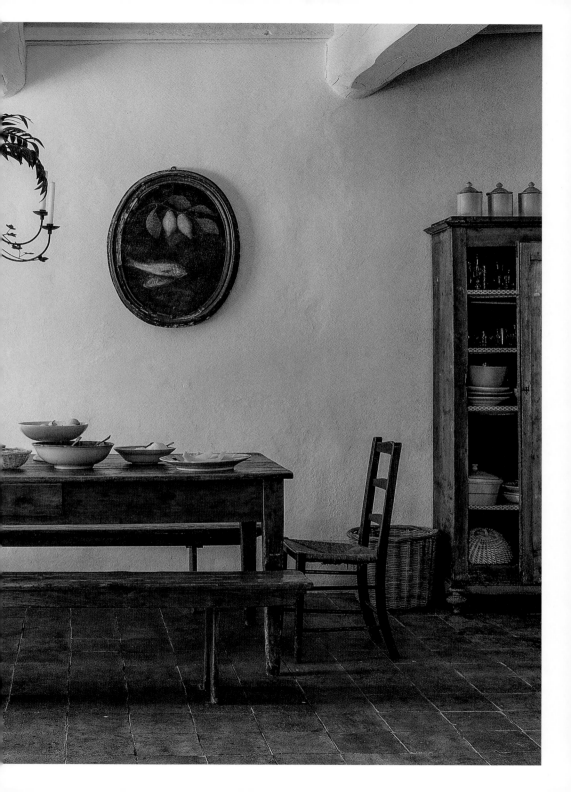

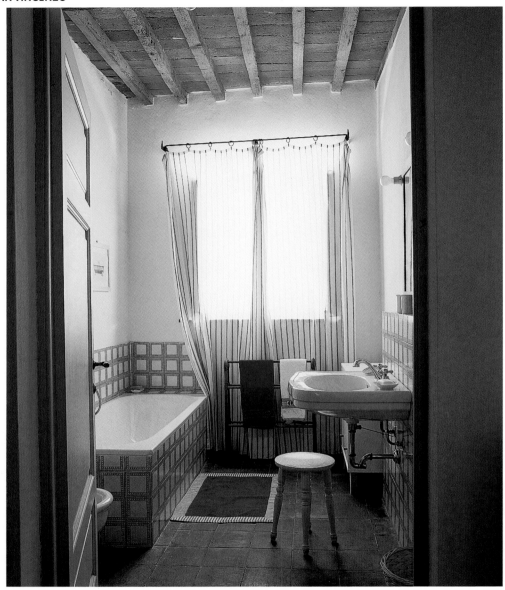

↑ A blue and white bathroom, cool and pleasant. • Wie frisch ein Badezimmer in Blau und Weiß wirkt ... • Une salle de bains bleue et blanche, une fraîcheur agréable ...

→ It is good to rest under the mosquito net, with the windows wide open, in this grand old mahogany bed. • In diesem alten Mahagonibett mit Moskitonetz lässt es sich bei offenem Fenster wunderbar schlafen. • Il fait bon dormir, fenêtres ouvertes, dans ce vieux lit en acajou sous une moustiquaire.

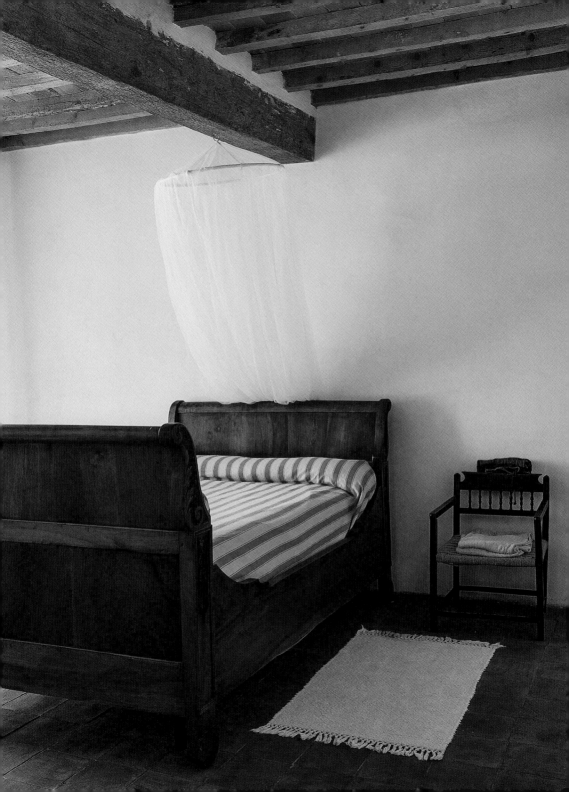

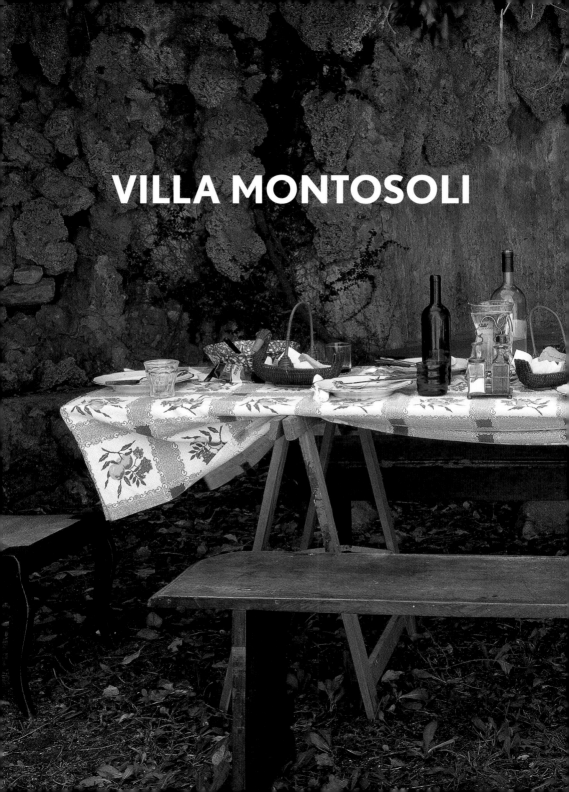

VILLA MONTOSOLI

VILLA MONTOSOLI

GIOVANNA LEONINI CARRATELLI
MONTALCINO

The Villa Montosoli is truly majestic, but since it is hidden behind a wall at the end of an avenue of laurels, few outsiders ever glimpse its façade or its tall glassed-in loggia. The villa stands on the site of a former *castello*; it was built for the Tuti family in 1535 by the celebrated architect Baldassare Peruzzi, and for the last forty years it has been the home of the Leonini family. What makes the Leoninis' interior so nice is their nonchalant habit of combining very valuable furniture and pictures with the ordinary flotsam of daily life. They don't stand on ceremony. In the *salotto*, which is decorated with neoclassical frescoes, they, their cats and their friends keep company without a trace of formality, and when Giovanna has set the table in the small, shady court yard and is ready to serve her celebrate *zuppa de pane*, bread soup, the Villa Montosoli fills with a sense of gaiety that is palpably Renaissance.

Majestätisch wirkt sie, die Villa Montosoli, aber da sie sich hinter einer Mauer am Ende einer lorbeergesäumten Allee verbirgt, bleibt die prächtige Fassade mit der verglasten hohen Loggia den Passanten verborgen. 1535 wurde die Villa von dem berühmten Architekten Baldassare Peruzzi für die Familie Tuti an der Stelle eines alten Castello errichtet. Der Antiquitätenhändler Giorgio Leonini und seine Frau Carla, eine sehr begabte Gemälderestauratorin, wohnen seit vierzig Jahren hier, und in dieser Zeit hat die Villa die Geburt von drei Töchtern miterlebt. Besonders sympathisch wirkt das Ambiente durch die unbekümmert-nonchalante Mischung aus wertvollen Möbeln und Gemälden sowie der typisch-chaotischen Unordnung, die im Alltag entsteht. Bei den Leoninis geht es nicht förmlich zu. Im „salotto" mit den klassizistischen Fresken muss keine Etikette beachtet werden, denn die Bewohner, die Katzen und die Freunde legen darauf keinen Wert. Und trotzdem: Wenn Giovanna den Tisch in dem kleinen schattigen Innenhof deckt und die berühmte Brotsuppe „zuppa di pane" serviert, verbreitet sich in der Villa Montosoli wie zur Zeit der Renaissance eine festliche Stimmung.

La Villa Montosoli est vraiment majestueuse, mais comme elle est cachée derrière un mur au bout d'une allée bordée de lauriers, elle ne révèle pas le spectacle de sa façade, ornée d'une haute loggia vitrée, aux passants en quête de beauté. L'antiquaire Giorgio Leonini et sa femme Carla, qui restaure avec talent les tableaux anciens, La famille Leonini habite depuis une quarantaine d'années cette maison construite en 1535 sur l'emplacement d'un ancien castello par le célèbre architecte Baldassare Peruzzi pour la famille Tuti. Ce qui rend l'intérieur des Leonini si sympathique, c'est la manière quasi nonchalante dont les meubles et les tableaux de grande valeur cohabitent avec le désordre chaotique lié à la vie de tous les jours. Chez les Leonini, on se rie des formalités. Dans le « salotto » décoré de fresques néoclassiques, les habitants, les chats et les amis tirent la langue à l'étiquette, et lorsque Giovanna dresse la table dans la petite cour ombragée et s'apprête a servir une délicieuse « Zuppa di pane », la maison prend un air de fête.

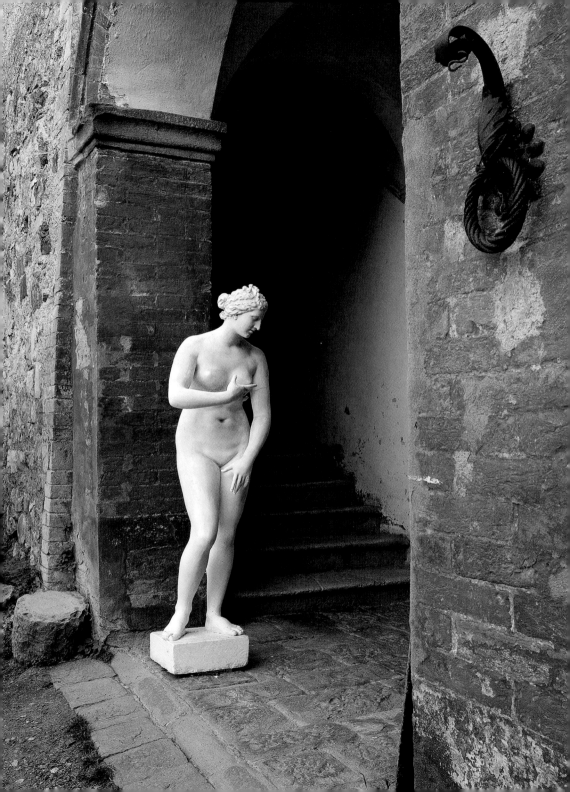

PP. 352–353 The remains of a simple, delicious Tuscan lunch. The table is set in the adjoining small courtyard, a *fin-de-siècle* grotto. • Das Mittagessen im angrenzenden kleinen Innenhof, einer Grotte aus dem Fin de Siècle ist beendet. Zurück bleiben die Reste einer ebenso köstlichen wie einfachen toskanischen Mahlzeit. • Le déjeuner dans la courette annexe, une « grotte fin de siècle », vient de s'achever. Restent les vestiges d'un repas simple et délicieux dont les Toscans ont le secret !

P. 355 Under the arches of the portico, a superb plaster Venus awaits admittance into the *piano nobile*. • Unter dem Eingangsportal wartet eine exquisite Venus aus Gips darauf, ins „piano nobile" vorgelassen zu werden. • Sous les arches du porche, une superbe Vénus en plâtre attend d'être admise au « piano nobile ».

← The avenue leading up to the villa is shaded by laurels. • Die lorbeerge-säumte Allee führt zur Villa. • L'allée qui mène à la villa est bordée de lauriers.

↓ Behind the Villa Montosoli, the horse eats his daily bucket of feed. • Hinter der Villa Montosoli nimmt das Pferd seine Ration Hafer in Emp-fang. • Derrière la Villa Montosoli, le cheval vient de recevoir son picotin.

↑ A crucifix watches over the residents of the Villa Montosoli. • Ein Kruzifix wacht über die Bewohner der Villa Montosoli. • Un crucifix veille sur les habitants de la Villa Montosoli.

→ A glimpse of the kitchen, the heart of the villa, where Giovanna is preparing her famous *zuppa di pane* or *ribollita*, a soup made from bread. She claims that his recipe dates back to the time of Christopher Columbus. • Blick in die Küche, das Herz der Villa. Hier bereitet Giovanna ihre berühmte Brotsuppe "zuppa di pane" oder „ribollita" zu, deren Rezept – darauf besteht sie – auf Kolumbus zurückgeht. • Un coup d'œil dans la cuisine, le cœur de la villa, où Giovanna prépare sa célèbre « zuppa di pane » ou « ribollita ». Elle insiste sur le fait que sa recette remonte à Christophe Colomb.

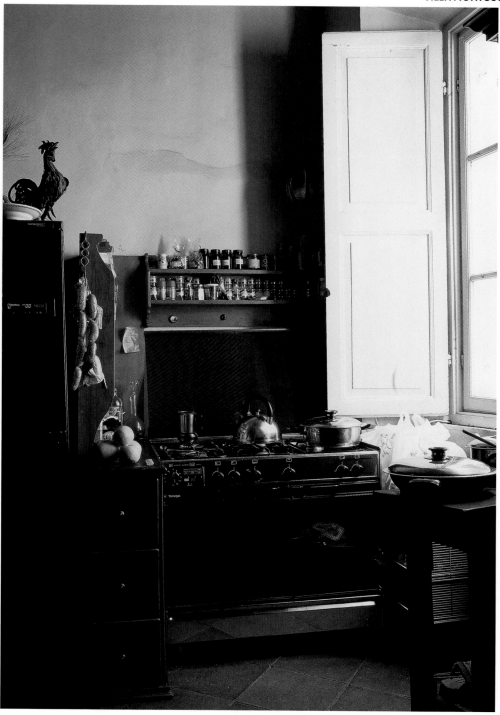

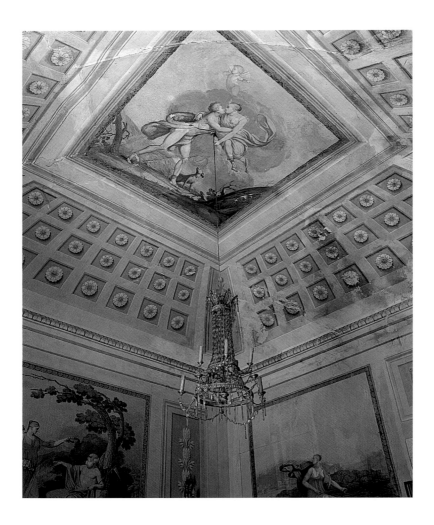

↑ and PP. 362-363 According to Giorgio Leonini, under these 18th-century frescoes lurk original paintings by Il Sodoma (1477-1549), a contemporary of Raphael. • Unter den Fresken des 18. Jahrhunderts verbergen sich laut Giorgio Originalfresken des Malers Sodoma (1477-1549), einem Zeitgenossen von Raffael. • Selon Giorgio, les fresques 18ᵉ recouvrent les fresques originales peintes par Il Sodoma (1477-1549), un contemporain de Raphaël.

→ The walls of the drawing room are covered in neoclassical frescoes dating from the late 18th century. • Die Wände des Salons schmücken klassizistische Fresken des späten 18. Jahrhunderts. • Les fresques néoclassiques du salon datent de la fin du 18ᵉ siècle.

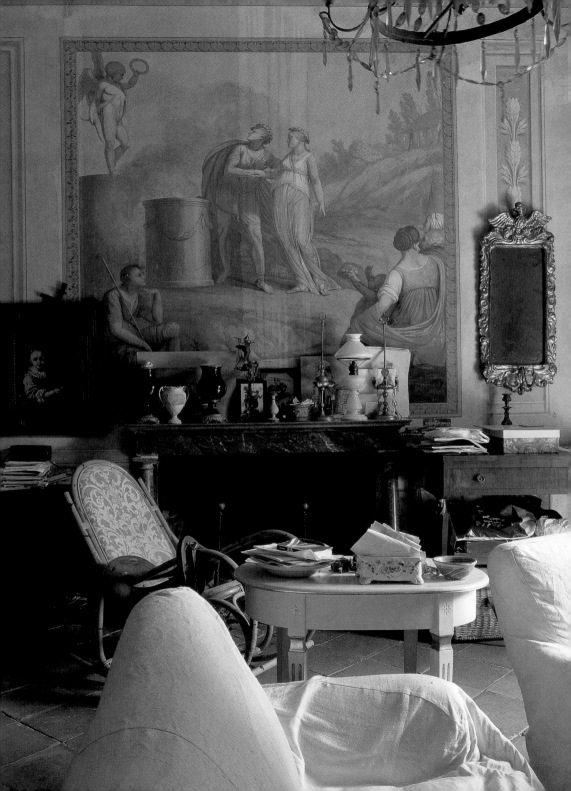

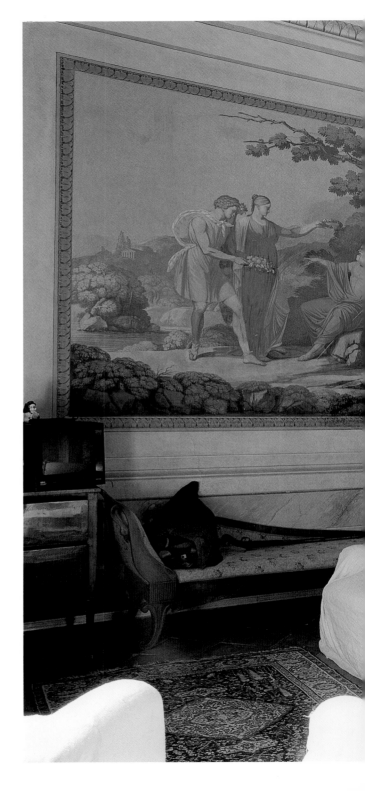

↑ In the same room, one corner is occupied by a 19th-century baroque mirror, a Forties' lamp and several pairs of thoroughly modern shoes. • Im selben Raum befinden sich ein „barocker" Spiegel aus dem 19. Jahrhundert, eine Stehlampe aus den 1940er-Jahren und einige schicke Schuhe, die in eine Ecke verbannt wurden. • Dans la même pièce, un miroir baroque 19e, une lampe à abat-jour des années 1940 et quelques paires de chaussures très actuelles ont été relégués dans un coin.

→ Carla's bedroom has an arched ceiling decorated with flower motifs. The headboard is made from a piece of 18th-century carved panelling. • Die gewölbte Decke in Carlas Schlafzimmer ist mit floralen Motiven verziert. Das hölzerne Kopfteil des Bettes stammt aus dem 18. Jahrhundert. • La chambre de Carla possède un plafond voûté à décorations florales. La tête du lit est un élément de boiserie 18e.

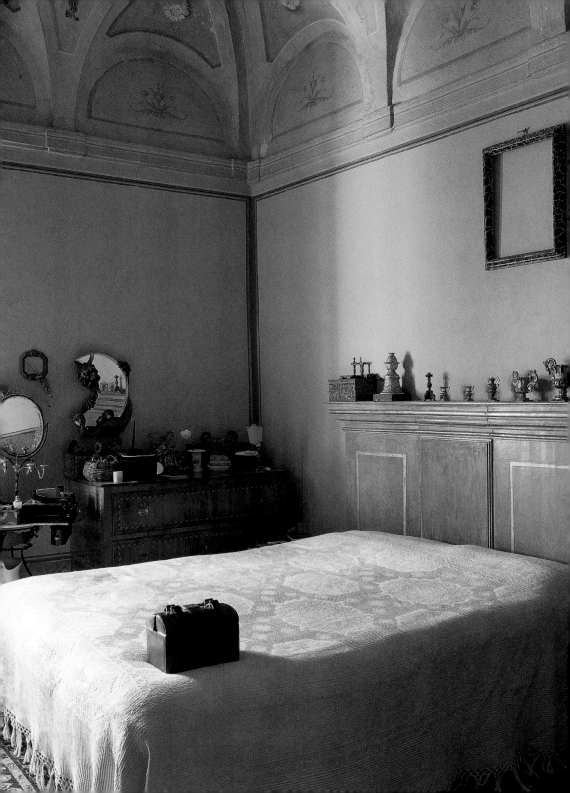

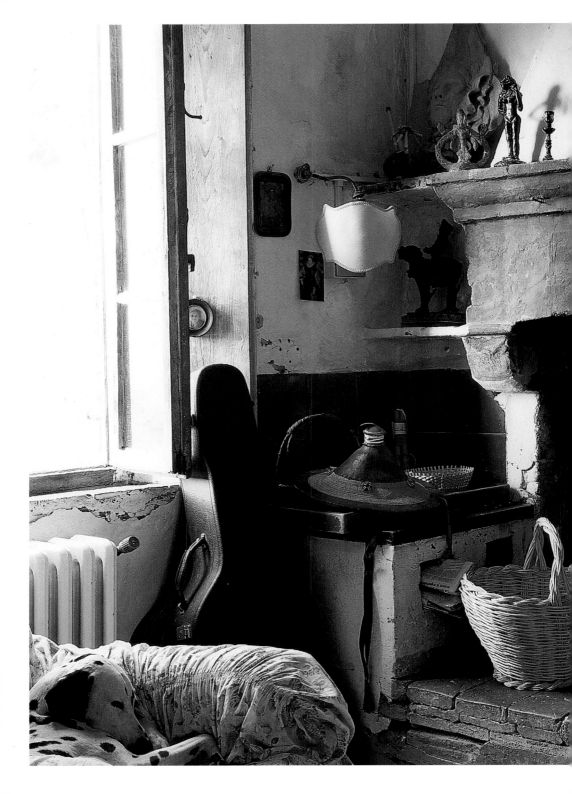

PODERE SCOPETO
DEI CAVALLI

PODERE SCOPETO DEI CAVALLI
BEATRICE CAZAC
MONTALCINO

Beatrice Cazac remembers the time when Montalcino and its surrounding country was not yet besieged by tourists. Since then the birthplace of the great Brunello wine has witnessed the arrival of a modern tide of visitors, attracted by its history and its great wines. Nevertheless Beatrice can be proud that it was she and nobody else who found Scopeto dei Cavalli, a farm tucked away on a steep wooded hillside whose oldest part dates from the 16th century. Enlisting the help of the Cooper brothers, Englishmen who specialise in the restoration of old houses, Beatrice stipulated that there should be no interference with the basic authenticity of Scopeto dei Cavalli (literally, Horses' Wood). Apart from the conversion of the stables into a comfortable sitting room and the installation of a bathroom, the house has retained every bit of its originality and charm. Surrounded by her family, her many friends, dogs, chickens, goats, olive trees and vines, Beatrice revels in the luxury of life at one remove from the rest of the world, far from the din of the masses and the looming menace of the 21st century.

Beatrice Cazac erinnert sich noch gut an die Zeit, als Montalcino und Umgebung noch nicht von Touristen heimgesucht wurden. Inzwischen lockt die Heimat des berühmten Brunello unzählige Menschen an, und so ist Beatrice zu Recht stolz darauf, den Bauernhof Scopeto dei Cavalli entdeckt zu haben. Denn dieser Hof, dessen ältester Teil aus dem 16. Jahrhundert stammt, liegt gut versteckt in einem abgelegenen Winkel der Region. Mit Hilfe ihrer englischen Landsleute, der Brüder Cooper, die sich auf die Restaurierung alter Gebäude spezialisiert haben, ist es Beatrice gelungen, die authentische Atmosphäre ihres Anwesens zu erhalten, dessen Name „Pferdewäldchen" bedeutet. Abgesehen von den Pferdeställen, die in einen behaglichen Wohnraum verwandelt wurden, und von dem neu installierten Bad wurde an dem Haus nichts verändert, sodass es immer noch seinen ursprünglichen Charme ausstrahlt. Umgeben von ihrer Familie, den zahlreichen Freunden, Hunden, Hühnern, Ziegen, inmitten von Olivenhainen und Weinbergen, kann sich Beatrice den Luxus erlauben, fernab vom Lärm und Trubel des 21. Jahrhunderts zu leben.

Beatrice Cazac se souvient du temps où Montalcino et ses alentours n'étaient pas encore assiégés par les touristes. Depuis, le pays natal du célèbre Brunello a vu affluer les masses curieuses de son histoire et avides de goûter son grand vin. Beatrice, quant à elle, est fort satisfaite d'y avoir déniché Scopeto dei Cavalli, une ferme dont la plus ancienne partie date du 16e siècle. En effet, la demeure se dérobe aux regards des curieux en se cramponnant au flanc en pente raide d'une colline boisée. Aidée par les frères Cooper, des Anglais spécialisés dans la restauration de demeures anciennes, Beatrice s'est démenée pour ne pas toucher à l'authenticité de sa «broussaille des chevaux». Sa peine a été récompensée : mis à part la transformation des écuries en séjour confortable et l'installation d'une salle de bains, la maison a gardé toute son originalité et tout son charme. Entourée par sa famille, ses nombreux amis, ses chiens, ses poules, ses chèvres, ses oliviers et ses vignes, Beatrice peut s'offrir le luxe de vivre à l'écart du monde, loin des bruits de la foule et de la menace du 21e siècle.

PP. 366-367 Farfalla, the Dalmatian, fast asleep in an armchair by the heavy old fireplace. • Farfalla, der Dalmatiner, ist in einem Sessel vor dem alten Kamin eingenickt ... • Farfalla, le dalmatien s'est endormi dans un fauteuil devant la vielle cheminée imposante.

P. 369 A horseshoe nailed to the door for good luck. • Das Hufeisen über der Tür soll Glück bringen. • Le fer à cheval cloué sur une porte est censé porter bonheur.

← One of the dogs has taken refuge in the shade. • Einer der Hunde hat sich in den Schatten zurückgezogen. • Un des chiens a cherché refuge à l'ombre.

↑ Beatrice has created a small terrace in front of the house – using an old kitchen table and a few benches. • Vor dem Haus hat Beatrice eine kleine Terrasse angelegt und mit einem alten Küchentisch und einigen Bänken ausgestattet. • Devant la maison, Beatrice a créé une terrasse modeste à l'aide d'une vieille table de cuisine et de quelques bancs.

↑ The walls and beams in Beatrice's bedroom are all whitewashed, and there's a ravishing view across the green valley from her balcony. • Die Wände und Deckenbalken im Zimmer von Beatrice sind weiß gekalkt. Vom Balkon aus hat sie einen herrlich weiten Blick in das grüne Tal. • Les murs et les poutres

de la chambre de Beatrice ont été blanchis à la chaux et, de son balcon, elle a une vue ravissante sur le vallon.

→ You don't need much to make a pleasant bathroom – just a half-timbered wall, an old basin and a bead curtain. • Man benötigt nicht viel für ein einladen-

des Badezimmer: Eine Ziegelstein-mauer, ein schlichtes altes Waschbecken und ein Holzperlenvorhang genügen ... • Il faut si peu pour faire une agréable salle de bains : un mur à colombages, un ancien lavabo et un rideau à franges de bambou ...

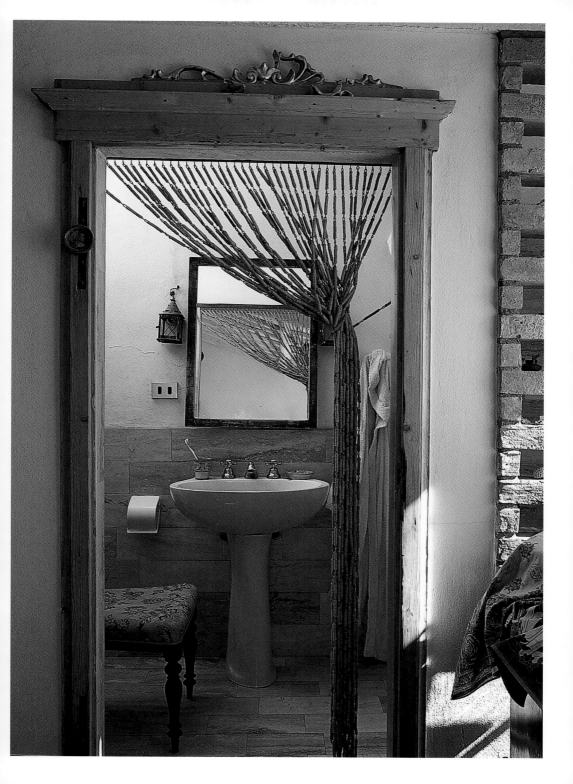

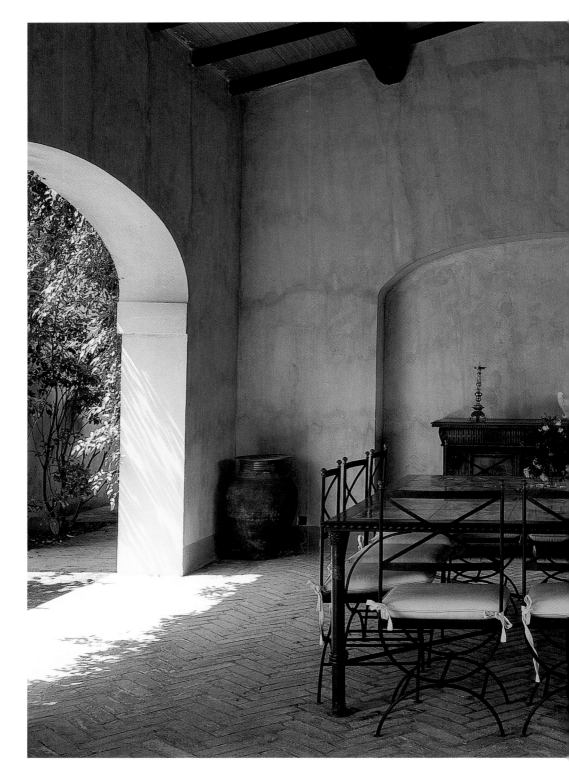

UNA CASA DI CAMPAGNA

UNA CASA DI CAMPAGNA
MAREMMA

The work of Stefano Mantovani and Manuel Jiménez is studiously elegant. In this case, the country house that awaited the attentions of Stefano and his partner had begun as a modest 18th-century construction, which was enriched over the years by the addition of a magnificent garden created by the architect Peironne, a few rooms of pleasing size and a spacious stable block. The present owners, who are from Sicily, have a passion for horses; in addition to their equestrian hobby, their daily life seems to be ruled by a love of hospitality, good cooking and the sheer delight of living in a green and beautiful landscape. Mantovani and Jiménez have achieved a *tour de force* here. They installed a new staircase, whose mezzanine with its chestnut balustrade reveals their insistence on first-class materials and a perfect finish. They also created an intimate dining room with light blue panelling, a loggia in the purest Mediterranean style and a bedroom with a pair of iron Sicilian bedsteads and walls upholstered with blue-and-white mattress ticking. In a word, this is a real family house with a warm and welcoming atmosphere.

Die beiden Innenarchitekten Stefano Mantovani und Manuel Jiménez setzen bei ihren gemeinsamen Projekten vor allem auf Eleganz. Bei dem Landhaus, das sie hier erwartete, handelte es sich um ein schlichtes Gebäude aus dem 18. Jahrhundert mit einem weitläufigen Pferdestall und einem herrlichen Garten, den der Architekt Peironne angelegt hatte. Die Hauseigentümer, die aus Sizilien stammen, sind Pferdenarren. Neben den Freuden hoch zu Ross gehören zu ihrem Alltag aber auch Gastfreundschaft, gute Küche und das Wohlgefallen, im Herzen einer grünen Landschaft zu leben. Die beiden Innenarchitekten vollbrachten für sie eine Glanzleistung. Unter anderem installierten sie ein Treppenhaus mit Absatz und Geländer aus Kastanienholz – Zeugnis ihrer Vorliebe für hochwertige Materialien und perfekte Verarbeitung. Sie entwarfen ein intimes Esszimmer mit zartblauen Vertäfelungen, eine mediterran geprägte Loggia, und für das Schlafzimmer wählten sie eine Wandbespannung aus blauweißem Matratzenstoff – kurz: ein echter Familiensitz, in dessen einladendem Ambiente es sich gut leben lässt.

Les réalisations du tandem Stefano Mantovani et Manuel Jiménez se distinguent avant tout par un grand souci de l'élégance. La maison de campagne qui attendait le coup de baguette de Stefano et de son partenaire n'était qu'une modeste construction 18e siècle, enrichie au cours du temps d'un magnifique jardin créé par l'architecte Peironne, de quelques pièces de dimensions agréables et d'une vaste écurie. Les propriétaires, d'origine sicilienne, ont une véritable passion pour les chevaux et en dehors des plaisirs équestres, leur vie quotidienne semble gérée par l'hospitalité, la bonne cuisine et la douceur de vivre. Mantovani et Jiménez réussirent un véritable tour de force qui impliquait l'installation d'une cage d'escalier – la mezzanine et sa balustrade en châtaignier révèlent leur prédilection pour les matériaux nobles et pour une finition impeccable – et la création d'une salle à manger intime, tapissée de lambris bleu clair, d'une loggia dans le plus pur goût méditerranéen et d'une chambre à coucher tendue d'un tissu à matelas bleu et blanc et qui abrite une paire de lits en fer siciliens. En un mot : une vraie maison de famille où il fait bon vivre dans un décor accueillant et chaleureux.

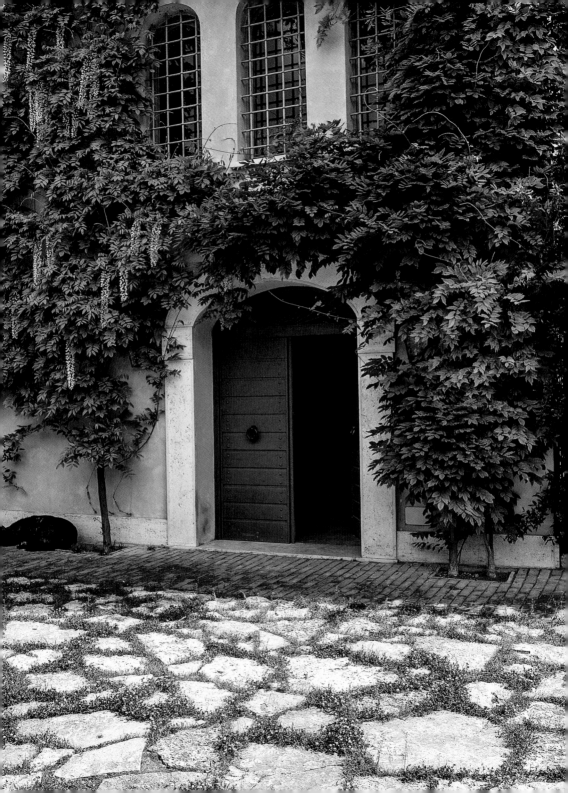

PP. 374–375 Mantovani and Jiménez constructed this imposing loggia with a view to creating an area for alfresco meals. The furniture is made of wrought iron. • Mantovani und Jiménez schufen mit dieser imposanten Loggia einen malerischen Rahmen für eine Mahlzeit „al fresco". Die Möbel sind aus Schmiedeeisen. • Mantovani et Jiménez ont construit cette loggia imposante afin de créer un espace pour les déjeuners et les dîners al fresco. Le mobilier est en fer forgé.

P. 377 A faithful dog, though greatly smitten by the heat, sticks to his post by the front door. • Ein treuer Hund, dem die Hitze zusetzt, wacht neben dem Eingang. • Un chien, accablé par la chaleur, monte la garde à côté de la porte d' entrée.

↑ In the entrance hall, ochre-yellow walls accentuate the bright colours of the earthenware and the warm tones of the furniture and fabrics. • In der Eingangshalle betonen die ockergelben Wände die lebhaften Farben der Keramikvasen, der Möbel und Stoffe. • Dans

le hall d'entrée, des murs ocre mettent en valeur les couleurs vives des faïences ainsi que les tonalités chaudes du mobilier et des tissus.

→ A rearing bronze horse creates a surprising contrast with the yellow-ochre walls of the hallway. • Das sich aufbäumende Bronzepferd bildet im Eingangsbereich einen faszinierenden Kontrast zu den ockergelben Wänden. • Un cheval cabré en bronze forme un contraste surprenant avec les mursocre de l'entrée.

→ Painted wood panelling in hunting-lodge style provides the ideal setting for a selection of works by animal painters and sculptors. The large Chesterfield sofa underlines the cosy, relaxed nature of the interior design. • Die Holzvertä-felung im Stil einer Jagdhütte bietet das ideale Dekor für eine Auswahl an Gemälden und Zeichnungen, Werke von Künstlern, die sich auf Tierbilder spezialisiert haben. Das mächtige Chesterfield-Sofa unterstreicht den gemütlichen und entspannenden Charakter des Raums. • Des lambris en bois peint, style « relais de chasse », forment le décor idéal pour un choix de tableaux et de dessins, œuvres d'artistes animaliers. La présence d'un grand canapé Chesterfield renforce le caractère « cosy » et décontracté de la décoration.

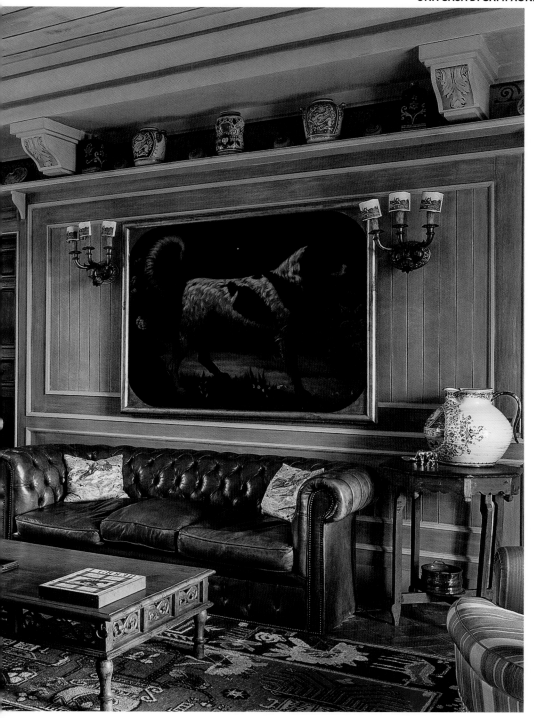

↑ On the mantelpiece of the small dining room the mistress of the house has placed a copper flower-box filled with dried fruit. • Auf dem Kaminsims im kleinen Esszimmer hat die Hausherrin einen Blumenkasten aus Kupfer mit vielen getrockneten Früchten dekoriert. • Sur la cheminée de la petite salle à manger, la maîtresse de maison a posé une jardinière en cuivre remplie de fruits séchés.

→ For the walls of the dining room, Stefano and Manuel chose a light blue shade. • Für die Wände im Esszimmer wählten Stefano und Manuel ein zartes Hellblau. • Stefano et Manuel ont choisi un ton bleu clair pour les murs de la salle à manger.

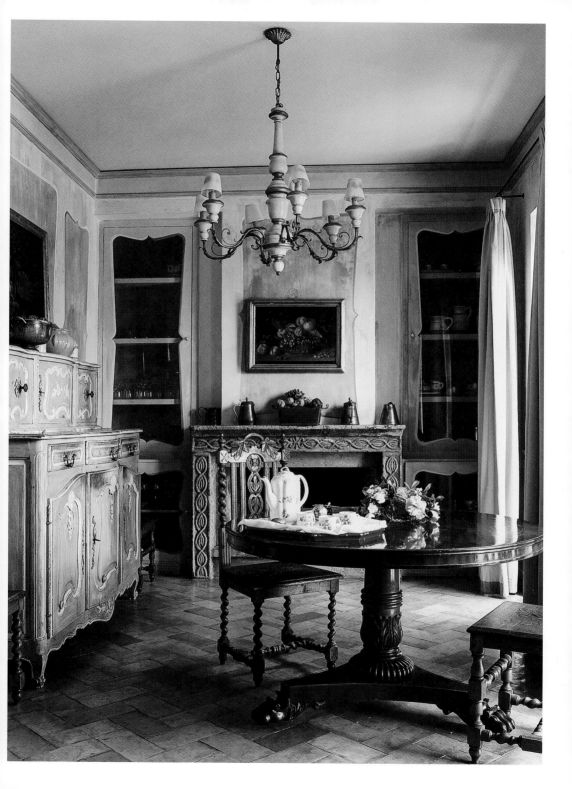

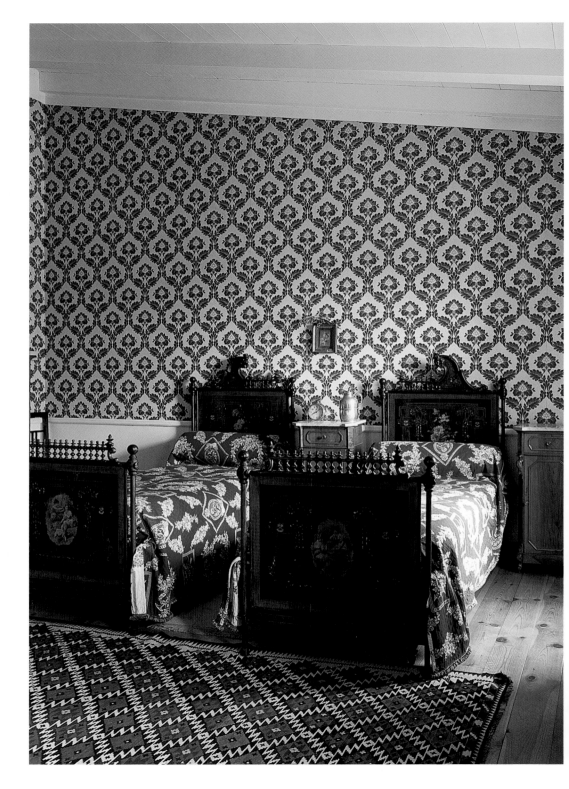

← In the principal bedroom, the occupants sleep in polychrome wrought-iron beds which the family inherited from their Sicilian ancestors. • Im Schlafzimmer der Hausherrin stehen bemalte Eisenbetten, die sie von einem ihrer sizilianischen Vorfahren geerbt hat. • Dans la chambre maîtresse, les habitants dorment dans des lits en fer polychromes hérités d'un ancêtre sicilien.

↑ An Art-Nouveau-style bathroom in white and blue echoes 1900 designs. •

Ein Badezimmer in Blau und Weiß, wie man es um 1900 liebte. • Une salle de bains Liberty bleue et blanche – nostalgie des décors 1900.

PP. 386–387 Mantovani and Jiménez upholstered the walls of this bedroom with an inexpensive blue-and-white floral fabric to emphasise the countrified aspect of the decoration. The alarm clock and the pewter thermos are period pieces. • Mantovani und Jiménez bespannten die Wände dieses

Schlafzimmers mit einem preiswerten blauweißen Blumenstoff, der das ländliche Flair betont. Der Wecker und die Thermoskanne aus Zinn sind alte Stücke. • Mantovani et Jiménez ont tendu les murs de cette chambre d'un tissu floral bleu et blanc à deux sous pour accentuer le côté campagnard de la décoration. Le réveil-matin et le thermos en fer blanc sont de vieilles pièces de collection.

CASTELLO ROMITORIO

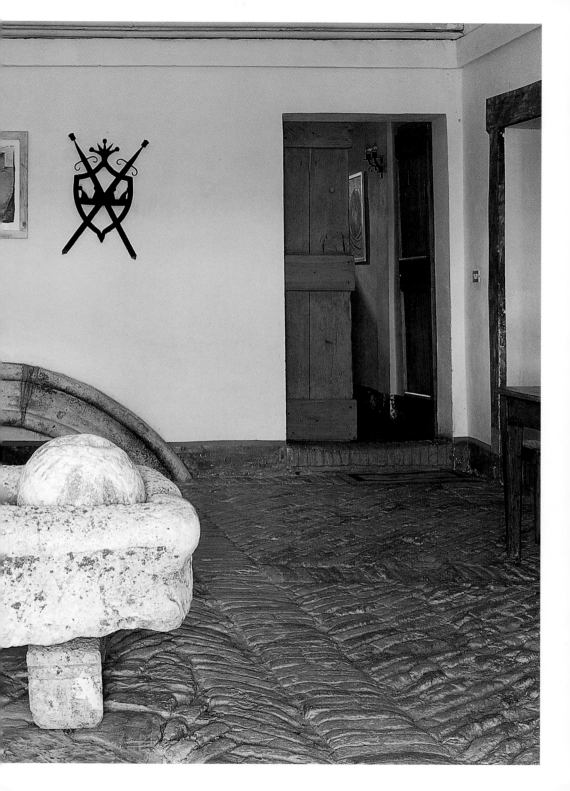

CASTELLO ROMITORIO

SANDRO CHIA
MONTALCINO

In 1986, the painter and sculptor Sandro Chia bought the castle known as Il Romitorio, or the hermitage, which stands on a hill near Montalcino. At the time, it was in a distressingly poor state of repair. Chia not only renovated the fabric of the building, which dates from the 13th century and has been used both as a prison and a monastery, but he also changed the landscape around it by planting olive groves, orchards and, most importantly, several hectares of vineyards. Today these produce one of the finest Brunellos you could hope to find in your glass. Inside, Il Romitorio is an attractive hotchpotch of styles. Biedermeier furniture and 18th-century armchairs jostle with Art Nouveau tables and archaeological remains, including Etruscan amphorae and Egyptian sarcophagi. On the walls next to the telephone and in other odd corners, are small figures drawn by Chia in pencil.

Der italienische Maler und Bildhauer Sandro Chia gehört heute zu den Spitzenerzeugern von Brunello di Montalcino, einem der bekanntesten Rotweine Italiens. Bemerkenswert ist auch das Domizil des Künstlers, das Castello Il Romitorio, das er 1986 in einem erbärmlichen Zustand kaufte. Chia restaurierte die Burg aus dem 13. Jahrhundert, die im Lauf ihrer wechselvollen Geschichte schon als Gefängnis und als Kloster diente. Auch die Umgebung gestaltete er nach seinen Wünschen, pflanzte Oliven- und Obstbäume, vor allem aber mehrere Hektar Wein an. Mittlerweile hat der Künstler in den alten Räumen ein originelles Ambiente geschaffen, in dem verschiedene Stilrichtungen frech und unbekümmert nebeneinander existieren. Schlichte Biedermeiermöbel vertragen sich bestens mit üppigen Fauteuils des 18. Jahrhunderts; neben Jugendstiltischen haben etruskische Amphoren und ägyptische Sarkophage ihren Platz gefunden. Hier und da, neben dem Telefon und in versteckten Winkeln des „castello", hat Sandro Chia mit Bleistift kleine Figuren an die Wand gezeichnet.

Juché sur une colline de Montalcino, le Château du Romitorio, construit au 13e siècle, a jadis fait office de prison et de couvent. Sandro Chia, peintre et sculpteur italien, l'a acheté en 1986. Il se trouvait alors dans un état pitoyable. Non content de le restaurer, il a également planté des oliviers, des arbres fruitiers et des hectares de vignobles, qui donnent aujourd'hui un excellent brunello. L'ameublement du château est très éclectique : des meubles Biedermeier jouxtent des fauteuils du 18e siècle, des tables art déco, des amphores étrusques et des sarcophages égyptiens. En outre, Sandro Chia a disséminé çà et là, dans les recoins les plus inattendus du château, de petites figures dessinées au crayon sur les murs.

PP. 388–389 The entry showing the Roman drinking trough. Between the two wrought-iron crests on the wall is a design by Sandro Chia for the label of the first wine produced on the castle estate, Romito del Romitorio. The arch beyond is a piece of marble Chia found and incorporated into the wall to produce a disorienting visual effect. • Die Steintränke aus römischer Zeit im Eingangsbereich. Zwischen den schmiedeeisernen Wappen hängt Chias Entwurf für das Etikett des ersten eigenen Weins, „Romito del Romitorio". Auffallend ist der Marmorbogen darunter, den er als Überraschungsmoment in die Wand einmauerte. • Dans le hall, l'abreuvoir

en pierre d'époque romaine. Entre des armoiries en fer forgé, on aperçoit le dessin de Sandro pour l'étiquette de son premier vin, « Romito del Romitorio ». Au-dessous, le remarquable arc en marbre, que Chia a maçonné dans le mur pour produire un effet dépaysant.

P. 391 Leaning against the wall in the attic studio is an untitled charcoal drawing by Sandro Chia. He discovered the sofa, the unusual table and the two bookcases in a second-hand dealer's shop in Montalcino. The statuette is a 17th-century work in plaster painted blue by Sandro Chia. • Das Atelier im Dachgeschoss. Das Sofa, den ungewöhnlichen

Tisch und die beiden Bücherschränke hat Chia bei einem Antiquitätenhändler in Montalcino aufgestöbert. An der Wand lehnt eine großformatige Kohlezeichnung des Künstlers. Die Gipsskulptur aus dem 17. Jahrhundert hat er blau bemalt. • L'atelier aménagé sous le toit. Sandro a déniché le divan, le guéridon et les bibliothèques chez un brocanteur de Montalcino. Au mur, un grand format au fusain de Sandro. Il a peint en bleu la sculpture en plâtre du 17e siècle.

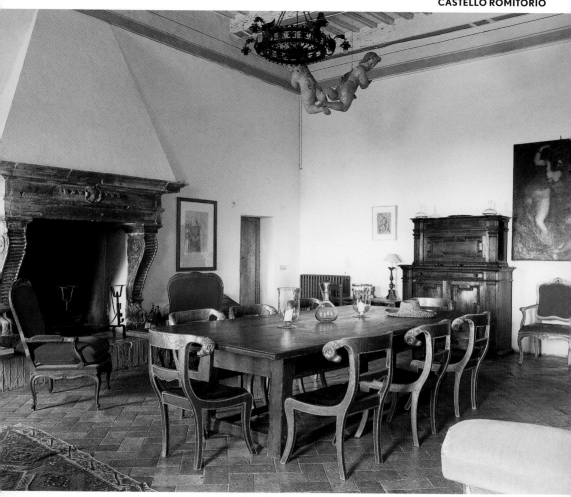

← A still-life miscellany including a bottle of wine produced at Il Romitorio. The antique print depicts the Colosseum in Rome. • Vor einem Druck mit dem Kolosseum in Rom gruppiert sich ein Stilleben aus unterschiedlichen Objekten, darunter eine auf Il Romitorio abgefüllte Weinflasche. • Devant une gravure représentant le Colisée romain, divers objets, entre autres une bouteille du vin de Il Romitorio, forment une nature morte.

↑ The chimney for the dining room fireplace is the only architectural addition to the castle, whose original structure has been left intact. The table legs came from a 17th-century friary. The English-style chairs were made in India. To the right of the dresser at the far end of the room is a painting of *Andromeda and Theseus* by Jacopo Palma il Giovane (1544–1628). • Der Kamin des Esszimmers ist die einzige architektonische Veränderung, die Chia an dem „castello" vorgenommen hat. Die englischen Stühle fertigte eine indische Manufaktur, während das Tischgestell aus dem 17. Jahrhundert aus einem Kloster stammt. Rechts hängt das Gemälde „Andromeda und Theseus" des venezianischen Malers Jacopo Palma il Giovane (1544–1628). • La cheminée de la salle à manger constitue l'unique ajout architectural au château, dont la structure est restée intacte. Les chaises à l'anglaise ont été réalisées par une manufacture indienne, les pieds de table proviennent d'un monastère du 17e siècle. A droite, le tableau « Andromède et Thésée », du peintre vénitien Jacopo Palma il Giovane (1544–1628).

← The kitchen. The original fireplace is adorned with an engraving by Sandro Chia. The cabinet standing against the wall on the right of the photograph is typical of the area. It was purchased from a second-hand dealer. • Die Küche mit dem originalen Kamin, auf dessen Sims ein Stich von Chia lehnt. Typisch für die Region ist der Vitrinenschrank. • La cuisine avec la cheminée d'origine, ornée d'une gravure de Chia. Le vaisselier à appliques est un meuble typique de la région.

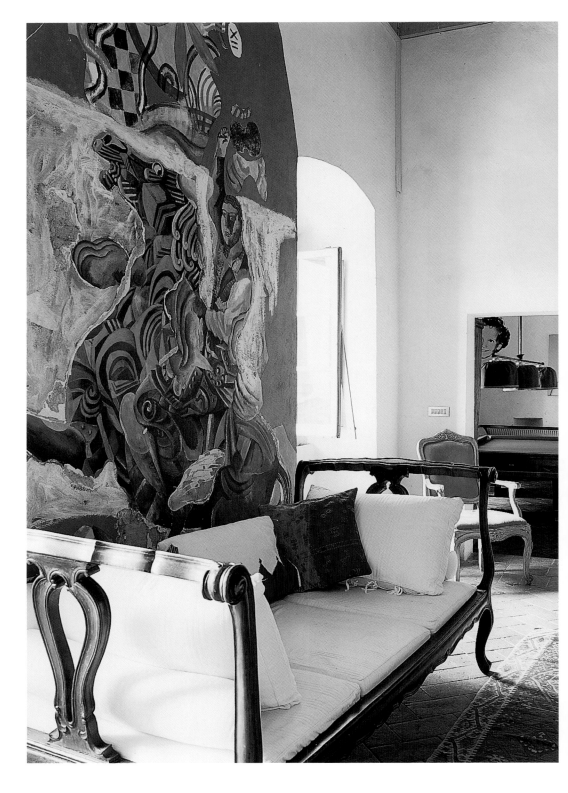

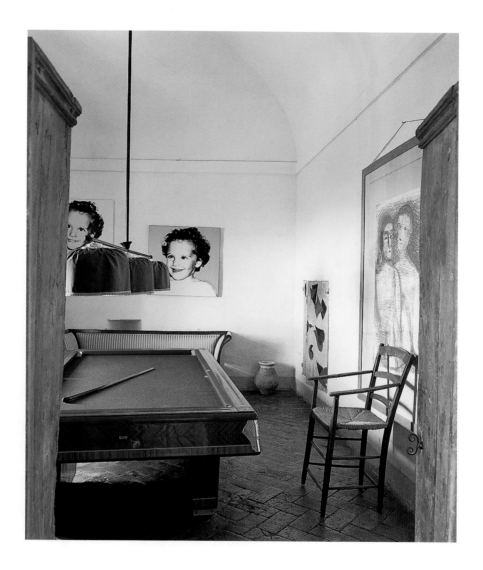

← A large mural in the dining room by Sandro Chia, which has been scraped away to reveal the plaster and stone underneath. The sofa is English and came from a second-hand dealer. • Im Speisezimmer befindet sich über dem englischen Sofa, das ebenfalls von einem Antiquitätenhändler stammt, ein großes Wandbild Chias. Es wurde an einigen Stellen abgekratzt, bis der Putz und der darunterliegende Stein zum Vorschein kamen. • Sandro Chia a gratté sa grande peinture murale pour laisser apparaître l'enduit et la pierre qui lui servent de support. Le divan anglais provient également d'un brocanteur.

↑ A number of works by Sandro Chia are on display in the small billiard room together with a double portrait of his eldest child. • Das Billardzimmer mit Werken von Chia und einem Doppelporträt seines ältesten Sohns. • La petite salle de billard renferme des œuvres de Sandro Chia et un double portrait de l'aîné de ses enfants.

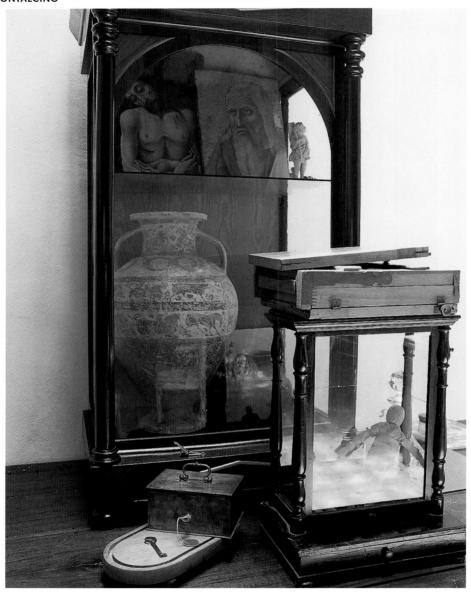

↑ The display cabinet where Sandro Chia keeps what he calls his "pirates' treasure". • Die Vitrine, in der Sandro seinen „Piratenschatz" aufbewahrt. • La vitrine dans laquelle Sandro Chia conserve ce qu'il appelle le « trésor des pirates ».

→ One of the bedrooms, showing the original beams that support the roofing. The iron bedstead is an Art Nouveau piece that came from a second-hand dealer in Pietrasanta. The engravings on the walls are by Sandro Chia. • In diesem Schlafzimmer befinden sich noch die Originalholzbalken. Das eiserne

Jugendstilbett hat Sandro bei einem Antiquitätenhändler in Pietrasanta gefunden. An der Wand hängen Stiche von Sandro Chia. • Une chambre à coucher avec son plafond aux poutres d'origine. Sandro a trouvé le lit art nouveau en fer chez un brocanteur de Pietrasanta. Au mur, des gravures de Sandro Chia.

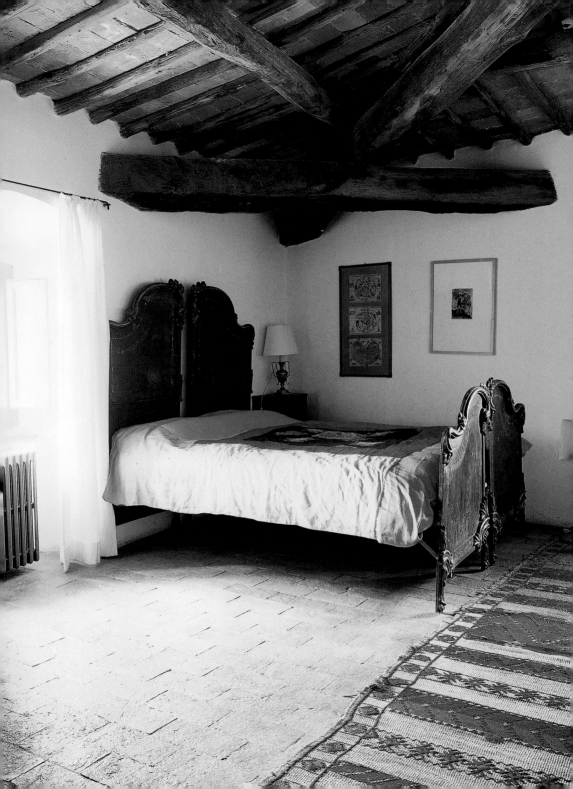

CASALE POGGETTI ALTI

CASALE POGGETTI ALTI

MAREMMA

Leave the marshlands of the Maremma along the Valle del Diavolo, skirting the boracic fumaroles of Larderello, and the cypress-lined road takes you to the farmhouse of Poggetti Alti. The stones used for the outer walls were found locally in the fields. Giancarlo and Maria Gloria Conti Bicocchi restructured the *casale* that belongs today to Maria Gloria's son, Stefano Isola, and to his wife, Matilde Gugliardo di Carpinello. But the artist Daniel Buren also lived here and left his mark. The doors, windows and floors have been left as they were and the rooms are still arranged as in the original plan; with the kitchen and stable, now a living room, on the ground floor and the bedrooms on the first floor. In the former stables, Giancarlo and Maria Gloria have created a strikingly stylish room: mangers and antique furniture contrast with other pieces whose spare lines were conceived by Giancarlo Bicocchi.

Die heißen Bordämpfe von Larderello liegen über der von Zypressen gesäumten Straße, die sich die Valle del Diavolo, das Teufelstal, hinaufwindet bis zum Casale Poggetti Alti. Der schlichte Gutshof wurde nach lokaler Tradition mit Felsbrocken errichtet, die die Bauern auf den umliegenden, steinigen Feldern sammelten. Damals schlief man im ersten Stock über der Küche und dem Stall. Zwischenzeitlich lebte und arbeitete in dem „casale" der Künstler Daniel Buren; heute wohnen hier Stefano Isola und seine Frau Matilde Gugliardo di Carpinello. Restauriert wurde Poggetti Alti von Stefanos Mutter Maria Gloria Conti Bicocchi und ihrem Mann Giancarlo Bicocchi. Bei der Restaurierung war ihnen wichtig, dass die alten Tür- und Fenstereinfassungen sowie die Fußböden erhalten blieben. Im ehemaligen Stall haben sie einen Wohnraum mit besonderem Flair eingerichtet: In dem Raum mit den original erhaltenen Futterkrippen fügen sich schnörkellose Entwürfe von Giancarlo Bicocchi gekonnt zwischen Möbeln des 19. Jahrhunderts ein.

Sous les nuages de vapeurs boriques de Larderello, une route bordée de cyprès remonte la Valle del Diavolo et mène au « casale » des Poggetti Alti. La bâtisse sobre a été construite de manière traditionnelle avec des pierres ramassées dans les champs des environs. Autrefois, on couchait au premier étage, au-dessus de la cuisine et de l'étable situées au rez-de-chaussée. Giancarlo et Maria Gloria Conti Bicocchi ont restauré le « casale » qui appartient aujourd'hui au fils de Maria Gloria, Stefano Isola, et à sa femme Matilde Gugliardo di Carpinello. Mais Poggetti Alti a accueilli aussi à une époque ultérieure l'artiste Daniel Buren qui y a laissé ses marques. Giancarlo et Maria Gloria ont tenu à conserver les encadrements des portes et des fenêtres, et les dallages d'origine. L'étable a été transformée avec beaucoup de goût en salle de séjour. À côté des anciennes mangeoires, des meubles du 19e siècle cohabitent parfaitement avec les créations dépouillées de Giancarlo Bicocchi.

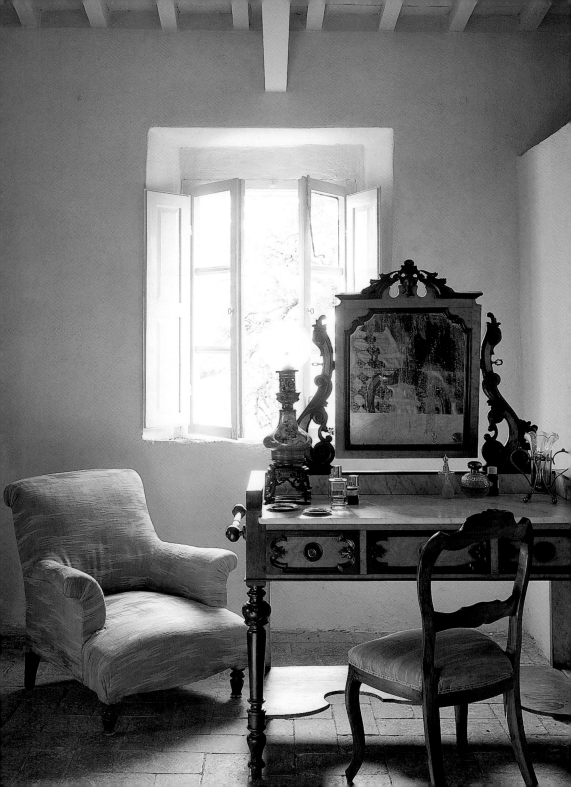

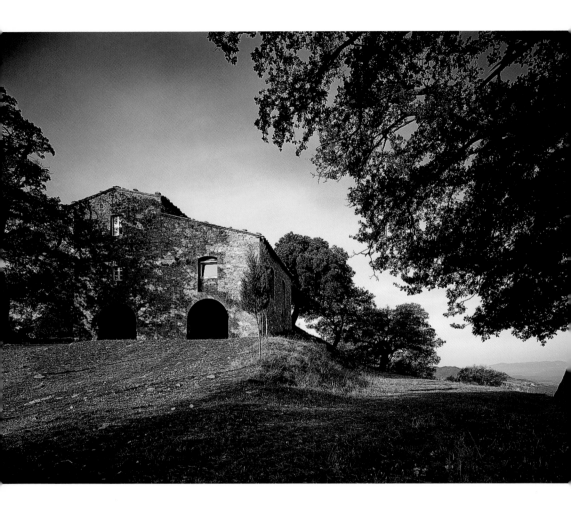

PP. 400–401 The corridor on the
first floor with the bedrooms leading
off. • Über diesen Flur erreicht man die
Schlafzimmer im ersten Stock. • Le
corridor du premier étage qui dessert
les chambres.

P. 403 A bedroom with a 19th-century
dressing table in natural wood and
amaranth. • Im Schlafzimmer steht ein
Toilettentisch aus dem 19. Jahrhundert
aus hellem Holz und Amarantholz. •
Une chambre avec une coiffeuse du
19ᵉ siècle de bois clair et d'amarante.

← The *casale* on the hilltop looks out over the *balze*, the crags of Volterra. • Das Gehöft auf einem Hügel in der Nähe der „balze", der steilen Abhänge von Volterra. • La ferme, au sommet de la colline tournée vers les «balze», des escarpements près de Volterra.

↓ The pergola on the southern side of the house with a table designed by Giancarlo Bicocchi and painted by Daniel Buren. • Die Pergola an der Südseite des Hauses mit einem Tisch, den Giancarlo Bicocchi entworfen und Daniel Buren bemalt hat. • La pergola

adossée au côté sud de la maison, avec une table conçue par Giancarlo Bicocchi et peinte par Daniel Buren.

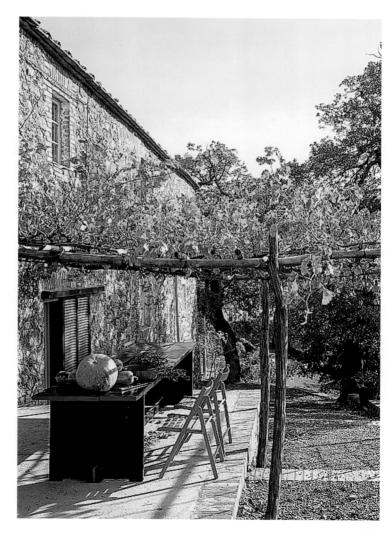

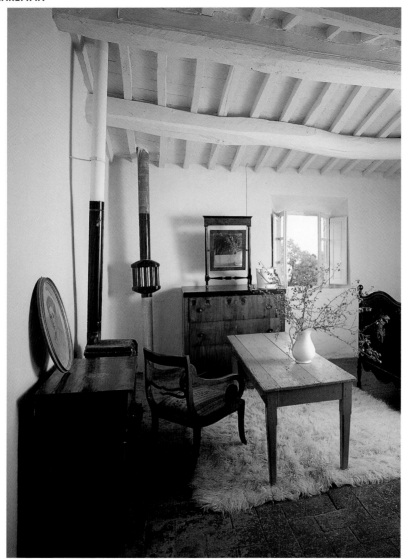

↑ Another bedroom with antique furniture belonging to the family, including an Empire chest of drawers and a painted iron bed. · Ein weiteres Zimmer mit alten Möbeln aus Familienbesitz, wie einer Empire-Truhe und einem Bett mit bemaltem Eisengestell. · Une autre chambre à coucher renferme de vieux meubles de famille, dont une commode Empire et un lit en fer peint.

→ The ceiling of all the rooms on the first floor is painted mint green and the walls pink. The wooden decoration on the canopy of the 19th-century, four-poster bed is original. · Alle Räume im ersten Geschoss haben eine mintgrün gestrichene Decke und rosafarbene Wände. Das Himmelbett aus dem 19. Jahrhundert besitzt noch die hölzerne Originalbekrönung. · Une autre

chambre au plafond peint en vert menthe et aux murs en rose, comme toutes les chambres du premier étage. Lit à baldaquin du 19ᵉ siècle avec son faîte en bois d'origine.

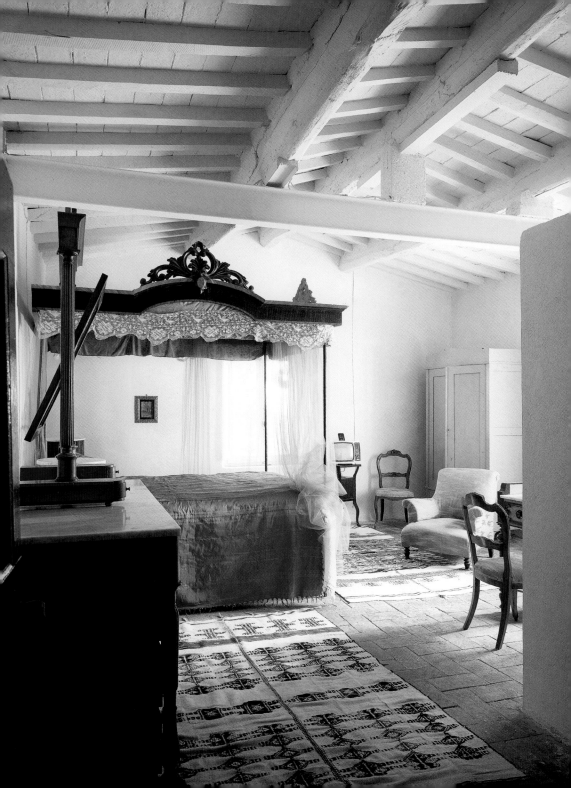

RITA FOSCHI

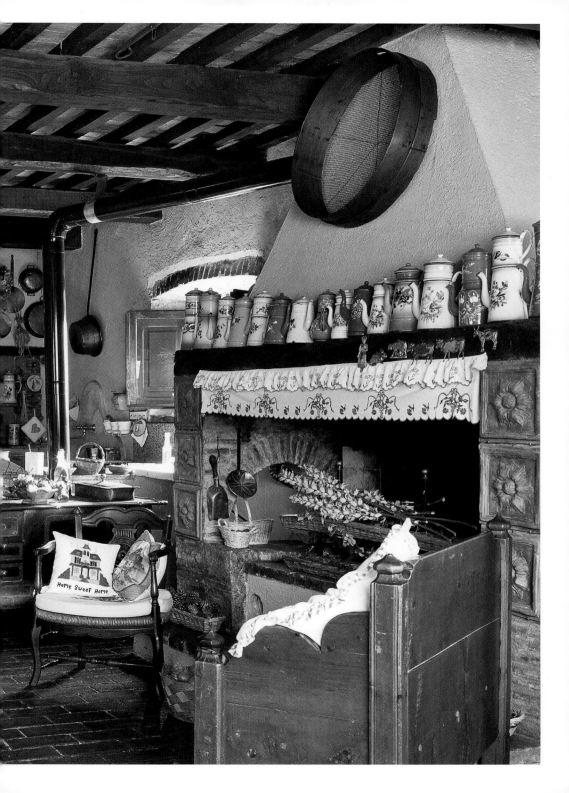

RITA FOSCHI
MAREMMA

Rita Foschi decided she could no longer put up with life in the city; so she, her husband and their two children left Rome for Tuscany, where they moved into a house in the countryside, near Grosseto. Rita's husband looks after the estate and her elder son is at university while the younger one gives her a hand with the new occupation she has taken up: dealing in antiques. This has enabled her to furnish the house, which was built in 1863. "But then it's always difficult," she confesses, "to know what to sell and what to hold on to. I end up by keeping whatever is in harmony with the spirit of the house, which we have restructured as faithfully as possible." The kitchen is a veritable museum of wooden implements used in the countryside, which come from all over Italy and France, as do her collections of embroidery, French coffee pots and hand-painted tins.

Eines Tages entschied Rita Foschi, dass sie nicht mehr in der Stadt leben wollte. Sie zog gemeinsam mit ihrem Mann und den beiden Söhnen von Rom in die Toskana und erwarb ein Haus auf dem Land, in der Nähe von Grosseto. Heute bearbeitet Ritas Mann die dazugehörigen Felder, der älteste Sohn studiert und der jüngere hilft der Mutter bei ihrer neuen Tätigkeit als erfolgreiche Antiquitätenhändlerin. Mit ihren „Fundstücken" hat sie auch das 1863 erbaute Haus eingerichtet. „Aber es ist für mich immer noch schwierig", erzählt sie, „mich von meinen Stücken zu trennen. Ich gebe nichts her, was zum Stil unseres Hauses passt. Bei der Restaurierung haben wir so weit wie möglich die ursprünglichen Strukturen bewahrt." Die Küche mit dem rosettengeschmückten offenen Kamin gleicht einem Museum des bäuerlichen Lebens: sie quillt buchstäblich über von Holz- und Metallgerätschaften, die Rita aus ganz Italien und Frankreich zusammengetragen hat. Ihre Sammelleidenschaft gilt insbesondere Stickereien aller Art, französischen Kaffeekannen und handbemalten Blechdosen.

Rita Foschi ne pouvait vraiment plus vivre en ville, à Rome. Elle s'est donc installée en Toscane avec sa famille, en pleine campagne, aux environs de Grosseto. Son mari s'occupe des terres, leur fils aîné va à l'université et le plus jeune l'aide dans sa nouvelle activité : elle s'est improvisée antiquaire, avec un certain succès. C'est de cette façon qu'elle a meublé la maison. «Mais – avoue-t-elle – il est toujours difficile de sélectionner ce que l'on veut vendre et ce que l'on désire conserver. Finalement, je garde ce qui va avec le style de la maison construite en 1863 et restaurée avec le plus grand soin». La cuisine est ainsi devenue un véritable musée des ustensiles de bois campagnards, recueillis avec amour dans toutes les régions d'Italie et de France, ainsi que les broderies, les cafetières françaises et les boîtes en fer-blanc peintes à la main.

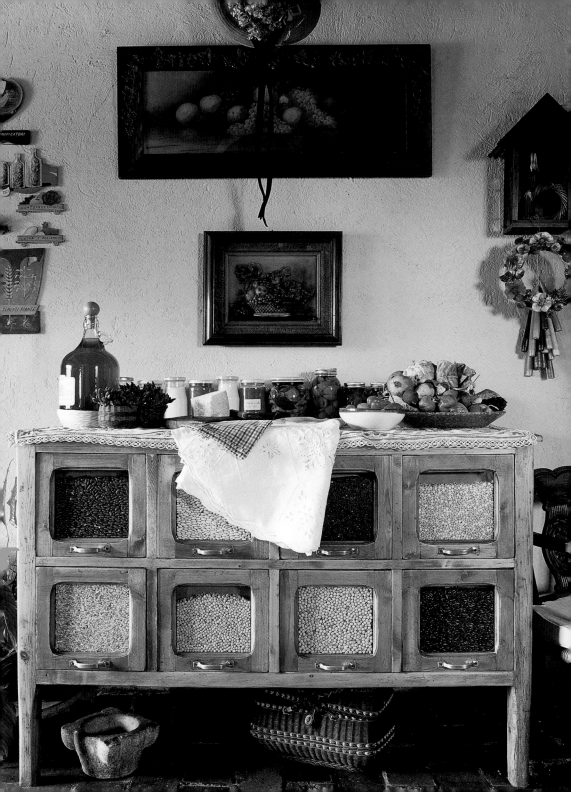

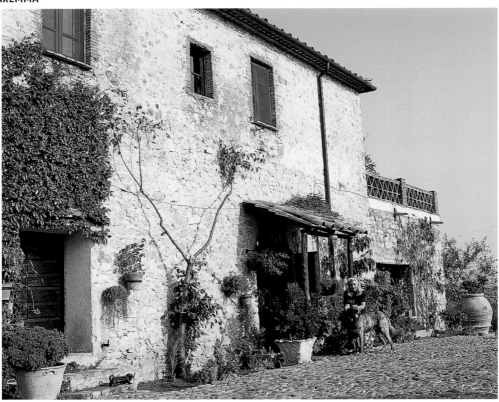

PP. 408–409 The immense kitchen. •
Die geräumige Küche. • La cuisine.

P. 411 Rita is an inveterate bargain
hunter, whose expert eye helped her
track down an unconventional but prac-
tical storage unit, which might well have
come from an old shop. Today, it is used
to store seeds and cereals, while also
providing space for homemade jams
and preserves. • Rita besucht gern
Flohmärkte, und so hat ihr geübtes Auge
ein Schrankmöbel erspäht, das seltsam
und praktisch zugleich anmutet und aus
einem alten Laden stammen könnte.
Heute werden in ihm Körner und Ge-
treide aufbewahrt, zudem dient es als

Abstellbuffet für hausgemachte Marme-
laden und Konserven. • Rita est une
« chineuse » remarquable et son œil
averti a déniché un meuble de range-
ment à la fois étrange et pratique qui
pourrait bien sortir d'un ancien magasin.
Aujourd'hui il contient des graines et
des céréales et sert de support aux
confitures et conserves faites maison

↑ The lady of the house loves old
stones and her penchant for authentic
"shabby chic" even extends to the out-
side of the house. • Die Hausherrin liebt
alte Steine, und ihre Vorliebe für ein au-
thentisches Ambiente und einen „shab-
by chic" macht sich sogar noch vor dem

Haus bemerkbar. • La maîtresse de
maison aime les vieilles pierres et sa
prédilection pour une ambiance authen-
tique et « shabby chic » se prolonge
même à l'extérieur de la maison.

→ Rita Foschi's philosophy is not to
meddle with the original look of a house
and to respect the beauty of old stones. •
Das originale Erscheinungsbild eines
Hauses bewahren und die Schönheit
alter Steine respektieren – das ist Rita
Foschis Philosophie. • Ne pas toucher
à l'aspect original d'une maison et res-
pecter la beauté des vieilles pierres est
la philosophie de Rita Foschi.

P. 414 In the kitchen, there is a small collection of hand-painted 19th-century tins. French watercolours and engravings with chicken motifs adorn the walls. · In der Küche befindet sich eine kleine Sammlung handbemalter Blechdosen aus dem 19. Jahrhundert. Verschiedene französische Aquarelle und Stiche mit Motiven aus dem Hühnerstall schmücken die Wand. · La cuisine abrite une petite collection de boîtes en fer-blanc peintes à la main. Au mur, on peut voir des aquarelles et des gravures françaises aux motifs de poulets et de poules.

P. 415 Candles and other objects crowd the top of the sewing cupboard. A Provençal basket can be made out on the left. The wall is brightened up by a fine collection of samplers, or examples of needlework for would-be embroiderers. · Auf der Nähkommode stehen Kerzen und andere Gegenstände, darunter auch ein ungewöhnlicher provenzalischer Korb. Die Wand schmücken Stickereien, die einst als Lehrmodelle dienten. · Sur le meuble de mercerie on a rassemblé des bougies et divers objets, notamment, à gauche, un panier provençal. Une splendide collection de carrés d'essai, c'est-à-dire d'exemples de broderies destinés à l'apprentissage, orne ce mur.

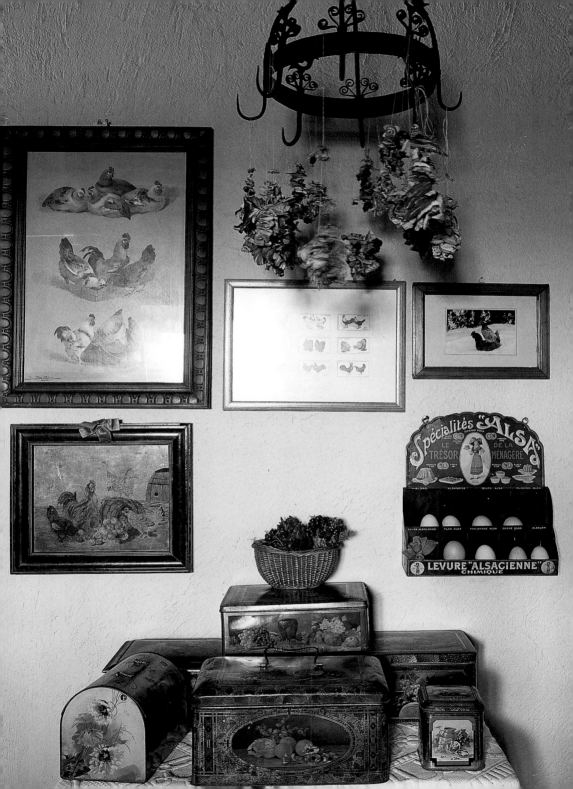

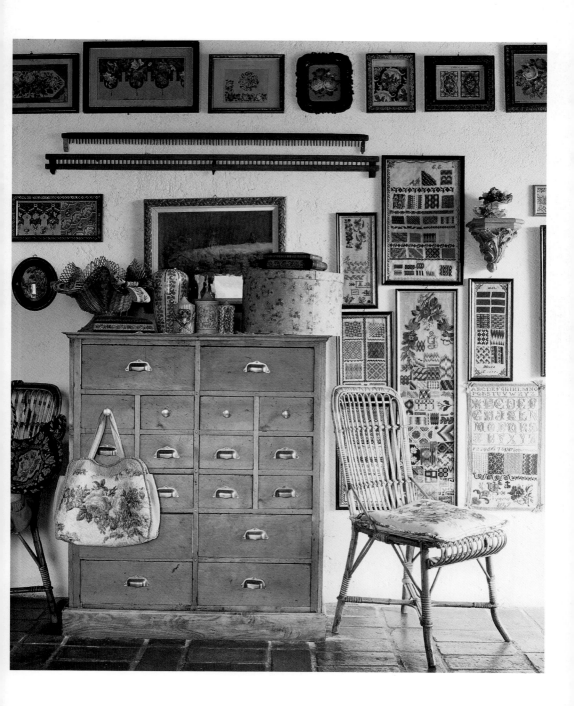

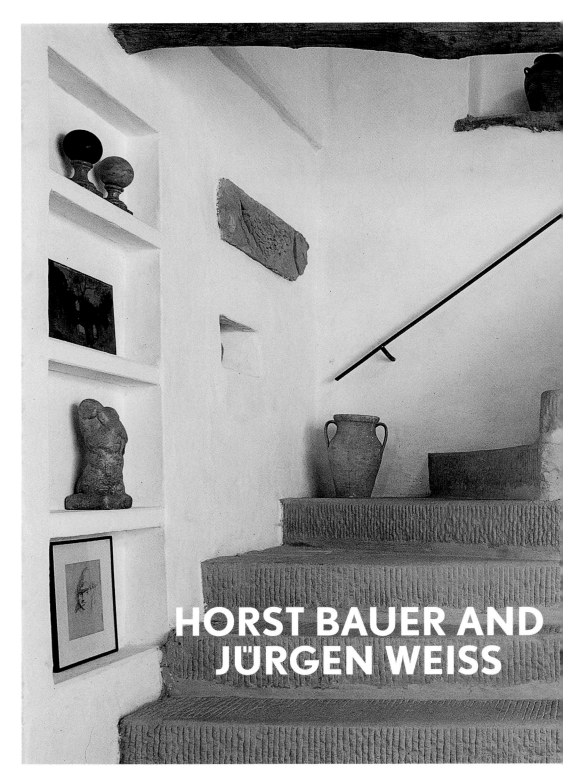

HORST BAUER AND JÜRGEN WEISS

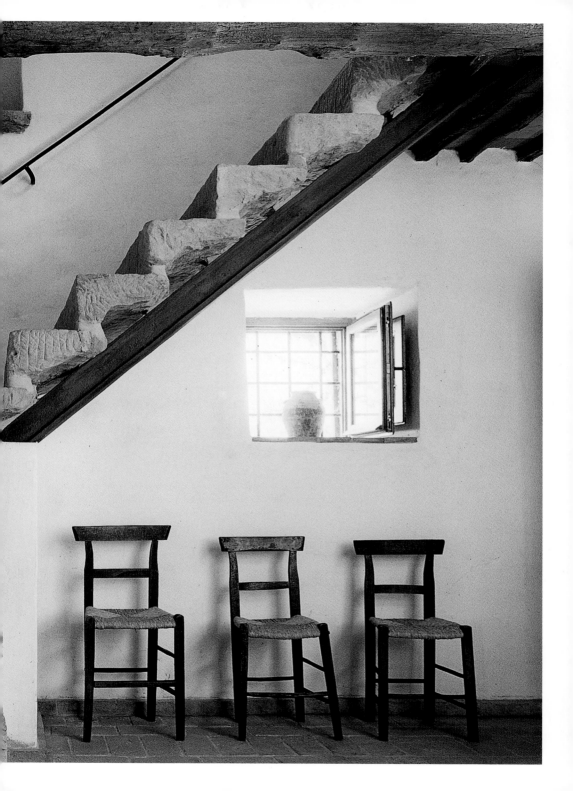

HORST BAUER AND JÜRGEN WEISS
MONTALCINO AND THE MAREMMA

As for many Italians, August is a holiday time for Horst Bauer and Jürgen Weiss – a time for their house in the sparse coastal hinterland. In the former farmhouse, they devote themselves to the creation of delicious dishes, experimenting with aromatic herbs from their own garden. They are antique dealers – with a shop in Munich – as well as expert interior designers. They brought a similar expertise to the restructuring of the *casale*, even finding authentic building materials, such as old beams for the ceilings and granite for the arches. They gutted the building so that they could redesign the interior and make larger rooms. Local traditions have been adhered to and the solar panels are carefully hidden from view. Inside there is an air of rarefied austerity: "A bed, a table and a chair are quite enough," assert the two antiquarians, who nevertheless continue to comb the open-air markets of the area in their search for interesting items.

Wie für viele Italiener sind die Augustwochen auch für Horst Bauer und Jürgen Weiss Ferienzeit – Zeit für ihr Haus im karg bewachsenen Hinterland der Küste. Der ehemalige Bauernhof wird dann zu einer Bühne, auf der sie sich dem Kreieren von köstlichen Gerichten hingeben. Dabei experimentieren sie mit aromatischen Kräutern aus dem eigenen Garten. Eine ähnliche Leidenschaft haben die beiden Münchener Antiquitätenhändler und erfahrenen Innen-architekten auch bei der Umstrukturierung des „casale" bewiesen, für die sie sogar originale Deckenbalken und Granitbögen auftrieben. Zunächst wurde das Gebäude entkernt, um großzügigere Räumlichkeiten zu schaffen. Solarzellen wurden an unauffälligen Stellen angebracht, damit die Ursprünglichkeit des Hauses gewahrt blieb. Die schlichten Innenräume inszenierten die beiden mit feinem Gespür und vornehmer Zurückhaltung. „Ein Bett, ein Tisch und ein Stuhl reichen völlig aus", lautet ihre Überzeugung. Trotzdem haben sie natürlich interessante und originelle Raritäten für ihr Heim gefunden – und sind auch weiterhin begeistert auf der Suche danach.

A l'instar de nombreux Italiens, Horst Bauer et Jürgen Weiss consacrent le mois d'août à leurs vacances et à leur mai-son, située dans l'arrière-pays côtier aride. L'ancienne ferme devient alors le théâtre de succulentes expériences culi-naires, relevées par les fines herbes aromatiques de leur potager. Ils ont fait montre d'une passion similaire quand ils ont restructuré le «casale», récupérant même de vieilles poutres et des arcs en granit d'origine. Ils ont modifié l'intérieur pour créer des espaces plus vastes et se sont efforcés de respecter le style traditionnel, en dissimulant les panneaux solaires avec soin. L'intérieur se veut résolument sobre, d'une élégance fine et discrète : «Il suffit d'un lit, d'une table et d'une chaise» – affirment les deux antiquaires de Munich, architectes d'intérieur confirmés. Cette profession de foi ne les a toutefois pas empêchés de dénicher des pièces originales et intéressantes pour leur maison, et ils continuent à prospecter la région avec enthousiasme, à la recherche de l'objet rare.

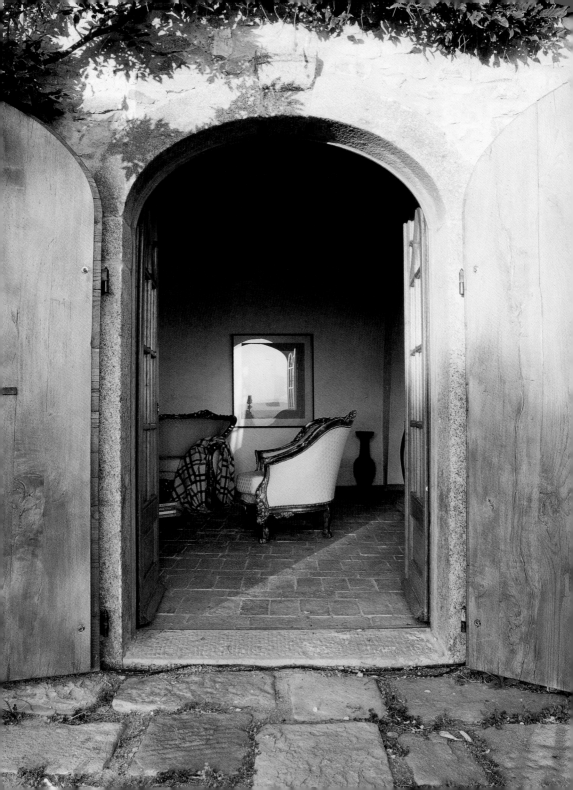

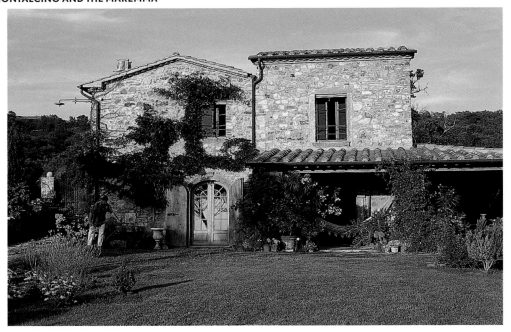

PP. 416–417 The staircase area of the house has a terracotta floor and is decorated with just a drawing, a painting and one or two antiques. The simple stone staircase itself leads up to the bedrooms on the first floor. It was originally from a different house and was built on old railway sleepers. The plain, straw-seated chairs were in the house when Bauer and Weiss took it over. • Die einfache Steintreppe führt zu den Schlafzimmern im ersten Geschoss. Sie stammt ursprünglich aus einem anderen Haus und wurde auf Trägern von alten Eisenbahnschienen eingebaut. Die Wände schmücken eine Zeichnung, ein Gemälde und einige antike Stücke. Die schlichten Stühle mit Sitzen aus Strohgeflecht fanden Bauer und Weiss in dem Haus vor. • Le sobre escalier en pierre qui mène aux chambres du premier étage faisait partie à l'origine d'une autre habitation et a été monté sur des supports de vieux rails de chemin de fer. Un dessin, un tableau et quelques objets anciens ornent l'espace au pavement de brique. Les chaises de paille sans prétention se trouvaient déjà dans la maison à l'arrivée de Bauer et Weiss.

P. 419 One of the entrances to the farmhouse with a door of solid wood. Above the neo-Baroque armchairs hangs a gouache by Serge Poliakoff (1906–1969). The heavy stone slabs outside are from an old village street. • Durch einen Eingang mit massiver Holztür betritt man den Bauernhof. Über den neobarocken Sesseln hängt eine Gouache von Serge Poliakoff (1906–1969). Die schweren Steinplatten des Außenbereichs stammen von einer ehemaligen Dorfstraße. • La porte de bois massif de l'une des entrées de la ferme. Au-dessus des fauteuils néobaroques est accrochée une gouache de Serge Poliakoff (1906–1969). Les lourdes dalles de pierre de l'extérieur proviennent d'une ancienne rue villageoise.

↑ The portico around the farmhouse came from a village church. • Der umlaufende Portikus des Bauernhauses schmückte einst eine Dorfkirche. • La galerie ouverte qui fait le tour de la ferme décorait autrefois l'église du village.

→ Beneath the portico is an inviting table for alfresco meals. The marble top rests on an old military bedstead. In front of the neoclassical vases is a still life of flowers and herbs. The Italian iron and cane chairs date from the Fifties; the candle above is hanging in a glass shade to protect it from the wind. • Unter dem Portikus lädt ein Tisch zum Essen im Freien ein. Die Marmorplatte ruht auf dem Gestell eines ehemaligen Militärbettes. Vor den beiden klassizistischen Vasen ist ein Stillleben aus Blumen und Kräutern arrangiert. Die italienischen Stühle aus Eisen und Rohrgeflecht stammen aus den 1950er-Jahren. • Sous le portique, une table invite à se restaurer en plein air. La plaque de marbre repose sur le cadre d'un ancien lit de camp. Devant les deux vases néoclassiques, un arrangement de fleurs et de plantes odorantes. Les chaises italiennes en fer et rotin datent des années cinquante. La bougie est suspendue à l'intérieur d'un vase de verre qui la protège du vent.

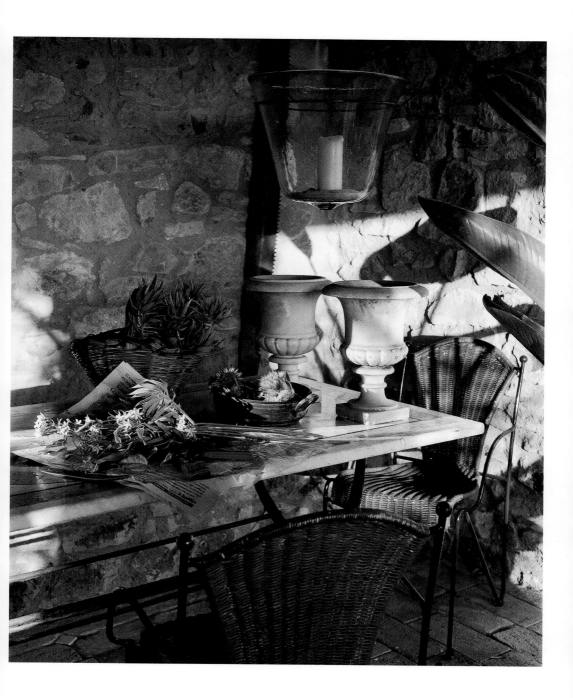

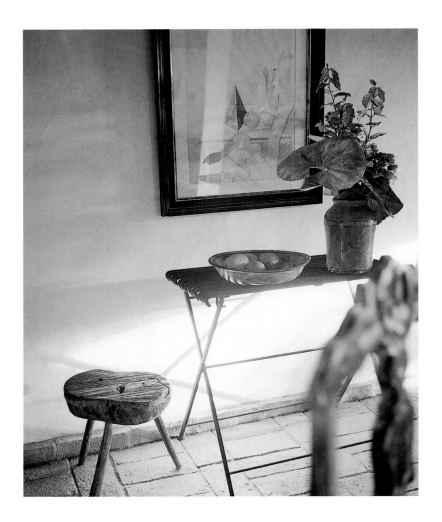

↑ Simplicity is one of the guiding principles of the house. Here, it is exemplified by a milking stool from the byre and a small iron table. The watercolour is by the German painter Horst Antes. • Der Bauernhof ist zurückhaltend möbliert. Hier ein einfacher Melkschemel aus dem Stall und ein kleiner Eisentisch. Das Aquarell ist ein Werk des deutschen Malers Horst Antes. • La ferme est sobrement meublée. Ici un tabouret à traire tout simple et une petite table en fer. L'aquarelle a été réalisée par le peintre allemand Horst Antes.

→ Looking from the dining-room and kitchen to the living room. Over the 17th-century Sienese fireplace are the horns of an eland. In the foreground is an 18th-century Roman bust in marble. The medieval marble reliefs above it represent the owners' signs of the zodiac. • Der Durchblick vom Esszimmer und der Küche in den Kaminraum. Über dem sienesischen Kamin aus dem 17. Jahrhundert hängt das Geweih einer Elenantilope. Im Vordergrund sieht man eine römische Marmorbüste aus dem 18. Jahrhundert. Die mittelalterlichen

Marmorreliefs darüber stellen die Tierkreiszeichen der Hausbesitzer dar. • Vue de la salle à manger et de la cuisine sur la salle où se trouve la cheminée. Au-dessus de la cheminée siennoise du 17e siècle, les cornes spiralées d'un élan. Au premier plan, un buste romain en marbre du 18e siècle. Les bas-reliefs médiévaux en marbre, au-dessus, représentent les signes zodiacaux des maîtres de maison.

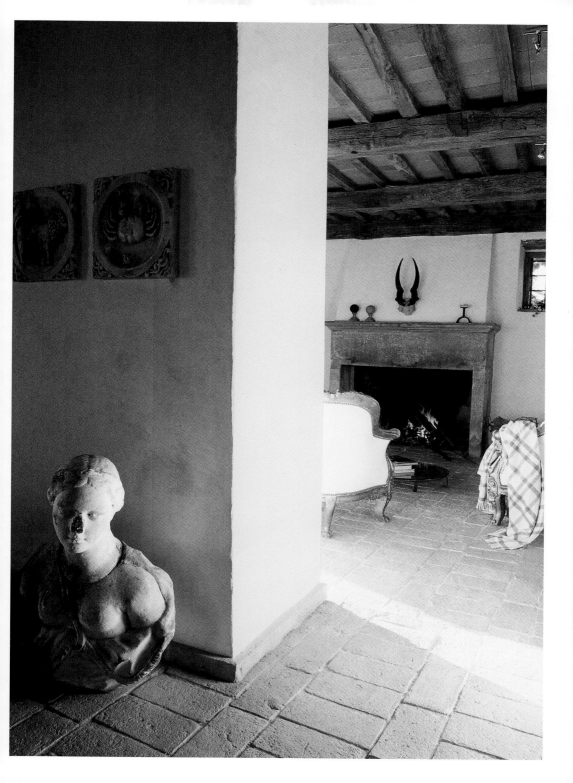

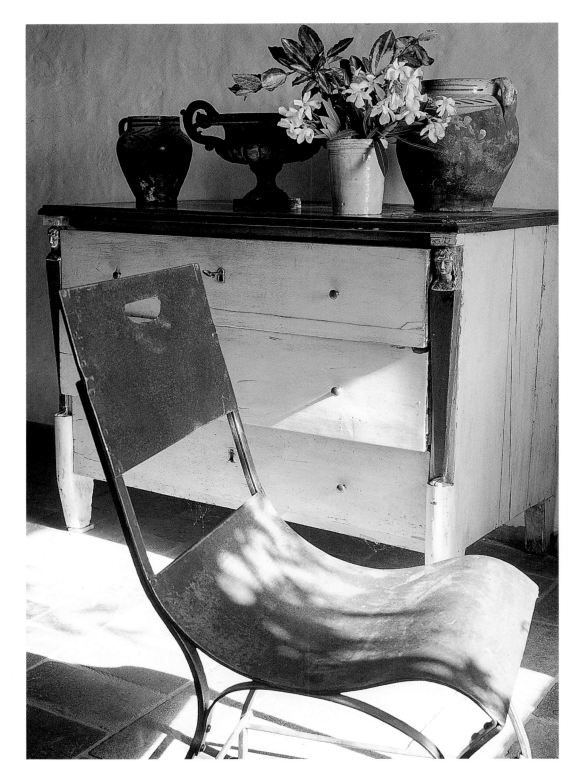

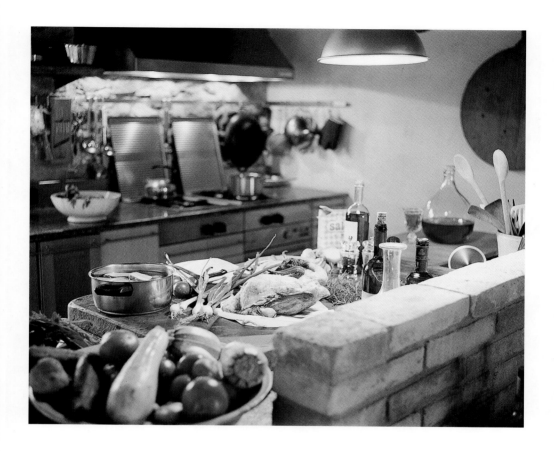

← A French iron chair dating from the turn of the century. In the background is a chest of drawers from Toulouse, with a collection of rustic ceramic vessels made locally. • Ein französischer Eisenstuhl aus der Zeit der Jahrhundertwende. Im Hintergrund sieht man eine Kommode aus Toulouse mit einer Sammlung rustikaler Keramikgefäße aus der Region. • Une chaise en fer française du tournant du siècle. A l'arrière-plan, on aperçoit une commode toulousaine avec une collection de céramiques rustiques régionales.

↑ The kitchen, where fabulous meals are created. Modern design and technology are in deliberate contrast to the rustic dining-room. • Die Küche, Ort gastronomischer Sternstunden. Zeitgenössisches Design und moderne Technik stehen bewusst im Kontrast zum rustikalen Essraum. • La cuisine, centre des exploits gastronomiques. Design et technique modernes contrastent volontairement avec la salle à manger rustique.

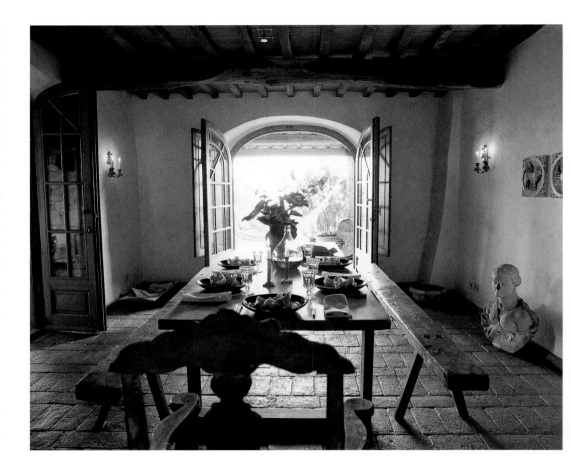

↑ Light floods into the dining room through the French doors. The two wooden benches are from a former monastery. The chair-back in the foreground belongs to a Catalonian farmhouse chair. • Durch die Flügeltüren flutet Licht in das Esszimmer. Die beiden Holzbänke stammen aus einem ehemaligen Kloster. Die Lehne im Vordergrund gehört zu einem katalanischen Bauernstuhl. • La lumière pénètre dans la salle à manger par les deux portes à vantaux. Les deux bancs de bois se trouvaient

à l'origine dans un ancien couvent. Le dossier au premier plan est celui d'un fauteuil paysan catalan.

→ This part of the house, opening onto the stairwell, is free of embellishment: just a terracotta floor, a French console table with a Neapolitan ceramic vessel and a large earthenware jar. On the wall are the horns of a kudu. • Auch dieser Teil des Hauses, der in das offene Treppenhaus übergeht, ist schnörkellos gehalten: Terrakotta-Fußboden, ein

französischer Konsoltisch mit einem Keramikgefäß aus Neapel, ein Tonkrug. An der Wand hängt ein Kudugeweih. • Cette partie de la maison, qui s'ouvre sur la cage d'escalier, offre aussi un caractère dépouillé : un pavement de brique, une console française ornée d'une céramique napolitaine, une jarre en terre cuite. Au mur, les cornes d'un koudou.

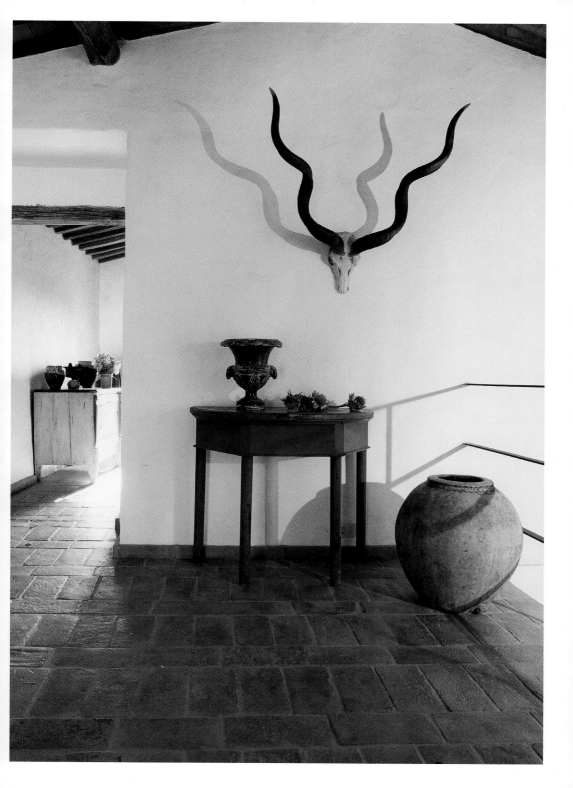

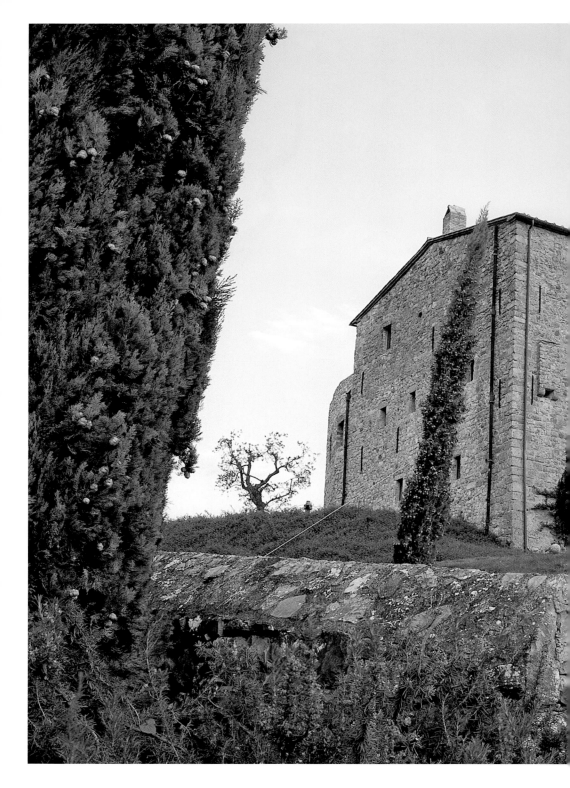

CASTELLO DI VICARELLO

CASTELLO DI VICARELLO
CINIGIANO

The Maremma is the other face of Tuscany: away from the rolling hills, Tuscany is less spectacular and more authentic, with a raw beauty that visitors passing through often fail to notice. But those who do take note sense something wild and romantic – and they fall in love with it. This is what happened to Carlo and Aurora Baccheschi Berti. They had seen the world and worked for many years on Bali as textile designers before discovering a tumbledown castle in the Maremma – and the magic of the place. They restored Castello di Vicarello energetically and stylishly, and turned it into a hotel that exudes the rustic charm of the region, a hotel that is run like a private home and, wonderfully, attracts just the right clientele: people who travel often and in style, and are as happy to talk about this as they are to hear the stories of like-minded guests. The best part of a stay is dinner, sitting at a long table, or relaxing together by the pools. Hotel guests have to do without extras such as television – but who needs a screen with pictures from round the world when the natural images of the Maremma are right outside?

In der Maremma zeigt die Toskana ihr zweites Gesicht: Abseits der sanften Hügel gibt sie sich hier unspektakulärer und ursprünglicher; von einer rauen Schönheit, an der manche Besucher achtlos vorüberfahren. Doch wer sie bemerkt, spürt etwas Wildromantisches, und er verliebt sich in sie. So ging es auch Carlo und Aurora Baccheschi Berti. Sie hatten die Welt gesehen und lange Jahre auf Bali als Textildesigner gearbeitet, ehe sie in der Maremma eine verfallene Burg entdeckten – und mit ihr ihre Magie. Sie restaurierten das Castello di Vicarello mit so viel Energie wie Stil und verwandelten es in ein Hotel, das den rustikalen Charme der Region verströmt, das wie ein Privathaus geführt wird und wunderbarerweise die exakt passende Klientel anzieht: Menschen, die oft und gepflegt reisen und gerne davon erzählen, genauso wie sie neugierig auf die Geschichten Gleichgesinnter sind. Am schönsten sitzt man beim Dinner an der langen Tafel zusammen oder entspannt gemeinsam an den Pools. Auf Extras wie einen Fernseher muss man verzichten – doch wer braucht schon flimmernde Bilder aus aller Welt, wenn er die natürlichen der Maremma direkt vor der Tür hat?

C'est dans la Maremme que la Toscane montre son autre visage : à l'écart des collines aux formes douces, elle est moins spectaculaire et plus authentique, d'une beauté rude que l'on peut méconnaître. Mais celui qui la remarque y discerne un romantisme sauvage et il en tombe amoureux. C'est ce qui est arrivé à Carlo et Aurora Baccheschi Berti. Ils avaient vu le monde et travaillé de longues années à Bali comme designers textiles, lorsqu'ils découvrirent un château fort en ruine dans la Maremme et la magie des lieux. Ils ont restauré le Castello di Vicarello avec autant d'énergie que d'élégance et l'ont transformé en un hôtel qui possède le charme rustique de la région. Il est dirigé comme une maison particulière et attire miraculeusement la clientèle adéquate : des gens qui voyagent souvent, recherchent le raffinement, et aiment autant raconter leurs passions qu'écouter les récits de ceux qui partagent leurs idées. Le soir, pour dîner, la longue table accueille tous les hôtes et il est bon aussi de se détendre ensemble au bord de la piscine. Il faut renoncer à la télévision – mais qui a besoin de voir des images du monde sur un écran quand le paysage de la Maremme est devant sa porte ?

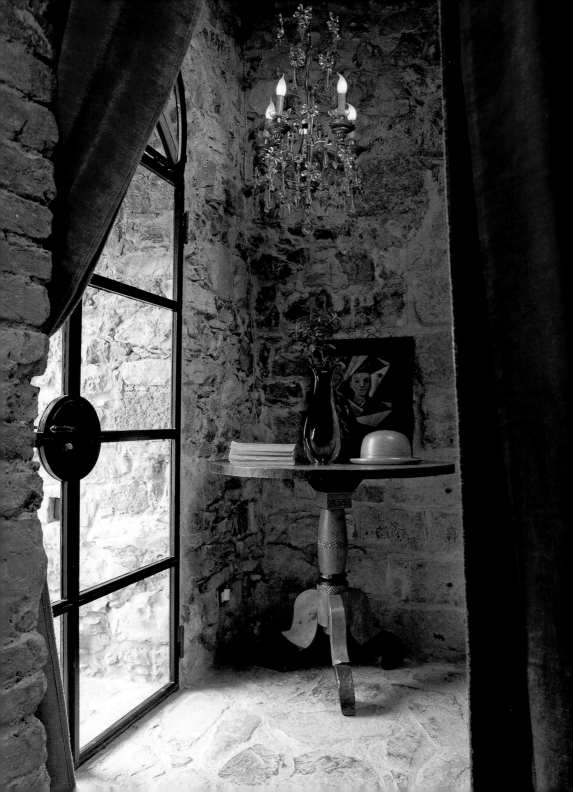

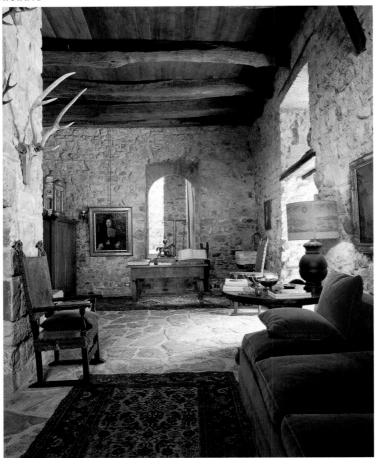

PP. 428–429 At first sight, the
Castello looks strangely like an ancient
fortress and its stark exterior, stripped
of any ornamentation, forms a close
connection with present-day minimalist
architecture. • Auf den ersten Blick
ähnelt das Castello auf merkwürdige
Weise dem Turm einer alten Festung.
Sein karges und von jeglicher Verzie-
rung befreites Äußeres lässt es wie
ein Pendant zur minimalistischen
Architektur unserer Tage erscheinen. •
A première vue le « castello » ressemble
étrangement à la tour d'une ancienne
forteresse et son aspect sévère et nu
de tout ornement le rapproche davan-
tage de l'architecture minimaliste de
notre ère.

P. 431 The interior walls in exposed
stone create a wonderfully romantic
setting that accentuates the beauty of
the furniture and the objects so care-
fully chosen by the owners. • In seinem
Innern vermitteln die bloßen Steinmau-
ern ein herrlich romantisches Ambiente,
und ihre Präsenz hebt die Schönheit
der von den Besitzern sorgfältig ausge-
wählten Möbel und Objekte hervor. •
A l'intérieur les murs en pierres appa-
rentes forment un décor romantique
à souhait et leur présence fait ressortir
la beauté des meubles et des objets
choisis avec soin par les propriétaires.

↑ When it comes to interior design,
Carlo and Aurora have endeavored
to preserve the castle's original architec-
ture and to focus on the beauty of the
materials used and the generous pro-
portions of the various rooms. • Was die
Ausstattung betrifft, haben sich Carlo
und Aurora bemüht, die ursprüngliche
Architektur des Gebäudes zu bewahren
und sich entschieden, ihren Akzent
auf die Schönheit der Materialien und
die großzügigen Proportionen der ver-
schiedenen Räume zu konzentrieren. •
Côté décoration, Carlo et Aurora ont
essayé de à préserver l'architecture
originale du château et ils ont choisi
de mettre l'accent sur la beauté des
matériaux et les proportions généreuses
des différentes pièces.

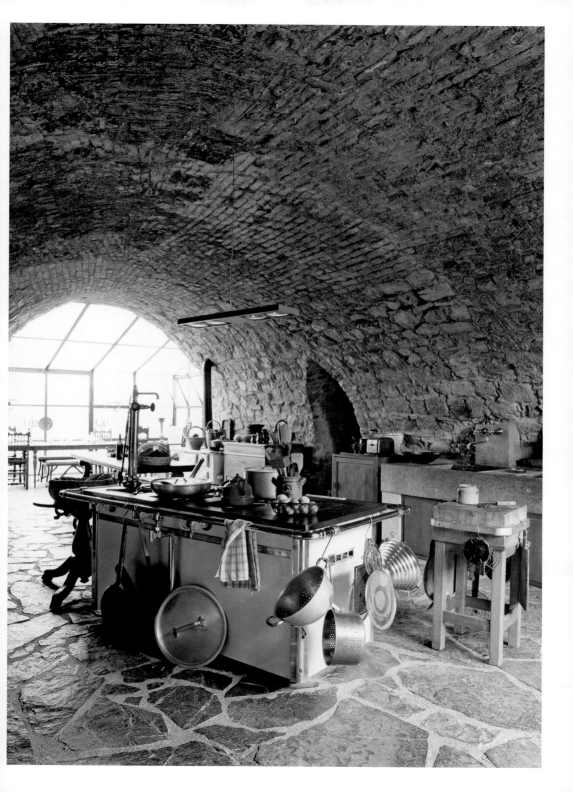

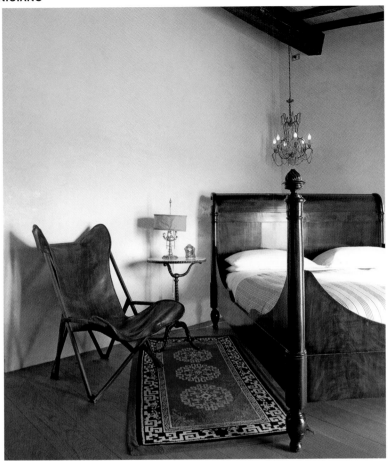

P. 433 In the kitchen, a vintage stove stands beneath the impressive, cut-stone, vaulted ceiling. It was deliberately placed right in the middle of the space, testifying to the owners' passion for the mouthwatering, typically Italian, traditional local cuisine. • Unter dem beeindruckenden Gewölbe aus behauenem Stein steht in der Küche ein alter Herd. Ganz bewusst wurde er mitten im Raum platziert. Auf diese Weise zeugt er von den Intentionen der Bewohner, eine für die Region und für Italien typische Küche anzubieten. • L'impressionnante voûte en pierres de taille de la cuisine abrite une ancienne cuisinière. Elle a été placée intentionnellement au beau milieu de l'espace et témoigne de l'intérêt des habitants pour une

cuisine de terroir succulente et typiquement Italienne !

↑ One of the guest bedrooms features a beautiful Empire bed in solid mahogany and a campaign chair from the same period, each chosen for its unmistakably excellent quality. • Für eines der Gästezimmer wurde ein sehr schönes Empire-Bett aus massivem Mahagoni und ein aus der gleichen Epoche stammender Sessel aufgrund ihrer offensichtlichen Qualitäten ausgewählt. • Dans une des chambres d'hôte un très beau lit Empire en acajou massif et un siège – dit « de campagne » – de la même époque ont été choisis pour leur qualité évidente.

→ The shape of the marble bath is inspired by its Ancient Roman counterparts, but the accessories are most definitely state-of-the-art. • Die Form der marmornen Badewanne hat ihr Vorbild in den Badewannen des antiken Rom. Die Accessoires im Designer-Stil jedoch stammen zweifellos aus vergangenen Tagen unserer Zeit.... • La forme de la baignoire en marbre s'inspire des baignoires du temps de la Rome Antique mais les accessoires « design » sont indéniablement nés hier....

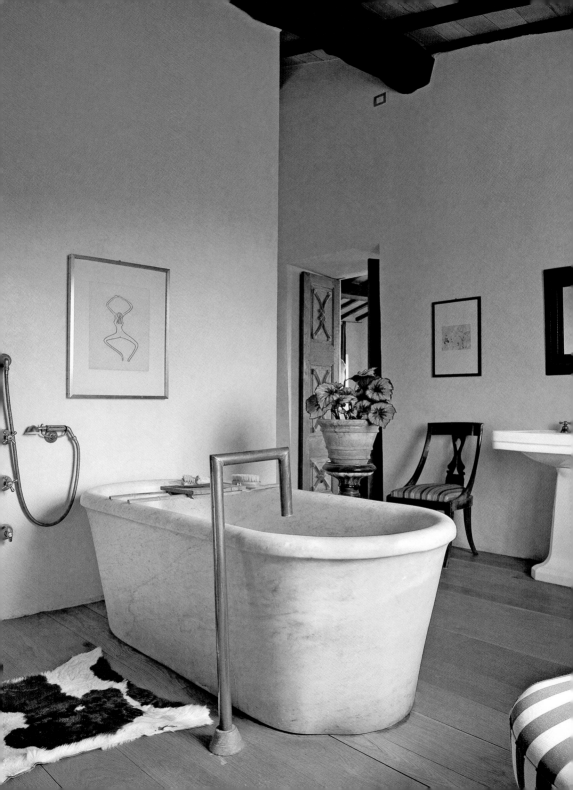

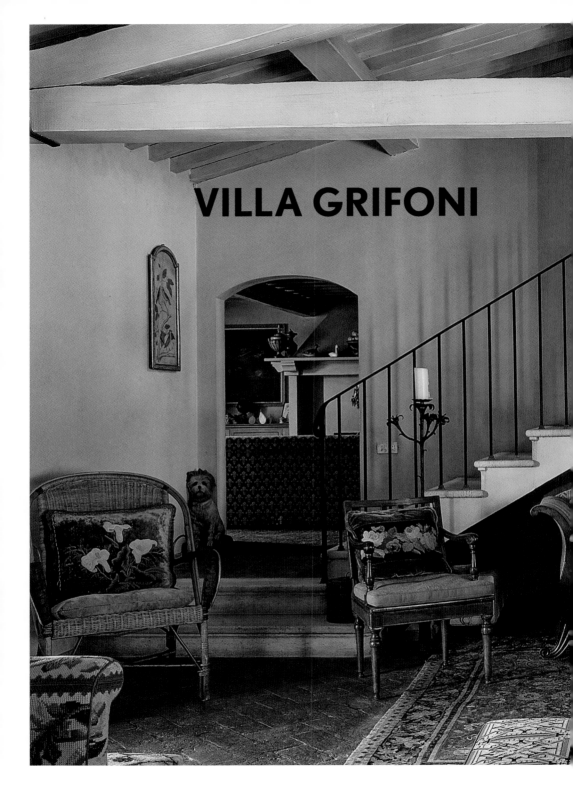

VILLA GRIFONI

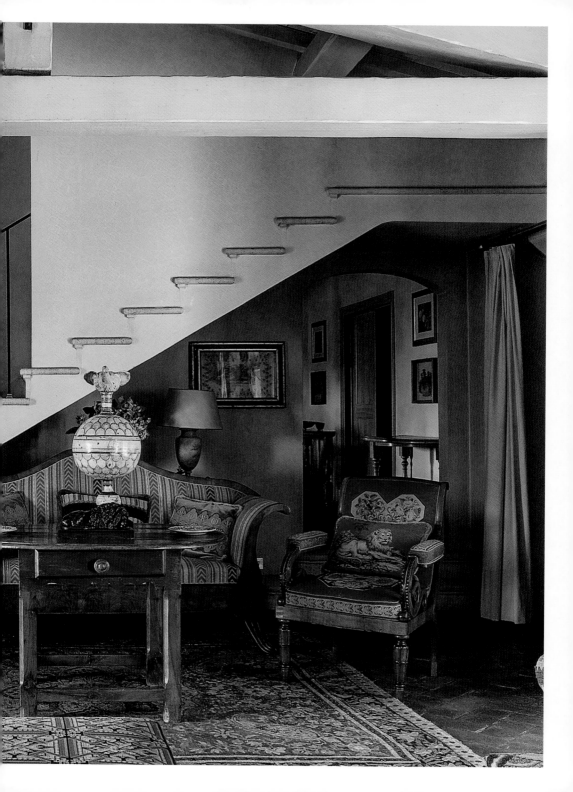

VILLA GRIFONI
CHIUSI

Thirty years ago the young Roman interior designer Cesare Rovatti was called to the bedside of a Tuscan country house like a doctor to a patient whose life hung in the balance. The place was hardly a ruin; on the contrary, it was a beautiful stone building in excellent repair. But its owners had a feeling that Cesare might find a way to tame their cavernous old pile and bestow upon it the atmosphere of an English country house. And so it proved. Rovatti was able to get the best out of the vaulted, typically chiaroscuro rooms. His range of delicate tones blended perfectly with the rustic Italian furniture dating from the 18th and 19th centuries. The style also went well with the assortment of Victoriana – tapestry-covered cushions, bronze animals, oddly realistic earthenware bulldogs and a multitude of English paintings representing animals of every shape and size. The owners, who come to Chiusi to escape their hyperactive professional lives in Rome, still go into ecstasies over the view across their English park from their bedroom balcony. Within is a pretty four-poster bed – and a space in which Rovatti has yet again proved that classical interiors never go out of fashion and that his decor is still as fresh and young as ever.

Vor dreißig Jahren wurde der junge Innenarchitekt Cesare Rovatti aus Rom mit einer solchen Dringlichkeit in ein Landhaus in der Toskana bestellt, wie man sonst einen Notarzt ans Krankenbett ruft! Die Besitzer hatten sich in den Kopf gesetzt, dass Cesare dem weitläufigen Anwesen das Flair eines englischen Landhauses verleihen könnte. Tatsächlich gelang es Rovatti, die Vorzüge der großen Räume hervorzuheben, in denen Licht und Schatten miteinander spielen. Die Farbtöne harmonieren gut mit den antiken italienischen Möbeln und den viktorianischen Sammelstücken der Grifonis: Kissen mit Gobelinbezug, Bronzetiere, eine verblüffend lebendig wirkende Keramik-Bulldogge und zahlreiche englische Gemälde mit Tieren aller Größen und Arten. Die Eigentümer erholen sich hier am Wochenende von ihrem Berufsalltag in Rom. Immer wieder begeistern sie sich für die Aussicht auf den englischen Landschaftsgarten, wenn sie auf der Terrasse ihres Schlafzimmers stehen. Hier hat Rovatti erneut bewiesen, dass klassische Interieurs nie aus der Mode kommen: Seine Ausstattung wirkt immer noch zeitlos schön.

Il y a déjà trois décennies que le jeune décorateur romain Cesare Rovatti fut appelé au chevet d'une maison de campagne toscane comme un médecin que l'on appelle d'urgence au chevet d'un grand malade! La belle demeure en pierre rustique n'était pas une ruine, au contraire. Mais ses propriétaires pensaient que Cesare pourrait maîtriser les volumes de cette grande bâtisse et lui donner ce côté «manoir anglais» qui leur tenait à cœur. Rovatti a su tirer le meilleur parti de ces grandes pièces voûtées où jouent l'ombre et la lumière, et sa palette aux tons délicats se marie à merveille avec les meubles rustiques italiens du 18e et du 19e siècles et avec cette collection hétéroclite nommée Victoriana composée de coussins en tapisserie, d'animaux en bronze, de bouledogues en faïence et d'une multitude de tableaux anglais représentant toutes sortes d'animaux. Les propriétaires qui se reposent ici de leur vie professionnelle trop active à Rome s'extasient toujours à la vue du parc à l'anglaise depuis la terrasse de la chambre à coucher. Une chambre où trône un joli lit à baldaquin et où Rovatti, une fois de plus, nous prouve que les intérieurs classiques ne se démodent jamais et que sa décoration, n'a pas pris une seule ride.

PP. 436-437 The staircase leading to the first floor is classically austere. • Die Treppe, die ins Obergeschoss führt, ist von beispielhafter Schlichtheit. • L'escalier qui mène à l'étage est d'une sobriété exemplaire.

P. 439 A 19th-century bronze bird seems about to take wing from the mantelpiece • Ein Vogel aus Bronze aus dem 19. Jahrhundert ist auf dem Kaminsims gelandet. • Un oiseau en bronze 19ᵉ semble vouloir s'envoler de la tablette de la cheminée.

↑ Beware of the dog! • Achtung, Wachhund! • Attention, le chien monte la garde !

→ The Grifonis love warm colours and comfort. With this in mind, Rovatti created a set of furniture upholstered with tapestry-like fabrics. • Die Grifonis mögen warme Farbtöne und eine behagliche Atmosphäre. Rovatti entwarf Möbel mit gobelinartigen Bezügen. • Les Grifoni adorent les tonalités chaudes et le confort. Rovatti a créé un mobilier couvert de tissus imitant la tapisserie.

PP. 442-443 The spacious, beautiful kitchen is notable for its tiles, which cover the floor, walls and fireplace, and for its rustic pine furniture. • Das Besondere an dieser schönen großen Küche sind die hellen Holzmöbel und die Fliesen an Boden, Wänden und Kamin. • Belle et vaste, la cuisine se distingue par son décor à carrelages qui couvre le sol, les murs et la cheminée rustique et par son mobilier campagnard en bois blond.

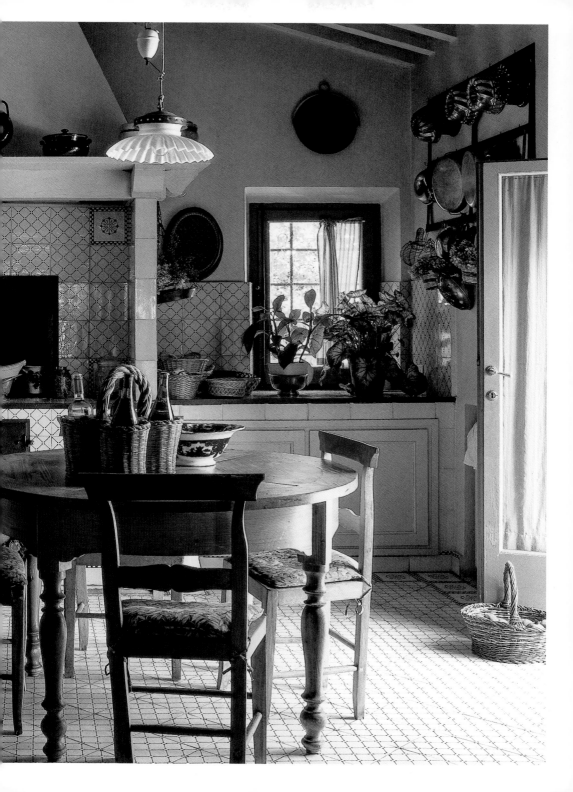

↑ The key of this painted wooden wardrobe is hung with a passementerie tassel. • An dem Schlüssel zu dem bemalten Holzschrank hängt eine Troddel. • La clef de cette armoire en bois peint est ornée d'un gland en passementerie.

→ The spirit of the 19th century predominates in this romantic guest bedroom: moss-green walls, wrought-iron bedsteads and oil lamps. • Der Geist des 19. Jahrhunderts wird in diesem Gästezimmer mit den moosgrünen Wänden, dem schmiedeeisernen Bett und den Petroleumlampen spürbar. • L'esprit 19e règne dans cette chambre d'amis aux murs vert mousse où les lits en fer forgé et les lampes à pétrole évoquent des images teintées de romantisme.

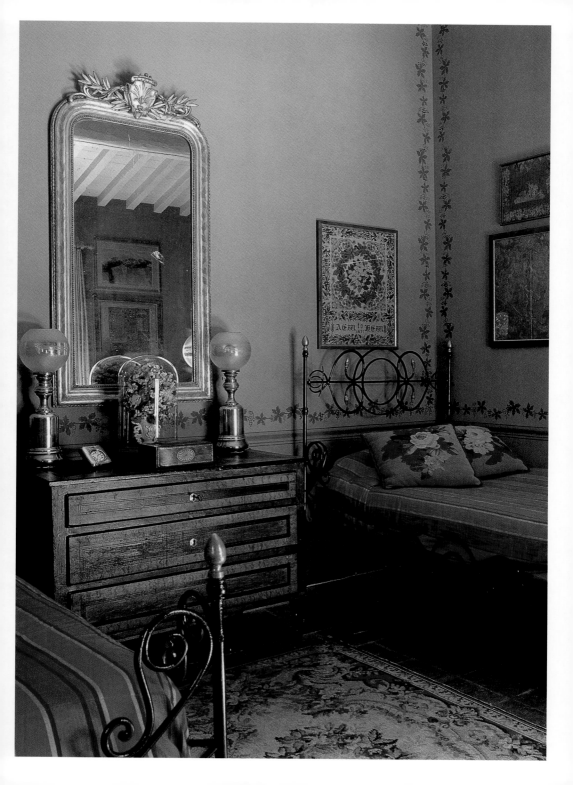

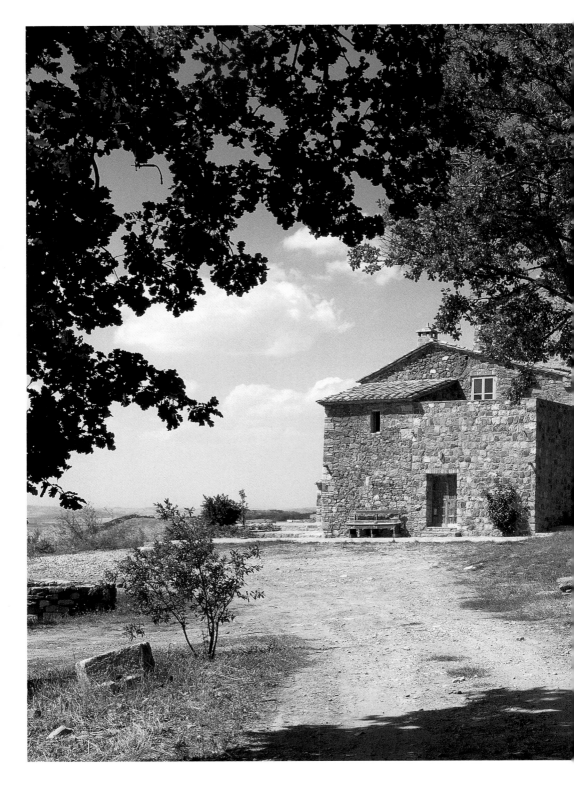

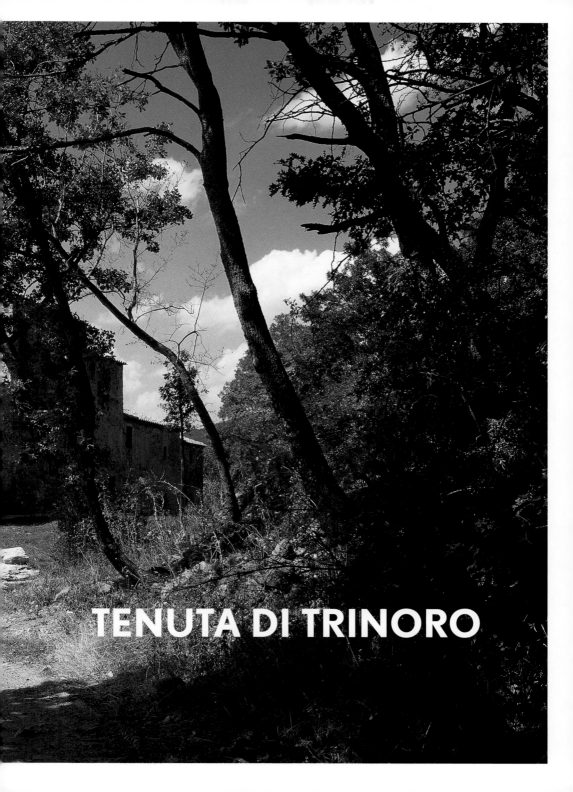

TENUTA DI TRINORO

TENUTA DI TRINORO
ANDREA FRANCHETTI
SARTEANO

Almost thirty years ago Andrea Franchetti immersed himself body and soul in a project which seemed perfectly mad at the time. The idea was to transform 2,000 hectares of arid land in the Orcia valley, south of Siena, into an internationally recognised vineyard. To say that he has succeeded would be an understatement; with matchless tenacity, courage and the unrestrained deployment of bulldozers this tall, fairheaded winegrower has managed to make Tenuta di Trinoro wine the uncontested number one of its kind. At the same time, Franchetti was determined to make his own permanent home in this lovely corner of Tuscany, and accordingly installed himself in a fortified 11th-century tower on the estate. The interiors of Franchetti's house are remarkable for their beauty and austerity, all decorated in a minimalistic style that borders on the ascetic. Andrea Franchetti pours out a glass of his delicious wine, a ray of sunshine lingers on a bowl piled high with ripe tomatoes, and *la vita è bella*...

Es war vor beinahe dreißig Jahren, als sich Andrea Franchetti mit Leib und Seele in ein Vorhaben stürzte, das völlig unmöglich schien: Er wollte 2 000 Hektar trockenes Land im Orcia-Tal südlich von Siena in ein Weinbaugebiet von internationalem Rang verwandeln. Dieses Ziel hat er tatsächlich mehr als erreicht. Mit viel Hartnäckigkeit, persönlichem Engagement und dem Einsatz einiger Bulldozer stampfte der groß gewachsene, blonde Weinbauer Tenuta di Trinoro aus dem Boden und machte aus seinem Wein ein unbestrittenes Spitzenprodukt. Und da Andrea auch im hügeligen Herzen dieses paradiesischen Fleckens der Toskana leben wollte, richtete er sich in einem ehemaligen Befestigungsturm aus dem 11. Jahrhundert ein. Die Innenräume des Palazzo sind von bemerkenswerter Schlichtheit und Schönheit. In der Küche, dem Wohnzimmer, Bad und den Schlafzimmern regiert eine fast asketische Kargheit. Andrea Franchetti bietet uns ein Glas seines delikaten Weins an, ein Sonnenstrahl fällt auf eine mit „pomodori" gefüllte Schale, und „la vita è bella" ...

Il y a près de trente ans que le Baron Andrea Franchetti s'est jeté corps et âme sur un projet qui semblait une folie manifeste : transformer 2 000 hectares de terre arides dans la vallée d'Orcia au sud de Sienne en un domaine viticole de renommée internationale. Dire qu'il a réussi le pari est une expression trop modérée : à coup de courage et de bulldozers, ce grand blond obstiné a fait de la Tenuta di Trinoro et de son vin un « numero uno » incontesté. Et comme il voulait vivre au cœur de ce coin de paradis toscan vallonné, il s'est installé dans une tour fortifiée du 11e siècle. Les intérieurs du palazzo sont d'une beauté et d'une sobriété remarquables, et dans la cuisine, le séjour, la salle de bains et les chambres à coucher règne un dépouillement qui frôle l'ascétisme. Andrea Franchetti nous sert un verre de son délicieux grand vin, un rayon de soleil s'attarde sur une jatte remplie de « pomodori » gorgées de soleil, et « la vita è bella » ...

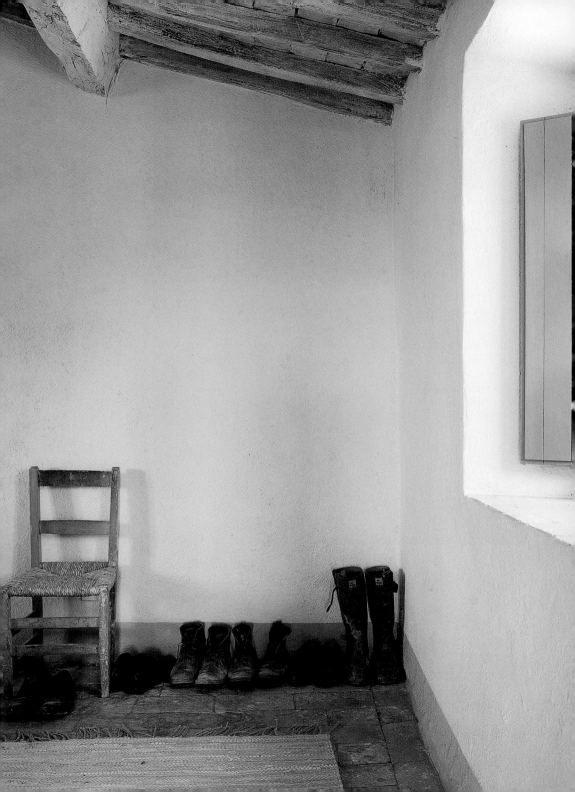

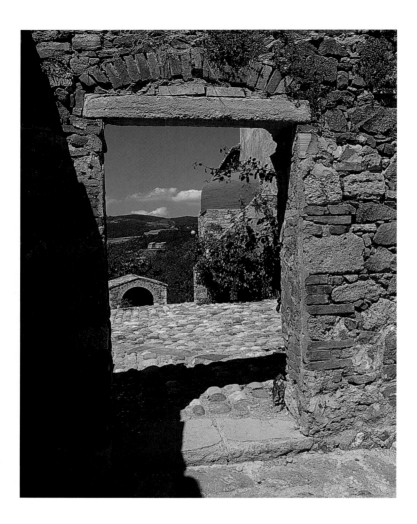

PP. 446–447 The house looks out from its hilltop across the vineyards of Tenuta di Trinoro. • Der Palazzo auf der Anhöhe überragt die Weinberge der Tenuta di Trinoro. • Du haut de sa colline, le palazzo domine les vignobles de la Tenuta di Trinoro.

P. 449 A smallish room serves as the entrance to the house. This is where you take off your dirty boots and shoes. • Ein winziges Zimmer dient als Eingangs-

bereich. Hier zieht man die schmutzigen Schuhe und Stiefel aus. • Une pièce de dimensions modestes sert d'entrée. Ici, on retire ses chaussures et ses bottes encrassées.

↑ The entrance is crowned by a dome of cyclamen-coloured stone reminiscent of Byzantine architecture. • Der Eingang wird von einer zyklamfarbenen Steinkuppel überwölbt, eine Hommage an die byzantinische Architektur. •

L'entrée est coiffée d'un dôme en pierre couleur cyclamen, réminiscence de l'architecture byzantine.

→ A bouquet of herbs, wilting in a terracotta jug. • Ein Kräuterstrauß in einem Terrakottakrug dürstet nach Wasser. • Un bouquet de fines herbes assoiffées languit dans une cruche en terre cuite.

← Andrea Franchetti is a real gourmet – a *buongustaio* – and the sideboard of his kitchen is full of spices, dried pasta, olive oils and vinegars of all kinds. • Andrea Franchetti ist ein echter Gourmet – ein „buongustaio" – und auf der Anrichte in seiner Küche finden sich Kräuter, Pasta, Olivenöl und mehrere Essigsorten. • Andrea Franchetti est un vrai gourmet – un «buongustaio» – et le buffet de sa cuisine est rempli d'épices, de pâtes, d'huile d'olive et de vinaigres.

↑ A prosciutto ham, from which the first slices have just been taken, sits on top of a barrel. • Auf dem alten Fass bietet der angeschnittene „prosciutto" einen appetitlichen Anblick. • Sur un vieux tonneau, un jambon entamé forme un petit tableau appétissant.

PP. 454–455 Ochre walls, a cotto floor and rustic furniture ... all the charm of rural Tuscany is reflected in the decoration of the kitchen. • Ockerfarbene

Wände, ein Boden aus Terrakottafliesen und Bauernmöbel! Der ganze Charme der ländlichen Toskana spiegelt sich in der Dekoration der Küche. • Des murs ocre, un sol en terre cuite et des meubles campagnards! Tout le charme de la Toscane rurale se reflète dans la décoration de la cuisine.

453

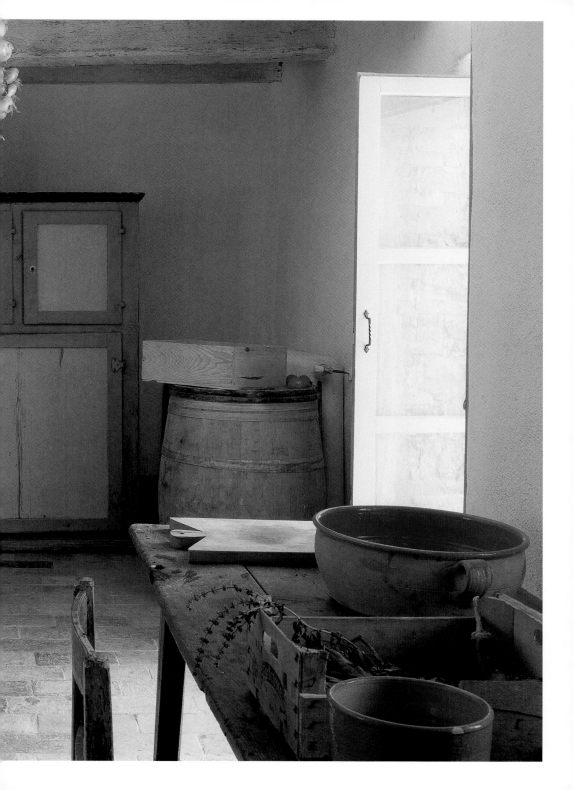

↑ A few dozen ripe tomatoes have been left in the shady hallway out of the oppressive heat. · In der schattigen Kühle des Eingangsbereiches lagern einige Dutzend reife Tomaten. · Dans la fraîcheur ombragée de l'entrée, quelques douzaines de tomates reposent à l'abri de la chaleur accablante.

→ A bright red coat hanging from the top of a linen cupboard echoes the colour of the tomatoes. · Der rote Mantel am Wäscheschrank findet farblich ein Echo in den „pomodori". · Un manteau rouge vif accroché au rebord d'une armoire à linge fait écho aux tomates.

↑ The light in the linen room has a simi-
lar quality to the chiaroscuro of the
Renaissance masters. • Das Spiel von
Licht und Schatten in der Wäschekam-
mer erinnert an das „chiaroscuro", das
Helldunkel, eines typischen Renais-
sance-Gemäldes. • Le clair-obscur
qui règne dans la lingerie évoque les
tableaux des maîtres de la Renaissance.

→ Andrea Franchetti has converted
one of the rooms on the first floor into a
spacious, entirely minimalist bathroom.
The shower, stripped of its usual glass
walls and plastic curtain, is a real eye-
opener. • Andrea Franchetti hat einen
der Räume in ein riesiges minima-
listisches Bad verwandelt. Besonders
bemerkenswert: die Dusche ohne

Trennwände oder Vorhang. • Andrea
Franchetti a transformé une des pièces
à l'étage en salle de bains spacieuse et
minimaliste! La douche sans parois
en verre et rideau traditionnels est une
trouvaille extraordinaire.

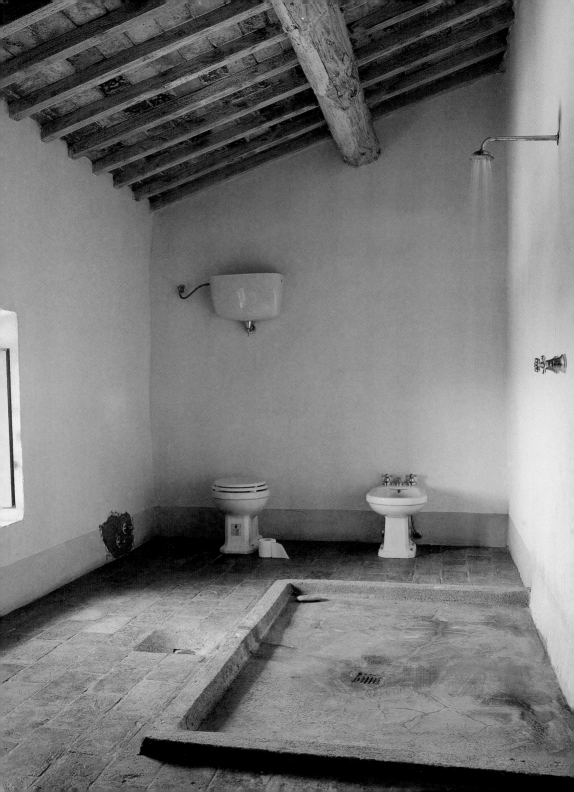

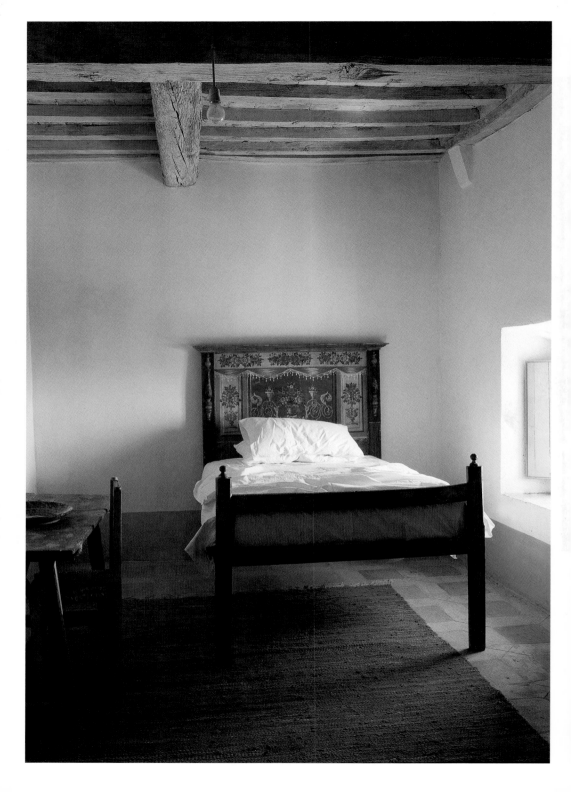

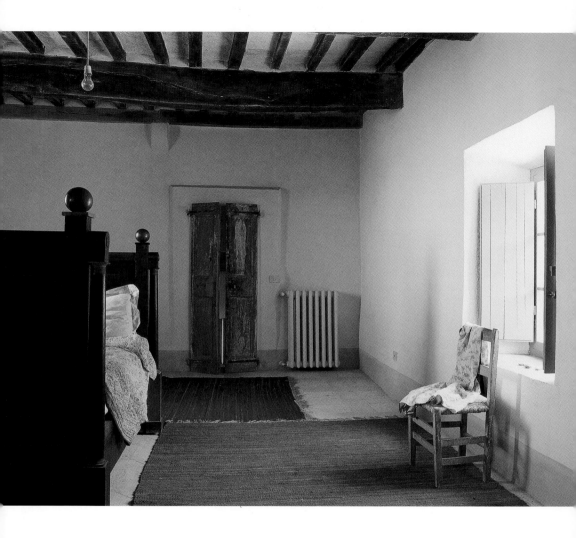

← In a guest bedroom, the head of the 19th-century bed is decorated with flower motifs. • Blumenmotive zieren das Kopfteil des Betts aus dem 19. Jahrhundert in einem der Gästezimmer. • Dans une chambre d'amis,la tête du lit 19ᵉ est décorée de motifs floraux.

↑ In one of the bedrooms, the sobriety of the décor exactly offsets the austere architecture of the house. The Empire bed is made of mahogany. • In einem der Schlafzimmer betont die karge Einrichtung die nüchterne Architektur des Palazzo. Das Empire-Bett ist aus Mahagoni. • Dans une des chambres, la sobriété du décor va de pair avec l'architecture dépouillée. Le lit Empire est en acajou.

P. 1 Detail of the fresco in the entrance corridor of Villa di Geggiano. • Detail des Freskos im Eingangsflur der Villa di Geggiano. • Détail de la fresque qui orne le couloir de l'entrée de la Villa di Geggiano.

P. 2 In Tuscany old villas overflow with frescoes and *vedute*, usually inspired by pastoral subjects or the distant silhouette of an ancient fortress. • Die alten Villen in der Toskana sind mit einer Fülle von Fresken und Veduten ausgeschmückt, die in der Regel Landschaftsmotive aufgreifen oder in der Ferne erkennbare Umrisse einer Festung früherer Epochen darstellen. • En Toscane, les villas anciennes regorgent de fresques et de « vedute » qui s'inspirent d'office d'un thème pastoral ou de la silhouette lointaine d'une ancienne forteresse.

P. 6 Tomato-filled jars lined up on the shelves of an 18th-century cobalt-blue dresser. • Gläser mit eingemachten Tomaten in den Regalen eines kobaltblauen Schrankes aus dem 18. Jahrhundert aufgereiht. • Bocaux remplis de « pomodori » alignés sur les rangements d'un meuble 18ᵉ peint en bleu cobalt.

P. 9 In Tuscan orchards, the fruit is harvested using traditional methods, including the help of a ladder. • Die Ernte wird in den Obstgärten der Toskana noch immer auf traditionelle Weise – und mit Hilfe einer Leiter – eingebracht. • Dans les vergers de Toscane la récolte des arbres fruitiers se fait toujours de façon traditionnelle et.... à l'aide d'une échelle.

We would like to express our profound gratitude to all those who have assisted us in making this book, and especially to those people all over Tuscany who received us with such sincerity and warmth while we were doing our research. In addition to acknowledging the help of the owners and inmates of the wonderful houses shown in these pages, we wish to offer our special thanks to Mr. Giorgio Leonini, who guided us so surely in our wanderings; and to Laurie and Andrea Laschetti, Elisabetta Pandolfini, Lucia and Giuliano Civitelli, Marten van Sinderen, Roberto Budini Gattai and Valentina Buscicchio, without whom we would have been totally unable to translate the most beautiful and authentic aspects of Tuscany into words and images.

Wir möchten all jenen unsere Dankbarkeit ausdrücken, die uns bei der Realisierung dieses Buches geholfen haben. Selten sind wir so herzlich und liebenswürdig aufgenommen worden. Wir bedanken uns bei den Eigentümern und Bewohnern der herrlichen Häuser, die dieses Buch illustriert, und ganz besonders bei Giorgio Leonini, der uns ein wunderbarer Führer war, bei Laurie und Andrea Laschetti, Elisabetta Pandolfini, Lucia und Giuliano Civitelli, Marten van Sinderen, Roberto Budini Gattai und Valentina Buscicchio. Ohne sie wäre es uns nicht möglich gewesen, die Schönheit und Ursprünglichkeit der Toskana in Bilder umzusetzen.

Il est difficile de trouver les mots pour exprimer notre reconnaissance envers tous ceux qui nous ont aidés à réaliser ce livre. Nous avons rarement reçu un accueil aussi sincère et chaleureux. En dehors des propriétaires et des habitants des merveilleuses maisons qui illustrent ces pages, nous tenons à remercier vivement M. Giorgio Leonini qui fut un guide hors pair, ainsi que Laurie et Andrea Laschetti, Elisabetta Pandolfini, Lucia et Giuliano Civitelli, Marten van Sinderen, Roberto Budini Gattai et Valentina Buscicchio. Sans leur aide, il nous aurait été impossible de traduire en images ce que la Toscane possède de plus beau et de plus authentique.

Barbara & René Stoeltie

IMPRINT

EACH AND EVERY TASCHEN BOOK PLANTS A SEED!
TASCHEN is a carbon neutral publisher. Each year, we offset our annual carbon emissions with carbon credits at the Instituto Terra, a reforestation program in Minas Gerais, Brazil, founded by Lélia and Sebastião Salgado. To find out more about this ecological partnership, please check: www.taschen.com/zerocarbon
Inspiration: unlimited. Carbon footprint: zero.

To stay informed about TASCHEN and our upcoming titles, please subscribe to our free magazine at www.taschen.com/magazine, follow us on Instagram and Facebook, or e-mail your questions to contact@taschen.com.

© 2023 TASCHEN GmbH
Hohenzollernring 53, D–50672 Köln
www.taschen.com

Original edition: © 2000 TASCHEN GmbH

Printed in Bosnia-Herzegovina
ISBN 978-3-8365-9442-4

TEXTS BY
Barbara and René Stoeltie, Paolo Rinaldi, Christiane Reiter, Max Scharnigg, Kristin Rübesamen, Julia Strauß, Dian Dorrans Saeks

ENGLISH TRANSLATION
Anthony Roberts, Isabell Varea-Riley, George Giles Watson, Pauline Cumbers, Iain Reynolds, Robert Taylor, John Sykes

GERMAN TRANSLATION
Marion Valentin, Egbert Baqué, Antje Longhi, Franca Fritz & Heinrich Koop

FRENCH TRANSLATION
Pascal Vareijka, Sabine Boccador, Christèle Jany, Philippe Safavi, Michèle Schreyer, Annick Schmidt, Alice Petillot